In memory of Keith Andrews

Adam Elsheimer 1578–1610

Rüdiger Klessmann

with contributions from
Emilie E.S. Gordenker
Christian Tico Seifert

National Gallery of Scotland, Edinburgh
Dulwich Picture Gallery, London
Städelsches Kunstinstitut Frankfurt

in association with
Paul Holberton publishing, London

Published to accompany the exhibition *Devil in the Detail: The Paintings of Adam Elsheimer 1578–1610* held at Städelsches Kunstinstitut und Stadtische Galerie, Frankfurt, from 17 March to 5 June 2006, National Gallery of Scotland, Edinburgh, from 23 June to 3 September 2006, and Dulwich Picture Gallery, London, from 20 September to 3 December 2006.

Paperback edition published by the Trustees of the National Galleries of Scotland in association with Dulwich Picture Gallery.
NGS Publishing
Belford Road, Edinburgh EH4 3DS
www.nationalgalleries.org

Hardback edition published by
Paul Holberton publishing
37 Snowsfields, London SE1 3SU
www.paul-holberton.net

ISBN (paperback) 1 903278 78 3 (978 1 90327878 9)
ISBN (hardback) 1 903470 47 1 (978 1 90347047 3)

British Library Cataloguing in Publication Data
A catalogue record for this book is available from the British Library.

Designed by Gini Klose, Oberhaching/Munich
Printed by Peschke Druck, Munich

Jacket/cover image: detail of *The Flight into Egypt*, cat.no.36
Back jacket/cover image: detail of *Jupiter and Mercury in the House of Philemon and Baucis*, cat.no.35
Frontispiece: detail of *Emperor Heraclius' Entry into Jerusalem,* from *The Finding and Exaltation of the True Cross,* cat.no.20

Contents

Errata

Please note that there are errors with the footnotes on pages 212–20. Four of the footnote references in the text have inadvertently been excised. Consequently, footnote references in the text do not correspond with the footnotes at the end of the essay. The text should be corrected as follows:

PAGE 212
There are two footnote references missing after footnote 41. The missing references are as follows:

The date on Thomann von Hagelstein's work was initially read as '1609',[42] then as '1607'.[43]

Footnote reference 42 should be read as 44 to correspond with the list of footnotes at the end of the essay. Therefore, footnote reference 43 becomes 45, and so on, until footnote reference 78 (76 in text).

PAGE 215
There are two footnote references missing after footnote 78 (76 in the text). The missing references are as follows:

It is possible, for example, that Giovanni Battista Caracciolo (1578–1635) was familiar with one of them and that his painting of the same subject reflects that knowledge.[79] As has been pointed out by Kurt Bauch, the work's influence is particularly evident in the painting by Johann Heinrich Schönfeld (1609–1684), the *Liberation of Saint Peter*, which was executed in Naples in c.1643–44.[80]

Footnote reference 77 should be read as 81 to correspond with the footnotes at the end of the essay. From this point on, please add four to every footnote reference to ensure correspondence with the footnotes at the end of the essay.

Foreword

Adam Elsheimer is one of the unsung heroes in the history of Western European art. Although his work is well known among specialist circles, it remains unjustifiably obscure to a wider public. This exhibition seeks to right that wrong. Elsheimer transformed every genre he touched – narrative, landscape and the depiction of interiors – and he played a crucial part in the creative development of three of the most important artists of the seventeenth century: Rubens, Rembrandt and Claude Lorrain. As we undertake this rediscovery, the wise observation of the foremost Elsheimer scholar of recent times should be remembered: 'Each age created a new Elsheimer for itself, and it is time for a closer look at the work in order to discover whether the accretions can beremoved and the real, essential artist revealed.'

With these words Keith Andrews, the distinguished Keeper of Prints and Drawings at the National Gallery of Scotland from 1958 to 1985, opened his groundbreaking 1977 monograph on Adam Elsheimer. The most important Elsheimer scholar of his day, Andrews set out to review the artist's oeuvre and to identify the hand of the painter so highly prized by his own contemporaries. In the first monograph by Heinrich Weizsäcker, published in 1938, about sixty works were attributed to Elsheimer. By 1966, when the first Elsheimer exhibition was organised in Frankfurt by Ernst Holzinger – the director of the Städel at the time – this number had been substantially reduced. But it was Keith Andrews who, on the basis of in-depth research and scrupulous scholarship, arrived at the even smaller number of works that is still largely accepted today.

Nearly thirty years after the publication of Andrews's trail-blazing monograph on Elsheimer, it is time to take a fresh look at the great painter from the perspective of our own time. The enduring validity of Andrews's findings is evident from the fact that the number of works attributed to the artist has hardly changed. With the present exhibition, we are once again placing Adam Elsheimer's oeuvre in the limelight. The show is dedicated to the memory of Keith Andrews, to whom we largely owe our present understanding of Elsheimer. At the same time, it offers those of us in Frankfurt an opportunity to commemorate the initiative of Ernst Holzinger, who was responsible for purchasing the *Conversion of Paul* and the first panels of the *Frankfurt Tabernacle* and critically investigated the artist's work. Rüdiger Klessmann, currently the foremost Elsheimer scholar, has written the accompanying catalogue, which places special emphasis on the contemporary context of Elsheimer's work. The torrent of scholarly studies published in the past years, devoted not only to Elsheimer's artistic circle, but also to intellectual life in Rome in the period around 1600 and the scientific interests of the time, have led to a new understanding of the artist.

Klessmann sketches the portrait of a painter who came from the long-established mercantile town of Frankfurt and travelled to the Eternal City, where he not only discovered an artistic world but also an intellectual one. Elsheimer's paintings, until now appreciated primarily for aesthetic reasons, reveal a highly inquisitive mind and a thirst for knowledge that was surely the driving force behind his assimilation of the view through a telescope or magnifying glass, and also of new discoveries such as the study of the Milky Way. The fascinating essay on Elsheimer's contemporaries by Christian Tico Seifert sheds light on the painter's lively exchanges with other artists and the lasting influence he exerted on them with his innovative compositions. The high esteem enjoyed by Elsheimer – whose paintings were already much sought after within his own lifetime – is the subject of the illuminating essay by Emilie Gordenker, who retraces the history of his works in British collections.

Adam Elsheimer was born in Frankfurt in 1578 and is the most important artist to have emerged from this city. The Städelsches Kunstinstitut possesses the largest collection of his works in the world and has long been dedicated to the investigation of his artistic activities. The author of the 1938 monograph, Heinrich Weizsäcker, was formerly the Director of the Städel. For all of these reasons, Frankfurt had been planning an Elsheimer exhibition as a tribute to Herbert Beck, who this year is retiring from his position as Director of the Städel. The opportunity then arose to join forces with the National Gallery of Scotland and the Dulwich

Picture Gallery (where a similar project was in the making) and to organise a truly comprehensive exhibition of the artist's work. Elsheimer was widely known in Britain at a very early date, attested to by the English miniaturist and writer Edward Norgate. In 1644 – only thirty-four years after Elsheimer's death – Norgate wrote that the Italians had referred to the artist as 'il diavolo per glie cose picole'. Best translated as 'devilishly good at small things', this pithy statement pinpoints precisely what lies behind Elsheimer's fame: his miniature-like works on copper which offer complex narratives, entire landscape panoramas and astounding light effects in a multitude of details. It is from this Norgate quotation that the British venues of the exhibition have drawn their title *Devil in the Detail.*

We are extremely fortunate in being able to show all of the surviving paintings by Elsheimer with only two exceptions, as well as many works on paper which are directly related to extant and lost compositions. The exhibition thus represents the first, possibly the last, and in any case a very splendid opportunity to see so many of Elsheimer's works together. For this, we are extremely grateful to the lenders, whose generosity has made it possible for us to show an almost complete overview of Elsheimer's surviving paintings. We also owe this amazing success in large part to Rüdiger Klessmann, former Director of the Herzog Anton Ulrich-Museum in Brunswick and esteemed scholar of the art of the period around 1600. We are extremely privileged to have benefited from Rüdiger Klessmann's expertise and sage advice, as well as the high standard of his scholarship, as is evident in this catalogue.

In Frankfurt, Michael Maek-Gérard, Head of the Baroque Department, was curator of the exhibition. Michael Zuch, Exhibition Assistant, was responsible for the careful editing of the German catalogue and, with Chief Registrar Katja Hilbig and her Assistant Doris Prade, the organisation of the loans. Diane Webb and Judith Rosenthal provided translations from German to English, Rita Hummel from English to German. We are indebted to the Deutsche Bank, especially Tessen von Heydebreck, for supporting the exhibition.

In Edinburgh Emilie Gordenker, Senior Curator, Early Netherlandish, Dutch and Flemish Art, curated the exhibition. Julia Lloyd Williams, formerly of the National Gallery of Scotland, conducted the initial negotiations for the Edinburgh showing. In addition, we would like to thank all our colleagues in the National Galleries of Scotland who have worked on the exhibition, especially Agnes Valencak-Kruger, Exhibitions Registrar, Lesley Stevenson, Senior Paintings Conservator, Keith Morrison, Frames Conservator, Charlotte Robertson, Curatorial Administrator, and Janis Adams, Head of Publishing. The exhibition in Edinburgh has been made possible by an anonymous donation and has been supported by the Bacher Trust, Randy and Lara Lerner, and the Lynn Foundation.

At Dulwich Picture Gallery, our thanks are due to Victoria Norton, Head of Exhibitions, Eloise Stewart, Exhibitions Officer, and Mella Shaw, Exhibitions Assistant. We also owe a debt of gratitude to the Gallery's former Director, Desmond Shawe-Taylor, now Surveyor of the Queen's Pictures, whose energy and enthusiasm drove the early stages of the project. The show at Dulwich could not have happened without the generous support of the Arthur & Holly Magill Foundation; as always, the Friends of Dulwich Picture Gallery have also been exceptionally generous. Our profound thanks go to all of them for their support.

Max Hollein
Director, Städelsches Kunstinstitut

Michael Clarke
Director, National Gallery of Scotland

Ian A. C. Dejardin
Director, Dulwich Picture Gallery

Chronology

1578

Adam Elsheimer is baptised on 18 March 1578 in the Lutheran Barfüsserkirche in Frankfurt am Main. His father, the master-tailor Anthonius Elsheimer, left Wörrstadt in Rheinhessen to settle in Frankfurt in 1577. His mother, Martha Reuss, is the daughter of a master-cooper of Frankfurt. Adam's godfather is Adam Keck, an apothecary whose shop is called 'zum Schwan'.

Extract from the Frankfurt baptismal records, 18 March 1578

1582

Elsheimer's father acquires a house next to the 'Rote Badstube', now at Fahrgasse 120. Here Adam continues to live until his departure from Frankfurt in 1598. In 1635 the house is still in the possession of Adam's younger brother Johann, also a painter. It is destroyed by Allied bombing in 1944.

1596

Together with the glass-painter Johannes Vetter the Younger, Elsheimer signs a design (now in Düsseldorf) for an armorial window honouring the Frankfurt butcher and town councillor Philipp Mohr and his wife Katharina. Mohr is a relative of Elsheimer's godfather, Adam Keck; in 1579 Mohr's wife becomes godmother to one of Elsheimer's sisters.

1596?

A drawing signed by Elsheimer (now in Karlsruhe), formerly in the possession of the Strasbourg painter Friedrich Brentel, makes it likely that Elsheimer undertook a journey to Strasbourg with Johannes Vetter in or shortly before 1596.

1598

Elsheimer delivers a signed design for an etching, published in 1598 with other etchings by him in the Frankfurt *Messrelationen*, a newsheet issued twice a year in connection with Frankfurt's trade fair. This was probably a commission arranged by his teacher, Philipp Uffenbach.

1598

Elsheimer signs and dates a drawing (now in Brunswick), presumably while staying in Munich, that is part of an *album amicorum* belonging to an unknown person from Munich.

1600

On 21 April, in Rome, Elsheimer writes a dedication on a leaf (now in Munich) in the *album amicorum* of Abel Prasch the Younger from Augsburg. Prasch, the son of the organist of the same name at the cathedral in Augsburg, is staying in Rome, together with his younger brother Max, to witness the celebrations marking the jubilee year, or *Anno Santo*, of 1600. Another page from an *album amicorum*, in Dresden, containing a depiction of a Roman fountain, bears the inscription 'Adam Ehlsheim in Roma 1600'. It is not known to whom the album belonged.

1604

Elsheimer is first mentioned in a publication, the *Schilder-Boeck* by Karel van Mander, who not only stresses the high quality of Elsheimer's painting but also describes his working method.

1606

On 11 December Elsheimer signs a contract in the presence of the notary Petrus Martinus Trucca stipulating the terms of his marriage to Carola Antonia Stuart of Frankfurt, widow of the Verdun-born painter Nicolas de Breul. The bride, originally from Scotland, brings to the marriage, in addition to a dowry of 1,000 *scudi*, her furniture, her household belongings and some paintings. The witnesses are the painters Pietro Facchetti and Paul Bril. The marriage is solemnised on 22 December, the witnesses being the artists mentioned above and Dr Johann Faber of Bamberg in Germany. Elsheimer lives in the Via Paolina (now Via Babuino).

1607

The annual census (*Stato d'anime*) taken in the parish of San Lorenzo in Lucina records Elsheimer, his wife, Hendrick Goudt ('Sr Henrico pictore') and some servants as the residents of a house in the Via Bergamaschi (now Via Greci).

1607

Elsheimer first pays membership fees to the Accademia di San Luca. A portrait of the painter hanging in the academy is dated 1606.

1608

Elsheimer's son, Giovanni Francesco, born on
4 October, is baptised in San Lorenzo in Lucina. His
godfather is Johann Faber.

1608

Hendrick Goudt, Elsheimer's pupil and a member of
his household, completes an engraving after his mas-
ter's painting the 'small Tobias'.

1609

On 9 February Elsheimer signs a contract with Paolo
de Fratis, agreeing to rent an apartment on the top
floor of a house in the Via Paolina (now Via Babuino).

1609

The census taken of the parish residents (*Stato
d'anime*) records Elsheimer, his wife and Hendrick
Goudt as living in the house in the Via Paolina. Their
one-year-old son, Giovanni Francesco, is not men-
tioned, perhaps because he has been entrusted to a
wet-nurse, in accordance with Roman custom.

1609

Rubens, who left Rome in October 1608, writes a letter
to Johann Faber from Antwerp on 10 April. Rubens
mentions that the German philologist in the employ of
the Pope, Gaspar Scioppius (Schoppe), has brought
about Elsheimer's conversion to Catholicism. He
further bids Faber to give his regards to Elsheimer and
Hendrick Goudt, saying he has fond memories of the
conversations he had with them in Rome.

1610

Hendrick Goudt completes an engraving after Els-
heimer's painting *The Mocking of Ceres*. The sheet
bears a dedication to Cardinal Scipio Borghese, one of
Rome's leading art collectors.

1610

Elsheimer dies on 11 December and is buried the same
day in the parish church of San Lorenzo in Lucina. On
17 December his widow declares that any claims on
the painter's estate should be brought forward and will
be decided upon after the inventory has been drawn
up on 19 December. Elsheimer's creditors include
Hendrick Goudt, Paul Bril and his landlord. The inven-
tory reveals the painter's extremely straitened circum-
stances.

1610

Johann Faber informs Rubens of Elsheimer's death on
18 December. Rubens answers this letter, which has
not survived, in a letter written on 14 January 1611
from Antwerp, in which he voices this moving lament:

'Surely, after such a loss, our entire profession ought to
clothe itself in mourning. It will not easily succeed in
replacing him; in my opinion he had no equal in small
figures, in landscapes, and in many other subjects. He
has died in the flower of his art, while his corn was still
in the blade. One could have expected things from him
that one has never seen before and never will see. Fate
had only shown him at his very beginning. For myself,
I have never felt my heart more profoundly pierced by
grief than at this news.'[1]

1 Translation
from Andrews
1977, p.51.

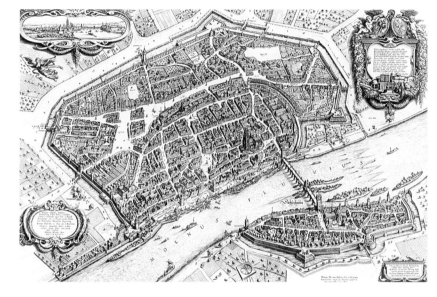

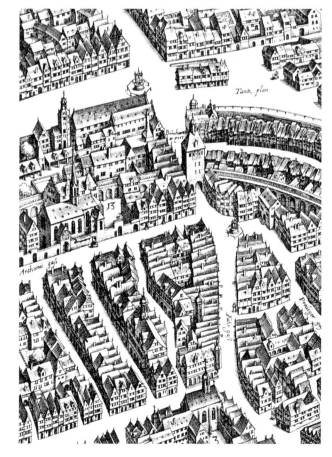

Matthäus
Merian,
*View of
Frankfurt from
the south*

Detail of the
above showing
the Fahrgasse

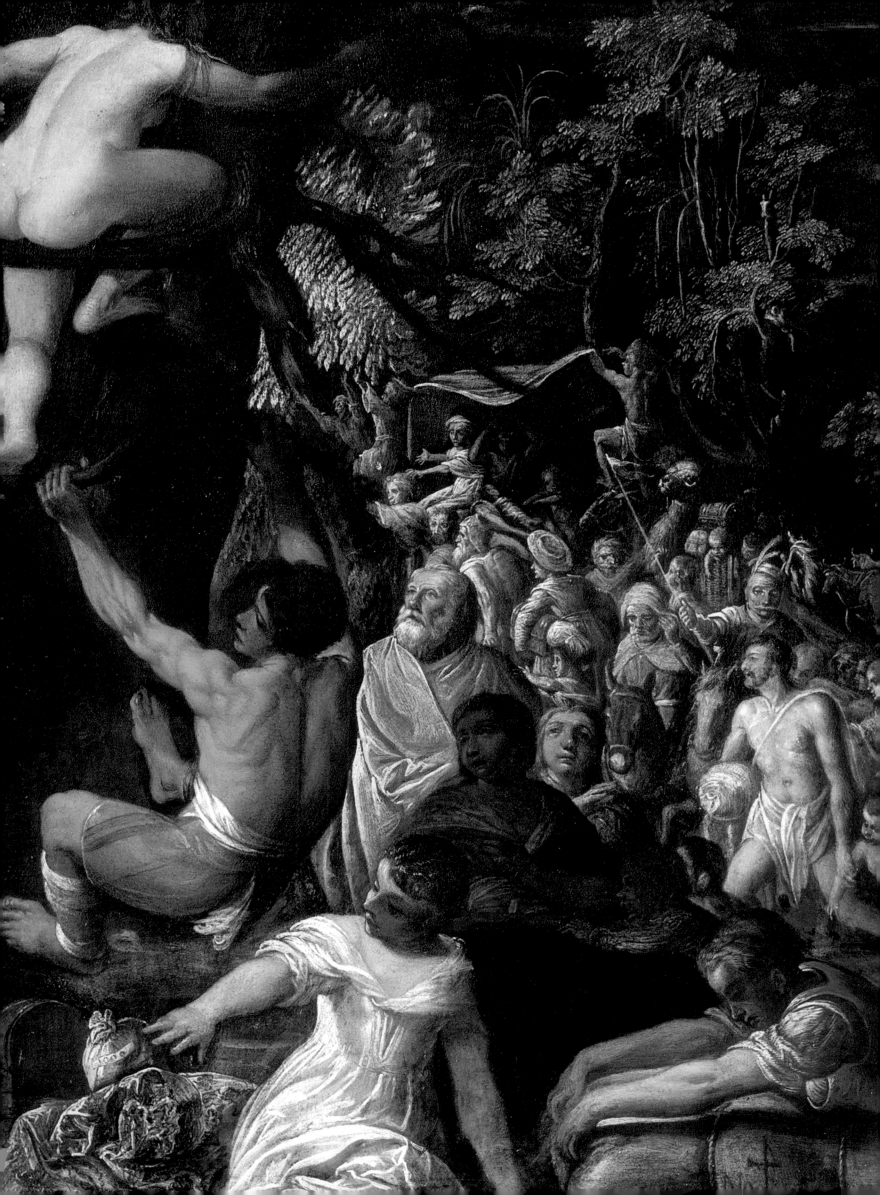

Adam Elsheimer: His Life and Art

RÜDIGER KLESSMANN

Adam Elsheimer spent his formative years in a medieval city with town gates and narrow streets full of visual delights for young people. The imperial city of Frankfurt am Main, often the scene of official gatherings and festive processions staged by the German emperor and princes, was proud of its wealth of art treasures and stately homes. As an artistic centre, Frankfurt stood in the shadow of Nuremberg, but it had a reputation as a flourishing hub of commerce and the venue of well-attended trade fairs. Young Adam lived here – we assume – in modest circumstances. He was the eldest of ten children, and his father, a tailor, owned a narrow house in the Fahrgasse near the collegiate church of St Bartholomew (also the cathedral), which in turn was within a stone's throw of the Dominican monastery, with its unusually rich holdings of Gothic art.[1] Next to the immense high altar, painted in 1501 by Hans Holbein the Elder, stood the much-admired altarpiece executed in 1509 by the Nuremberg master Albrecht Dürer, who had been commissioned to make it by the Frankfurt merchant Jakob Heller (fig. 1). The central part of the multi-panelled altarpiece displayed Dürer's depiction of the Assumption and Coronation of the Virgin; the side panels showed portrayals of saints painted by Mathis Gothart Nithardt (called Grünewald), as well as a *Transfiguration of Christ* by the same master. A *Baptism of Christ* by Hans Baldung Grien also appears to have had a place in the church.[2] The altarpiece installed in the church around 1506, displaying a depiction of the Holy Family by the Antwerp-born 'Master of Frankfurt', may also be counted among the treasures that attracted those with an interest in art. It may be taken for granted that the young Elsheimer, despite his Protestant upbringing, visited the Dominican Church and gazed in wonder at these treasures, given the fact that they reappeared in his work later on.

We are indebted for almost everything we know about Adam Elsheimer, including his character and personal life, to Joachim von Sandrart, the painter and writer who published a detailed account of Elsheimer in his *Teutsche Academie der Edlen Bau-, Bild- und Mahlerey-Künste* (German academy of the noble arts of architecture, sculpture and painting), which appeared in 1675.[3] Sandrart, a generation younger, had a soft spot for Elsheimer – like himself a native of Frankfurt – but the two never met. In 1629, when Sandrart arrived in Rome for the first time, Elsheimer had been dead for nineteen years, but there were still many in the city who talked about the German painter who had died at the age of only thirty-two. In his home town, too, Sandrart could have learned quite a bit about his much-admired colleague, which makes his account indispensable to us.[4]

Protestant Frankfurt – in Elsheimer's day a stronghold of Lutheranism – attracted many foreigners, owing to its reputation as an open-minded, outward-looking city. The comparatively liberal city government made great efforts to position itself pragmatically between the imperial rule of the Catholic Habsburgs, to whom the imperial city was bound by the laws governing the election of the emperor, and the Lutheran and Calvinist citizens, who were united in their rejection of the Catholic hierarchy but divided as to the practice of their divergent denominations.[5] Establishing peace between the Catholics and the Protestants was a prerequisite to safeguarding the city's political and economic privileges. Around the mid-sixteenth century,

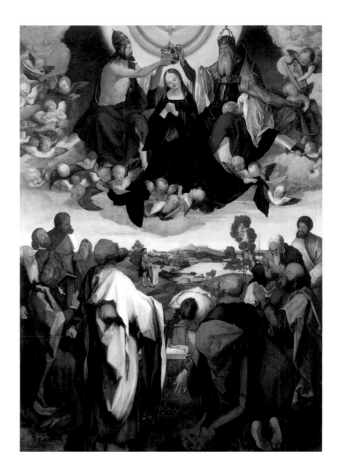

Fig. 1
Jobst Harrich after Dürer, *The Coronation of the Virgin*, copy of the *Heller Altarpiece*, Frankfurt, Historisches Museum

facing page: detail from cat. no. 11

large numbers of Protestant emigrants – fleeing religious persecution in their native countries – flocked to Frankfurt from all parts of Europe. Dutch, French and English refugees, most of them Calvinists, settled in the city, forming their own communities. The practice of the Catholic faith, which had been forbidden in 1533, was reinstated in 1549; Mass was celebrated at first only in the Cathedral, but a short while later other churches were put at the disposal of the burghers who had remained Catholic.

Among the immigrants it was the Calvinist Dutch, most of whom practised skilled trades, who had the greatest impact on Frankfurt's economic and artistic life. They arrived in increasing numbers after the fall of Antwerp in 1585, and in their wake came a great many wealthy Flemish merchants. The resulting economic upturn was, however, accompanied by far-reaching

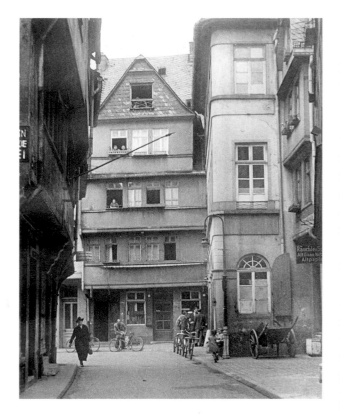

Fig.2
Adam
Elsheimer's
parental home,
Frankfurt,
Fahrgasse 120
(destroyed 1944)

changes for the citizens. The large numbers of foreigners, who introduced the local industries to new methods of production, led to considerable tension in this city with its medieval social structures, tension which the town council attempted to defuse by enacting stringent measures against the Calvinists. The problems arising from the establishment of these immigrant communities in Frankfurt worked to the advantage of some of the smaller towns in the vicinity. Often the immigrants who felt compelled to leave Frankfurt settled in towns and villages in the Rhineland Palatinate, where Friedrich III, the Elector Palatine, encouraged the influx of Calvinist merchants and craftsmen. Noteworthy in this context is the town of

Frankenthal to the south of Worms in the Palatinate, where several Netherlandish painters, including Gillis van Coninxloo, worked for a time. Scholars long believed in the existence of a so-called Frankenthal School, in which Netherlandish artists, led by Coninxloo, were said to have developed their own style of landscape painting. However, research has shown this idea to be untenable,[6] and has also laid to rest the theory that this circle had a strong impact on Elsheimer's beginnings as a painter.

Elsheimer's father – Anthonius, who came from the Hessian wine-growing area to the southwest of Frankfurt[7] – had settled in the city in 1577, in which year he obtained citizenship as a master-tailor and married Martha Reuss, the daughter of a master-cooper. Adam was born the following year and was baptised on 18 March 1578 in the Barfüsserkirche, which had become Frankfurt's main Lutheran church. His father appears to have been a successful tailor, for as early as 1582 he was able to buy a small house with enough room for a workshop and what was to become his large family. Inferring from this that he was well-to-do, as has occasionally been suggested, would be carrying things too far, given the fact that he had to support ten children. Adam's paintings betray a particular predilection for sumptuous dress, possibly a reflection of the high-ranking dignitaries among his father's clients, who assured the family of financial security. Elsheimer's parental home (fig.2), where he spent his youth, remained intact , though largely ignored, until the Second World War. It was destroyed, along with the medieval town centre, by Allied bombing in 1944.[8]

Nothing is known about Adam's early upbringing and schooling, but because he could not fulfil his father's hopes of training his eldest son to assist him in the workshop, Adam was apprenticed – as Sandrart reports – to Philipp Uffenbach, who already had a reputation as one of Frankfurt's promising young painters. Elsheimer, then fourteen years old, seems to have been one of the first pupils of Uffenbach, who had taken over a workshop in the city in 1592. An artist's training customarily ended after four years, at which time he was free to take a position as a journeyman.[9] One of the first signed drawings by Elsheimer, dated 1596, suggests that he changed workshops in this year.[10]

Towards the end of Elsheimer's period of training, his master received an important commission from a Catholic patron. Uffenbach's large *Ascension of Christ*, made for Frankfurt's Dominican Church and dated 1599, represents an attempt to produce a fitting pendant, equal in status and format, to Dürer's *Heller Altarpiece* (fig.3).[11] It is likely that Elsheimer not only witnessed the preparations for this painting but also took part in its execution, which could have taken up to

three years. As regards style, manner of painting and technique, Uffenbach saw himself as a follower of the great masters of Dürer's time, since he himself had been apprenticed to Adam Grimmer, a pupil of Matthias Grünewald. He even owned a group of drawings from Grünewald's estate, which the young Elsheimer must certainly have studied. Sandrart, too, recalled that as a schoolboy he had occasionally visited Uffenbach, who had shown and explained the precious sheets to him. The apparently friendly relations between Sandrart and Uffenbach means that his remarks on Elsheimer's training deserve special attention. Thus we learn that 'painting big' ('das gross malen') was supposedly Elsheimer's first study, which he later abandoned, and this could also be taken as proof of his participation in the execution of Uffenbach's large altarpiece.[12]

Another master who could have been important to Elsheimer's training was the glass-painter Johannes Vetter the Elder, since in 1596 his son, of the same name, and Elsheimer both signed a design for an armorial window.[13] The two young artists also undertook a journey to Strasbourg, where – according to an *album amicorum* – they met the miniaturist Friedrich Brentel.[14] These circumstances have led to the assumption that Elsheimer was trained in the workshop of Vetter the Elder, but this disregards the fact that Vetter was one of Sandrart's Frankfurt sources – as Sandrart himself states – and if Elsheimer had indeed been one of his pupils he would certainly have had no reason to hide the fact. Their relationship, therefore, could not have been one of master and pupil but at most an agreement on Elsheimer's part to work as a journeyman in the glass-painter's workshop. We no longer have any idea of Vetter's activities as an artist. By contrast, Sandrart emphasises Uffenbach's reputation in Frankfurt as a versatile master, well grounded in artistic theory ('he himself was well versed in the rules of proportion, geometry, perspective and anatomy'), thereby focusing attention on Elsheimer's broad education and artistic potential.

Uffenbach, who also wrote treatises on the natural sciences, was for Elsheimer a true *pictor doctus*. The results of Uffenbach's astronomical investigations, published in Frankfurt in 1598 as *Zeitweiser der Sonne ober die gantze Welt* (Timetable of the sun over the whole world), may well have sparked at this early date Elsheimer's interest in the stars, evidence of which appears in his Roman work. According to Sandrart, Elsheimer had been occupied with drawing even before his apprenticeship, perhaps forming part of a group of young artists who got together to draw from a live model. The few early works that can be dated to Elsheimer's Frankfurt period – which possibly represent only a small part of his youthful production – are modest in quality and betray the young painter's

Fig.3
Philipp Uffenbach, *The Ascension of Christ*, 1599, Frankfurt, Historisches Museum

search for direction as well as for work. These youthful works include two small paintings on copper, a witch scene, thought to function as a charm against evil (fig.4, cat.no.1), and a portrayal of Saint Elizabeth (fig.5, cat.no.2), whose reputation as a carer of the sick suggests that this picture was intended for a hospital. Both depictions bear witness to the influence exerted by German precedents on the young painter still trying to find his way in the world. The former painting proves to be an exact copy of an engraving by Dürer (fig.58), while the latter contains various motifs borrowed from Dürer's prints.

An important work from Elsheimer's early period, which was first properly dated by Andrews, is the

Fig.4
Adam Elsheimer, *The Witch*, The Royal Collection Trust, England

Fig.5
Adam Elsheimer, *Saint Elizabeth Tending the Sick*, London, The Wellcome Institute for the History of Medicine

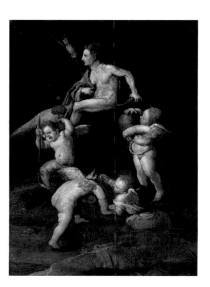

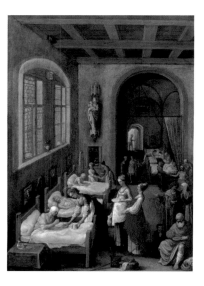

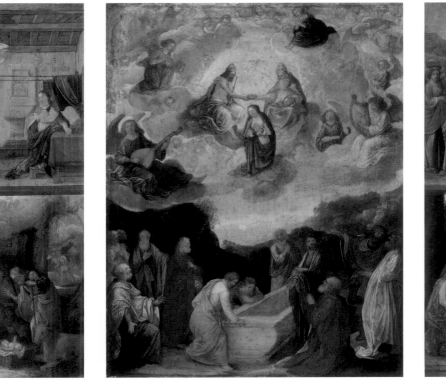

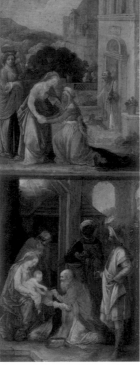

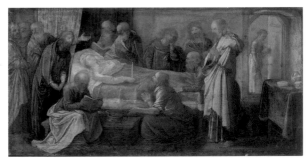

Fig.6
Adam Elsheimer,
*House Altar
with Six Scenes
from the Life
of the Virgin*,
Berlin, Staat-
liche Museen,
Gemäldegalerie

small *House Altar with Six Scenes from the Life of the
Virgin* (fig.6, cat.no.3). Elsheimer painted it in the
manner of a miniature, closely following the style of
Dürer's *Heller Altarpiece* in the Dominican Church
(fig.1), with which he had been familiar since child-
hood. In the central panel he followed Dürer's example
mainly in the group of apostles assembled around the
sarcophagus, whereas in the heavenly sphere, in the
Coronation of the Virgin, he dispensed with the multi-
tude of small angels, replacing them with a few large
angels playing musical instruments, the models for
which have not yet been identified. Evidently the
painter wanted to show that other sources and motifs
were also at his disposal. The small side panels show
most clearly the artist's awakening powers of invention
and his delight in narrative, especially the portrayals of
The Annunciation and *The Nativity*. The small *House
Altar* must have been commissioned by a Catholic,
perhaps one of the frustrated burghers of Frankfurt
who had been deprived of a church since the Refor-
mation. Another possibility is that Elsheimer painted
this work at some point on his way to Munich, where
the Counter-Reformation was rapidly gaining ground

and where also Dürer's art was held in the highest
regard. The presence of a Frankfurt motif – the now
demolished Gallows Gate, which features, as noted by
Koch, in *The Visitation* on the right-hand panel[15] –
does indeed suggest a Frankfurt patron.

Departure from Frankfurt

When Elsheimer set off for the South, he could scarcely
have done so at his teacher's behest. Sandrart reports
that Uffenbach never travelled anywhere; he preferred
to stay in Frankfurt, having acquired 'a great deal of
experience by listening to others and reading books'.
We do not know what the journeyman painter was
planning to do, or whether he actually set out with the
goal of reaching Italy, although Venice was considered
the ideal place to learn to paint. That he had reached
Munich by 1598 is evidenced by a signed and dated
drawing, now in Brunswick, which was originally part
of an *album amicorum* belonging to someone from
Munich or its environs (fig.7).[16] Although doubt has
repeatedly been cast on the authenticity of the date

following Elsheimer's signature, the painter could hardly have undertaken this journey in any other year. The sheet shows a young painter, having been led by a Muse to Mercury, kneeling to beg the god's favour. Mercury is the god of the visual arts and the protector of travellers.[17] The drawing reflects the style of the artists at the Bavarian court, in particular Christoph Schwarz and Friedrich Sustris. This drawing, which seems to represent the confession of a painter who cannot live without recognition and commissions, could well reflect Elsheimer's own situation.

Which paintings might Elsheimer have made during his stay in Munich? One of them could be the small *House Altar with Six Scenes from the Life of the Virgin*, which was undoubtedly commissioned by a Catholic (cat.no.3). Its style based on Dürer's example, would have been well suited to the ideals of the Bavarian court under Maximilian – later to become the first Elector of Bavaria – who had ruled since 1597 and whose artistic tastes favoured the earlier German masters. Munich already boasted an extensive collection of paintings by these old masters, thanks to the cultivation of the arts by Duke Wilhelm IV.[18] This offered the young artist from Frankfurt the opportunity to broaden his knowledge in this area. Two other early works, which are always regarded as pendants, are also considered part of Elsheimer's Munich oeuvre: *The Conversion of Saul* and *Jacob's Dream*, in which the artist's efforts to strike out on his own are clearly visible (figs.8, 9, cat.nos.4, 5). When these paintings surfaced in 1938 in the collection of an English aristocrat, they were said to be by Elsheimer, but they in no way corresponded to the prevailing notions of this artist's oeuvre. Both pictures betray traces of his Frankfurt training and beginner's weaknesses, which are especially noticeable in the turbulent staging of Saint Paul's drama. Their style is reminiscent of Frederick van Valckenborch, who in 1597 had returned from Italy to Frankfurt and impressed Elsheimer with his intense manner of painting. In *Jacob's Dream*, Elsheimer succeeded for the first time in giving a single figure a monumental character, even in this small format. The painter, seeking a new, realistic view of

the theme, was here striving to acquire the personal style that would eventually come to fruition in Venice. These pictures show Elsheimer to be attuned, as it were, to the Mediterranean palette that he would later develop in Italy.

It is not known how long Elsheimer stayed in Munich or when he travelled to Venice. The entries published by Koch from the account books of the Bavarian court show small payments made to an 'Adam Maller [Maler = painter], poor student', which could only have been for minor jobs carried out at the end of July 1599 at the earliest.[19] These could perhaps be linked to Elsheimer, but only if it is accepted (as Koch does) that 'Maller' is an occupational designation. The 'student' would then have belonged to the circle of assistants to Friedrich Sustris, which means that Elsheimer could not have travelled to Venice until the late summer of 1599. This scenario is unlikely, however, since Elsheimer's presence in Rome is documented from April 1600, which would leave at most eight months for his stay in Venice – a period of immense importance for his development as a painter.

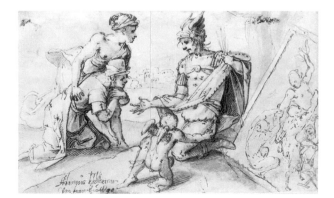

Venice: a School for Painters

No archival records have yet been found to document Elsheimer's visit to the Serenissima, and this has caused his sojourn there to be called into question,[20] but without doubt wrongly, since the Venetian influence subsequently seen in his painting is very striking indeed. The stylistic range of the paintings will serve as proof in the absence of documentary evidence. This is especially true of the impact on Elsheimer of the

Fig.10
Adam Elsheimer,
*The Holy Family
with the Infant
Saint John*,
Berlin, Staatliche
Museen,
Gemäldegalerie

Fig.12
Albrecht Altdorfer,
*Landscape with
Satyr Family*,
Berlin, Staatliche
Museen,
Gemäldegalerie

Fig.11
Adam Elsheimer,
*The Baptism of
Christ*,
London, The
National Gallery

Munich-born Johann Rottenhammer, who lived in Venice from 1595/96 to 1606. He probably worked off and on in Rottenhammer's workshop as an assistant, certainly not – as has often been maintained – as a pupil, since he had already completed his training. Rottenhammer's 1597 *Rest on the Flight into Egypt* in Schwerin (fig.134) is typical of his style at this time – in its combination of German and Venetian precedents – recollections of which are evident in Elsheimer's work. In this context two drawings by Rottenhammer – published by Müller Hofstede, and now to be found in Copenhagen – are remarkable because they were apparently in Elsheimer's possession.[21] The drawings in question are studies made in Rome from antique sculpture; one of the sheets bears an inscription on the back, which could have been written by Elsheimer: 'this Mr Rottenhammer has drawn and presented to me' (*das hat der her roten hamer gerisen und mir fer ert*). If the identification of the handwriting is correct, the drawing would be the first document to confirm the meeting of the two artists. It is possible that Rotten-hammer deliberately chose the studies of antique statuary as a present because he had noticed his younger colleague's interest in antique sculpture. Even though we know no drawn studies of antique models by Elsheimer's hand, some of the figures in his paint-ings must have required such preparatory sketches. His *Realm of Minerva* in Cambridge even shows artists drawing a young man who is forced to assume the uncomfortable pose of an antique Marsyas statue (fig.82).

As unclear as Elsheimer's date of arrival in Venice is – whether it was actually in late summer 1599 or the year before (which is more likely) – it is, however, certain that two of his most charming paintings were made in Venice: *The Holy Family* in Berlin and *The Baptism of Christ* in London (figs.10, 11, cat.nos.7, 8), which are closely related in character and technique. Both pictures reflect the influence of Venetian painting, namely the styles of Jacopo Tintoretto and Rotten-hammer, and show at the same time impulses stem-ming directly from the art of Albrecht Altdorfer. Elsheimer must have seen and scrutinised works by this painter from Regensburg – who had already been dead for sixty years – either in Munich or on his way to Venice. Did he in fact travel to Munich via Nuremberg and Regensburg? Elsheimer's assimilation of Altdorfer's ideas is evidenced by the sweeping move-ments of the angels as they clasp hands and dance down from heaven, the chain of mountains in the distance with medieval castles and gnarled trees, and the light particular to Altdorfer's paintings, as well as the enchantment they exude (fig.12). The old German representational tradition and the atmospheric, painterly qualities of the Venetian masters combine in Elsheimer's work to produce an unusual blend, which

continued to define his style even in later years. In both of the above-mentioned religious works, the painter chose dynamic, ascendant compositions whose upward thrust is halted by the rounded top of the copper support. This lends the small pictures a classical dimension reminiscent – despite the difference in size – of altarpieces produced by the Venetian masters.

Rome: Hub of the Arts

Adam Elsheimer was twenty-two in 1600, the year of his arrival in Rome, the city he was never to leave. Here he witnessed the great stream of people who flocked to Rome from all over the world in the *Anno Santo*, the Church's jubilee year, to pray at the city's holy places and to admire its art treasures. On 21 April of that year Elsheimer wrote a dedication in the *album amicorum* of a German acquaintance – the jurist Abel Prasch the Younger, a son of the Augsburg organist of the same name – which is the earliest proof of Elsheimer's presence in Rome.[22] The ironical tone of the entry suggests that it was not his first meeting with Prasch, whom he had perhaps met at Augsburg on his way from Frankfurt to Munich, a stopover that is admittedly speculative. Another piece of evidence confirming his arrival in Rome is a drawing preserved in Dresden, *Neptune and Triton*, with figures that recall a Roman fountain (fig.13).[23] This leaf, cut out of an unidentified *album amicorum*, bears the signature 'Adam Ehlsheim in Roma 1600', but mentions no exact date. One of the first artists the young man from Frankfurt would probably have sought out was the highly esteemed Antwerp landscape painter Paul Bril, a member of the older generation, who had already been living in Rome for more than twenty years. Rottenhammer, who had been active in Rome around 1593–94 before settling in Venice, had kept in touch with Bril, and their continued association occasionally led to artistic collaboration. He could have given his young fellow countryman a recommendation to make his start in Rome somewhat easier. At any rate, Elsheimer and Bril were soon on friendly terms.

When Elsheimer reached Italy, his skills as a painter were still fairly weak ('still fairly mediocre', as Karel van Mander wrote in his *Schilder-Boeck*, published in 1604 in Haarlem) but in Rome he evidently made great progress, becoming a capable artist through hard work.[24] Elsheimer had apparently not done much drawing, preferring to study closely the works of the great masters in churches, for example, and to commit all this to memory. This aptitude for retaining images (a faculty also described by Sandrart), was at odds with traditional art theory, which assigned the highest place to drawing. Could this be why Van Mander called Elsheimer 'an art-full worker', an expression which –

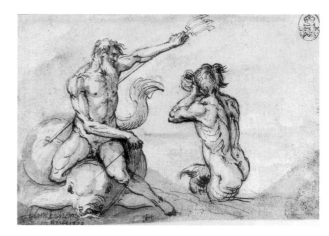

Fig.13
Adam Elsheimer,
Neptune and Triton,
Dresden,
Kupferstich-kabinett

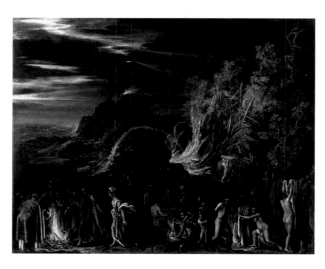

Fig.14
Adam Elsheimer,
Saint Paul on Malta,
London, The National Gallery

according to Miedema[25] – does not otherwise occur in the *Schilder-Boeck* and which was more commonly used to describe artisans? Nonetheless, Van Mander is unstinting in his praise of Elsheimer's ability to paint his inventions. His short account was the first and only one to appear in Elsheimer's lifetime.

Which of Elsheimer's pictures first caught the attention of the Roman art world can no longer be ascertained. Shortly after settling in the city, he struck out on a new artistic path, painting three multi-figured nocturnal scenes in horizontal format, which as such, both in style and subject matter, contrast sharply with the works he made in Venice. Strictly speaking, these are the first history paintings he ventured to make. The rarely depicted theme of *Saint Paul on Malta* (fig.14, cat.no.9) was most likely the first of the three, for the dramatic movement of the landscape still shows mannerist traits, and also betrays some awkwardness in the frieze-like arrangement of the foreground, middle ground and background. The expressive treatment of light recalls works by Frederick van Valckenborch, which Elsheimer could have known – the 1603 *Storm with Shipwreck* in Rotterdam (fig.67) may serve as an example of his work, although it certainly originated after Elsheimer's painting.[26] The use of multiple sources of light in one composition – a characteristic of Elsheimer's later work – is a feature first observed in

Fig.15
Adam Elsheimer,
The Burning of Troy,
Munich,
Bayerische
Staatsgemälde-
sammlungen,
Alte Pinakothek

Saint Paul on Malta and was perhaps inspired by Van Valckenborch.

In Elsheimer's *The Burning of Troy* in Munich (fig.15, cat.no.10), which must have originated shortly thereafter, throngs of people emerge from the background in a wedge-shaped mass. Most of the painting is taken up by the darkness of night, which reveals several burning buildings with flames throwing sparks in the distance. Especially remarkable are the tiny points of light scattered profusely over the pictorial space, which on closer inspection prove to be torches carried by the fleeing figures – rich and poor, clothed and naked – which Elsheimer portrays with exceptional genius. Among the figures crowded into the foreground is the family of the hero Aeneas – whose heroic rescue of his father, Anchises, is the culmination of this episode – but the focal point is Aeneas' wife Creusa, who looks back mournfully before perishing in the darkness.

The portrayal of this theme with its fiery effects was certainly inspired by Flemish examples, namely those of Jan Brueghel the Elder and Pieter Schoubroeck. Once in Rome, Elsheimer must have become acquainted with the works these artists made there at the end of the sixteenth century.[27] Brueghel's *Burning of Troy* and *Lot and his Daughters* (both in Munich, figs.16, 17) are characteristic examples of his dramatic nocturnal scenes, which also show the moon emerging from behind dark clouds, a motif that was to become one of Elsheimer's favourites. Pieter Schoubroeck, who spent

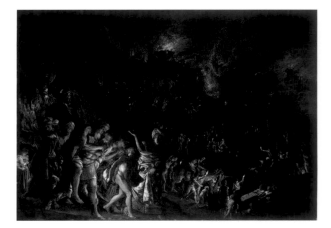

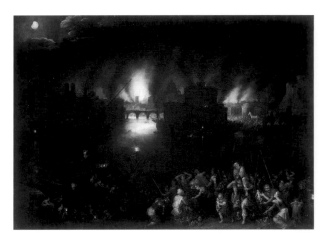

Fig.16
Jan Brueghel the
Elder, *The
Burning of Troy*,
Munich,
Bayerische
Staatsgemälde-
sammlungen,
Alte Pinakothek

some time in Rome in 1595, painted nocturnal scenes in the style of Brueghel, as evidenced by his *Burning of Rome*, now in Brunswick (fig.18).[28] It is by no means certain that Elsheimer, while still in Frankfurt, studied the paintings made by the Flemish immigrants active in Frankenthal, as often conjectured. His early work, at least, does not support this hypothesis. The pictures of fires and catastrophes painted by the Northerners had definitely acquired a certain Roman clientele, for whom Elsheimer also catered. A comparison of his work with that of Flemish masters shows more disparities than similarities, however, for Elsheimer's narrative style is clearly different, being more naïve in its description, and his figures are actually rendered on a large scale but within a very small space. In general his development tends towards a strong emphasis of the figure, which is newly defined in its relation to the pictorial space.

In *The Flood* (fig.19, cat.no.11), which was perhaps inspired by depictions of the same theme by members of the Bassano family, the large figures in the foreground lend expression to the significance of the event, while the ranks of fleeing figures are arranged in the background. The fact that the foremost figures are cut off by the lower edge of the picture brings them much closer to the viewer and also magnifies the intensity of their fear. Two women are busy safeguarding their possessions, while behind them a child, its cradle

Fig.17
Jan Brueghel
the Elder,
*Lot and his
Daughters*,
Munich,
Bayerische
Staatsgemälde-
sammlungen,
Alte Pinakothek

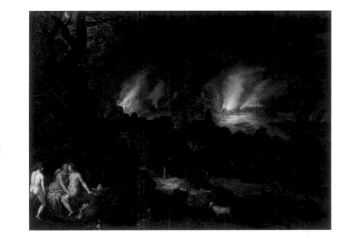

Fig.18
Pieter
Schoubroeck,
*The Burning
of Rome*,
Brunswick,
Herzog Anton
Ulrich-Museum

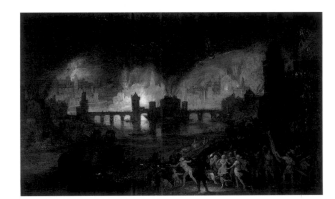

afloat, looks helplessly at a man fighting to keep his head above water. On the left a naked couple seek refuge in a tree. The selfish behaviour of these few people stands for humankind's collective guilt and hence the reason for this sign of God's wrath. In his dramatisation of the story and the construction of its stage-like setting, Elsheimer achieved a new realistic quality, which becomes apparent when compared with *The Burning of Troy*. Scholars have correctly pointed out the Venetian influence in this work, emphasising the impact made by Tintoretto and Rottenhammer and, therefore, concluding that Elsheimer painted it in Venice. It is more plausible, however, to assume that *The Flood* originated in Rome, since it must be seen as a sequel to the nocturnal history paintings and represents their stylistic conclusion. Moreover, the group of figures on the left may be considered a Roman element. This motif – a naked woman climbing a tree to safety, followed by a youth – obviously derives from Michelangelo's Flood fresco in the Sistine Chapel, which the painter certainly would have known. In modelling this figure he was aided by an engraving by Agostino Carracci (fig.71). The rear view of the youth also shows a close stylistic connection to his drawing of *Neptune and Triton*, dated 1600, now in Dresden (fig.13).[29]

The history paintings of Elsheimer's first Roman period also include portrayals of *Saint Christopher* and *Judith and Holofernes* (figs.20, 21, cat.nos.13, 14), two nocturnal scenes in vertical format, in which the sources of light are of special significance. Both are closely related to *The Burning of Troy*: the poses of Aeneas and Christopher correspond in large measure, and Aeneas' wife Creusa, who beckons in desperation, is obviously based on the same precedent as Judith. Three sources of light illuminate the scene in *Saint Christopher*: the beams emanating from the head of the Christ Child (*lumen mundi*), the moon emerging from stormy clouds, and the torch in the hand of the hermit in the background. By contrast, *The Flood* is lit only by the lightning of the storm, which is not directly visible but falls dramatically onto the scene, announcing impending doom. No other sources of light are discernible.

For the setting of *Judith and Holofernes*, Elsheimer chose for the first time a dark interior, lit by two candles. A bright light coming from the back illuminates the Jewish heroine and the naked body of Holofernes, who has already been dealt the death blow. A second candle at the right edge of the picture, which unlike the first does not flicker violently, sheds an atmospheric light on the objects laid out on the table: precious vessels with wine and fruit, symbolising the hedonistic life of the slain general.[30] The composition was presumably inspired by a 1564 engraving by Maerten van Heemskerck (fig.22), but the stimulus to

treat this subject unquestionably came from Caravaggio, who had caused a stir around 1599 in Rome with his brutal and extremely realistic portrayal of this biblical story (fig.23). The countless variations on this theme produced by Caravaggio's followers provide ample testimony to the influence exerted by his painting. Despite the considerable differences between Elsheimer's small painting and the life-size picture by the controversial Lombard – the most salient of which are the latter painting's horizontal format and half-length figure – the parallels between individual

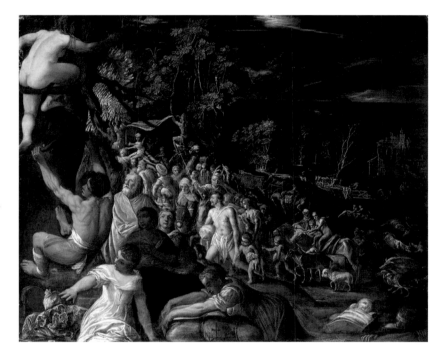

Fig.19
Adam Elsheimer,
The Flood,
Frankfurt,
Städelsches
Kunstinstitut
und Städtische
Galerie

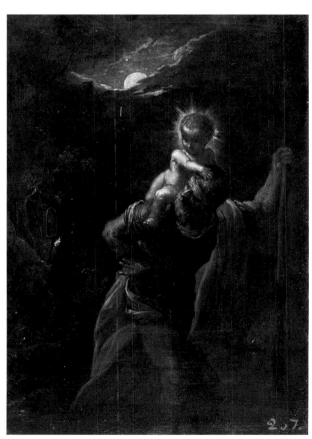

Fig.20
Adam Elsheimer,
*Saint
Christopher*,
St Petersburg,
Hermitage

Fig.21
Adam Elsheimer,
*Judith and
Holofernes*,
London,
The Wellington
Museum, Apsley
House

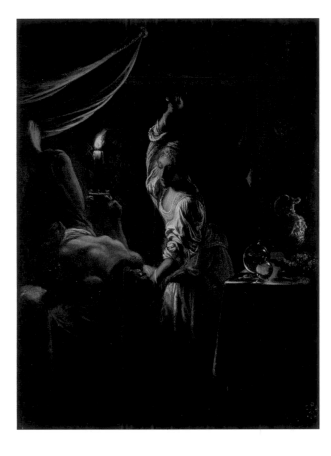

Fig.22
Maerten van
Heemskerck,
*Judith Slaying
Holofernes*,
engraving

Fig.23
Michelangelo da
Caravaggio,
*Judith and
Holofernes*,
Rome, Galleria
Nazionale

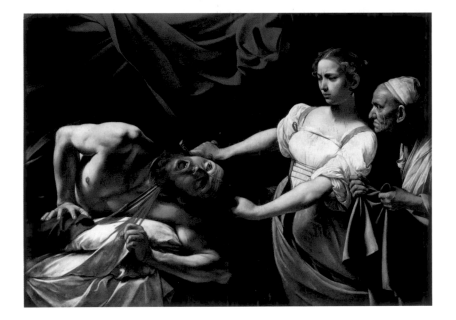

motifs are clearly recognisable. The pain-racked body of Holofernes – who faces death with tensed arms and bulging eyes while Judith holds a shock of his hair in her left hand – and the curtains falling on the body of the murdered man are portrayed in similar fashion by both painters. Completely different, however, is Elsheimer's deployment of light, which penetrates to the depths of the interior, transforming it into the scene of a drama, fundamentally different from the frieze-like arrangement and the coldness of undefined space characterising Caravaggio's composition.

Throughout his career Elsheimer consciously experimented with the possibilities of light. It is safe to assume that he was a keen observer of Caravaggio's working methods, which were developing at the same time, even though he chose to take a different path. Elsheimer elected to portray the differentiation of light, also in the metaphorical sense, unlike the Lombard, who used light effectively to stage-manage his pictures.[31] Shortly after Elsheimer had settled in Rome, Caravaggio set to work on his altarpieces for the church of Santa Maria del Popolo, not far from the young German's lodgings. The pose of the apostle portrayed in his *Conversion of Saul*, lying on his back with outstretched arms, recalls that of Elsheimer's slain Holofernes and may well have played a role in the conception of *Judith*. Clearly, the difference between these two artists' manner of painting, which naturally depended on the format of their pictures, could not have been greater. Yet they seem to have had similar working methods, using very few preliminary drawings and devising the individual forms directly on the support.[32] Certainly Elsheimer was particularly attracted to Caravaggio's provocative realism, which cast traditional themes in a new mould, because this approach reflected his own objectives.

Rubens and Elsheimer's Circle of Friends in Rome

In 1601 Elsheimer first met Peter Paul Rubens, who had recently entered the service of Vincenzo Gonzaga, the duke of Mantua, and had been given an important commission in Rome. Though their meeting is undocumented, it may be inferred from the circumstances of Rubens's work. The Antwerp master, only slightly older than Elsheimer, was carrying out a commission from Archduke Albert of Austria to paint three large altarpieces for Santa Croce in Gerusalemme, one of the most visited churches in the city and the repository of the pieces of the True Cross of Christ brought by Saint Helena from Jerusalem.[33] This event is the subject of the central painting, *The Triumph of Saint Helena* (fig.24), in which the empress is portrayed holding the cross she has just discovered, standing next to the pillars of a splendid antique temple. (This painting is now preserved, together with its side panels, in the cathedral at Grasse in France).[34] Elsheimer certainly noticed that the narrative power and space-defining treatment of light in the paintings of his Flemish colleague were very close to his own notions, despite the great difference in format of their pictures, and may have tried to discuss such matters with him. Rubens's preoccupation with this subject had sparked his interest in the ongoing archaeological excavations – since the discovery of the catacombs in 1578 – to find records of the early days of Christianity. He was stimulated in these endeavours by the zeal of Cardinal Caesar Baronius (1538–1607), Superior of the Oratorian congregation in Rome and ecclesiastical historian, whose research helped to explain both the historical and the theological significance of the finds and who also played a role several years later in the commission Rubens received to paint an altarpiece for the church of Santa Maria in Vallicella.[35] It is no wonder that Rubens derived inspiration for his figure of the Empress Helena not only from pictures by Raphael but also from a marble statue of the empress dating from Roman times.[36]

Caesar Baronius, author of the multi-volumed *Annales Ecclesiastici* (Italian edition, 1590),[37] had met Archduke Albert in Ferrara in 1598. He probably became acquainted with Rubens and his brother Philipp around 1601 through the offices of Justus Lipsius (1547–1606), who taught philosophy at the University of Louvain and was the leader of the neo-Stoic movement there.[38] These connections and their interest in antique traditions and examples must have appealed to Elsheimer as well, as evidenced by the pictures comprising his altarpiece portraying *The Finding and Exaltation of the True Cross* (cat.no.20), for which he depended on texts by Baronius.[39] Von Henneberg was the first to point out, on the basis of

Fig.24
Peter Paul
Rubens,
*The Triumph of
Saint Helena*,
Grasse Cathedral

convincing arguments, the close relations between the Cardinal and Elsheimer, in which Rubens probably also had a hand. This contact might have prompted Elsheimer to pay tribute to the famous historian in a subtle scene at the edge of the picture. In *The Digging for the Cross* depicted on the predella, the empress watches the workers and follows the explanations of the bishop standing next to her, whose facial features – according to Von Henneberg – are those of Baronius.

In this period Rubens made many drawings from antique sculpture, from which he successfully drew inspiration for paintings, possibly spurring Elsheimer to take up this practice as well, as evidenced by *Saint Lawrence Prepared for Martyrdom* and *The Stoning of Saint Stephen* (cat.nos.18,19). Rubens in turn felt drawn to Elsheimer's naturalness of invention and to what he perhaps regarded as a traditional German delight in detail. In Rubens's *Crowning with Thorns* – a nocturnal scene in flickering light, painted around 1601–02 for Santa Croce in Gerusalemme – a young man, who is also discernible in the tumult in Elsheimer's *The Burning of Troy* (cat.no.10), hurries past with a torch.[40] It may be assumed that Rubens, while in Rome, also became acquainted with Elsheimer's *Saint Paul on Malta* (cat.no.9) and that this was a source of inspiration for his *Shipwreck of Aeneas* (Berlin), which he probably made in Italy.[41] In this context mention must again be made of Elsheimer's *Judith and Holofernes* (cat.no.14), a dramatic nocturnal scene lit by candlelight, which particularly captivated Rubens. His oil sketch for a nocturnal *Adoration of the Magi*

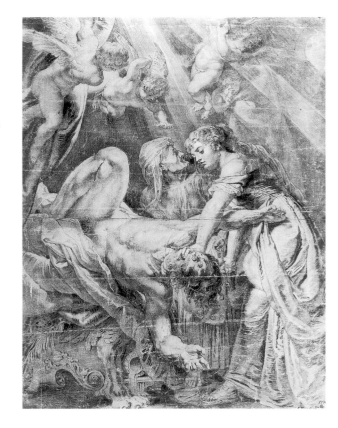

(Groningen) – the *modello* for the monumental painting, now in Madrid, which he completed in 1610 for Antwerp's town hall – reflects Elsheimer's narrative skills.[42]

Rubens repeatedly made drawings of motifs from Elsheimer's paintings, as shown by his studies after *Saint Christopher* and *Judith and Holofernes* (cat.nos.13, 14), which he used for paintings of his own.[43] The composition of the latter picture provided the basis for Rubens's reworking of the theme, a painting possibly begun in Italy that has not survived, though the composition has been preserved in a pen drawing by Cornelis Galle I (fig.25).[44] Also during his second visit to Rome in 1606, Rubens produced drawings after works by Elsheimer, including *The Stoning of Saint Stephen* (cat.no.19).[45] In 1936 Weizsäcker marvelled at Rubens and was amazed by the 'master of accomplished monumental art, for whom no canvas, no wall surface seemed large enough to hold the products of his imagination', who was also 'an admirer of a painterly prowess that shows its greatest strength precisely in the smallest of formats'.[46]

The close contact between the two artists continued until Rubens left Italy for good in October 1608. Their association was encouraged by their mutual circle of friends, which included, in addition to Rubens and his brother Philipp – who, like Elsheimer, both lived close to the Piazza di Spagna – the Bamberg doctor Johann Faber and Gaspar Scoppius (Schoppe), a philologist from Neumarkt (not far from Nuremberg) who had been living in Rome since 1598.[47] Philipp Rubens, who obtained his doctorate in law in 1603 in Rome, was

devoted to the literature of antiquity, and his wealth of knowledge certainly benefited not only his brother but Elsheimer as well. Faber was on friendly terms with the Marchese Federico Cesi – a naturalist and friend of Rubens, who in 1603 founded the Roman academy of science, the Accademia dei Lincei[48] – and also with the Dutch scholar Johannes van Heeck (Giovanni Ecchio), who associated with the astronomer Johannes Kepler and the son-in-law of the famous Tycho Brahe (d. 1601) in Prague, and supplied books and scientific texts to Cesi and his Roman friends. One of the first members of the academy was Johann Schreck (Terenzio), a friend of both Rubens and Cesi, who told his Roman acquaintances about his studies in Padua with Galileo Galilei. In 1603 the founder members of the Accademia dei Lincei, who chose the sharp-sighted lynx as their heraldic animal, had their first official documents bound and supplied with a coloured title page that included a gouache displaying a lynx in a wreath of olives (fig.26).[49] It is a reasonable assumption, considering the manner of drawing, that Elsheimer painted the animal. The naive rendering is no doubt due to the fact that the draughtsman had no opportunity to study a live lynx. This attribution is supported by the monogram AE (in ligature) inscribed on the verso, which corresponds to the monogram on Elsheimer's painting of *The Flood* (cat.no.11).

It is astounding that Elsheimer – who was the son of an artisan, and had certainly not had a privileged upbringing or much formal schooling – could apparently hold his own in a circle of intellectual friends, the majority of whom came from Justus Lipsius's learned

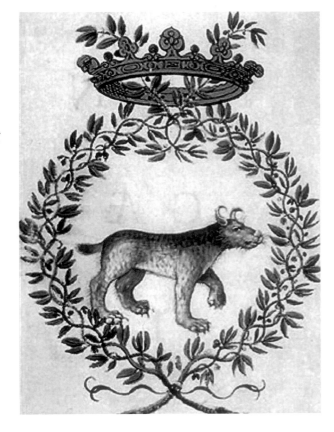

circle of colleagues. It was an ability that Elsheimer perhaps owed to his Frankfurt teacher Philipp Uffenbach, who – as Sandrart had already observed – occupied himself more with scientific inquiry than with artistic practice.[50] Faber – who cured Rubens, while in Rome, of a serious illness (for which Rubens thanked him with a portrait and another painting) – is the only scholar in this circle who is known to have loved paintings. His remarkable art collection,[51] which contained a number of works by Elsheimer that are difficult to identify, was more or less the focal point of the get-togethers Faber held at his house in the Vicolo dei Calderari near the Pantheon, which Elsheimer and Paul Bril also attended. When one considers that all of these Northern-born friends originally came from Protestant milieus and later converted to Catholicism, it is not surprising that the Lutheran-bred Elsheimer converted at the instigation of Scoppius,[52] probably in part so as not to be excluded from commissions to paint religious subjects. Scoppius, an outspoken propagandist for the Counter-Reformation, and Faber, botanist and official herbalist to the Pope, both occupied high-ranking positions and received salaries from the Vatican, and both certainly had the connections necessary to help the young painter from Frankfurt.

The World of Saints and Martyrs

The beginning of the Protestant German's intense confrontation with the Early Christian world of the saints is marked by his painting of *The Three Marys at the Tomb* (fig.27, cat.no. 15), which is generally dated to around 1603. This was followed at fairly short intervals by a number of paintings intended for private devotion or a house altar in a Catholic home. Elsheimer's turning to religious subjects, which after his conversion to Catholicism would have enlarged his clientele, was accompanied by a clear change in his style. No other picture in his oeuvre is so infused with Italian influence as this scene at the tomb of Christ. His preoccupation with the art of Caravaggio and the Carracci brothers is reflected in the figures' declamatory gestures and the Roman facial types; the natural *coulisse* in the background reveals Elsheimer's close connection with Rome's leading landscape painter, Paul Bril.

We come across the same female type in Elsheimer's *Pietà* in Brunswick (fig.28, cat.no.16), which portrays Mary tenderly caring for the body of her son after his death on the cross. The painting's form and conception recall related compositions by Giovanni Bellini and Annibale Carracci,[53] as well as Michelangelo's statue in St Peter's, but a comparison with these Italian examples shows Elsheimer's emphasis on the intimacy of the relationship and the vulnera-

bility of the slender bodies of mother and son. The stylistic proximity of the *Pietà* to *The Three Marys at the Tomb* cannot be overlooked. The characteristics shared by these two works include their close viewpoint, which shows the figures only down to the knees, the rendering of the clothing, the parallel folds emphasising body volume, and a handling of light that exudes mystery. The plants and tendrils, depicted with botanical accuracy, which hang down from the wall of rock, form a niche-like background in both paintings. The *Pietà* is crowned by a group of hovering angels, who – following Raphael's example – appear as bodiless beings consisting only of head and wings. The cloth they carry remains unfinished. The painting is probably the one found in Elsheimer's bedroom at the time of his death.[54]

Among the group of devotional pictures that Elsheimer made in this period, two paintings, depicting the sufferings of the first martyrs, deserve special attention. The portrayals of Saint Lawrence and Saint Stephen (cat.nos.18,19) are closely related in style and composition. In both pictures the painter used antique sculpture as a model and focal point to explain the events taking place; both works feature ancient buildings in the background. Instead of the wooded, mountainous landscapes looming on the horizon of earlier paintings made in Venice, such as *The Holy Family* and *The Baptism of Christ* (cat.nos.7, 8), we now see, apparently for the first time, identifiable elements of Roman architecture, intended to lend authenticity to the events portrayed. In *Saint Lawrence Prepared for Martyrdom* (fig.29, cat.no.18), Elsheimer does not follow pictorial tradition but presents his own inventions, which include the allegorical incorporation of the steadfastness and virtue of Hercules, an antique statue of whom dominates the scene, and the metaphorical equation of the saint's death on the gridiron with the demigod's death on the pyre.[55] The determination to portray this idea might have arisen from Elsheimer's

Fig.27
Adam Elsheimer,
The Three Marys at the Tomb,
Bonn,
Rheinisches
Landesmuseum

Fig.28
Adam Elsheimer,
Pietà,
Brunswick,
Herzog Anton
Ulrich-Museum

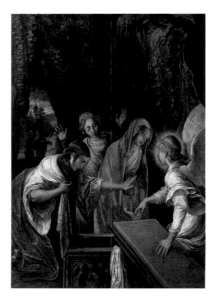

23

conversations with Rubens, who later treated the same subject, portraying the saint's martyrdom in a completely different composition, but one in which reminiscences of Elsheimer's work are nevertheless recognisable.[56]

Formally speaking, the severity of the composition of *Saint Lawrence* recalls German woodcuts, and may thus be recognised as preceding the painting of Saint Stephen. Elsheimer must have realised that the orthogonal build-up of the picture was rather an impediment to the development of his narrative style. For *The Stoning of Saint Stephen* (fig.30, cat.no.19) he chose a dynamic composition derived from Tintoretto, in which Baroque elements, mainly allusions to Caravaggio, appear in the foreground. Its wealth of figures and theatrical detail particularly attracted the Netherlandish artists present in Rome between around 1603 and 1605, those whom Sandrart referred to as 'companions' of Elsheimer;[57] indeed, echoes of the *Stoning* resound in many works by Rubens, David Teniers the Elder, Pieter Lastman and Jan Pynas.[58] The picture also functions as a yardstick for the particular talents which the Netherlanders admired in the German figure painter. It is not known when this painting left Elsheimer's studio, but it eventually came into the possession of Paul Bril. These two scenes of martyrdom were probably commissioned by pious art lovers; it could hardly have been otherwise in the case of the bloody stoning, for this gruesome scene was not a suitable subject for the free market. If Elsheimer was indeed receiving commissions in Rome for religious subjects of this nature – commissions not as a rule granted to Protestants – he must already have

converted to Catholicism by this time, earlier than hitherto assumed. The existence of a small *Pietà*, also made at this time (now in Brunswick; cat.no.16), which can be identified with the one hanging in the painter's bedroom at the time of his death, supports the assumption that he painted this picture for his own household.

The execution of these scenes of martyrdom established Elsheimer's name as a religious history painter. As a representative and torch-bearer of old German traditions in painting he would have attracted the attention of ecclesiastical circles and Roman art collectors. This was a prerequisite to his first important commission, *The Finding and Exaltation of the True Cross*, now in Frankfurt, which he delivered around 1603–05 to an unknown patron presumably living in Rome (fig.31, cat.no.20). It seems a miracle that the altarpiece is once again complete, and has recently been reconstructed. The seven panels that make up the altarpiece, although documented together early on,[59] had been dispersed and some had gone missing. The last panel was finally reunited with the others when it was acquired from its Australian owner in 1981. The central panel of the retable, bearing *The Exaltation of the Cross* and *The Coronation of the Virgin*, is accompanied on its sides and lower edge by six smaller pictures, which depict events from the story of the Holy Cross. There has never been a satisfactory explanation for the choice and thematic connection of the scenes and their anti-clockwise sequence. The panel to the left of the vision of the cross shows the Empress Helena embarking for the Holy Land to secure the lost cross of Christ; its pendant on the right portrays the cross being recovered by the Emperor Heraclius after it was stolen by the Persians, a scene referring to the *Imitatio Christi*. The representations largely follow the events as related in the *Golden Legend*,[60] though some details – such as Zacharias exhorting the emperor to humility when he returns triumphantly with the cross – were taken from the *Annales Ecclesiastici* by Caesar Baronius.[61] The four panels of the predella, which are to be interpreted metaphorically, suggest that the Jews, too, must yield when the restitution of the Holy Cross of Christ is at stake, that a great effort is necessary to secure it, that unwavering faith is required to recognise it, and that even an emperor must relinquish his power in order to obtain it. The central panel, an artistic high point in Elsheimer's sacred oeuvre, appears to have been inspired by related depictions by Titian and Tintoretto – noteworthy in this context is the latter's vast picture of Paradise in the Doge's Palace[62] – as well as by the splendour of Veronese's costumes and colours, all of which Elsheimer was able to study in Venice. His composition is probably based on Rottenhammer's *Coronation of the Virgin* (fig.83).[63] In contrast to the rather traditional subject matter of the

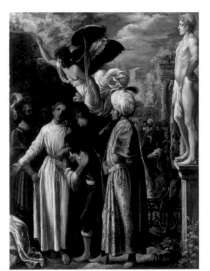

Fig.29
Adam Elsheimer,
*Saint Lawrence
Prepared for
Martyrdom*,
London,
The National Gallery

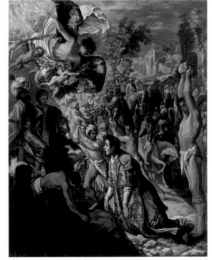

Fig.30
Adam Elsheimer,
*The Stoning of Saint
Stephen*,
Edinburgh, National
Gallery of Scotland

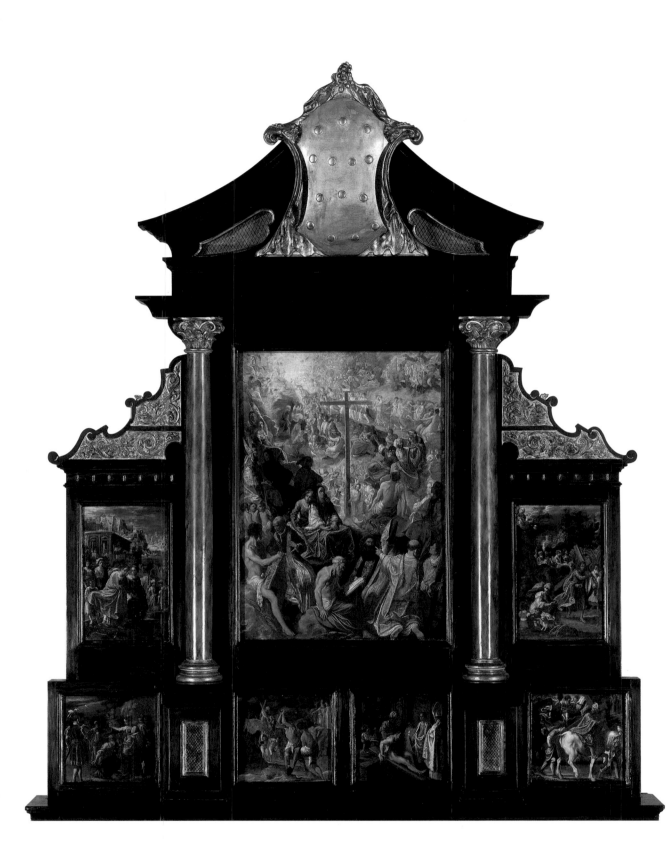

Fig. 31
Adam Elsheimer,
*The Finding and
Exaltation of
the True Cross*
('The Frankfurt
Tabernacle',
or *True Cross
Altarpiece*),
Frankfurt,
Städelsches
Kunstinstitut,
on loan from the
Städelscher
Museums-Verein

central panel, the side panels are surprisingly anec-
dotal in character.

In connection with this major work by Elsheimer,
several contemporary documents have survived – a
rare occurrence in the painter's oeuvre – which refer to
the original design of the altarpiece and the high es-
teem in which it was immediately held. In 1612, when
the altarpiece was put up for sale for the first time after
the death of its maker, highly regarded connoisseurs –
such as Agostino Tassi, Ludovico Cigoli and Cardinal
del Monte – were summoned to assess it (figs. 32, 33).[64]
It remains unclear, however, who Elsheimer's patron

was, and who – if not the painter himself – chose the
episodes to be depicted in the discovery and recovery
of the True Cross. It is of course possible that the
painting was commissioned by a clerical dignitary
who already had plans for its thematic content.
Because the ecclesiastical historian Cardinal Baronius
had been in contact with Elsheimer, perhaps from as
early as 1601, he might have acted as an adviser in this
matter, as he did when Rubens was commissioned in
1606 to paint an altarpiece for Santa Maria in
Vallicella.[65] The fact that Rubens's second version of
his painting for the high altar is reminiscent of

Elsheimer's *Exaltation of the Cross* could be more than mere coincidence.

The *True Cross Altarpiece* is the only work by Elsheimer for which there is a preparatory drawing – also corresponding in size – executed in pen, brush and wash, which was intended as the design for *The Digging for the Cross* (cat.no.38). In contrast to the free pen and wash designs for the composition of *Il Contento* (cat.nos.39–41), the *True Cross* drawing is more powerful in its modelling and handling of light, owing to the dense pen hatching and dry brush technique; it displays, moreover, clearly emphasised outlines, identical with those of the painting, which were pricked for transfer.[66] The sheet affords some insight into the artist's working methods, by means of which he prepared the design for exact transfer to the preparped copper plate. This is the only case in which we can observe the progression from a completed design to the execution of a painted picture. The fragmentary preservation of his drawn works, which later included gouaches and etchings, means that we do not know whether Elsheimer used this method for all his paintings or, more likely, only on those occasions when he was required to keep to certain measurements, as is the case with altars and pieces of furniture.

The Painter of Miniatures Discovers Landscape

By mid-decade Elsheimer's small paintings on copper had earned him a reputation in Rome that allowed him to hold his own in the face of Italian competition. This may be deduced from another commission, which he must have received soon after completing the *True Cross Altarpiece*. The unidentified patron called upon Elsheimer's exceptional skill as a miniaturist. Nine small copper paintings by his hand of uniform size – only nine centimetres in height – have survived (there were probably more of them originally), which were evidently intended to be inlaid in a costly piece of furniture (fig.34, cat.no.21). The collector's cabinet is now lost, but its form can be roughly reconstructed on the basis of preserved examples, and corresponds to a type that was very popular among aristocratic collectors before and around 1600. The fact that only saints and biblical figures decorate these panels, now at Petworth, suggest that the cabinet was made for a pious individual or some devotional purpose. The paintings – at least some of them – were probably made around 1605, as Andrews proposed on the basis of motifs borrowed by David Teniers the Elder, who occasionally worked with Elsheimer in Rome but returned to Antwerp in 1605.[67]

The figures – which stand alone, dominating the picture plane and thereby recalling series of engravings by Schongauer and Dürer – revert to the small-scale style of Elsheimer's Frankfurt years, as seen in the *House Altar with Six Scenes from the Life of the Virgin* (cat.no.3). The creative spirit of his panels, however, is anything but retrospective. The figures are portrayed in a landscape, and even though they always inhabit the front of the picture plane, they lead the viewer's gaze to the distant landscape surrounding them. The background – as a rule appearing abruptly, without any transition – the rather low viewpoint and the bright illumination lend the figures an unexpected monumentality. It is precisely the inner greatness of these pious figures that brings attention to the richness of God's Creation and the great diversity of flora and fauna. Despite their very small scale, these small paintings reveal a new approach to the depiction of nature, by means of which Elsheimer effected a lasting

Fig.32
Sketch of Elsheimer's *True Cross Altarpiece*, 1612, Florence, Archivio dello Stato

Fig.33
Drawing of the frame of Elsheimer's *True Cross Altarpiece*, 1612, Florence, Archivio dello Stato

change in the vision of landscape in the seventeenth century. He eliminated the traditional *coulisse* formed by natural elements – usually defined, as seen in the side panels of the *True Cross Altarpiece*, by looming mountains, castles and forests – and replaced it with an opening-up of the pictorial space, and in doing so gave it a critical role in the theme of the representation. In this respect these cabinet panels represent an important new phase in the development of this painter, who in the following period would devote himself increasingly to landscape.

Elsheimer's new approach to nature is confirmed by his nearly contemporaneous *Flight into Egypt* of around 1605 (fig.35, cat.no.23), a small oval picture of unbelievable delicacy, which is very closely related to the panels at Petworth. Like those pictures, it might once have been an inlay in a piece of furniture. Here the vastness of the peaceful landscape, which unfolds behind the cave, serves as a thematic contrast to the dangerous situation in which the fugitives find themselves. The artists in Elsheimer's circle, most of whom were Netherlanders, must have recognised the novelty and special significance of his ability to render nature. Only three years later, in 1608, Pieter Lastman adopted Elsheimer's composition for a painting of the same theme (fig.146), though he probably did not understand the Frankfurt painter's concerns. It could also have been Elsheimer's contact with the painting of Paul Bril, whom he knew personally, that provided the impetus for his change of style. That the two artists were on friendly terms is evidenced by Bril's presence at Elsheimer's wedding in 1606. Elsheimer's stylistic proximity to Bril is already recognisable in some of his early works, such as *The Three Marys at the Tomb* (cat.no.15) and *Saint Jerome in the Wilderness* (fig.36, cat.no.17).

Around 1605 Paul Bril painted a mountainous landscape as the setting for Ovid's version of the story of Mercury and Herse (fig.37, cat.no.24). The composition suggests the involvement of a second hand. Indeed, Wenceslaus Hollar reproduced the picture's central group in an etching and supplied it with Elsheimer's name (cat.no.56). Moreover, tradition has it – in records that can be traced back to 1761[68] – that Elsheimer actually painted the figures. Given their style, which recalls that of the women surrounding Helena in the *True Cross Altarpiece*, this attribution is plausible, as Waagen had already observed. If so, this is the only surviving painting on which the two artists collaborated. As early as 1620, Giulio Mancini mentioned that Elsheimer had worked together with other artists in Rome. In the case of Paul Bril the influence was reciprocal, as can be seen in Bril's work of around 1605, a fact already pointed out by Johann Faber (1628), who was close to both artists.[69]

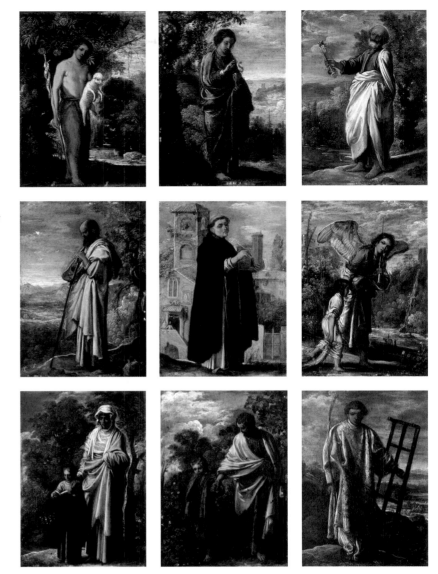

Fig.34
Adam Elsheimer, *Saints and Figures from the Old and New Testament*, from left to right:
a) *Saint John the Baptist* b) *Saint John the Evangelist* c) *Saint Peter*
d) *Saint Paul* e) *Saint Thomas Aquinas* f) *Tobias and the Angel*
g) *Saint Anne with the Virgin Mary* h) *Saint Joseph with the Christ Child*,
Petworth, Petworth House, The Egremont Collection (The National Trust);
i) *Saint Lawrence*, Montpellier, Musée Fabre

Fig.35
Adam Elsheimer,
The Flight into Egypt,
Fort Worth, Texas,
Kimbell Art Museum

Fig.36
Adam Elsheimer,
Saint Jerome in the Wilderness,
Private Collection

Fig.37
Adam Elsheimer
(attributed)
and Paul Bril,
*Mercury and
Herse*,
Chatsworth,
Trustees of the
Chatsworth
Settlement

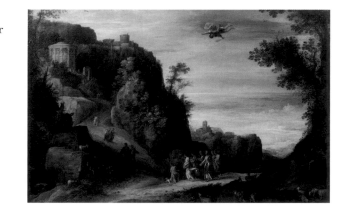

Fig.38
Adam Elsheimer,
Il Contento,
Edinburgh,
National Gallery
of Scotland

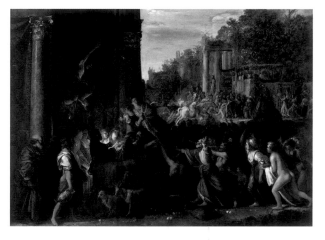

New Mythological Themes

In 1606 an Italian edition of the picaresque Spanish novel *Guzman de Alfarache* by Mateo Alemán appeared in Venice. The first volume of the original was published in Madrid in 1599, and was soon followed by numerous reprints. A masterpiece of Spanish literature, the book apparently caused an immediate stir in Rome. This is the only explanation for Elsheimer's treatment of a scene from the seventh chapter of the novel in his painting *Il Contento* (fig.38, cat.no.25), since the theme was hitherto unknown in painting. The intervention of the gods of antiquity, here Jupiter and Mercury, in the activities of people given over to pleasure, even taking such pleasure for granted, can only be seen as a moralising appeal that also corresponds to the Christian ethos. This erudite depiction, ill-suited for sale on the free market, must be considered a commission, even though documented evidence is lacking. This intellectually demanding subject indicates that Elsheimer was expected to do great things in Rome. The person who commissioned the painting, which was found unfinished in Elsheimer's studio at the time of his death, was probably – according to research carried out by Arnold Witte – Cardinal Odoardo Farnese (1573–1626), who was closely linked with the Spanish court through his background and family connections. He is named as the first owner of *Il Contento* on a drawn copy of the

work dated 1615. In installing his art collection in the Palazzetto Farnese – from 1603 Annibale Carracci, Domenichino and Lanfranco took part in its decoration and furnishing – he followed a comprehensive plan which aimed at portraying the perfection of God's Creation yet included the mythological world, a concept in which a permanent place was apparently reserved for Elsheimer's *Il Contento*. In contrast to the Galleria Farnese – built to house the collection of antiquities – which featured Annibale Carracci's monumental frescoes, here Odoardo designed an almost private gallery, in which he favoured mythological subjects and landscapes, with the objective of amassing a collection that provided an all-encompassing spiritual overview. It is indeed remarkable that he considered the sublime art of Elsheimer suited to his scheme.

We do not know when or how Elsheimer became acquainted with the book by Alemán, but the person who commissioned the painting certainly played an intermediary role. Visualising the mythical narrative was undoubtedly a challenge, since the painter had to manage without any precedents. No other work by Elsheimer allows us to follow his compositional preparations as closely as this one. Three carefully executed pen and wash drawings have survived – there might well have been more – which could have functioned as *modelli* in discussions with the patron (cat.nos.39–41). As the gradual modifications of Elsheimer's designs show, his consideration of this unusual subject led him to produce a composition dominated by scenes of thronging masses. The tumult of indignant people in the foreground is just as essential to the composition as the distant festival with sport and games, in which countless tiny figures take part. Moreover, the decoration of the temple, in front of which Jupiter descends, contains allusions to the Habsburg Empire, giving the antique scene an unexpected, contemporary twist. The fact that several passages remained unfinished raises the question of whether the painter possibly felt inadequate to the job of fulfilling his patron's high expectations and providing the wealth of detail required. After all, at this point in his artistic development Elsheimer had already begun to employ fewer figures and to simplify the pictorial space, making the landscape more than ever the focus of attention.

In his *Schilder-Boeck* of 1604, Karel van Mander reports that Elsheimer supposedly drew little,[70] an observation that is confirmed by the small number of sheets known today, even taking into account lost drawings and those not yet discovered. The surviving designs for *Il Contento* are among the few that afford insight into the work done in preparation for the execution of a painting. In their use of pen and wash, these preliminary designs correspond in essentials to the style of other artists of his generation, bearing in

mind that such drawings were probably submitted to patrons in order to discuss the work in progress. While in the case of Elsheimer special studies of figures or other details are altogether lacking, we do have a few brush studies for paintings, in which he tried out the spatial arrangement and light effects. In their monochrome gouache technique and small format these drawings represent an idiosyncratic speciality of Elsheimer,[71] characterised by dry brushstrokes usually on prepared paper, a brittle paint surface and dots of white. They depict complete compositions, but are seldom larger than ten centimetres. As far as their connection with known paintings is concerned (cat.nos.42–45, 47), they can be seen as preceding these works and, therefore, serving as preparatory studies.[72] The small sheets are extremely appealing; their unmistakably experimental nature heightens their effect. In so far as we can judge from the scant number of authentic gouaches, they seem not to have originated before 1605. The Ceres gouache in Hamburg (fig.39, cat.no.42) was presumably made at the beginning of this experimental phase in Elsheimer's development as a draughtsman, a period that was followed by attempts at etching (cat.no.46).

As recorded in the inventory of Elsheimer's estate,[73] the few books found in his studio included *The War of the Jews* by Flavius Josephus, *Trattato della nobiltà della Pittura* (Treatise on the nobility of painting) by Romano Alberti (Rome 1585), Boccaccio's *Decameron* and an edition of Ovid's *Metamorphoses*. His paintings testify to his careful reading, doubtless stimulated by his acquaintance with Philipp Rubens, and show that he was inspired by the poetry of antiquity to come up with very individual interpretations. One of these is the story – taken from the *Metamorphoses* – of Ceres, the goddess of fertility and agriculture, who sets out in search of her abducted daughter, Proserpina. Elsheimer treated this subject in a number of studies. In *The Mocking of Ceres* (fig.40, cat.nos.26, 27) he took up a subject hitherto unknown in painting, at the same time reverting to his predilection for nocturnal scenes. By choosing a vertical format he demanded comparison with Roman history paintings, perhaps prompted to do so by the example of Caravaggio.

The depiction of the goddess appearing before a peasant's hut is given a dramatic accent by its four sources of light, including the disc of the moon. The light of a torch coming from below lends Ceres the monumentality of an antique statue. Her pose and drapery were inspired, as Weizsäcker observed, by an Attic statue of Athena, which Elsheimer could have seen in Giustiniani's palace in Rome. He had already used antique statues as models for his portrayals of martyrs (cat.nos.18, 19). The thirsty young woman taking a drink, illuminated by flickering light, dominates the scene through her association and contrast

Fig.39
Adam Elsheimer,
The Mocking of Ceres,
Hamburg,
Kunsthalle

Fig.40
Copy after
Adam Elsheimer,
The Mocking of Ceres,
Madrid,
Museo del Prado

with the aged peasant woman who looks at her questioningly. This confrontation prepares the viewer for the uncanny event. The goddess – the 'nurturing one', who gave life to the earth, as the milking scene in the background stresses – is infuriated by the insulting behaviour of the boy Stellio and inflicts a punishment as much at odds with her nurturing nature as the contrast between light and dark. Stellio's reptilian sleekness presages the story's dark ending: his

metamorphosis into a lizard. This last episode was also attempted in a preparatory gouache, but in the end it was not included in the painting (cat.no.43).[74] Despite its small format, Elsheimer's *Mocking of Ceres* may be considered one of the most powerful images to emerge in early seventeenth-century Rome, and is thus worthy of comparison – as Andrews insists – with Caravaggio's *Conversion of Saul*. Hendrick Goudt's outstanding engraving (1610) after this painting (cat. no.50), which probably originated around 1605 and was the last one he made in Rome, points to the special significance of this work, apparent from the influence it continued to exert.[75]

Hendrick Goudt and Elsheimer, an Uneasy Liaison

It is not known in which year Hendrick Goudt – a descendant of a wealthy, noble family from Holland – came to Rome and why he sought out Elsheimer. It is generally assumed that he went to him as a pupil, even though he had already completed his training as an engraver in Holland (perhaps with Jan van de Velde I).[76] This was an art that he mastered to perfection, as evidenced not only by his prints and calligraphic inscriptions but also by his minutely detailed pen and ink drawings, which he made as autonomous works of art on parchment for collectors and also used as the basis for engravings after paintings by Elsheimer (figs.41, 42).[77] In Rome he also made free preparatory drawings that were sometimes closely related to Elsheimer's paintings, which suggests a master–pupil relationship. Still, no painting has ever surfaced that could be attributed with likelihood to Goudt.[78] There is no doubt, however, that Goudt lived for several years in the Elsheimer household[79] – his residence there was first recorded in 1607 (as 'Sr Henrico pictore'), and again in 1609 in the parish census – and that while living there he made three engravings after paintings by his master (cat.nos. 49–51). The relations between the two were sometimes extremely strained. As early as 1620, Giulio Mancini mentioned in a eulogy of Elsheimer his quarrel with Goudt, who – according to Sandrart's account – had given financial support to the deeply indebted Elsheimer and had waited in vain for repayment. Thus the painter was supposedly imprisoned for a short time, which is quite possible, though no substantiating evidence has been found. This explains why, immediately after Elsheimer's death, Goudt laid claim to several valuable works of the deceased and took them back to Holland. From 1611 he was recorded as a member of the Utrecht Guild of Saint Luke as an engraver. From the paintings of which he had taken possession, and which he kept for many years in his

Fig.41
Hendrick Goudt,
*Tobias and the
Angel*, drawing,
New York, The
Pierpont Morgan
Library

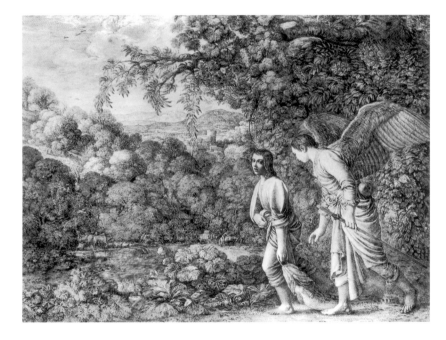

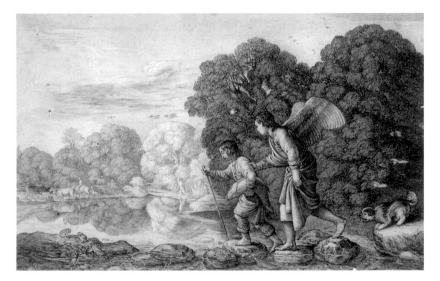

Fig.42
Hendrick Goudt,
*Tobias and the
Angel*, drawing,
Paris, Musée du
Petit-Palais,
Dutuit Collection

house in Utrecht, where Sandrart admired them,[80] Goudt made four masterly engravings (cat.nos.52–55), which ensured the dissemination throughout Europe of the nature and high quality of Elsheimer's art. Goudt's entire graphic oeuvre consists of seven engravings after Elsheimer. This series of prints was completed in 1613, after which he seems to have stopped working. The fact that he deliberately supplied these sheets with his own name only (as well as his noble titles) and suppressed Elsheimer's authorship testifies to his enduring resentment of his teacher.[81]

Presumably attributable to the beginning of Goudt's Roman period is a tiny engraving marked 'HG' (cat.no.49), which depicts a lost painting by Elsheimer (bearing the monogram 'AE') in oval format. It was probably the first engraving Goudt made after his master's work, since the relatively hard hatching does not match the high quality of his larger prints (cf., for example, cat.nos.50 and 53). The composition with the Beheading of John the Baptist, which has also survived in a preparatory drawing by Elsheimer (cat.no.44) and a number of copies, is closely related in style to *Il Contento* and *The Mocking of Ceres* (cat.nos.25, 27) and is also thought to reveal, as Weizsäcker mentioned, the influence of Caravaggio.

Marriage and Admittance to the Painters' Academy

Late in the autumn of 1606 Elsheimer decided to marry. The financial security he had hoped for had apparently been provided by the high-ranking patron who commissioned *Il Contento*, and this had perhaps made his decision easier. His bride, Carola Antonia Stuart (Stuarda), was the widow of a fellow painter in Rome, Nicolas de Breul, a native of Verdun, who had died only a few weeks previously.[82] De Breul had married Carola Antonia in the autumn of 1600. The couple lived in the same neighbourhood as Elsheimer, since 1605 with their infant son. Carola, who was of Scottish descent, had moved from Frankfurt to Rome in 1600 at the latest. Her family probably belonged to the community of British emigrants who had gathered in Frankfurt in the sixteenth century, which means that Elsheimer's acquaintance with her could have come about through their shared background.

Even though so little is known about Elsheimer's wife, the art-historical literature has treated her with contempt, because she was married to three men in the space of five years.[83] Something must be said in her defence. When Carola Antonia married Elsheimer on 22 December 1606, she was a single woman who had been hard hit by fate. Just three months before she had lost her only child and shortly thereafter her husband. The marriage was solemnised, for reasons of health,

not in San Lorenzo in Lucina but by special dispensation at the home of the bride, which suggests that the clergy took no offence at the customary year of mourning not being kept in her case – a circumstance objected to in the literature. Her need for protection, on whatever grounds, could have been the deciding factor. When Elsheimer died in 1610 after four years of marriage, he was survived by a wife who now had to care for their two-year-old son, Giovanni Francesco,[84] run a household deeply in debt and cope with the pressure of countless creditors. Three months later she was forced to leave their apartment, probably because she could not pay the rent. Her third marriage – to the Roman painter Ascanio Quercia,[85] nearly eleven months after the death of Elsheimer – provided Carola Antonia with the security she sought for herself and her child up until her death in 1620. Neither Rubens, who wrote from Antwerp to offer Carola his support after Elsheimer's death,[86] nor Elsheimer's friend Dr Faber, who acted as a witness to her third marriage in 1611, ever had a bad word to say about her, but most biographers have regarded her with strong disapproval nonetheless.

On 11 December 1606 Elsheimer's marriage contract was recorded in a notarial act witnessed by Paul Bril and the painter and engraver Pietro Facchetti, both members of the painters' Accademia di San Luca. Eleven days later the above-mentioned men, together with Johann Faber, took part as witnesses in the wedding ceremony. This is the first documentation of Elsheimer's friends,[87] who had certainly played a role in his life before this time. In this year Elsheimer was already a member of the painters' academy – an

Fig.43
Copy after
Adam Elsheimer,
Self-portrait,
1606,
Rome,
Accademia di
San Luca

exceptional honour for *oltremontani* – as emerges from the inscription on his portrait in the collection of the academy (fig.43);[88] his payment of membership fees is first recorded in 1607. Pietro Facchetti, who was then around seventy years old, no doubt attended the wedding as a representative of the academy of which he had long been a committed member.[89] A native of Mantua, he was known not only as a portraitist of the Pope and the aristocracy but also as a versatile agent. He took charge of the purchase and copying of art works for the duke of Mantua, and in this capacity maintained ties with Rubens, with whom he appraised Caravaggio's *Death of the Virgin* in 1607. Dr Faber, who was employed by the Pope as a herbalist and physician, was proud of the few works by Elsheimer that he had acquired for his collection, and even praised one in particular, quite unexpectedly out of context, in his book on the animals of Central America.[90] Paul Bril, who certainly recognised early on the talent of the young artist from Frankfurt, would have valued the stimulating work they carried out together, for he also owned two paintings by Elsheimer (cat.nos.15, 19). After about 1605 Elsheimer's influence became discernible in Bril's cabinet pictures, as the expert collector Dr Faber had already noticed.[91]

Aurora and the Discovery of Nature

Around the time of his wedding, Elsheimer again turned to a story from classical mythology, when he

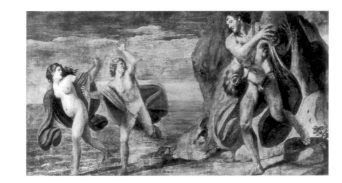

Fig.44
Sisto
Badalocchio,
*Polyphemus
Pursuing Acis
and Galatea*,
Rome, Palazzo
Verospi del
Credito Italiano

Fig.45
Adam Elsheimer,
Aurora,
Brunswick,
Herzog Anton
Ulrich-Museum

treated the flight of the lovers Acis and Galatea from the one-eyed giant Polyphemus. The episode, taken from Ovid's *Metamorphoses*, was not often depicted, though it was in the air, so to speak, as the fresco by Sisto Badalocchio in the Palazzo Verospi suggests (fig.44).[92] This episode was the original theme of the painting now in Brunswick known as *Aurora* (fig.45, cat.no.29). For unknown reasons Elsheimer rejected his first conception of the painting, a fact confirmed with the aid of infrared imaging (fig.103). He apparently decided not to replace the eliminated figures, and any intended addition of other figures never took place. In this respect *Aurora* can be considered one of the rather many paintings that Elsheimer left unfinished. The view into the landscape remained untouched throughout this change of plans. Its brightness emphasises the diagonal division of the pictorial space. The rising sun, which opens up the breadth of the view all the way to the horizon, reveals hills and trees in misty morning light, in which appears the goddess of the dawn. Hendrick Goudt supplied his 1613 engraving of the painting (cat.no.53) with a Latin inscription evocative of the literary origin of the first depiction. In translation it reads: 'Aurora, driving away the night, after removing its veil, gives back the longed-for day with her rose-coloured mouth'. It is the first time that Elsheimer elevated a landscape and its atmosphere to the status of the main subject of a picture, even if the working of the stars must be understood as referring to the mythical event and the fate of the lovers. The way had already been paved for the metaphorical use of cosmic processes in Elsheimer's work, as demonstrated by the small paintings of the Petworth series and *The Flight into Egypt* preserved at Fort Worth (cat.nos.21–23), but it was *Aurora* which first endowed landscape as a subject with a new quality that became exemplary for the development of European painting.[93] His artistic dialogue with Paul Bril may have contributed to the fact that Elsheimer the figure painter now recognised landscape as a theme in its own right.

The first rejected version of *Aurora* encourages an examination of Elsheimer's artistic milieu to ascertain whether there were painters who shared his ideas. A workshop in the traditional sense – with pupils and assistants – is never mentioned, nor would that be expected, considering Elsheimer's individualistic and miniaturistic working method.[94] The sources always mention his housemate Hendrick Goudt, who – as his drawings show – closely followed his master's work in his capacity as an engraver, as well as his friend and colleague Paul Bril, who was, however, a generation older and saw figure painting as a matter of secondary importance. Apart from this, the contemporary sources are silent, even to the extent of giving the impression, as do Martinez and Sandrart,[95] that

Elsheimer was a loner accustomed to solving his artistic problems on his own. It is, therefore, all the more surprising to find in a painting by Carlo Saraceni – *Landscape with the Abandoned Ariadne* (fig.155) – a direct reference to Elsheimer's no longer extant *Acis and Galatea*,[96] which is proof that the painter, who had been living in Rome since 1598, must have had access to Elsheimer's studio, enabling him to see *Aurora* in the making. Saraceni's painting, which belongs to a series of six mythological representations (now in Naples),[97] was attributed in 1883 by Bode – then still ignorant of this connection – to Elsheimer, until Longhi identified the Italian painter as the author of the series. The accompanying *Flight of Icarus* by Saraceni (fig.46) is also clearly dependent on *Aurora*. In addition, there is evidence of Elsheimer's influence in other works by Saraceni that can be assigned to his early Roman period. Little is known of the relations between Saraceni and Elsheimer, who were closely acquainted only for a short time. Saraceni's knowledge of the Acis and Galatea composition is important because it shows that the influence Elsheimer exerted on him not only emanated from general developments in painting but is also traceable to visits to his studio.[98]

The history paintings with landscapes that Elsheimer made around 1606–08 show that the representation of nature and its atmospheric manifestations was becoming more important. It was Elsheimer's so-called 'small Tobias' (fig.49, cat.no.30) which first attracted the attention of many artists in Rome, not least through the masterly engraving by Hendrick Goudt (cat.no.49) that appeared in costly editions, documented early on, which appealed especially to art collectors.[99] Elsheimer's *Apollo and Coronis*, *The Realm of Venus* and *Latona and the Lycian Peasants* must have been made in rapid succession (figs.47, 48, cat.nos.31–33), and finally, too, the lost 'large Tobias', the composition of which survives in copies (fig.50, cat.no.34). These paintings are linked by a completely individual view of landscape and the changing light, as well as by the poignant stillness of nature, which is preserved even in such emotional scenes as the death of Coronis and the mocking of Latona. Giovanni Baglione (1642) speaks of the 'marvellous harmony' (*mirabile armonia*) with which Elsheimer's figures coalesce with the true-to-life landscape. It prompts us to ask 'whether the landscape is there to provide a backdrop, or whether the story is merely a peg on which to hang that pronounced notion of nature or the cosmos'.[100] In his 'small Tobias' Elsheimer strikes a magical chord. The dark, looming silhouette of the forest and the group of figures approaching from the side correspond inversely to the composition of the first version of *Aurora* with Acis and Galatea (cat.no.29). After *The Mocking of Ceres* (cat.no.26) of 1605, the 'small Tobias' is the only painting by

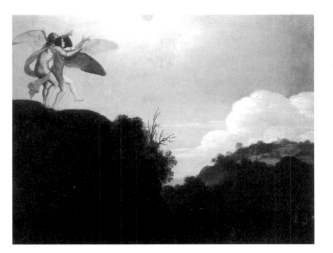

Fig.46
Carlo Saraceni, *The Flight of Icarus*, Naples, Museo Capodimonte

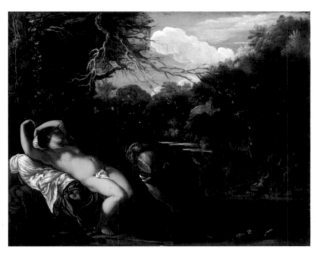

Fig.47
Adam Elsheimer, *Apollo and Coronis*, Liverpool, Walker Art Gallery

Fig.48
Adam Elsheimer, *Latona and the Lycian Peasants*, Cologne, Wallraf-Richartz-Museum – Fondation Corboud

Elsheimer that can be dated with certainty to before or around 1607, as Hendrick Goudt produced an engraving of it in 1608 (cat.no.49). Sandrart praises in particular the beauty of nature which surrounds Tobias, 'the true-to-life manner of which has never been seen before'. He noted, certainly reliably, that upon viewing the picture Roman contemporaries spoke with amazement 'of Elsheimer's newly invented artistry in painting'. Indeed, the pictures painted by the young German were a novelty, and not just in Rome. It is hardly surprising that it was precisely the 'small Tobias' that

Fig.49
Adam Elsheimer,
*Tobias and the
Angel* ('the small
Tobias')
Frankfurt,
Historisches
Museum

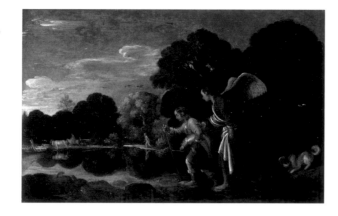

Goudt chose for his debut as a printmaker – his engraving made the composition famous in Rome – for he may well have seen himself as the promoter and authorised agent of his master.[101]

Elsheimer's bold attempt at a new vision and rendering of nature, probably undertaken unconsciously, was astonishing in view of the dominant role played by important artistic personalities in early seventeenth-century Rome. His painting is generally seen as emanating from the perspective of one individual, as the achievement of a profoundly sensitive loner.[102] By contrast, Thielemann has pointed out – without questioning the importance of the personal achievement – the significance of the non-artistic sphere from which the painter received important stimuli. Within his Roman circle of friends, Elsheimer could participate – especially through his patron Johann Faber – in the work carried out by the natural scientists who had banded together in 1603 to form the Accademia dei Lincei, founded by Federico Cesi, which had at its disposal the latest findings in such fields as botany, geology and astronomy. In addition, Elsheimer witnessed the philosophical discussions engaged in by his literary-minded friends – most of whom were directly or indirectly influenced by the philosopher Justus Lipsius – including Rubens and his brother Philipp, as well as Gaspar Scoppius, who represented the Louvain philosopher's neo-Stoic movement in Rome and certainly discussed artistic forms of expression based on this doctrine. In this context it is interesting that Cesi used the term 'pittura filosofica'. Lipsius's claim (*Physiologia stoicorum*)[103] – that the close study of natural phenomena and the meditative examination of the whole of nature would reveal the measure and meaning of divine Creation – is thought by Thielemann to reach fulfilment in Elsheimer's unprecedented and all-encompassing display of nature, which attained its apex in his *Flight into Egypt* (cat.no.36).[104] Elsheimer was always willing to take on difficult tasks, according to Sandrart, who was perhaps thinking of the painter's learned goals when he wrote: 'All of his doings greatly surpassed the thoughts of many other artists.'

The absolutely original creation of the 'small Tobias'

represented an important step in Elsheimer's development and his reputation as an artist. Its success also sparked off a demand for copies, large numbers of which have survived to the present day, though their exact date of origin has often been a matter of dispute. As early as 1620, Mancini complained that the painter's work was seldom to be seen, since he had not painted much and the few works that existed were owned by princes or kept hidden for fear of theft. Elsheimer's slow working method, necessary to such a miniaturistic technique (sometimes requiring the use of a magnifying glass), is confirmed by Rubens and Sandrart, so there must have been a great demand for additional versions of sought-after paintings.[105] The fact that copies of Elsheimer's paintings were produced by others already in his lifetime makes it certain that some of them – of outstanding quality – were made by copyists who had the benefit of working from the original, perhaps in the artist's studio. It is known that Cornelis van Poelenburch, who lived in Rome from 1617 to 1625, as well as Dirk van der Lisse, supplied collectors with copies of Elsheimer's pictures.[106] Jean-Baptist Le Brun issued a warning in his *Galerie des Peintres* (Paris 1792) regarding the many Elsheimer copies on the art market by Thomann von Hagelstein, David Teniers the Elder and Pieter van Laer,[107] the first two of whom are recorded as pupils of Elsheimer and in any case knew him personally.[108] Le Brun's source of information is uncertain, however, and the painters he mentions cannot be connected with specific pictures. Of the most frequently copied works, *The Mocking of Ceres*, the 'small Tobias' and *Apollo and Coronis* deserve special mention. Written records give no evidence for the production of copies by Elsheimer himself, which is repeatedly alleged, for obvious reasons. On the contrary, the chroniclers mention his unproductiveness and slow method of working (Van Mander, Mancini, Baglione, Sandrart), the frequency of pictures left unfinished (Baglione) and even his sloth (Rubens),[109] the latter thought to be the result of his melancholic temperament. There are in fact a number of unfinished paintings by Elsheimer, which surely suggests that he would have found neither the time nor the energy to copy his own works.[110]

Elsheimer took up the Tobias theme once more, possibly encouraged by his friends and patrons; the interval between the new rendering and the 'small Tobias' cannot have been more than two years. The composition of the lost painting, generally known as the 'large Tobias', has survived in reliable copies (fig.50, cat.no.34). The two compositions differ considerably. The second has a higher vantage point, affording an extended view into the depths of the picture; the landscape thereby offers the additional view of two sunlit chains of mountains behind the shaded valley, which is enlivened by passing shepherds. The tree-

tops – which appear spherical in the evening twilight and stand out in different hues on the hills – and the brightness of the sky, visible in places through the dark foliage, are characteristic of Elsheimer's keen observation of nature. His new vision of the landscape made a deep impression on his Roman contemporaries and occasionally triggered reactions among painters, as evidenced by Orazio Gentileschi's painting of Saint Christopher in Berlin, which was long thought to be a work by Elsheimer (fig.51).[111] Elsheimer's 'small Tobias' with its childlike wayfarer can be compared to German pictures of guardian angels, but the 'large Tobias' presents us with a youth, who – as the biblical story relates – vanquishes the dangerous fish, resolutely goes his own way, and proceeds to take a wife. Tobias could be said to have Italian features; the figures recall – in their gait and attitude – those of Carlo Saraceni, whose relationship to Elsheimer has still to be explained. The pair of travellers are framed, as it were, by thickly growing trees, bushes and vigorous plants, rendered with botanical precision. These are by no means the additions of an unknown copyist, since they are also clearly recognisable in the engraving after the painting that Hendrick Goudt, the last known owner of the work, made in 1613 in Utrecht (cat. no.54). It is conceivable that the strikingly detailed rendering of the plants in Elsheimer's 'large Tobias' is due to wishes expressed (or transmitted) by his close friend, the connoisseur Johann Faber, who was in charge of the botanical garden at the Vatican.

The Changing Light

Elsheimer's realistic yet poetic rendering of nature did not confine itself to the world of plants and the chang-

ing light. In portraying the story of Apollo and Coronis (cat.no.31), the nude figure of the slain Coronis may have been inspired by the sleeping Bacchant in Titian's *Bacchanal of the Andrians* (then in the Aldobrandini Collection in Rome) (fig.52),[112] but comparison of the two reveals Elsheimer's new realism; the depiction – like the dramatic story on which it is based – unmistakably portrays a pregnant woman. Despite the vivid colours and the sunlight glancing off the figures and the tree-tops, one senses the tragic ending of this love story – foreshadowed by the large, dead branch of the tree – and the sound of mourning echoing in the summery landscape.

By contrast, *The Realm of Venus* (fig.53, cat.no.32a and b, cat.no.59), which is part of the thematic conception of a group of three pictures, testifies to a cheerful world seldom found in Elsheimer's work. This painting, perhaps originally intended for inlaying in a costly piece of furniture, unites three allegorical motifs. Juxtaposed with the Arcadian land of Venus is the dark and melancholy *Realm of Minerva* on the one hand and the hierarchically superior *Realm of Juno* on the other. The last painting is no longer in existence, but all three compositions have survived in etchings by Wenceslaus Hollar, who copied the pictures in the collection of the Earl of Arundel. The scenes embody the three forms of life: the sensual, the active and the contemplative. The naked Venus rests in the sunlight, affording us a beautiful rear view as she looks round invitingly, while satyrs and maidens frolic in a clearing in the forest. By contrast, *The Realm of Minerva*, patroness of the arts and sciences, is dominated by darkness. In a dimly lit interior, two artists, busy drawing a model hanging from the ceiling, share the small room with a couple of scholars, immersed in their studies with the aid of books and a globe. The

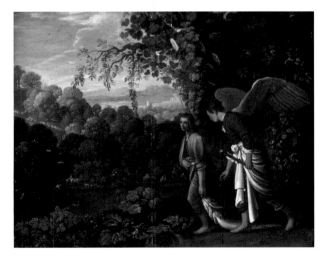

Fig.50
Copy after Adam Elsheimer,
Tobias and the Angel,
Copenhagen, Statens Museum
for Kunst

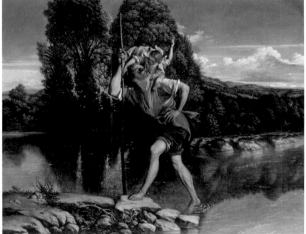

Fig.51
Orazio Gentileschi, *Landscape
with Saint Christopher*,
Berlin, Staatliche Museen,
Gemäldegalerie

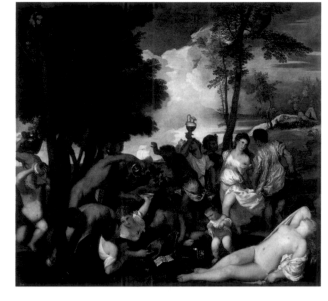

Fig.52
Titian,
*The Bacchanal of
the Andrians*,
Madrid, Prado

Fig.53
Adam Elsheimer,
*The Three
Realms of the
World*:

a) *The Realm
of Venus*,
Cambridge,
Fitzwilliam
Museum

b) *The Realm
of Minerva*,
Cambridge,
Fitzwilliam
Museum

c) Wenceslaus
Hollar after
Elsheimer,
*The Realm of
Juno*,
Frankfurt,
Graphische
Sammlung im
Städelschen
Kunstinstitut

aloof goddess, seated in a corner, strikes a melancholy pose – reminiscent of Dürer's engraving – which alludes to the arduous lives of artists. In *The Realm of Juno*, the Renaissance palace within the composition – quite unusual in Elsheimer's work – plays a dominant role. Weizsäcker explains Elsheimer's turning to architectonic elements as the result of possible contact with Jan van Santen, a Dutch architect living in Rome – a theory that seems plausible.[113] Thanks to an etching by Wenceslaus Hollar, we know of another picture with a dominant architectural motif, which depicts the temple of Bethesda and is described as a work by Elsheimer.[114] It shows a side of the painter's art that has so far been given little attention. The literary sources for these representations of the realms of the world are considered to be – as Andrews established – either Cartari's *Imagini delli Dei* (1556) or Fulgentius's *Mythologiae*. The stimulus for such subject matter could also have come from the unknown person who commissioned the works. Depictions such as these reveal Elsheimer's special talent for giving visual expression to mythical literature or even philosophical theories, a prerequisite of which is the ability to engage in learned discourse.

In 1608 Elsheimer turned to Ovid's *Metamorphoses* once again, taking up the subject of gods appearing in earthly guises, this time in a rustic interior. In his depiction of Jupiter and Mercury visiting the house of Philemon and Baucis (fig.54, cat.no.35), a rare subject in painting, there are three sources of light, which lead the viewer through the windowless hut. Baucis, the old woman with a severe profile, had already appeared in *The Mocking of Ceres* (cat.no.27). The painter's ingenious use of differentiated monochrome shades enables him to breathe life into this quiet story set in a cramped space. The dusky light, which emanates from various places to penetrate the vaguely defined interior and fill it with warmth, testifies to Elsheimer's masterly control of paint. The similarity of the atmosphere and the room to those in *The Realm of Minerva* (cat.no.32b) is obvious, and yet the latter picture has a different feel: the meagre sources of light cannot overpower the darkness, and melancholy permeates the interior inhabited by artists and scholars. The mood of the event taking place under the old couple's roof is completely different, however. The strangers have brought light to the hut of Philemon and Baucis – actually the divine light radiating from their beings – and with it a hint of cheer. The distinguished visitors, waiting for their hosts to provide food and drink, cannot have failed to notice the brightly lit picture of Mercury and Argus, a reminder of adventures restricted to gods. This humorous touch, eagerly adopted by Goethe in a short essay,[115] appears like a ray of sunshine dispelling the gloom that frequently darkened the painter's life.

A Glance Heavenwards

The art of narrative painting, which Elsheimer mastered in a way that few others did, may show to best advantage in those themes unfettered by literary sources or pictorial traditions, giving free rein to the imagination. Among these are the Flight of the Holy Family into Egypt, of which the Bible gives only a brief account.[116] Elsheimer treated the story twice, and a comparison of these pictures quickly reveals the wealth of ideas the painter brought to bear on this subject. It is difficult to imagine a greater difference than that between *The Flight into Egypt* in Munich (fig.55, cat.no.36), conceived as a nocturnal piece, and the same scene set in a sun-drenched landscape painted several years previously, a picture now in Fort Worth (cat.no.23). In the nocturnal scene, the expanse of the pictorial space is determined mainly by cosmic phenomena. The evocative meadows and forest paths of Elsheimer's earlier landscapes, which delimit the view, are now replaced for the first time by a curved expanse of clear, starry sky whose boundless heights, including the trail of the Milky Way, reflect the grandeur of God's Creation. Here, too, Elsheimer deployed three sources of light, though the self-reflecting disc of the moon should be considered a fourth, and – as seen in *The Mocking of Ceres* (cat.nos.26, 27) – each has been given an appropriate meaning. The fugitives realise that no danger awaits them on their nocturnal path, marked out from above, as it were, and lit by the light of the moon reflected in the woodland lake, by the shepherds at the fireside. who present the wayfarers with an earthly goal, and by the Milky Way, which leads to heaven. The ass, carrying Mary and the Christ Child, finds its way through the dark alone. Elsheimer had originally planned to let Joseph walk ahead, leading the beast by the reins. as custom dictated;[117] it was only at a later stage that he decided to have Joseph bring up the rear (fig.56), thereby clearly showing that the fleeing family have a heavenly guide. The discussion surrounding the depiction o fhe galaxy and Elsheimer's interest in the astronomical research of his day has pushed the theological significance of the representation to the sidelines, even though it deserves no less attention than the scientific aspect. The visual connection of the Holy Family in the centre of the picture with 'Jacob's Street' – as the Milky Way was called in the Middle Ages, and referred to by Sandrart[118] – suggests that the only path of importance to these travellers is the path to heaven, which Jacob, the progenitor of the Jews, saw in a dream as a ladder (Genesis 28:12). In this sense the night sky may be considered symbolic of God's presence.

Elsheimer was the first to paint the Milky Way as a dense array of stars and also to give an exact rendering of the moon's surface. Galileo was the first to publish

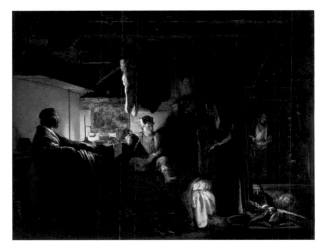

his observations of the moon in 1610,[119] so this raises the question of when and how the painter learned of the discovery made by this great astronomer in Padua, particularly as his *Flight into Egypt* bears the date 1609 on the back. This has given rise to a discussion about whether Elsheimer intended this view of the night sky as the rendering of a specific configuration of stars.[120] Suppositions of this nature have not been proved; moreover, the position of the stars in the painting cannot be explained by a true-to-life situation. This notwithstanding, Elsheimer's artful rendering of the stars and also the surface of the moon are so precise as to be unequalled in the history of art. As Thielemann emphasised,[121] in the summer of 1609 there were in Rome a number of telescopes, constructed by the natural scientist Federico Cesi, who corresponded with Galileo in Padua and was closely associated with Elsheimer through their circle of friends. Cesi, who was the first to call the optical instrument a telescope, was working on a book titled *Caelispicium* (View of the Heavens), which remained unfinished at his death. Thus the artist was in no need of Galileo's findings in order to paint his picture. Elsheimer certainly had the opportunity in Rome to observe the moon and the stars with the aid of a telescope, thereby receiving the inspiration to enlarge upon the subject of a starry sky in painting. He was no doubt aware of the significance of this artistic endeavour. The picture, on which Elsheimer must have worked for a long time, became his leave-taking from this world.

It is understandable to be curious about the physical appearance of an admired artist, especially an artist as talented as Elsheimer. The extent to which our curiosity is satisfied, however, differs from artist to artist and depends completely on the number and reliability of surviving likenesses. It is generally considered a matter of luck, but there could be a connection between the number of surviving portraits and the nature of the sitter. We know only one portrait of Elsheimer that is directly connected with the painter (fig.57, cat.no.37), and all others derive from this one.[122] Doubt

Fig.55
Adam Elsheimer,
*The Flight into
Egypt*,
Munich,
Bayerische
Staatsgemälde-
sammlungen,
Alte Pinakothek

had something to do with scruples which made the artist, who was not a portraitist, reluctant to hand it over. Elsheimer probably learned little about portraiture from his Frankfurt teacher Philipp Uffenbach, who did not make a name for himself in this genre, which is all the more reason to admire the high quality of this painting, which Bode thought comparable to the good portraits painted by the young Frans Pourbus.[126]

Elsheimer's reserve, in the true sense of the word, as well as his worried or even downcast features are in keeping (if our supposition is correct) with the description given by the Spanish painter Jusepe Martinez, who – admittedly without having met Elsheimer personally – made a note of it during his stay in Rome around 1625.[127] 'He was very withdrawn and of an introspective disposition, so much so that he walked the streets as though in a trance, and spoke to no one who did not speak to him first. He thought himself a much less significant artist than he actually was; his friends rebuked him, telling him that he should change his manner and have more confidence in himself, as was his due; his answer was always that he would follow their advice as soon as he found his works satisfactory.' This is the most detailed characterisation of Elsheimer that we have, and there is no reason to doubt its reliability, especially as it does not contradict the accounts of Van Mander, Mancini, Baglione and Sandrart. His behaviour was regarded as eccentric, yet all his friends remarked upon his kind-heartedness. A melancholy that can be inferred from his self-portrait was in the painter's nature, and Sandrart attributes it to Elsheimer's visual memory, which enabled him to recall many hours of observations without recourse to drawn *aides-memoires*: 'In the end this arduous method made him tired and melancholy, to which he was anyway inclined.' Baglione (1642) talks of stomach complaints caused by the concentration necessary to paint very small pictures in a bent position, supposedly a contributing factor to Elsheimer's premature death. There were certainly other reasons for his suffering, however, for he was oppressed by serious financial difficulties and was humiliatingly forced to endure a short spell in prison. The length of this undocumented prison sentence is unclear, nor is it known when his illness manifested itself, but he seems not to have worked any longer after completing his *Flight into Egypt*, which he probably finished in 1609.[128]

is often cast on the possibility of its being a self-portrait: for one thing, because he was not a portraitist and there are no other known portraits by his hand, and also because a life-size face does not easily lend itself to comparison with the miniaturistic style of his small paintings on copper. Andrews convincingly argues that the painting on canvas, preserved in Florence, is an authentic self-portrait by Elsheimer, which displays all the characteristics of such – in format, pose and glance, as well as the resting left hand holding brush and palette – and is identical with the one found in his studio at the time of his death.[123] Its format is in keeping with the collection of portraits in the Accademia di San Luca in Rome; moreover, Elsheimer's honourable enrolment in 1606 would have obliged him to supply them with his portrait.[124] Elsheimer could have painted it between 1606 and 1608, when his fame was at its height. In 1642 Baglione reported the portrait's presence in the academy, from where it later made its way – in unexplained circumstances – to Florence.[125] The late delivery of the painting (after Elsheimer's death) may have

Fig.56
Attributed to
Adam Elsheimer,
*The Flight into
Egypt*,
Paris, Galerie
Terrades

When Elsheimer died on 11 December 1610 and was buried the same day in San Lorenzo in Lucina,[129] Rubens was one of the first to be informed by Johann Faber. Rubens was devastated by the fate of his friend in Rome: 'For myself, I have never felt my heart more profoundly pierced by grief than at this news, and I shall never regard with a friendly eye those who have brought him to so miserable an end.'[130] The sources tell of the solemn farewell accorded to Elsheimer by his

Roman friends and the representative of the Accademia de' Pittori at the grave of the painter, dead at the age of only thirty-two, whose kind nature was held in high regard by all. In 1624, a younger member of the circle of the Accademia dei Lincei, Justus Rycquius of Ghent, composed a poem in Latin in honour of Elsheimer, an epitaph of friendship which he dedicated to Federico Cesi but also addressed to Johann Faber.[131] These verses draw our attention to Elsheimer's landscapes, to the trees at the edge of a clearing and to the beauty of approaching spring. They are moving words, honouring the painter who met such an untimely death and whom Rubens saw at the height of his powers, words to which Ludwig Tieck's outburst also belongs: 'I must speak of you, Elsheimer, who first showed me nature in this way.'[132] What must claim our attention even more, though, is the path taken by Elsheimer in his short life, and the artistic legacy which has permeated European painting to the extent that pictures by Rubens, Rembrandt and Claude Lorrain, to name but a few, still keep alive the memory of this great painter.

Fig. 57
Adam Elsheimer,
Self-portrait,
Florence,
Galleria degli
Uffizi

During the process of preparing for and writing this book, I benefited repeatedly from the help of institutes, museums and colleagues. I would hereby like to express my gratitude to them, above all the Rijksbureau voor Kunsthistorische Documentatie, The Hague, the Centrum voor de Vlaamse Kunst van de 16e en de 17e eeuw (Rubenianum), Antwerp, the Bibliotheca Hertziana, Rome, the Kupferstichkabinett of the Staatliche Museen, Berlin, the Museo Nacional del Prado, Madrid, the Bayerischen Staatsgemälde-sammlungen, Munich, and the Graphische Sammlung Albertina, Vienna.

It would not be possible in this context to mention everyone who aided me by word and deed in the publication of this catalogue, but I would like to express my sincere thanks to the following: Angelika Arnoldi-Livie, Holm Bevers, Bruno Bushart, Marcus Dekiert, Thomas Döring, Barbara Dossi, Silke Gatenbröcker, Emilie Gordenker, Bob P. Haboldt, Egbert Haverkamp-Begemann, Anna Kozak, Veronika Poll-Frommel, Konrad Renger, Martin Schawe, Jan Schmidt, Christian T. Seifert, Martin Sonnabend, Bożena Steinborn, Andreas Thielemann, Alejandro Vergara, Arnold Witte.

My very special thanks go as well to Michael Maek-Gérard and Michael Zuch for their patience and manifold assistance and to Diane Webb for her careful translation into English.

NOTES

1 H. Weizsäcker, *Die Kunstschätze des ehemaligen Dominikanerklosters in Frankfurt am Main*, Munich, 1923.

2 G. von der Osten, *Hans Baldung Grien. Gemälde und Dokumente*, Berlin, 1983, p.144; perhaps identical with the painting in the Städel, inv.no.HM21.

3 Sandrart 1675, p.160.

4 According to Sandrart, his sources of information in Frankfurt included the glass-painter Johannes Vetter the Elder and Elsheimer's teacher Philipp Uffenbach.

5 H. Dechent, *Kirchengeschichte von Frankfurt am Main seit der Reformation*, 2 vols., Leipzig and Frankfurt, 1913, vol.I, p.198ff.; Müller 1956, p.69ff.; K. Wettengl, 'Georg Flegel in Frankfurt am Main', in *Georg Flegel 1566–1638. Stilleben*, exh. cat. published by K. Wettengl, Historisches Museum, Frankfurt a. M., 1993, p.19ff.

6 Krämer 1986, p.226f.

7 Elsheimer's father previously lived in Wörrstadt (south of Mainz); his name might derive from the neighbouring village of Elsheim.

8 The house at Fahrgasse 120 bore a memorial plaque.

9 K. Simon, in Thieme/Becker 33 (1939), p.538f. On the situation in Frankfurt around 1600, cf. H. J. Ziemke, *Frankfurter Malerei in der Zeit des jungen Goethe*, Frankfurt a. M., 1982, pp.25–36.

10 Design for an armorial window, signed and dated by Adam Elsheimer and Johannes Vetter; Andrews 1977, no.28; Andrews 1985, no.28.

11 Frankfurt am Main, *Historisches Museum*, inv.no.B 303.

12 On this subject, see Koch 1977, p.116f.

13 Andrews 1977, no.28; Andrews 1985, no.28.

14 Andrews 1977, p.156, no.27.

15 Koch 1977, p.154, no.76.

16 Andrews 1977, no.30.

17 Thielemann 2006 A.

18 T. Vignau-Wilberg, *In Europa zu Hause. Niederländer in München um 1600*, Munich, 2005, p.25ff.

19 Koch 1977, p.170.

20 Gronert 2003, pp.211–16.

21 Müller Hofstede 1983, pp.183–89.

22 Andrews 1977, p.47.

23 Andrews 1977, no.32; Andrews 1985, no.32.

24 Van Mander 1604, fol.296; Andrews 1977, p.52.

25 Van Mander/Miedema 1994, vol.VI, pp.72–74; Van Mander/Miedema 1994, I, p.442.

26 Exh. cat. Essen/Vienna 2003, no.79.

27 Krämer 1995, pp.97–102.

28 R. Klessmann, *Herzog Anton Ulrich-Museum Braunschweig, Die flämischen Gemälde des 17. und 18. Jahrhunderts*, Brunswick, 2003, p.90, no.71.

29 DeGrazia Bohlin 1979, no.186; Andrews 1977, no.32.

30 Neumeister 2003, p.279; Uppenkamp 2004, pp.75–78.

31 A. Sutherland Harris, in exh. cat. New York 1985, p.187.

32 K. Christiansen 1986, pp.421–45.

33 Müller Hofstede 1970; regarding Elsheimer's liaison with Rubens cf. Baumstark 2005.

34 Vlieghe 1973, II, no.110.

35 Müller Hofstede 1966, p.2f., passim; Von Henneberg 1999, p.35, passim.

36 I. Lavin, 'An Ancient Statue of the Empress Helen Reidentified', *Art Bulletin* 49, 1, 1967, p.58f.

37 C. Baronius, *Annales Ecclesiastici a Christo nato ad annum 1198*, 12 vols., 1588–1607; new edition, edited by A. Theiner, Brussels, 1864–83.

38 Huemer 1996, p.XVII, 50; M. Morford, *Stoics and Neostoics: Rubens and the Circle of Lipsius*, Princeton, 1993.

39 Von Henneberg 1999, p.36.

40 Müller Hofstede 1970, p.90; Vlieghe 1973, II, no.111.

41 Berlin, Gemäldegalerie, inv.no.776 E; cf. Jaffé 1989, no.40 (c.1604/05); the dating of this picture is disputed.

42 Andrews 1977, p.146; Held 1980, I, no.325.

43 Klessmann 2006.

44 Renger 1977, pp.44–46, no.21.

45 Klessmann 2006.

46 Weizsäcker 1936, p.100.

47 Huemer 1996, p.XVII.

48 Cf. Baldriga 2002; Freedberg 2002.

49 Huemer 1996, p.XIX.

50 Sandrart 1675, p.160.

51 Weizsäcker 1936, pp.83, 324, n. 143.

52 Huemer 1996, p.13.

53 Vienna, Kunsthistorisches Museum, inv.no.230; Posner 1971, vol.II, no.97, no.139.

54 Andrews 1972, p.597f.

55 Bachner 1997, pp.249–53.

56 Munich, Alte Pinakothek, inv.no.338; Renger/Denk 2002, p.344f.

57 Cf. Seifert in this catalogue.

58 Klessmann 2006.

59 Orbaan 1927, p.158; Crinò 1965, p.575.

60 *Golden Legend*, vol.I, p.278ff.;vol.II, p.168ff.

61 Von Henneberg 1999, p.36.

62 H. Tietze, *Tintoretto. Gemälde und Zeichnungen*, London, 1948, p.241.

63 Schlichtenmeier 1988, p.81f., 205, no.G 15.

64 Orbaan 1927; Crinò 1965; Lenz 1989, pp.38–44; Cigoli wrote: 'Questi sono li sette piccoli quadretti messi tutti in ornamento di pero del disegno che apparisce di contro. Sono di mano d'Adamo Todesco…' (These are the seven small pictures, which are all inserted into a frame of pear wood of the shape appearing opposite. They are by the hand of Adam the German ….).

65 Von Henneberg 1999, p.39f.

66 Van Gelder/Jost 1967, p.32f.; Andrews 1977, no.41; Andrews 1985, no.41.

67 Duverger/Vlieghe 1971, p.19.

68 R. and J. Dodsley, *London and its environs described*, vol.II, London, 1761, p.229; Waagen 1854, III, p.347.

69 Faber 1628, p.748.

70 Van Mander 1604, fol.296.

71 Möhle thinks it possible that Elsheimer was inspired in Venice by the chiaroscuro drawings of Veronese. Möhle 1966, p.41.

72 Möhle considers the figural gouaches 'as a genre on the borderline between painting and drawing' and sees them as 'independent works of art in themselves … and not, as Weizsäcker assumed, as designs for planned paintings or etchings'. Möhle 1966, p.41.

73 Cf. Andrews 1972, p.597.

74 Andrews 1977, no.51.

75 Seifert 2006 A.

76 A. Sutherland Harris, in exh. cat. New York 1985, p.199ff.

77 Stampfle 1983, pp.257–59. In addition to Goudt's pen and ink drawings on parchment we also know prints on silk of a few of his engravings; cf. Seifert 2006.

78 An adaptation of Elsheimer's *Philemon and Baucis* (cat.no.35) – formerly Warnas, Sweden, Wachtmeister Collection, recently London, sale Sotheby's, 13 December 2001, lot 26 – was attributed by Weizsäcker to Goudt. Cf., in this catalogue, Seifert, fig.160.

79 Andrews 1977, p.47.

80 Sandrart 1675, p.180. When Sandrart visited Goudt in 1625/26, the latter had been declared mentally deranged and placed under legal restraint.

81 Mancini reports that Goudt and Elsheimer were reconciled when the latter took ill after their quarrel.

82 M. Silvestre in *AKL*, vol.14, p.175; J. Bousquet, *Recherches sur le séjour des peintres francais à Rome au XVIIe siècle*, Montpellier, 1980.

83 Noack 1909, col. 515; Andrews 1972, p.596.

84 The son, Joannes Franciscus, whose baptism was recorded on 10 October 1608 in the baptismal register of San Lorenzo in Lucina (cf. Andrews 1977, p.47), was named after his godfather, Johann Faber and – certainly at Carola Antonia's request – after her child, Franciscus, who had died on 13 September 1606. Elsheimer's son, who survived his mother, planned to enter the order of Saint Benedict, according to a 1629 contract entered into with his stepfather, Ascanio Quercia (cf. Andrews 1977, p.51, document 17).

85 Noack 1909, col. 515. Quercia assumed some of Elsheimer's debts (cf. Andrews 1977, p.51, document 17).

86 Letter written by Rubens to Johann Faber on 14 January 1611; Andrews 1977, p.51.

87 Noack 1909, col. 513.

88 Andrews 1977, p.155, fig. 99; the portrait, made by a copyist, ended up in the academy's collection when Elsheimer's self-portrait (cat.no.37) was given for unknown reasons to Cosimo III de' Medici in Florence.

89 S. Poeschel, in *AKL* 36, p.136f.

90 Faber 1628, p.748; Andrews 1977, p.153.

91 Andrews 1977, p.153; the composition of Paul Bril's 1612 miniature *Landscape with the Temptation of Christ* clearly depends on Elsheimer's *Aurora* (cat.no.29).

92 Palazzo Verospi, now Credito Italiano, is located at Corso 374. There is no record of the date of the fresco's origin, though it was presumably painted after 1617; cf. L. Salerno, in *Via del Corso*, published by U. Barberini, Rome, 1961, p.177; Klessmann 1988, p.160ff.

93 The influence exerted by the painting inspired Goethe, in 1820, to write a poem to accompany a print of the *Aurora* engraving by Hendrick Goudt; J. W. Goethe, *Werke. Gedichte*, 4th vol., Weimar, 1891, no.5a.

94 Cf. Seifert's essay in this catalogue.

95 Martinez, p.41; Sandrart 1675, p.162.

96 Klessmann 1988, p.162.

97 A. Ottani Cavina, in exh. cat. New York/Naples 1985, p.192, no.59.

98 Jan Pynas, at this time with Pieter Lastman in Rome, also appears to have studied the painting as evidenced by a drawing made after it; cf. Klessmann 1988, p.162f.; Seifert points out the likelihood of contact between Pynas and Saraceni in his contribution to this catalogue.

99 On Goudt's drawings on parchment and the prints on silk, cf. Seifert in this catalogue.

100 Thielemann 2006.

101 Cf. Sandrart 1675, p.180; and Seifert in this catalogue.

102 Thielemann 2006.

103 This summary is based on Thielemann 2006.

104 Thielemann 2006.

105 See further also R. Klessmann, *Johann Liss. A monograph and catalogue raisonné*, Doornspijk, 1999, p.111f.

106 Cf. Klessmann 1988, p.166f.

107 Andrews 1977, p.57.

108 Sandrart, p.160ff.

109 See Rubens's letter to Johann Faber, Antwerp, 14 January 1611, in which he refers to 'il peccato d'accidia'; cf. Ruelens/Rooses 1887–1909, vol.VI, p.327f.; Magurn 1955, no.21; Lenz 1989, p.76.

110 Cf. Andrews 1972, p.598.

111 Berlin, Staatliche Museen, Gemäldegalerie, inv.no.1707; Longhi 1943, p.22; Waddingham 1972 B, p.611.

112 Titian, *Bacchanal of the Andrians*, Madrid, Prado; Tietze 1936, no.45.

113 Weizsäcker 1936, p.117.

114 Parthey 114; Andrews 1977, p.166, A 18 (rejected works).

115 J. W. Goethe, 'Nach Falconet und über Falconet' (1776), in *Werke,* I, vol.37, Weimar, 1896, p.319 .

116 W. Augustyn, in *RDK* IX, col. 1352ff.

117 Cf. M. Dekiert, in exh. cat. Munich 2005, p.35; on the examination and restoration of the painting, cf. V. Poll-Frommel, in exh. cat. Munich 2005, p.203f.

118 Sandrart 1675, p.162.

119 Galileo Galilei, *Sidereus Nuncius*; cf. Krifka 2000, pp.441–44; Dekiert, op. cit. p.32.

120 Ottani Cavina 1976, p.139. See further Munich 2005.

121 Thielemann 2006. Cardinal Scipione Borghese, with whom Elsheimer was in contact, seems also to have possessed a telescope in 1609; cf. Freedberg 2002, p.430, n.2.

122 Weizsäcker names a total of sixteen portrait engravings, all of which were made after Elsheimer's self-portrait in Florence (cat.no.37). Weizsäcker 1936, p.132f. Of these, the engraving by Frisius and Hondius (cat.no.47) deserves special mention. The fact that it was included in the series of portraits *Pictorum aliquot celebrium praecipue Germaniae inferioris effigies*, published by Hendrick Hondius the Elder in The Hague around 1610, at which time Elsheimer's painting was still to be found in his studio in Rome, means that there must have been a drawn copy that served as a model in Holland.

123 Andrews 1973 A, p.3.

124 Andrews 1973 A, p.3.

125 The self-portrait is documented in the collection of the Uffizi since 1704.

126 Andrews misunderstood Bode's remark that Elsheimer's self-portrait was comparable to the portraits painted by the young Frans Pourbus. Andrews 1973, p.4, n. 6. Bode clearly considers it an autograph work by Elsheimer. Bode 1883, p.263.

127 Martinez 1866, p.40f.; Bode 1883, p.245ff.

128 A letter written by Rubens on 10 April 1609 to Dr Faber shows that he knew nothing at this time of either Elsheimer's illness or an altercation with Goudt. Cf. Andrews 1977, p.51.

129 Noack 1909, p.515; Andrews 1977, p.48.

130 Ruelens/Rooses 1887–1909, VI, p.327f.; Magurn 1955, no.21.

131 D. Jaffé and E. McGrath, 'A humanist tribute to Elsheimer', *Burlington Magazine* 131, 1989, p.700f.

132 *c.*1800: Ludwig Tieck, *Gedichte*, Frankfurt a. M. 1995, p.189.

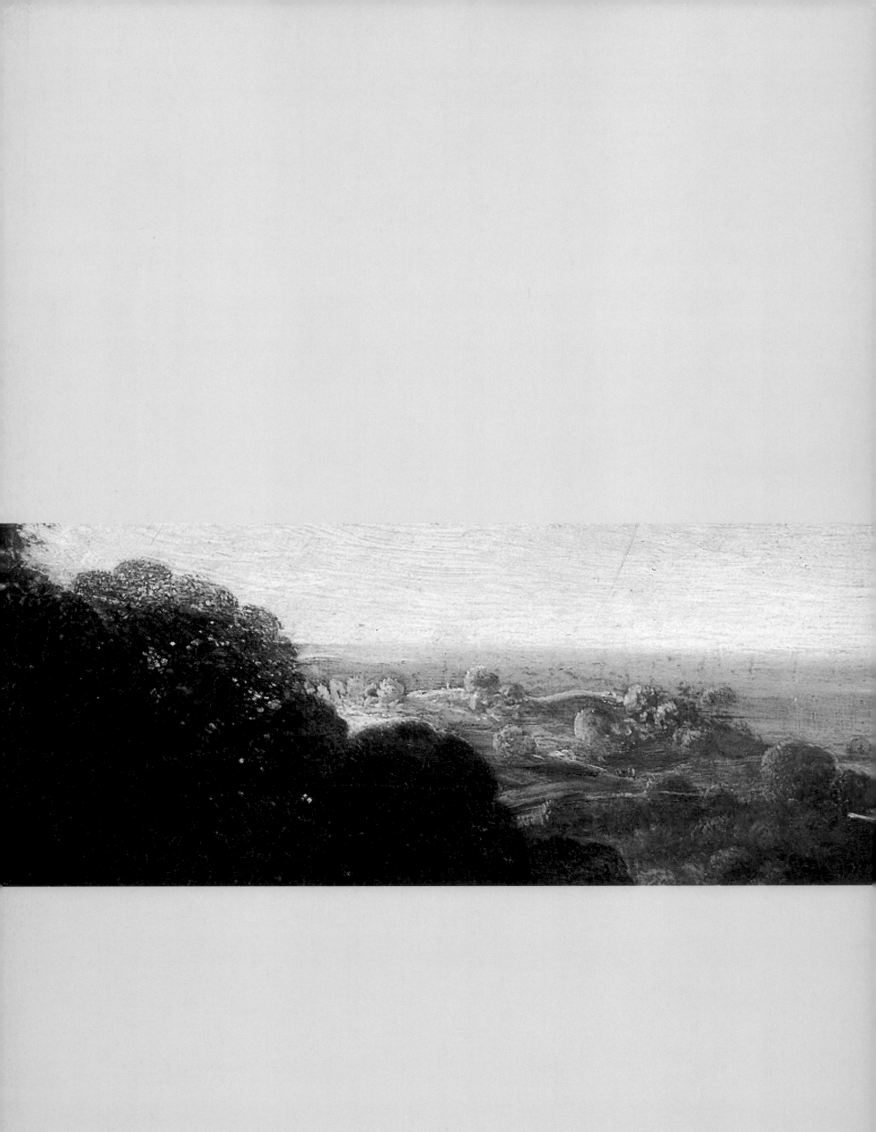

Catalogue

RÜDIGER KLESSMANN

ADAM ELSHEIMER

I The Witch

Copper, 13.5 x 9.8 cm
Lent by Her Majesty Queen Elizabeth II,
inv.no.733

PROVENANCE Sir Arthur Hopton
(c.1588–1650); Collection of Charles I (1639)

LITERATURE Abraham van der Doort,
Catalogue of the Collections of Charles I,
published by Oliver Millar, *Walpole Society* 37,
1960, p.77; C.H. Collins Baker, *Catalogue of
Pictures at Hampton Court*, Glasgow, 1919,
p.41 (attributed to Elsheimer); Waddingham
1972 B, p.602; Andrews 1973, p.162; Andrews
1977, no.1; Koch 1977, p.138f.; Andrews
1985, no.1

This small painting – based on Albrecht
Dürer's engraving *Witch Riding Back-
wards on a Goat*, made around 1500–03
(fig.58) – shows a naked woman seated
backwards on a horned beast, riding
through the air. She holds a distaff be-
tween her legs, and her hair, strangely
enough, streams in the direction she is
moving. Four cupids, romping on the
ground below her, play with sticks and
vessels.[1] Elsheimer, who admired Dürer,
made an exact copy of his image – the
possession of which was thought to have
the power to ward off evil – but trans-
formed it into a nocturnal scene to heigh-
ten its mystery. Why the young painter
chose to copy a print that was nearly a
century old has never been asked. It can
hardly be a coincidence that Elsheimer
painted this picture of a demon at a time
when witch trials were being held on an
unprecedented scale all over Europe. He
or his unknown patron must have feared
the threat of witchcraft. It is certain that
'in the late sixteenth and early seven-
teenth century people from all levels of
society were thoroughly convinced that

witches and sorcerers existed and that
their sinister doings, aimed at both people
and animals, should be punished by
death'.[2] In view of the exponential in-
crease in the persecution of innocent
people – a misfortune suffered by many –
it must be assumed that pictures such as
this were commissioned and painted in
the hope of averting danger. In the
Frankfurt of Elsheimer's day, many
women were tried for witchcraft, though
none were put to death; this was in stark
contrast to the situation prevailing since
1590 in the immediate vicinity of the city,
in the Archbishopric and Electorate of
Mainz, where the persecution of witches
had increased to horrific levels.[3] This is
where Elsheimer's father lived, before he
settled in Frankfurt.

The first mention of the picture – which
is recorded in the 1639 inventory of the
collection of Charles I as a gift from Sir
Arthur Hopton – states explicitly that
Elsheimer painted it after a print by
Dürer before he went to Italy. Hopton
could only have learned this unusually
exact and undoubtedly reliable informa-
tion from the work's previous
(Frankfurt?) owner, from whom he
bought the painting on one of his tours of
Europe in 1629 or 1635. Despite the
unusual subject, the attribution to
Elsheimer – as Andrews emphasises – is
confirmed by the characteristic manner
of painting and the transparent modelling
of the figures and drapery. The picture
could have been made around 1596–98.
Waddingham, who first published *The
Witch*, pointed out another version of the
painting, which was to be found in 1890
under Elsheimer's name in the collection
of Franz Jäger in Vienna, where it was
sold at auction in 1900. A copy in hori-
zontal format is in the Hermitage in St
Petersburg.[4]

Fig.58
Albrecht Dürer,
*Witch Riding
Backwards on a
Goat*, engraving

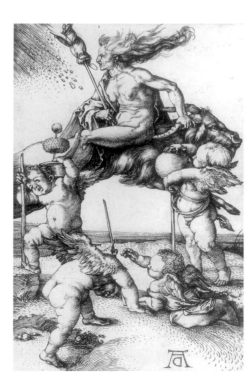

NOTES
1 On the meaning and iconology of Dürer's
 engraving (Bartsch 67, Hollstein German,
 vol.68), cf. Mesenzeva 1983.
2 S. Lorenz, 'Der Hexenprozess', in exh. cat.
 *Hexen und Hexenverfolgung im deutschen
 Südwesten*, Karlsruhe, 1994, p.79; *Hexen
 und Hexenprozesse in Deutschland*, edited
 by W. Behringer, Munich, 1988, p.182.
3 W. Eschenröder, *Hexenwahn und
 Hexenprozeß in Frankfurt am Main*,
 Gelnhausen, 1932, p.13.
4 T. Frimmel, *Berichte und Mitteilungen des
 Altertumsvereins zu Wien* 30, Vienna, 1890,
 p.24; Vienna, Hirschler sale, 26 April 1900,
 lot 14; St Petersburg, Hermitage,
 inv.no.8604; Nikulin 1987, p.74; Mesenzeva
 1983, p.194, no.22, fig.9.

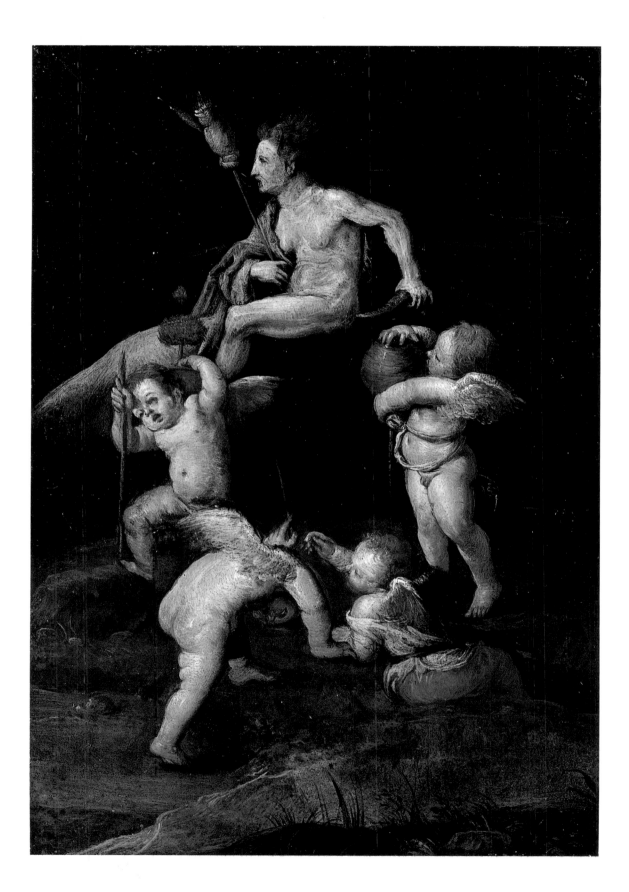

ADAM ELSHEIMER

2 Saint Elizabeth Tending the Sick

Copper, 27.6 x 20 cm
London, The Wellcome Institute for the History of Medicine, inv.no.IC44650i

PROVENANCE Hammelburg, Prof. Paul Stolz (1927); Amsterdam, P. de Boer; Amsterdam, R.W. de Vries; sale Cologne (Lempertz), 1 December 1927, lot 63 (as Elsheimer); sale Amsterdam (A. Mak), 5 June 1928, lot 173 (as Elsheimer); R.W. de Vries, from whom acquired in 1928

LITERATURE Krämer 1978, pp.319–26; Andrews 1979, p.171; Andrews 1985, p.174, no.2 A; Lenz 1989, p.8

Elizabeth of Hungary (1207–1231) – also called Elizabeth of Thuringia, a Hungarian princess who married a German landgrave – entered the Franciscan Order after the death of her husband and subsequently devoted herself to caring for the poor and the sick.[1] The painting shows the saint, accompanied by two elegantly dressed helpers, distributing food and drink to bedridden people in a hospital ward. In the arched space above the window, the arms of the Hungarian dynasty indicate Elizabeth's royal lineage; on the windowsill below stands a vase of roses, the saint's attribute. Above the coat of arms, a swallow – a symbol of the Resurrection – nestles against a beam in the ceiling.[2] To the left of the arched opening leading to the next ward hangs a large statue of the crowned Virgin with the Christ Child, raising his hand in blessing. To the right, a patrician wearing a red beret and fur-collared cloak speaks to a servant and indicates with outstretched hand the exemplary actions of the princess.

The painting – discovered only in 1927 and first published in 1978 by Gode Krämer – is typical of Elsheimer's early work, which displays technical and artistic weaknesses and no sign of contact with Italian painting. The lack of skill at rendering perspective is especially noticeable. The figures stem from the repertoire of fifteenth- and sixteenth-century German figure types, particularly as regards their costumes. Andrews points out similarities to the woodcuts of Albrecht Altdorfer, and Lenz to the engravings of Dürer.[3] As Krämer remarks, Elsheimer was influenced in his treatment of the theme by a frieze of wall-paintings portraying Saint Elizabeth executed around 1520 in the choir of the Hospital Church of the Teutonic Order in the Sachsenhausen area of Frankfurt. Here, too, there is the motif of a row of beds, and the sick being tended by the saint (fig.59).[4] Despite the work's shortcomings, no convincing rejection of the attribution has been forthcoming; indeed, the character and manner of the painting of the figures display such compelling parallels to Elsheimer's later works that his authorship cannot be doubted. The narrative style and conception of the figures demonstrate close connections with the panels of the small *House Altar* in Berlin (cat.no.3). Pentimenti and traces of perspective lines bear witness to Elsheimer's painstaking manner of painting. Despite its exactness of detail, the picture does not portray an existing interior, though it recalls depictions by the Antwerp architectural painter Hendrick van Steenwyck the Elder, who was active in Frankfurt from 1586 until his death in 1603. The Catholic subject matter of this work, which must have originated before the painter's departure for the south around 1597, strongly suggests that it was a commissioned work, which Elsheimer executed in the overwhelmingly Protestant city either for the Hospital Church or for a member of the Teutonic Order.

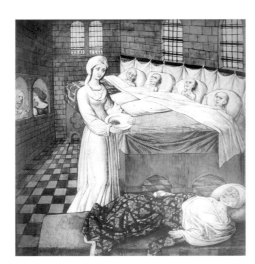

Fig.59
Anonymous master, *Saint Elizabeth and the Leper*, Frankfurt, Deutschordenskirche (Church of the Teutonic Order)

NOTES
1 *Golden Legend*, vol.II, p.302ff.
2 Dittrich 2004, p.473.
3 Andrews 1979, p.171: Altdorfer, *The Beheading of John the Baptist*, 1512 (Winzinger 1963, vol.II, no.18); Dürer, *The Promenade*, engraving (Bartsch 94; Hollstein German, vol.83).
4 Krämer 1978, p.322.

3 House Altar with Six Scenes from the Life of the Virgin

a) central panel: *The Coronation of the Virgin*,
copper, 26 x 21 cm
b/c) left wing: *The Annunciation / The Nativity*,
copper, each panel 12 x 10 cm
d/e) right wing: *The Visitation / The Adoration
of the Magi*, copper,
each panel 12 x 10 cm
f) predella: *The Death of the Virgin*, copper,
10 x 21 cm
Berlin, Staatliche Museen, Gemäldegalerie,
inv.no.664

PROVENANCE Berlin, Königliche Sammlung
(before 1830)

LITERATURE Bode 1880, pp.58, 248; Bode
1883, p.250f., 280; Bothe 1939, p.34;
Weizsäcker 1952, p.69 (as Hendrick van der
Borcht); Andrews 1973, p.164ff.; Andrews
1977, no.2; Koch 1977, p.140ff.; Waddingham
1978, p.853; Andrews 1985, no.2

This altarpiece, intended for private de-
votion, shows in the two upper compart-
ments of the side wings *The Annuncia-
tion*, the archangel's announcement to
Mary of the birth of Jesus, and *The Visita-
tion*, Mary's meeting with Elizabeth (Luke
1:26–38, 36–56). On the left-hand panel,
Mary – sitting at a table in a room with a
crudely timbered ceiling and rustic fur-
nishings – listens to the announcement of
the angel, sweeping in on a cloud and
holding a white lily (a symbol of purity).
The back wall of the room is taken up by a
bed, the curtains of which are pulled to
the side. In the foreground stands a chair
with a bobbin, a symbol of virtuous do-
mesticity since the late Gothic period.[1]
The right-hand panel shows the two preg-
nant women meeting in the forecourt of a
large building. The matronly Elizabeth –
the elder of the two, who will become the
mother of John the Baptist – kneels before
Mary, recognisable as the Virgin by her
long, flowing hair. Mary is accompanied
by a woman carrying a basket on her
head; waiting at the portal is Elizabeth's
husband, Zacharias, the high priest of the
temple. The tower in the background –
which, as indicated by pentimenti, the

Fig.60
Albrecht Dürer,
The Nativity,
engraving

painter later corrected – is in Koch's view
an important building in medieval
Frankfurt, the Gallows Gate, which was
demolished in 1809.[2]

The two lower compartments of the
wings are devoted to *The Nativity* and
The Adoration of the Magi (Luke 2:1–20;
Matthew 2:1ff.). The Holy Family has
found refuge on the ground floor of a
ruined building; a cloud with angels
hovers above them. Mary kneels in prayer
next to the Christ Child – lying on a basket
turned upside-down – whom Joseph
gazes at in wonder. The naked infant
wears a swaddling-band, an unusually
realistic detail that does not otherwise
occur in painting. Behind Mary, a stair-
way leads up to a portico with columns
that disappear into the clouds, an allusion
to the palace of King David, in the ruins of
which the Holy Family found shelter, as
well as to the exaltation of the Virgin.[3] In
the background, the two men approach-
ing – who are visible through the doorway
– are shepherds summoned from the
field. Various details – the staircase, for
example, and the archway in the distance
– were obviously inspired by Dürer's
1504 engraving of *The Nativity* (fig.60).[4]
Discernible in the foreground, beside the
basket on which the child lies, is a large
opening to a cellar, a detail ignored until
now. This motif, known from Nether-
landish altarpieces painted by Rogier van
der Weyden and his followers, refers to
the legendary cistern of Bethlehem, re-
lated in the *Speculum Humanae Salva-
tionis*. King David, engaged on the field of
battle, had water brought from this
source by three of his loyal companions,
an Old Testament prefiguration of the
Three Kings who travelled to Bethlehem
to receive the water of eternal mercy from
Christ.[5] In the pendant on the right-hand
side, *The Adoration of the Magi*, the
painter dispensed with the kings' tradi-
tional entourage – owing to the
constraints imposed by the small format –
but here, too, he depicted an opening in
the floor in front of the Christ Child.

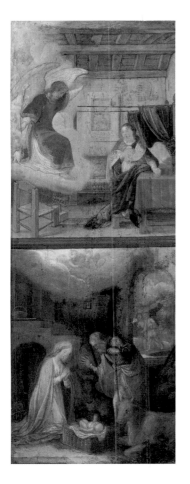

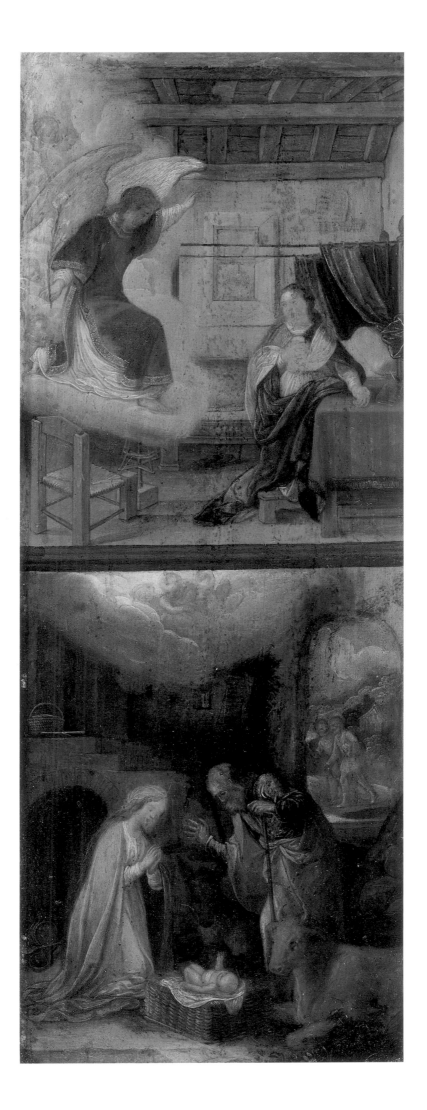

3 b/c
left wing

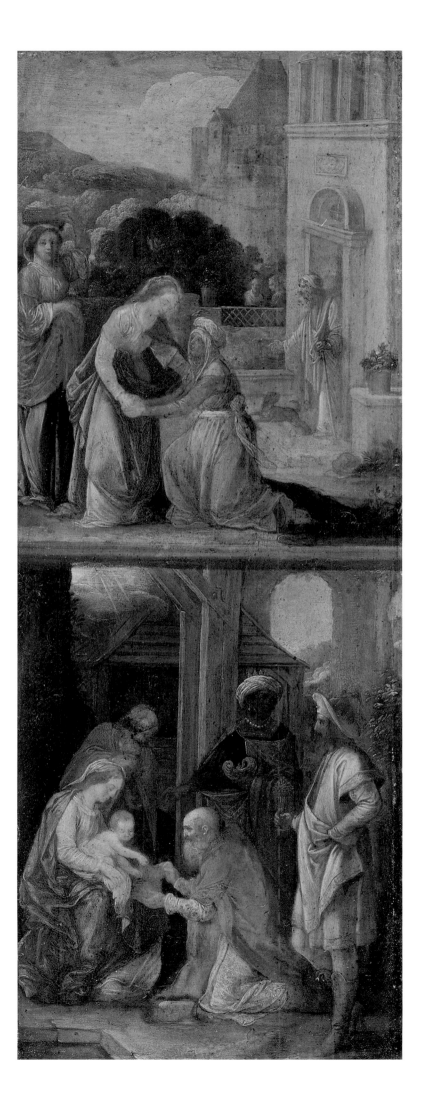

3 d/e
right wing

3 a
central panel

3 f
predella

According to Koch, this depiction shows similarities to the woodcut Dürer made of this theme in 1511 (fig.61).[6]

The central panel conflates *The Assumption of the Virgin* and *The Coronation of the Virgin* in heaven, performed by God the Father and Christ, surrounded by a host of angels (as described in *The Golden Legend*). Elsheimer's composition is based in the main on Dürer's *Heller Altarpiece*, which he must have seen from an early age in Frankfurt's Dominican Church.[7] The apostles, who witness the miracle from their place beside the Virgin's empty sarcophagus, are depicted like those in Dürer's altarpiece, without the vigorous gestures typical of the Nuremberg master, though Dürer's prints did provide a model.[8] Elsheimer also adopted Dürer's motif of a landscape opening up into a vast vista, above which the heavenly event takes place. *The Death of the Virgin* is treated in a separate depiction on the predella.[9] The twelve apostles stand by the deathbed of the Virgin, who holds a burning candle in her hand. Striking is the archaic composition, which points to the use of a medieval precedent.[10]

Since it was first documented in the Royal Museum in Berlin in 1830, the small *House Altar* has been assessed variously, certainly in part because of its poor state of preservation. The paint surface is extremely abraded, especially that of the middle panel; this damage must have occurred early in the painting's history. At first it was thought to be a work of the 'Netherlandish school under Italian influence'. Wilhelm Bode was the first to recognise the altarpiece as an early work of Elsheimer (in 1880), though

he later retracted his opinion. It was not until 1973 that Andrews resolutely defended Elsheimer's authorship on convincing grounds. The figures of the predella are similar, first of all, to the Petworth panels (cat.no.21), as well as to the depiction of *Saint Elizabeth Tending the Sick* (cat.no.2). The motif in the latter picture of the servant standing in the doorway was used again by Elsheimer in the predella. The apostle, depicted in profile standing at the feet of the dying Virgin, exudes the spirit of Dürer; he appears again in the series of saints at Petworth. That this is one of Elsheimer's early works, which he made in Germany, can no longer be doubted, though the question remains as to its exact place of origin: did he paint it in Frankfurt or during his sojourn in southern Germany, in the circle of the Bavarian court, for example, where the Counter-Reformation exerted a strong influence?

NOTES

1 S. Lüken, *Die Verkündigung an Maria im 15. und frühen 16. Jahrhundert*, Göttingen, 2000, pp.57, 298, 438, no.191.

2 Koch 1977, p.154, no.76.

3 K. Arndt, *Altniederländische Malerei*, Berlin, 1968, p.14.

4 Dürer, *The Nativity of Christ*, engraving 1504 (Bartsch 2, Hollstein German, vol.2).

5 S. Neilson Blum, *Early Netherlandish Triptychs. A Study in Patronage*, Berkeley and Los Angeles, 1969, p.20; *Speculum Humanae Salvationis*, I, part 2, chapter IX, p.129.

6 Dürer, *The Adoration of the Magi*, woodcut 1511 (Bartsch 3, Hollstein German, vol.208). Cf. Koch 1977.

7 The altarpiece was sold in 1616 to Duke Maximilian of Bavaria and replaced by a faithful copy made by Jobst Harrich, which is now in Frankfurt, Historisches Museum (fig.1). The original by Dürer was lost in a fire in Munich in the eighteenth century. Cf. F. Anzelewsky, *Albrecht Dürer. Das malerische Werk*, Berlin, 1971, p.219ff. On its iconography, cf. p.61f.

8 The relationship of Elsheimer's composition to Dürer's altarpiece is treated in detail by Koch 1977, p.142f..

9 *Golden Legend*, vol.II, p.78ff.

10 Koch refers to the similarly constructed death scene in the *Death of the Virgin Altarpiece* (Maria-Schlaf-Altar) in Frankfurt's Cathedral of St Bartholomew. Koch 1977, p.152.

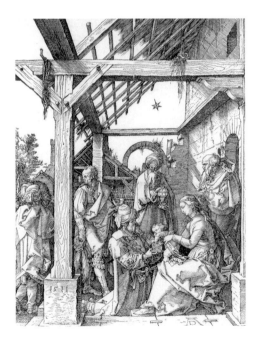

Fig.61
Albrecht Dürer,
The Adoration of the Magi, woodcut

4 The Conversion of Saul

Copper, 19.7 x 25.1 cm
Frankfurt am Main, Städelsches Kunstinstitut
and Städtische Galerie, inv.no.2107

PROVENANCE (?) Earl of Arundel (before
1646); Duke of Norfolk; sale London
(Christie's), 11 February 1938, lot 84;
Matthiesen, San Francisco; San Francisco, W.
Heil Collection; acquired 1966

LITERATURE Heil 1949, p.221ff.; Weizsäcker
1952, p.VII; exh. cat. Frankfurt 1966, no.22;
Waddingham 1967, p.47; Bauch 1967, p.92;
Van Gelder/Jost 1967, p.141f.; M. Stuffmann
1969, p.169f.; Waddingham 1972 B, p.601;
Andrews 1973, p.169f.; Lenz 1977, p.16ff.;
Andrews 1977, no.4; Lenz 1979, p.298ff.;
Cropper/Panofsky-Soergel 1984, p.480;
Andrews 1985, no.4; Lenz 1989, p.22ff.

Saul (later Saint Paul), a ruthless persecutor of the Christians, was on his way to Damascus with his attendants when, just as he was nearing the city, he was suddenly struck down by a light from heaven. Blinded by the glare, he fell from his horse and heard the voice of the Lord saying, 'Saul, Saul, why persecutest thou me?' Saul then asked, 'Who art thou, Lord?' and received the answer, 'I am Jesus, whom thou persecutest' (Acts 9:1–9). The picture is a multi-figured scene showing panic-stricken people and horses beneath a cloud-darkened sky, from which a ray of light bursts forth. In the middle, Saul lies on the ground, arms outstretched, with several letters scattered beside him, which – as the Bible relates – were documents he was going to present as incriminating evidence against the Christians. The sight of the fallen horse, with its legs in the air, at once parallels and heightens the helplessness of the recumbent Saul.

The composition reveals the painter's inexperience and the difficulties he had in treating this subject. In Lenz's words, 'the group's "disarray" and the differences in poses and gestures are so great as to give the impression that here a number of individual studies have been assembled'. Considering the great number of prints on which artists could have drawn, there is little point in identifying general motifs, but in this case it can be assumed that Elsheimer made use of Hans Baldung Grien's famous woodcuts of wild horses in the woods (fig.62).[1]

The painting first surfaced in 1938 in a private collection in England, where it was recorded, together with *Jacob's Dream* (cat.no.5), as a work by Elsheimer. The two panels are generally considered to be pendants, even though their

Fig.62
Hans Baldung
Grien, *Fighting Horses*, woodcut

compositions bear no relation to one another, in view of their common provenance, their identical sizes and supports, and their similarity of style. There is no reason to assume a conceptual link, and yet there is practically no doubt that they were made at almost the same time. *The Conversion of Saul* shows, by virtue of the additive style and the artificial poses of the figures, all the characteristics of an early work, which does not match the quality of the first paintings Elsheimer made in Venice and furthermore betrays no Italian influence. As noted by Andrews, the recumbent figure of Saul occurs in a similar pose in Elsheimer's design for an armorial window, which is dated 1596.[2] Waddingham points out its closeness in style to works by Frederick van Valckenborch, who settled in Frankfurt when Elsheimer was still living there. In the light of this possible connection, the dating of the picture, as proposed by Andrews and Lenz, to the painter's German period of around 1598, is quite justified.

Like its pendant, *Jacob's Dream* (cat.no.5), *The Conversion of Saul* displays severe abrasion; moreover, both pictures appear to be unfinished in places. The documentation of companion pieces, related in both size and subject, attributed to Elsheimer – in the possession before 1619 of the Flemish painter Karel Oldrago, who was active in Rome – is connected by Cropper and Panofsky-Soergel with the present painting, on the assumption that, as Waddingham suggests, they were made in Italy.[3] However, because the descriptions in the inventory of Oldrago's estate are very brief and rather vague, this identification remains uncertain. If it is correct, however, the small pictures, which Elsheimer perhaps painted during his stay in Munich, could easily have been taken to Rome.

NOTES

1 Exh. cat. *Hans Baldung Grien*, Kunsthalle, Karlsruhe, 1959, nos.78–80; Bartsch 56–58.
2 Düsseldorf, Kunstmuseum, inv.no.FP 5473; Andrews 1977, no.28; Andrews 1985, no.28.
3 Waddingham 1972 B, p.601; Waddingham 1978, p.854.

5 Jacob's Dream

Copper, 19.5 x 26.1 cm
Frankfurt am Main, Städelsches Kunstinstitut
and Städtische Galerie, inv.no.2136

PROVENANCE (?) Earl of Arundel (before
1646); Duke of Norfolk; sale London
(Christie's), 11 February 1938, lot 84; London,
art dealer Matthiesen; Basle, Robert von Hirsch
Collection; sale London (Sotheby's), 21 June
1978, no.120; acquired 1978

LITERATURE Waddingham 1972 B, p.60of.;
Andrews 1973, p.171f.; Andrews 1977, no.3;
Waddingham 1978, p.854; Lenz 1979,
p.298ff.; Cropper/Panofsky-Soergel 1984,
p.479; Andrews 1985, no.3; Sello 1988, p.22ff.;
Lenz 1989, p.22ff.

Jacob, the third of the great Jewish patri-
archs, was journeying to Harran. At
night, having lain down on some stones to
rest, he dreamed of a ladder reaching up
to heaven, with angels climbing up and
down. God spoke to Jacob from on high,
saying that the land on which he was
lying would one day belong to him and his
descendants (Genesis 28:13). Elsheimer
rendered Jacob as a simple journeyman,
sleeping – with a dog guarding him – at
the foot of a mighty tree trunk. Behind
Jacob an impenetrable forest rises
sharply to the left; on the right, the view
opens up to a wide river valley, above
which glows the light of God. This striking
contrast in landscape could have a sym-
bolic meaning. Andrews points out the
relationship of the representation to a
woodcut of the same subject by Tobias
Stimmer (1539–1584) (fig.63).[1] The pose
of Elsheimer's Jacob is obviously based
on that of a recumbent figure in Dürer's
woodcut of the Resurrection, on which

Elsheimer's teacher Philipp Uffenbach
also drew.[2]

The poor state of preservation of this
painting, which was perhaps left unfin-
ished in several places, makes it difficult
to assess. It displays abraded passages,
especially on the right-hand side.
Nevertheless, the attribution to Elsheimer
is convincing. It has been suggested that
the dense wood in the background be-
trays the influence of the Netherlandish
painters' colony in Frankenthal, and
Waddingham considers the possible
impact of Paul Bril, but German pre-
cedents for this motif are also conceiv-
able. The flaws in the composition and
technical execution suggest that the
picture originated before Elsheimer's
departure for Italy around 1598.

Fig.63
Tobias Stimmer,
Jacob's Dream,
illustration to
Flavius Josephus,
*Historien und
Bücher*, Strasbourg
1578

NOTES
1 Flavius Josephus, *Historien und Bücher*,
 Strasbourg, 1578.
2 Dürer, *The Resurrection of Christ*, woodcut
 (Bartsch 15, Hollstein German, vol.124).

6 The Adoration of the Magi

Copper, 22 x 28.3 cm; initials in ligature on a bale at the right (unidentified monogram) Lent by Her Majesty Queen Elizabeth II, inv.no.1323

PROVENANCE (?) Rome, Karel Oldrago (1619); London, Kensington (1697); Buckingham House (1821) (as Martin Roter); Windsor (as Rottenhamer); Hampton Court 1904

LITERATURE Waddingham 1972 B, p.601 (Elsheimer); Andrews 1973, p.174, n. 21 (Rottenhammer); Andrews 1977, p.166, A 9 (Rottenhammer and Bril); Lenz 1978, p.168 (Rottenhammer and Elsheimer); Waddingham 1978, p.854 (Elsheimer); Cropper/Panofsky-Soergel 1984, p.480 (Elsheimer?); Andrews 1985, pp.17, 45, n. 4, p.202, A 9 (Rotten-hammer and Bril); Rapp 1989, p.131, n. 14 (Elsheimer); Pijl 1998, p.660, n. 10 (not Bril)

The wise men from the East followed the star that led them to Bethlehem, where they found Mary and the baby Jesus. They knelt before the newborn king of the Jews and presented him with precious gifts (Matthew 2:1–11). The wise men, originally astrologers at the Persian court, have been seen as kings since the third century. In the middle of the picture are three splendidly dressed monarchs, who presumably symbolise the three continents: the first kisses the feet of the Christ Child; the other two, representing Asia and Africa, stand behind him with their gifts.

The attribution of the painting to Elsheimer, first put forward by Wadding-ham, has not yet gained general acceptance. It deserves further discussion, however, as long as a collaboration between Elsheimer and Johann Rotten-hammer – who worked with other painters as well – is considered a possibility. It should be noted that the figures of Mary and the Christ Child (and the angels above her) are closely related to similar ones in Rottenhammer's *Rest on the Flight into Egypt* of 1597 in Schwerin (fig.134). Waddingham points out that the model-ling of the kneeling, naked slave in the right-hand corner of *The Adoration of the Magi* is comparable to that of the youth climbing a tree in Elsheimer's *The Flood* (cat.no.11). The turbaned man standing behind the slave resembles, in Wadding-ham's view, a prototype for the figure of the Emperor Decius in Elsheimer's *Saint Lawrence Prepared for Martyrdom* (cat.no.18). The two blonde women – who participate in the devotional ceremony from their places by the pillar behind Mary – appear in similar poses in Els-heimer's *Embarkation of the Empress Helena* (cat.no.20b), where the boy with

the hat and poultry basket occurs as well, dressed as a page and carrying the train of Helena's cloak. The list of similarities to figures in autograph works by Elsheimer mentioned above could be extended. Admittedly, this painting has anatomical weaknesses, as well as shortcomings in the drawing of the figures. The mountains rising up in the background of this *Adora-tion* reflect the landscape style of Jan Brueghel the Elder, who collaborated with Rottenhammer. According to Waddingham, Rottenhammer can be exected to have urged Elsheimer to study closely the work in the Scuola di San Rocco by Tintoretto, from whom he him-self had drawn much inspiration, as mentioned by Ridolfi as early as 1648. Tintoretto did indeed exert a fundamental influence on Elsheimer's work during his years in Rome, as seen in *The Flood* and the altarpiece portraying *The Finding and Exaltation of the True Cross* (cat.nos.11, 20). *The Adoration of the Magi*, which is not at all homogeneous in style, betrays many things that might be acceptable in the work of a beginner or in a collabora-tive effort, but which nevertheless are irritating. It must be assumed, therefore, that the picture is the work of a painter who was closely associated with Rotten-hammer, or was even his pupil, at the end of the 1590s, which leaves the question of a possible connection to Elsheimer unre-solved. Dotted contours reveal that the painter made use of a drawing pricked for transfer to lay in the design. No satisfac-tory explanation has yet been offered for the monogram on the bale next to the slave. Apart from the sign of the cross rising up in the middle of it – occurring in similar fashion in Elsheimer's *The Flood* – the letters in question seem to be MR or MVR written in ligature.

7 The Holy Family with the Infant Saint John

Copper, 37.5 x 24.3 cm
Berlin, Staatliche Museen, Gemäldegalerie,
inv.no.2039

PROVENANCE (?) Rome, Karel Oldrago (1619);
(?) Rome, Stefano Landi (1620–35); Nurem-
berg, art dealer Theodor Stroefer, Hirschel-
gasse 26 (before 1893); by descent to August
Stroefer, from whom acquired for the museum
in 1928

LITERATURE Voss 1929, p.20ff.; Drost 1933,
p.40; Weizsäcker 1936, I, p.67ff.; Weizsäcker
1952, no.14; H. Möhle in exh. cat. Berlin 1966,
no.7; J. Held, in exh. cat. Frankfurt 1966,
no.11; Andrews 1977, no.7; Cropper/
Panofsky-Soergel 1984, p.479; Andrews 1985,
no.7; E. Schleier, in *Gemäldegalerie Berlin.
Geschichte der Sammlung und ausgewählte
Meisterwerke*, edited by H. Bock, Berlin, 1985,
p.348f.; Sello 1988, p.37ff.; A. J. Martin, in exh.
cat. Venice 1999, p.618, no.204

Fig.64
Albrecht Altdorfer,
*The Rest on the
Flight into Egypt*,
Berlin, Staatliche
Museen, Gemälde-
galerie

In a densely wooded, summery land-
scape, Mary – sitting at the foot of a tree
with its top broken off – holds in her lap
the baby Jesus, who greets the infant
Saint John with an embrace. To the left
sits an angel, which must be the young
visitor's companion, for at his feet stands
the emblem of John the Baptist, a lamb
with a reed cross. Joseph, sitting at the
right edge of the picture, observes the
scene of welcome. A large number of
angels, cascading down from heaven, turn
to the pair of children, thereby stressing
the importance of the event, which suit-
ably takes place in the centre of the com-
position. The representation, which has

no historical basis, was long interpreted
incorrectly as the rest on the flight into
Egypt, though the story offers no explana-
tion for the presence of the infant Saint
John. The legendary meeting of Jesus and
John as children enjoyed its own pictorial
tradition in the sixteenth century, when
the children were generally portrayed
without their parents present.

 The painting is closely related in style,
as well as in use of colour and treatment
of light, to *The Baptism of Christ* (cat.
no.8), which also has a rounded top. Both
works feature at the upper right a large
angel, wearing a red robe or drapery,
who looks down upon the principal scene.
The paintings, probably produced in close
succession, resemble the painting of
Albrecht Altdorfer in such devices as the
use of hovering angels to develop the
pictorial space. The figure of Joseph at the
right edge of *The Holy Family* is even
assumed to be a direct borrowing from a
work of Altdorfer, as evidenced by com-
parison with his 1510 *Rest on the Flight
into Egypt* in Berlin (fig.64).[1] The two
large angels in the curved top – the angel
on the left emerging from behind a tree,
the one on the right scattering flowers –
were derived, as regards their figure
types and strong foreshortening, from
examples by Tintoretto. Venetian features
and reminiscences of Altdorfer here
combine to produce a blend typical of the
early Elsheimer, in which Germanic
characteristics predominate: these can be
seen in its fairy-tale-like quality, the

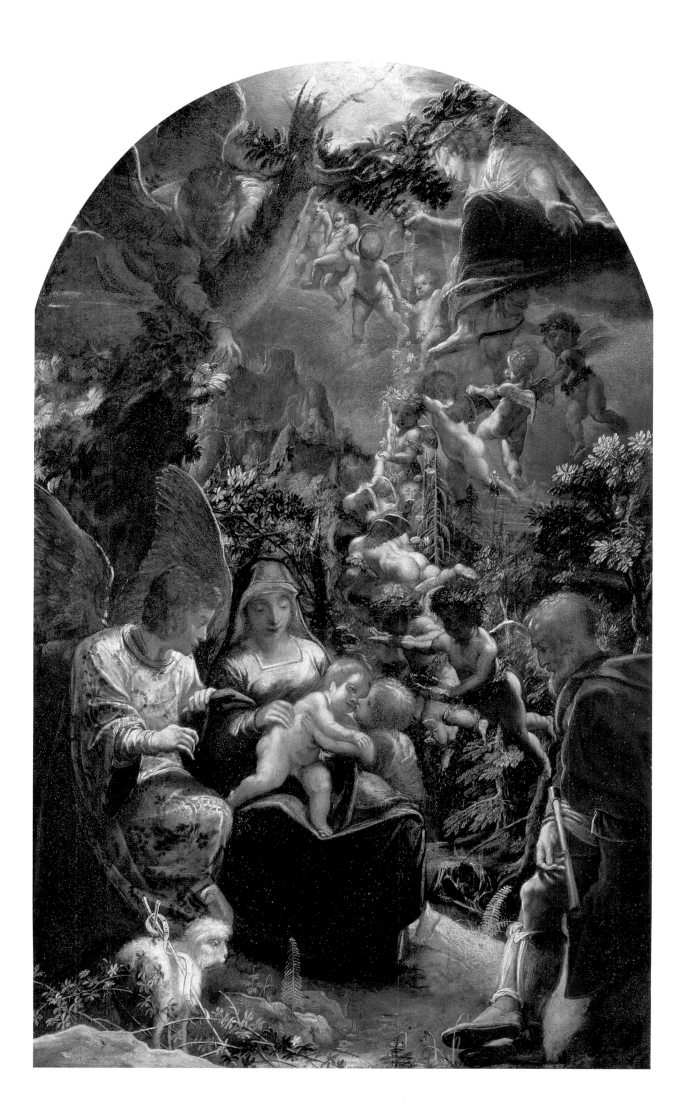

luxuriant vegetation and wealth of figural detail, and the jumbled disorder of the landscape. The close connection with Rottenhammer's style also suggests that the painting was made in Venice around 1599, but it is likely that *The Holy Family* preceded *The Baptism of Christ* with its more pronounced Italian influence. Striking indeed is the costly dalmatic worn by the angel seated next to Mary, which anticipates the splendid robes of the Eastern figures Elsheimer painted later in Rome, for example in *Saint Lawrence Prepared for Martyrdom* and *The Stoning of Saint Stephen* (cat.nos.18, 19).

Karel (Carlo) Oldrago, a Flemish painter living in Rome who was an acquaintance and neighbour of Elsheimer and Paul Bril, kept a substantial collection of pictures that bore the name of Elsheimer

in his apartment on the Piazza di Spagna. According to the inventory drawn up at his death in 1619, it included 'a Madonna with many angels, half oval' and 'a Saint John the Baptist baptising the Lord',[2] both rounded at the top. It seems logical to connect the copper plates mentioned above – as Cropper and Panofsky-Soergel have suggested – with the Berlin and London paintings (cat.nos.7, 8), both of which have similar dimensions. The identification can by no means be considered certain, however, since the inventory gives no further description. Remarkably, no copies of these paintings have surfaced yet, apart from a pen and ink drawing in Paris after *The Baptism of Christ*, which Andrews thinks was probably made by a seventeenth-century German artist (fig.65).[3]

NOTES

1 Berlin, Staatliche Museen, Gemäldegalerie, inv.no.638 B.
2 'una madonna con molti angeli mezza ovata'; 'un San Giovanni battista che battezza Il Signore'.
3 Paris, École des Beaux-Arts, 302 x 264 mm, inv.no.M 1129, as Poussin. I have no first-hand knowledge of this drawing.

8 The Baptism of Christ

Copper, 28.1 x 21 cm
London, The National Gallery, inv.no.3904

PROVENANCE Rome, Karel Oldrago (1619);
Rome, Stefano Landi (1620–35); sale London
(Christie's), 1 March 1771, lot 59 (Elshamer);
sale London (Christie's), 27 March 1779, lot 70;
London, Sir Joshua Reynolds; sale London
(Christie's), 14 March 1795, lot 27; sale
London (Christie's), 25 April 1812, lot 132; sale
London (Christie's), 27 May 1882, lot 16; Henry
Wagner (1882); donated to the museum in 1924

LITERATURE Drost 1933, p.38ff.; Weizsäcker
1936, I, p.66f.; Longhi 1943, p.45, n. 31
(Lastman?); Weizsäcker 1952, no.18; Levey
1959, p.43; Krämer 1973, p.148; Andrews
1977, no.8; Cropper/Panofsky-Soergel 1984,
p.476; Andrews 1985, no.8; Sello 1988, p.34f.

Fig.65
Copy after
Elshiemer by an
unknown seven-
teenth-century
German artist,
*The Baptism of
Christ*,
Paris, École
nationale
supérieure des
Beaux-Arts

According to the Gospels, Jesus came
from Galilee to the River Jordan to be
baptised by John. When Jesus rose from
the water, he saw the heavens open 'and
the Spirit of God descending like a dove,
and lighting upon him: and lo a voice
from heaven, saying, This is my beloved
Son, in whom I am well pleased'
(Matthew 3:13–17; Mark 1:9–11; Luke
3:21–22; John 1:29–34). Above this scene
of baptism hovers a ring of winged putti,
through which God, looking down from
the clouds, sends a ray of light – emanat-
ing from the dove of the Holy Ghost – to
strike the head of Jesus. We also recog-
nise 'the Spirit of God descending like a
dove' in the large angel with outspread
wings, who holds a regal red robe in
readiness for Jesus. The people gathered
on the shore awaiting baptism are figures
that might represent the various conti-
nents: a man of Eastern origin on horse-
back, whose attention is being drawn to
the proceedings by a knight, a young
Moor, and a mother sitting on the ground,
breast-feeding her child. The bearded
man removing his shoe and sitting alone
in the foreground, next to Jesus and John
the Baptist, is completely in shadow in the
otherwise brightly lit summer landscape.
These three figures form a striking trio.
The man with the shoe probably symbol-
ises the unbaptised, who have not yet
been blessed by the light of God. The
motif recalls Moses' vision of the burning
bush and the words God called out to him:
'Draw not nigh hither: put off thy shoes
from off thy feet, for the place whereon
thou standest is holy ground' (Exodus
3:5). In view of this text and the parallels
to the calling of Moses, it can be assumed
that the trio in the foreground are to be
interpreted theologically.

No other painting by Elsheimer shows
so cogently the result of his sojourn in
Venice and his study of Venetian art. The
use of impasto in the figures reflects the
style of Veronese and Tintoretto, which
steered Elsheimer's manner of painting in
a new direction, and his first attempt –
guided by Rottenhammer's example – to
come to grips with the portrayal of the
naked body. The picture as a whole,
however, is still rooted in the traditions of
fifteenth- and sixteenth-century German
art and in the South German world of
images that Elsheimer had just left. The

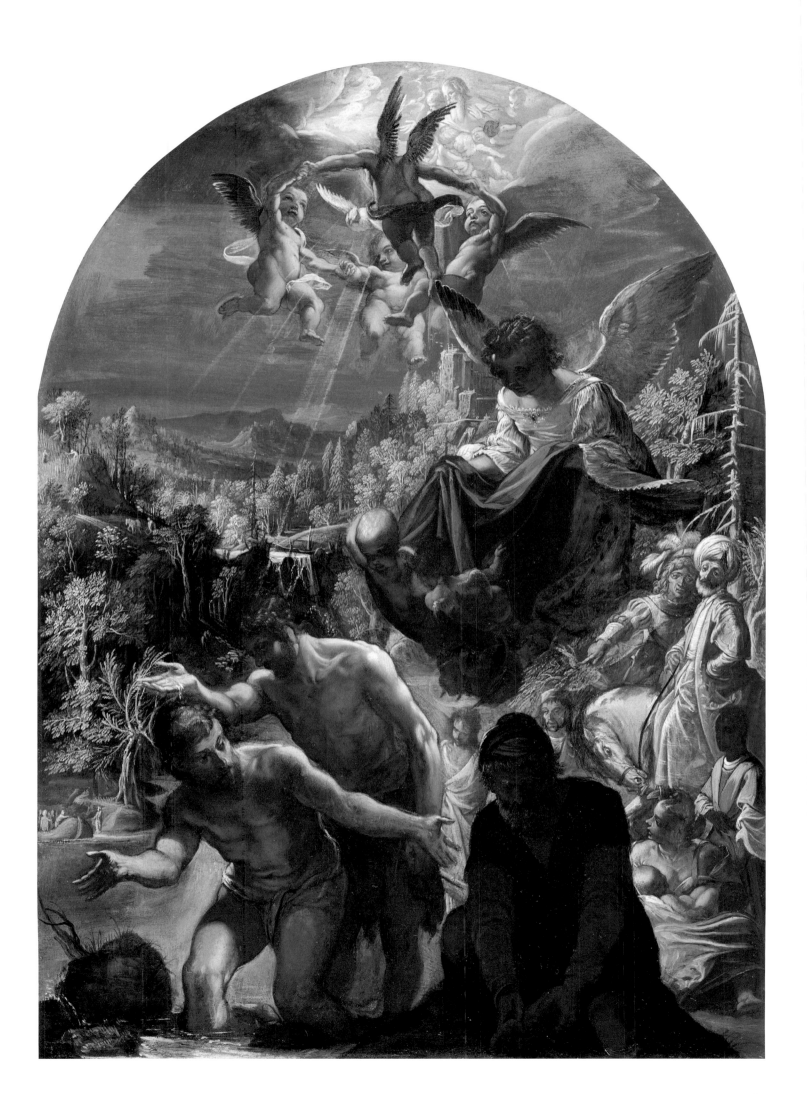

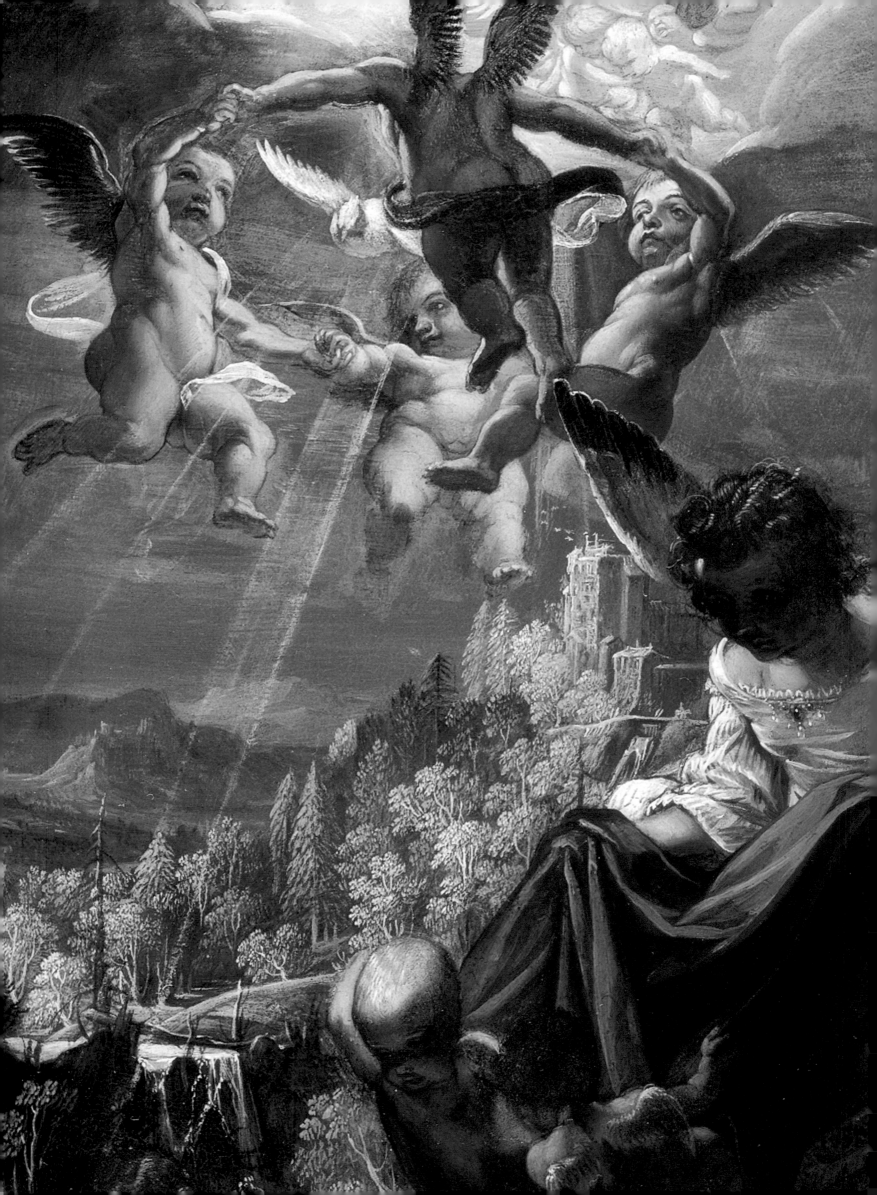

putti dancing in a circle, who fit snugly into the curved top of the picture, as well as the large angel wearing a red robe, are in the style of Albrecht Altdorfer, as is the sketchiness of the wooded landscape, painted in a rich range of green hues. A hovering circle of dancing angels – much more elaborate and confined within a church interior, but nonetheless comparable in its spatial effect – dominates Altdorfer's *Nativity of the Virgin* in Munich (fig.66), a painting that was probably to be found in Regensburg in Elsheimer's day, which means he might have seen it on his journey through southern Germany.[1]

In the spatial arrangement of the picture, with its main figures in the immediate foreground and a view opening up behind them into the depths of the landscape, Elsheimer succeeded in going a step beyond the slightly confusing composition of *The Holy Family* (cat.no.7), in style as well as thematic treatment. The rendering of this baptismal scene has been criticised for its exaggerated use of body language, but this is only the logical result of the painter's first encounter with what was to him the new, grand idiom of Roman art.[2] Elsheimer probably painted this picture, which came hard on the heels of *The Holy Family*, around 1599 in Venice. It is also quite possible that both paintings started out, and even remained for a while, in the same collection.[3]

NOTES

1 Altdorfer, *The Nativity of the Virgin*, Munich, Alte Pinakothek, inv.no.5358. Cf. R. Kroos, '"Der Engel Tanz". Regensburger Archivfunde zur Mariengeburt von Albrecht Altdorfer in der Alten Pinakothek', *Kunstchronik*, 49, 1996, pp.229–35; critical commentary on the aforementioned article to be found in I. Lübekke, 'Zu Altdorfers Mariengeburt', in *Begegnungen mit alten Meistern. Altdeutsche Tafelmalerei auf dem Prüfstand*, edited by F.M. Kammel and C.B. Gries, Nurenberg, 2000, p.225. Lübbeke also thinks that this picture was installed in the cathedral at Regensburg and even considers it possible that Altdorfer donated it to the cathedral.

2 According to Krämer, the figure of Christ displays the same pose as Joseph in Tintoretto's *Flight into Egypt* in the Scuola di San Rocco. See Tietze 1948, fig.247.

3 On this subject, cf. cat.no.7.

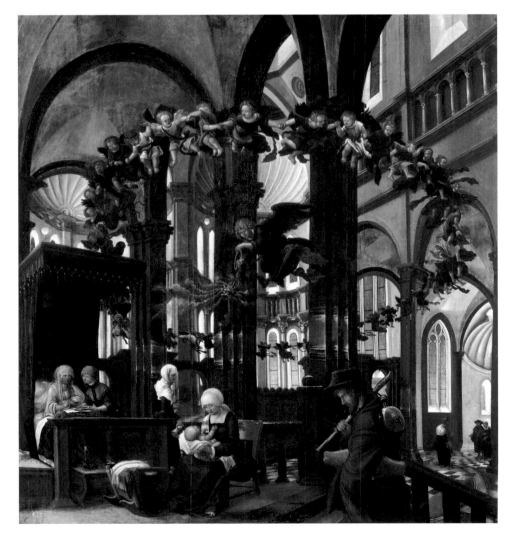

Fig.66
Albrecht Altdorfer,
The Nativity of the Virgin,
Munich, Bayerische Staatsgemälde-sammlungen,
Alte Pinakothek

9 Saint Paul on Malta

Copper, 17 x 21.3 cm
London, The National Gallery, inv.no.3535

PROVENANCE Perhaps given around 1614 as a
gift by Giovanni Battista Crescenzi ('James
Baptista Cresentio') to Sir Dudley Carleton
('The shipwreck of St Pablo small, by the hand
of Adam'); Corsham Court, Wiltshire; Methuen
Collection (1761); sale London (Christie's), 13
May 1920, lot 16; Walter Burns; donated to the
museum in 1920

LITERATURE Drost 1933, p.42f.; Weizsäcker
1936, I, p.177ff.; Weizsäcker 1952, no.31;
Levey 1959, p.42; Müller Hofstede 1970, p.90;
Andrews 1977, no.10; Andrews 1985, no.10

Saint Paul was shipwrecked near Malta
while on a voyage to Rome as a prisoner.
He and several other prisoners managed
to reach the shore of the island, where the
inhabitants welcomed them and lit a fire
to dry their clothes. While gathering
wood, Paul was bitten by a poisonous
snake, which he threw into the flames.
Since he remained unharmed despite the
snake bite, the islanders took him to be a
god (Acts 28:1–6). Elsheimer portrayed
the apostle with the snake and numerous
onlookers, standing around the fire on the
left; on the right a number of survivors
gather wood or take off their clothes. In
the middle distance the wreckage of the
ship is discernible in the waves whipped
up by the storm. Beneath the night sky,
on a high rock in the distance, we see the
fire of a lighthouse.

The figures in the foreground are
arranged like a frieze and there is no
apparent spatial relationship between
them and the landscape behind. The
disposition of the figures in a row at the
lower edge, parallel to the picture plane,
must betray the painter's hesitation over
the composition. The dramatic portrayal
of the nocturnal landscape, the strange
curve of the waves vaulting over a rock,
the bending of the trees in the face of the
storm, as well as the flickering light, are

reminiscent of similar paintings by the
Antwerp artist Frederick van Valcken-
borch (1566–1623), who undertook an
extended tour of Italy with his brother
Gillis in the 1590s. Van Valckenborch
returned to Frankfurt around 1597,[1]
when the young Elsheimer could have
become acquainted with the Fleming's
expressive manner of painting. No other
work by Elsheimer bears such clear
traces of Van Valckenborch's mannerist
style as this landscape with Saint Paul,
which should, therefore, probably be
dated earlier than it has been hitherto.
It could have been painted as early as
1598–99 in Venice, where there must also
have been works by Van Valckenborch.
The figures may well betray the influence
of Rottenhammer. *Saint Paul on Malta*
was evidently painted some time before
the nocturnal pieces Elsheimer made in
Rome, *The Burning of Troy* (cat.no.10)
and *The Flood* (cat.no.11), since the
smaller scale of its figures clearly distin-
guishes it from the two later paintings.

Fig.67
Frederick van
Valckenborch,
*Storm with
Shipwreck*,
Rotterdam,
Museum Boijmans
Van Beuningen

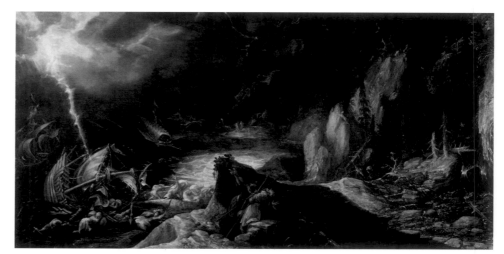

NOTES
1 Exh. cat. Essen/Vienna 2003, no.79; exh.
cat. Antwerp 2004, no.57.

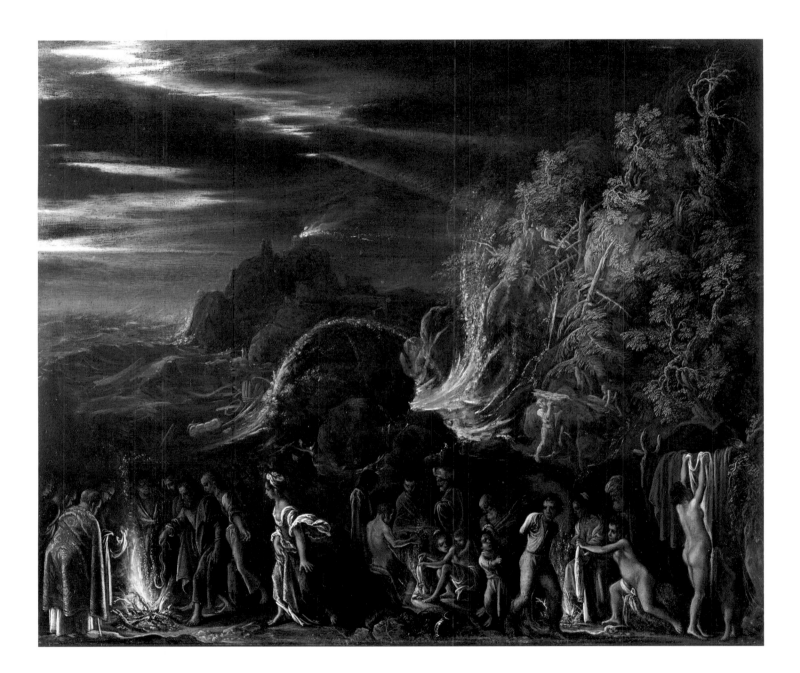

10 The Burning of Troy

Copper, 36 x 50 cm
Munich, Bayerische Staatsgemälde-
sammlungen, Alte Pinakothek, inv.no.205
(not exhibited)

PROVENANCE Düsseldorf, Kurfürstliche
Galerie; Mannheim (1756); Munich,
Kurfürstliche Sammlung (1802); Alte
Pinakothek (1836)

LITERATURE J. van Gool, *De nieuwe
Schouburgh*, The Hague, 1750, vol.II, p.562;
Bode 1883, pp.270, 279; Drost 1933, p.41;
Weizsäcker 1936, p.174; Weizsäcker 1952,
no.52; exh. cat. Frankfurt 1966, no.29; Müller
Hofstede 1970, p.90; Andrews 1977, no.11;
Andrews 1985, no.11; Neumeister 2003,
p.275f.

Fig.68
Raphael, *Fire in the
Borgo* (detail),
Rome, Vatican,
Stanza dell'Incendio

NOTES
1 Cf. Krämer 1995, pp.97–102.
2 Neumeister 2003, p.305, no.19.
3 Munich, Alte Pinakothek, inv.no.832;
 Darmstadt, Hessisches Landesmuseum,
 inv.no.AE 397; M. Winner, in exh. cat.
 Berlin 1975, no.110; Renger/Denk 2002,
 p.98.
4 Rome, Vatican Museum, *Fire in the Borgo*,
 fresco, 1514.
5 Copper, 42 x 54 cm, 'after Adam Elsheimer',
 Sibiu (Hermannstadt); M. Csaki, *Baron
 Brukenthalisches Museum in
 Hermannstadt. Führer durch die
 Gemäldegalerie*, Hermannstadt, 1909, 6th
 edition, no.348. Copper, 23.2 x 28.4 cm, art
 market Hamburg; W. Sumowski, 'Varianten
 bei Elsheimer', *Artibus et historiae. An art
 anthology*, 25, 1992, p.149ff. (as
 Elsheimer).

When the Greeks succeed in entering and sacking the besieged Troy, its inhabitants flee from the burning city. The Trojan hero Aeneas manages to save his old father, Anchises, and the family's precious 'household gods' (Virgil, *Aeneid* II, 671–729). In the immediate foreground we recognise Aeneas (carrying his aged father on his back) and his family, hurrying through the night. Aeneas, bent under his heavy burden, follows his son, Ascanius, who lights the way with a torch, and his wife, Creusa, who turns to him with a look of terror. Discernible in the darkness of the background is the wooden horse, which the Greeks used to gain access to the city. The countless torches in the hands of the fugitives and the sparks flying from the burning buildings show the magnitude of the catastrophe.

Elsheimer's painting was obviously inspired by the nocturnal pieces and pictures of burning towns made by Jan Brueghel the Elder and Pieter Schoubroeck in the last decade of the sixteenth century in Rome (figs.17, 18). This type of Northern painting was much in demand

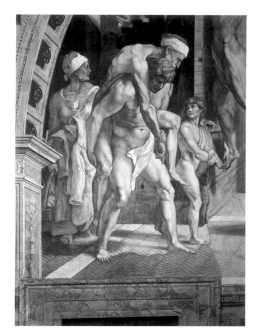

among Roman collectors.[1] The stylistic proximity of Elsheimer's painting to its Flemish examples is also apparent from the similar manner of painting and the use of a deep black coating on the copper plate.[2] A good example is Brueghel's *The Burning of Troy* – painted around 1595–96 and now in Munich (fig.17), and significant for the development of the Netherlandish nocturnal piece – for which Brueghel depended on a drawing he made in Rome in 1594 with a view of the Tiber bridge, St Peter's and Castel Sant'Angelo.[3] Elsheimer's painting also alludes to Roman motifs but at the same time displays remarkable differences from Brueghel's depiction. Elsheimer's work lacks the wide-open view into the distance and the high horizon, by means of which Brueghel extended the dark, urban landscape. Elsheimer portrays the dramatis personae on a larger scale, casting them in spotlighted roles at the front of a narrow stage, as it were, thereby letting the narrative take precedence over the landscape. His portrayal of Aeneas carrying his father is based – as is the drawing he made in an *album amicorum* (cat.no.12), now in a private collection – on a similar motif from Raphael's *Fire in the Borgo* in the Stanza dell'Incendio in the Vatican (fig.68).[4] Stylistically speaking, Elsheimer's group is closely related to his *Saint Christopher* (cat.no.13), as well as to his *Judith and Holofernes* (cat.no.14), who is apparently based on the same model as Aeneas' wife. Accordingly, it may be assumed that *The Burning of Troy* originated some time during his first two years in Rome.

A copy of the painting (copper, 42 x 54 cm) is preserved in the Brukenthal Museum in Sibiu (Hermannstadt), Rumania. A variant from the circle of Elsheimer (copper, 23.2 x 28.4 cm) is currently on the art market (Hamburg).[5]

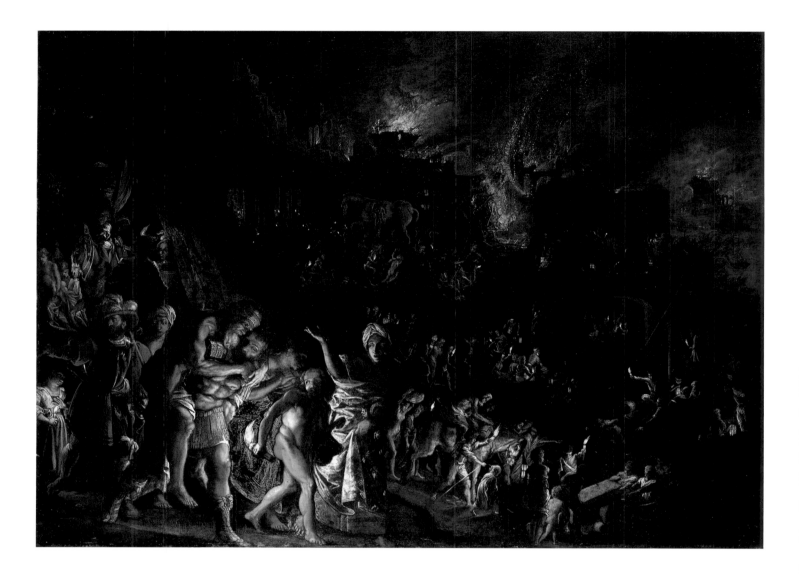

11 The Flood

Copper, 26.5 x 34.8 cm. In the foreground, an unidentified mark on the bale of cloth, to the right of which the monogram AE in ligature. On the back, an old inscription (*c.* 1600?): *Adam Elzhamer*
Frankfurt am Main, Städelsches Kunstinstitut and Städtische Galerie, inv.no.1607

PROVENANCE Augsburg, private collection (before 1920); Murnau, Marie Kunstmann Collection; acquired 1920

LITERATURE Weizsäcker 1921, p.129ff.; Weizsäcker 1936, p.63ff.; Heil 1949, pp.221–24; Weizsäcker 1952, no.1; exh. cat. Frankfurt 1966, no.1; Krämer 1978, p.325, n. 17; Andrews 1977, no.6; Andrews 1985, no.6; Sello 1988, p.57ff.; Lenz 1989, p.27ff.; Rapp 1989, p.128f.; exh. cat. Munich 1998, no.70

Fleeing from the rising waters, people who have lost their homes in the flood gather on a wooded hill in hopes of rescue (Genesis 6:17–22). On the left a youth follows a naked woman who has climbed into a tree. In the foreground two women try to protect their possessions. The one on the left, with a costly brocade gown crumpled up next to her, reaches out to touch a money-bag with '1000' written on it; the other woman, in a brilliant red dress, uses the weight of her body to shove a heavy bale of cloth onto dry land. The bound bale bears the sign of the cross, with the letters 'No' appearing next to Elsheimer's monogram. In the water flooding into the scene from the right, a child, afloat in its cradle, seems to be watching a man clinging for dear life to a

piece of wood. In the middle distance, countless people struggle to get themselves and their animals to safety. Floating in the distant darkness is Noah's ark, visible in the ghostly light of the storm.

Ever since the picture was discovered in a private collection in southern Germany, it has been thought to contain elements adopted from Venetian painting. Andrews – and before him, Weizsäcker – correctly pointed out the connections to paintings by Jacopo Bassano and his workshop (fig.69),[1] here most apparent in the dramatic nocturnal atmosphere and the narrative manner of depicting the fugitives from the flood. The work of Tintoretto also contains similar scenes, which Elsheimer could have studied, such as the *Naval Battle* in Madrid with people sinking in the waves.[2] The figures, by contrast, are mainly cast in the style of Rottenhammer. Nevertheless, it does not seem necessary to accept Andrew's assignment of *The Flood* to Elsheimer's time in Venice. The arrangement of the group of figures in the left foreground gives the composition a distinctive emphasis that points to Elsheimer's Roman experience, even though the idealistic character of Michelangelo's *The Flood* in the Sistine Chapel (fig.70) is not directly

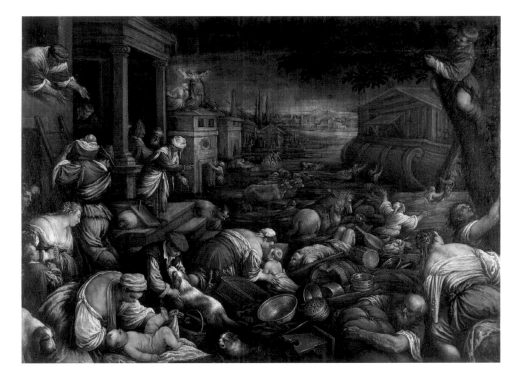

Fig.69
Workshop of
Jacopo Bassano,
The Flood,
Munich, Bayerische
Staatsgemälde-
sammlungen,
Alte Pinakothek

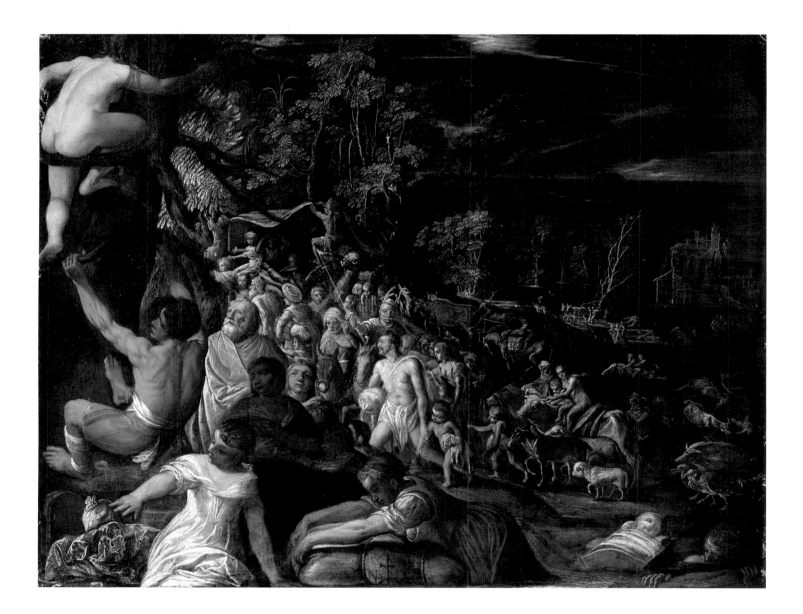

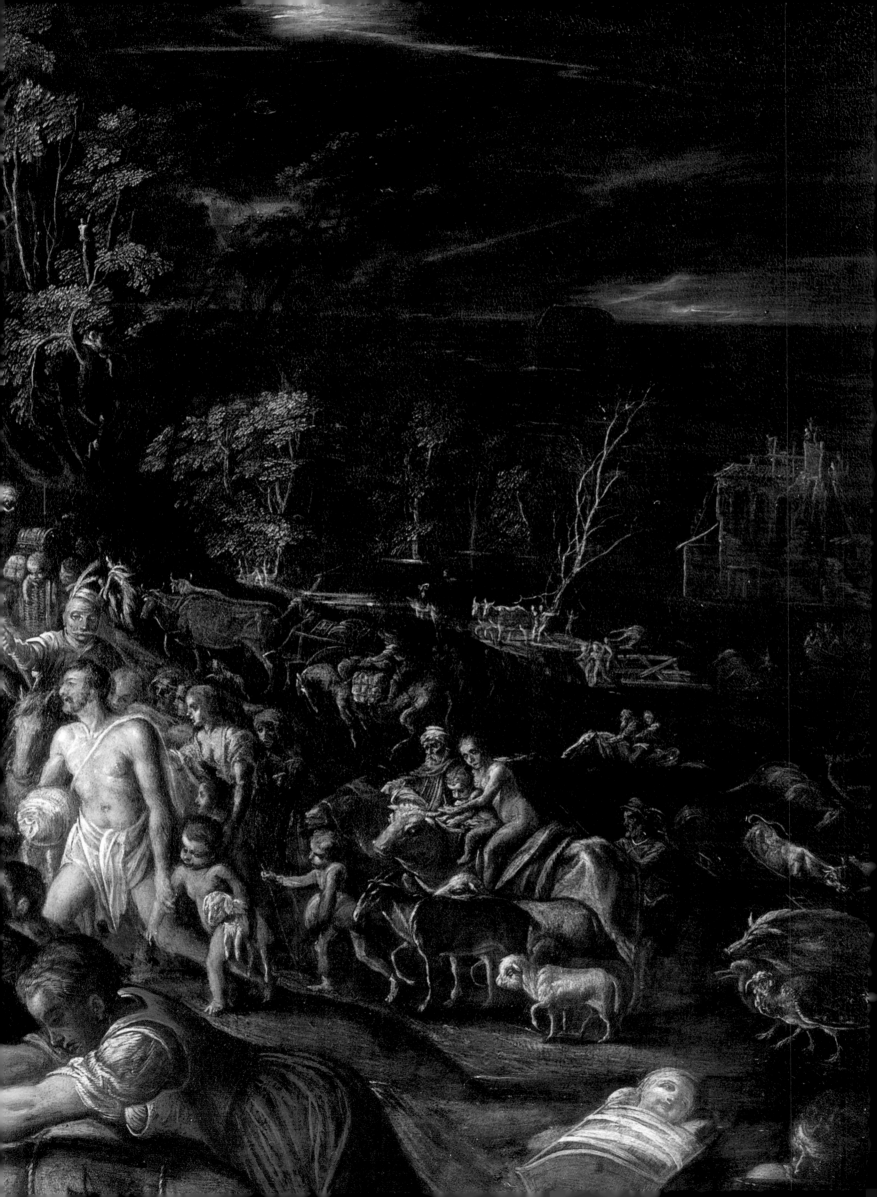

comparable. The strong lighting brings the plasticity of the bodies to the fore and gives the pictorial space a new order. The two nudes, who dominate the scene, recall Elsheimer's drawing, made in Rome and dated 1600, of *Neptune and Triton* in Dresden (fig.13).[3] The model for the naked woman climbing the tree was, according to Krämer, an engraving published around 1590–95 called *Satyr and Nymphs* from the series of *Lascivie* by Agostino Carracci (fig.71).[4] It is the bright figures in the foreground that first direct the eye to the danger threatening in the deep of night. Elsheimer's *Saint Paul on Malta*, the earliest known nocturnal piece by his hand (cat.no 9), probably originated in Venice. Compared with that painting, *The Flood* – and the same holds true for *The Burning of Troy* in Munich

(cat.no.10) – represents a considerable step forward in the painter's development, a step that must have required a certain amount of time. Bearing this in mind, it may be assumed that these two pictures were painted at the beginning of Elsheimer's Roman period.

An engraving by Philip Andrea Kilian, published in 1758 in Augsburg, depicts the left half of the painting and bears Elsheimer's full name. This could mean that *The Flood* was in an Augsburg collection at that time.[5]

NOTES

1 Jacopo Bassano, *The Flood*, Kromeriz (Kremsier), cf. Arslan 1960, vol.I, p.169. The comparative illustration shows a workshop repetition in Munich, Alte Pinakothek, inv.no.6048.
2 Tintoretto, *Naval Battle* (also called *The Rape of Helen*), Prado, inv.no.399; Tietze 1948, fig.245.
3 Andrews 1977, no.32; Andrews 1985, no.32.
4 Cf. DeGrazia Bohlin 1979, no.186. Krämer 1978, see Literature.
5 P.A. Kilian, *Index Pictuarum Chalcographicarum Historiam Veteris et Novi Testamenti ...*, Augsburg, 1758, fol.5.

Fig.70
Michelangelo,
The Flood (detail),
Rome, Sistine
Chapel

Fig.71
Agostino Carracci,
Satyr Whipping a Nymph, engraving

ADAM ELSHEIMER

12 Aeneas Saving Anchises from Burning Troy

Gouache on paper, 14.3 x 9.7 cm. Inscribed on the verso: *Aegidius Krix Sacr. Caes. M / Heroaldus eiusdemque Cancell / Imperialis amanuensis / Wratislao Burggraff e libero / Barone de Dona Sigr in / Lemberga*
Private Collection
(Frankfurt and Edinburgh only)

PROVENANCE Kurt Klemperer Collection; Berlin, Gerda Bassenge sale 22, 6–8 November 1973, lot 100 (German, seventeenth century); Berlin, private collection

LITERATURE Rapp 1989, pp.112–32

This small sheet shows the naked Aeneas, taking long, hurried strides through the night, carrying his father, Anchises, on his back. Anchises holds on to his son's head with folded hands (see cat.no.10 for more on this subject). The small work, painted with gouache on paper, was first published in 1989 by Rapp. It is a special case in Elsheimer's oeuvre, for despite its unusual medium and support, it should be classified as a painting rather than a drawing. Its format and technique can be explained by the fact that the sheet originally belonged to an *album amicorum*.[1] The painstaking, painterly execution, which surpasses the quality of most work to be found in such albums, is the result of the social standing and the expectations of the person who commissioned it. The person in question, as emerges from the inscription, is Aegidius Krix (or Grix), according to Rapp's research a Fleming from Brussels who was active as a secretary and herald at the court of Emperor Rudolf II in Prague. Owing to his diplomatic skills, he was entrusted with impor-

tant assignments abroad, especially in Italy; in fact, the Emperor raised him to the nobility in 1594 for services rendered in that country. Krix dedicated the undated picture to the burgrave Wratislaw Freiherr von Dohna, who resided in north Bohemia and was also connected with the imperial court. The circumstances of the burgrave's life reveal that this picture could only have been dedicated to him between 1599 and 1604.

In its subject, this work goes beyond the mere rendering of a story from antiquity. In keeping with emblem books circulating in the sixteenth century, Aeneas' deed was thought symbolic of filial piety – *pietas filiorum in parentes* – an example of the kind of ethical maxim that frequently appears in family albums. The connection with the relevant illustration in the Dutch edition, published in 1591 in Leiden, of the *Emblemata* of Alciati (fig.72) cannot be ignored.[2] Elsheimer might have drawn inspiration for the painterly rendering of his nude Aeneas from Raphael's fresco *Fire in the Borgo* in the Vatican, the left side of which features a monumental group of people being carried to safety (fig.68), which had already reminded Vasari of Aeneas' heroic deed. Stylistically speaking, the Aeneas sheet is closely related to Elsheimer's *Burning of Troy* in Munich (cat.no.10),[3] to which it is linked by more than just the motif of the fugitives. The treatment of light and the modelling of the figures in these two pictures are also closely related, suggesting contemporaneous origins despite the differences resulting from the varying techniques.

Fig.72
Jost Amman,
*Aeneas and
Anchises* (detail),
from *Alciati
Emblemata*,
Frankfurt 1567

NOTES
1 On the usage and significance of family albums, cf. P. Amelung, 'Die Stammbücher des 16./17. Jahrhunderts als Quelle der Kultur- und Kunstgeschichte', in exh. cat. Stuttgart 1980, vol.II, pp.211–22.
2 *Emblemata V.C. Andreae Alciati*, Leiden, 1591, p.232, Emblem CXCIV.
3 Andrews 1977, no.11.

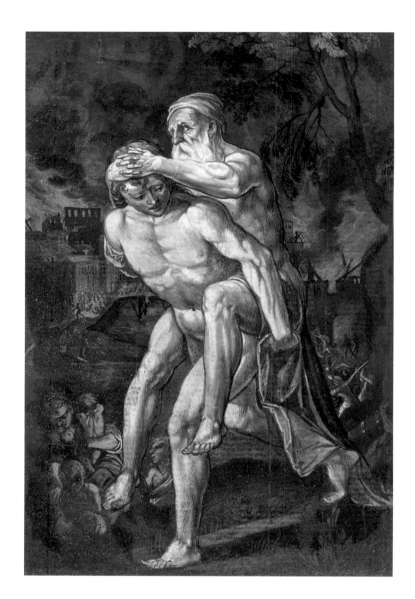

13 Saint Christopher

Copper, 22.5 x 17.5 cm
St Petersburg, Hermitage, inv.no.694
(Frankfurt only)

PROVENANCE Acquired between 1763
and 1774

LITERATURE Weizsäcker 1952, no.33;
Andrews 1977, no.5; Andrews 1985, no.5;
Nikulin/Aswaristsch 1986, p.26; Nikulin 1987,
p.69; Rapp 1989, p.126; M. Garlowa, in exh.
cat. Frankfurt 1991, no.18; exh. cat. Munich
1998, no.20; Neumeister 2003, p.275;
Klessmann 2004, p.55f.

NOTES

1 *Golden Legend*, vol.II, p.10ff.
2 *Saint Christopher*, woodcut 1511 (Bartsch
 103, Hollstein German, vol.VII, no.223);
 Saint Christopher, engraving 1521 (Bartsch
 51, Hollstein German, vol.VII, no.53).
 According to Neumeister, Netherlandish
 sources must also be considered; cf. also
 G. Unverfehrt, *Hieronymus Bosch. Die
 Rezeption seiner Kunst im frühen 16.
 Jahrhundert*, Berlin, 1980, pp.187–201.
3 Jost Amman, *Emblemata Nicolai Reusneri*,
 1581, no.XXXV, p.49.
4 *Saint Christopher*, engraving 1521 (Bartsch
 52, Hollstein German, vol.VII, 52).
5 Andrews 1977, no.11.
6 Van Gelder/Jost 1967, p.143; Andrews
 1977, p.141.
7 Held 1959, no.30; Burchard/D'Hulst 1963,
 no.43; Held 1986, no.73; Klessmann 2004,
 p.56.

The story of Saint Christopher is rooted in legend. Reprobus, a Canaanite of enormous stature, resolved to serve only the most powerful person in the land. He followed the suggestion of a hermit to obey only Christ, thereafter devoting his life to helping people to cross a dangerous river. One day, while carrying a child across the river, he was amazed to find his burden growing heavier and heavier, until it was almost too much for him. Only with great difficulty did he manage to reach the opposite shore, where the child revealed himself as Christ. It is to this incident that the patron saint of travellers owes his name, Christophorus, 'bearer of Christ'.[1]

The painting shows the saint carrying the Christ Child on his shoulders, supporting his weight with both arms and struggling through the water at night. The darkness of the scene is interrupted by three sources of light: the moon emerging from the clouds, the torch held by the hermit in the left background and the radiant circle of light emanating from the Christ Child's head, the glow of which lights up Christopher's pensive face. The composition displays elements deriving

from German prints, especially Dürer's woodcut of 1511 and his engraving of 1521 (fig.73).[2] According to Andrews, the pose of the Child, who holds on to the saint's hair, can be traced to a design by the prolific printmaker Jost Amman.[3] The hermit with the torch is also to be found in Dürer's works, namely in an engraving of 1521.[4] The quality of painting testifies to Elsheimer's involvement with Venetian art, which played a key role in shaping his early development. Seeing Titian's monumental fresco of Christopher in the Doge's Palace (fig.74) no doubt had a part in this. Titian's work even seems to resound in the inner greatness of Elsheimer's figure, despite the vast difference in size. Nevertheless, it is generally assumed that this painting originated after Elsheimer settled in Rome, since it is most closely related in terms of style to *The Burning of Troy* in Munich (cat.no.10), in which the figure of Aeneas largely corresponds to that of Christopher.[5] A dating of *Saint Christopher* to shortly after 1600, close in time to *The Burning of Troy* and *The Flood*, therefore seems reasonable.

The painting, first documented in St Petersburg after 1763, was presumably brought to England as early as the first half of the seventeenth century, since a number of old copies, including one from the collection of the Earl of Arundel, are to be found in English collections.[6] Evidently Rubens became acquainted with Elsheimer's *Saint Christopher* in Rome, where he made a drawing after it (now in London).[7]

Fig.73
Albrecht Dürer,
*Saint
Christopher*,
engraving

Fig.74
Titian, *Saint
Christopher*,
Venice, Doge's
Palace

14 Judith and Holofernes

Copper, 23.2 x 17.8 cm
London, The Wellington Museum, Apsley
House, inv.no.WM 1604–1948

PROVENANCE Antwerp, Peter Paul Rubens
Collection (after 1626); Philip IV of Spain
(1640); London, Duke of Wellington (1813)

LITERATURE Weizsäcker 1936, vol.I, p.98;
Weizsäcker 1952, no.6; exh. cat. Frankfurt
1966, no.3; Bauch 1967, p.62f.; K. Andrews,
'Judith and Holofernes by Adam Elsheimer',
Apollo, 98, 1973, p.206ff.; Andrews 1977,
no.12; Andrews 1985, no.12; Muller 1989,
pp.20, 68, 102, no.35; L.J. Slatkes, in exh. cat.
Raleigh 1998, p.36f.; L.J. Slatkes, in exh. cat.
London 2001 A, no.114; Neumeister 2003,
p.279f.; Uppenkamp 2004, pp.75–78;
Klessmann 2006; Thielemann 2006

During the siege of the Jewish city of
Bethulia by the Assyrian army, the beau-
tiful Jewish widow Judith and her maid
cross enemy lines and achieve their goal
of being received by the general Holofer-
nes in his tent. Judith succeeds in killing
him with his own sword, thereby forcing
the retreat of the leaderless Assyrian
troops and saving the threatened city
(Judith 13:1–12, Apocrypha). The bloody
deed is depicted in nocturnal darkness.
On the rear wall of the tent, lit by two

candles, there is, above the entrance, a
tapestry with a representation of amoretti
leading a lion, an image symbolising the
helplessness of the powerful who give in
to the temptations of love. The precious
wine jug, decorated with bacchanalian
scenes, the glass carafes and the grapes
on the table comprise, together with the
candle, a Vanitas representation testify-
ing to the pleasure-loving life of the Assy-
rian general. Judith commits the murder
with cold-blooded matter-of-factness,
raising the sword high up in the air for
the second time to finish the deed, while
her maid waits in the background. The
flames heighten the drama of the event,
featuring the twitching, bleeding body of
Holofernes.

The striking illumination and the still
life on the table, emerging in the flicker-
ing light, were presumably inspired by
Caravaggio. The representation has
always been considered unusual, and this
has prompted a search for examples
among the works of the great masters.
Only when compared with Veronese's
portrayals of Judith in Genoa and Vienna
or with the Judith painted by Caravaggio
around 1599 in Rome (fig.23)[1] – works
that are often cited in this context – does

the full originality of Elsheimer's inven-
tion become clear. To be sure, examples
from Netherlandish prints were also
known to him, as evidenced by the simi-
larity to Maerten van Heemskerck's
engraving from the Judith series of 1564
(fig.22).[2] Rubens seized the opportunity,
during his stay in Rome, to study
Elsheimer's painting closely and later on
even acquired it for his collection. He
chose this example for his own rendering
of the theme, as emerges from his pen
and wash drawing in Frankfurt (fig.75)
and from both the engraving and the
drawing of the 'large Judith' by Cornelis
Galle I (fig.25).[3]

In Venice Elsheimer had already begun
to use multiple sources of light as a means
of organising his pictures. In his noctur-
nal piece Saint Paul on Malta (cat.no.9),
the fires serve as a means of ordering the
pictorial space, but they do not really do
justice to the objectives of the depiction.
Only after settling in Rome did Elsheimer
achieve a more dynamic treatment of
light, which he used to pick out the main
action. This is just as true of the portrayal
of Saint Christopher (cat.no.13) as it is
of The Burning of Troy in Munich (cat.
no.10), and not least of Judith and
Holofernes, the painter's first depiction of
an interior scene using artificial light.
These last two paintings must have been
made in close succession. The head and
pose of Aeneas, fleeing from Troy, are
directly related to those of Saint
Christopher. Andrews saw an unmistak-
able resemblance between Judith and
Aeneas' wife, Creusa. The torch held by
Aeneas' son, Ascanius, unites the fugi-
tives in their endangered position, com-
parable in conception to the flickering
candle in Holofernes' tent, which links the
Jewish heroine and her victim. The
painting originated in the years 1601–03.

Fig.75
Rubens,
Judith Slaying
Holofernes,
Frankfurt,
Graphische
Sammlung im
Städelschen
Kunstinstitut

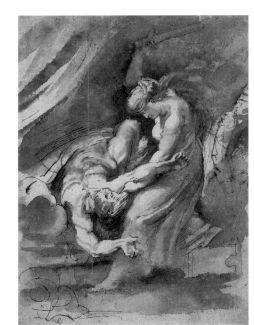

NOTES
1 Regarding Caravaggio, cf. exh. cat. London
 2001 A, no.109.
2 The New Hollstein (Heemskerck), vol.I,
 no.212; Neumeister 2003, p.279.
3 Held 1959, no.15; Hollstein German, vol.VII,
 no.31; Klessmann 2006.

15 The Three Marys at the Tomb

Copper, 25.8 x 20 cm
Bonn, Rheinisches Landesmuseum,
inv.no.G.K. 68

PROVENANCE Rome, Paul Bril (1626); Bril's
widow Ottavia Sbarra (1629); Bril's daughter
Faustina Baiocco (1659); Cardinal Curzio Origo
(1712); Otto Wesendonck; Otto-Günther von
Wesendonck; acquired 1909

LITERATURE Bode 1920, p.53; Drost 1933,
p.73; Bauch 1951, p.230 (Lastman); Weiz-
säcker 1952, p.VII, p.76 (circle of Lastman); H.
Möhle, in exh. cat. Berlin 1966, no.9; exh. cat.
Frankfurt 1966, no.18; Bauch 1967, p.60;
Krämer 1973, p.165 (Thomann von Hagel-
stein); Andrews 1977, no.13; Andrews 1985,
no.13; Baumstark 2005, p.53ff.

The three women called Mary went to the
tomb of Christ to anoint his body at the
end of the Sabbath. They discovered the
tomb open and the body gone. An angel
dressed in white, who was waiting for
them, announced that Christ had risen
from the dead (Matthew 28:1–8; Mark
16:1–8; Luke 24:1–11; John 20:1–9). In
this picture the angel turns to face the
women while leaning for support on the
lid of the sarcophagus, on which a pas-
sage from the Gospel according to Saint
Mark appears in Latin. This should be
regarded first and foremost as the textual
basis for Elsheimer's portrayal. In the
background two men approach: Peter and
John, whom Mary Magdalene had sum-
moned, a detail that is recorded only in
the Gospel according to Saint John.

What these women experienced on
Easter morning is not often treated in
painting, and Elsheimer's portrayal of the
scene also remains a rarity within his
oeuvre. Elsheimer offers a theatrically
staged production full of pathos. It is the
first time since his move to Rome that he
strikes an unmistakably Roman chord.
The mourning woman with her hands
raised in horror appears to be a deriva-
tion from Caravaggio's *The Entombment*

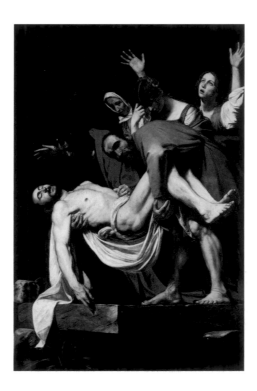

Fig.76
Caravaggio,
*The Entombment
of Christ*, Rome,
Vatican
Pinacoteca

of Christ in Rome (Vatican), painted
around 1602, which Elsheimer certainly
knew (fig.76).[1] This gesture of lamenta-
tion occurs in the work of other artists,
but it is fitting that Elsheimer's construc-
tion of the composition, the sharp treat-
ment of light and the pointedly linear
sweep of the women's garments were
influenced by the style of Caravaggio, for
it was precisely Caravaggio's *Entomb-
ment*, at that time in the Chiesa Nuova,
that attracted many painters. Elsheimer's
depiction culminates in the dialogue
between the two figures in the fore-
ground: on the left Mary Magdalene, who
gestures accusingly as she inquires about
the empty grave, and on the right the
angel, leaning – by way of explanation –
on the stone lid bearing the passage from
the Gospel according to Saint Mark. The
exact rendering of the lines from the Vul-
gate (Mark 16:1–7), which are also legible
to the viewer, is unusual in a picture of
this time and can only be explained as the
express wish of a buyer or patron. The
lush vegetation – the trees and plants
even hang from the roof of the cave in
which the miraculous event takes place –
recalls the primeval landscapes by Paul
Bril, who was a personal friend of Els-
heimer and eventually became the owner
of this painting. There is little to go on as
far as dating the picture is concerned. Its
style suggests that it was made before *The
Stoning of Saint Stephen* and the Frank-
furt *True Cross Altarpiece* (cat.nos.19,
20), which are generally dated to around
1603. The central panel of the altarpiece,
The Exaltation of the Cross, features two
women seated near the middle of the
depiction, Saint Catherine and Saint Mary
Magdalene, who were based on two of the
female figures Elsheimer used in *The
Three Marys at the Tomb*.

NOTE
1 Exh. cat. London 2001 A, no.141.

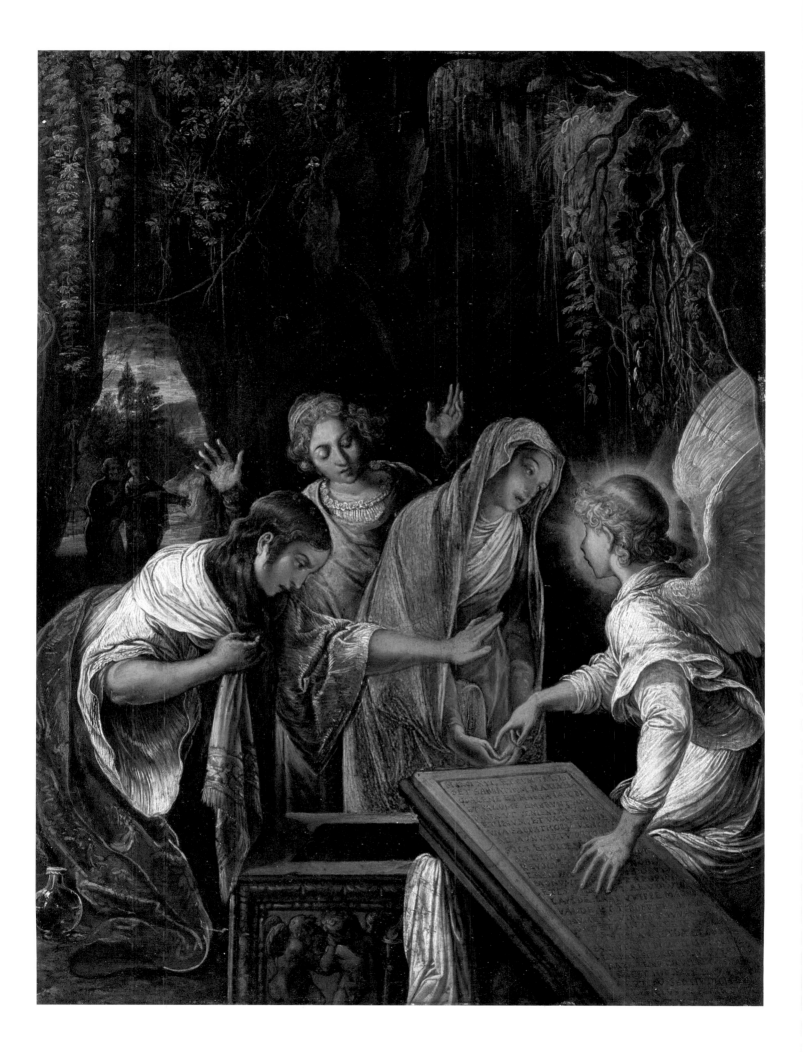

16 Pietà

Copper, 21 x 16 cm. On the back a male nude sketched with a brush in black paint Brunswick, Herzog Anton Ulrich-Museum, inv.no.852

PROVENANCE Rome, 1610 inventory of Elsheimer's estate; Vienna, Galerie Harding (1954); London, private collection; Zürich, Kurt Meissner (1956); Germany, private collection (Prof. Kurt Bauch); New York, Dr Doris Bauch (1985); New York, Bob P. Haboldt & Co; acquired 1988

LITERATURE E. Schaffran, 'Ein unbekanntes Gemälde des Frederik Sustris', *Weltkunst* 24, 1954, no.4, p.7 (as Friedrich Sustris); Bauch 1953, p.235f.; exh. cat. Frankfurt 1966, no.17; Waddingham 1967, p.47; Bauch 1967, p.60; Andrews 1972, p.597f.; Waddingham 1972 B, p.605; Andrews 1977, no.14; A. Sutherland Harris, in exh. cat. New York 1985, no.30; Andrews 1985, no.14; B.P. Haboldt, *Old Master Paintings and Drawings. The first five years*, New York, 1989, p.36, no.5; Klessmann 1989, pp.7–19; Jacoby 1989, p.115ff.; Thielemann 2006

All four Gospels tell of the death of Christ on the cross and his entombment (Matthew 27:57–58; Mark 15:42–46; Luke 23:50–54; John 19:38–40). The theme of Mary caring for the dead body of her son is not mentioned explicitly in these texts, but the subject was treated in the mystical and meditative literature of the Middle Ages, and it acquired its own pictorial tradition in the Renaissance, particularly in Venice. We find it in portrayals of half-length figures by Giovanni Bellini and his pupils, as well as in a monumental *Pietà* by Sebastiano del Piombo (fig.77).[1] Elsheimer's painting shows Mary bending over her dead son in an attitude of embrace. Having laid the slight, youthful body against a block of stone, she supports his head with her right hand and with her left dries the blood gushing from the wound in his side. Behind the head of Christ, which displays the bloody traces of the crown of thorns, small rays of light indicate his divinity. Lying on a stone at the left edge of the picture are the nails used in Christ's crucifixion, a glass vessel containing anointing oil and a sponge. Crowning the depiction is a group of hovering angels, who – following Raphael's example – appear as bodiless beings with only a head and wings. Vine

tendrils grow on the rock face, a fig tree stands in the left background, and in front of it an elder bush and a red-blossoming evergreen plant. Since the Middle Ages the fig tree has often been connected with Mary and appears as her attribute in many pictures made in the area of Venice and North Italy. The evergreen, to which many protective powers are attributed, is also associated with the Virgin Mary.[2]

As a result of disfiguring overpainting, including the addition of the misleading inscription 'Rome 1560', the work was long misjudged,[3] until it was recognised by Bauch, Andrews and Waddingham as an autograph work by Elsheimer. Restoration carried out around 1986 in New York, which included the removal of all retouches, confirmed Elsheimer's authorship and ruled out the involvement of another hand, which Andrews had previously assumed. A narrow area above the angels, perhaps reserved for a cloth they were supposed to hold, clearly remained unfinished. In its form and conception, Elsheimer's *Pietà* recalls similar representations by Annibale Carracci,[4] but its mood is more reminiscent of Michelangelo's sculpture in St Peter's. Stylistically, it is closely related to *The Three Marys at the Tomb* (cat.no.15), which – more than any other painting by Elsheimer – reflects Roman influence. Both works combine a close viewpoint, which shows the figures no more than three-quarter length, a varied treatment of light, which is rich in contrast, and drapery that emphasises volume by means of parallel folds. The minutely rendered plants and tendrils, hanging down from the rock face, form a niche-like background in both paintings. Finally, the pictures share an intensely colourful palette that focuses on white, blue and red. Another similarity between them is the girlish mother of Jesus with her narrow, sorrow-laden face.

Fig.77
Sebastiano
del Piombo,
Pietà,
Seville, Casa de
Pilatos

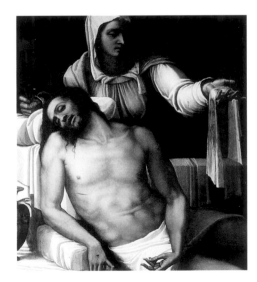

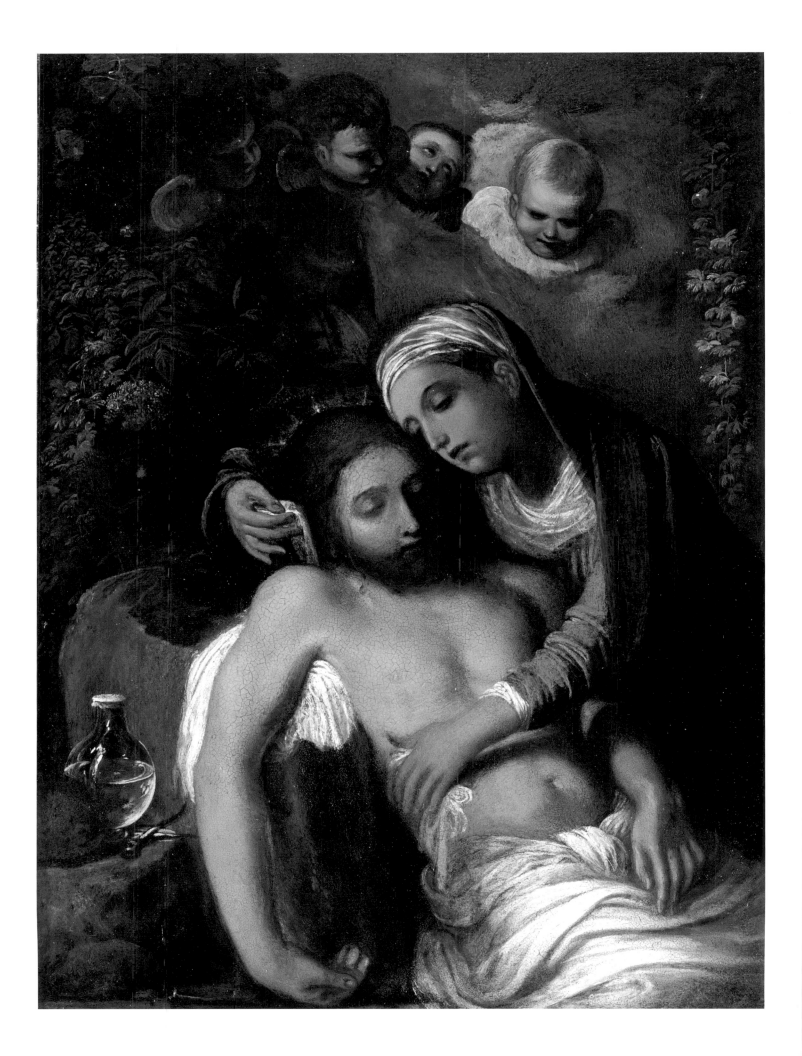

A small pen drawing executed in brown ink, now in Weimar (fig.78), can be considered an autograph design and *prima idea* for the *Pietà*.[5] According to this preliminary drawing, the painter initially intended to show the base of the cross and a ladder leaning against it behind the pair of figures, as well as a building in the distance. Mary leans her forehead against Christ's head, but does not touch the wound on his side, as she does in the painting. With regard to the biblical story, the drawing portrays the scene immediately following the descent from the cross, comparable to the *Lamentation* by Willem Key (*c.*1515–1568) in Munich,[6] whereas the present painting depicts the preparation of the deceased for burial. Examination of the picture under infrared light revealed pentimenti. Originally the head of Christ was sunk back on the supporting hand of Mary, as in the drawing in Weimar, while the final painting shows the head erect, so that

Mary's hand seems to touch him only lightly.

Depicted on the back of the copper plate is a male nude drawn with a brush, which was recognised and published by Jacoby as a study by Elsheimer. It is probably an interim study, made as a preliminary design for the pose of Christ, most likely done between the execution of the Weimar drawing and the realisation of the painting. The latter could have originated – as Andrews suggests – around 1603 and is probably identical with the painting mentioned in the 1610 inventory of Elsheimer's estate as 'a little painting on copper of the Pietà framed and gilt, rather old'),[7] which was found in the painter's bedroom at the time of his death.

Fig.78
Adam Elsheimer,
Pietà,
Weimar, Staatliche
Kunstsammlung

NOTES

1 It is unlikely, however, that Elsheimer could have seen this very painting. Formerly Ubeda, Spain, San Salvador, cf. M. Hirst, *Sebastiano del Piombo*, Oxford, 1981, p.128f., plate 163.
2 L. Behling, *Die Pflanze in der mittelalter-lichen Tafelmalerei*, Weimar, 1957, p.29f.; regarding the fig tree, cf. W. Prohaska, in *RDK* VII, col. 1046f.
3 E. Schaffran 1954, p.7 (as Friedrich Sustris).
4 Similar parallels were noticed by Wadding-ham and Sutherland Harris with reference to Carracci's etching *Christ of Caprarola*, cf. Posner 1971, vol.II, no.97.
5 Möhle 1966, no.10; Andrews 1977, no.36.
6 Munich, Alte Pinakothek, inv.no.539; *Katalog der älteren Pinakothek*, Munich, 1936, p.121. Key's devotional picture presumably depends on examples from the circle of Michelangelo.
7 Andrews 1972 : 'Un quadretto in Rame della Pieta corniciato et indorato, alquanto vecchio'.

17 Saint Jerome in the Wilderness

Copper, 13.3 x 16.2 cm.
Private Collection
(not exhibited)

PROVENANCE Private collection (as Rottenhammer); sale New York (Christie's), 10 January 1990, lot 235; London, Colnaghi

LITERATURE M. Waddingham, 'The "Penitent St. Jerome" by Adam Elsheimer', *Paragone* 40, no 17 (475), 1989, pp.58–60; Cocke 1991, p.108; Sumowski 1992, p.145; Pijl 2002, p.389

Saint Jerome (AD 342–420), the most learned of the four Latin Fathers of the Church, was the creator of the Vulgate, the Latin translation of the Bible. He came from Stridon in Dalmatia and lived for many years as a hermit in the Syrian desert before returning in 382 to Rome, where he had been educated and baptised. He is especially well known as the author of numerous scholarly works.

The picture shows Jerome as a hermit in the wilderness, kneeling before a stone bench on which lie pen and ink and an open book. His attribute – as per convention, the red cardinal's hat, here hanging on a branch – identifies him as a future Father of the Church. Another of his attributes is the lion resting in the foreground, from whose paw the saint once pulled out a thorn, as related in the *Golden Legend*. According to a rather unconvincing theory put forward by Cocke, the misshapen and, moreover, heavily retouched creature derives from an Egyptian statue of a lion, which in Elsheimer's day was displayed in Rome at the Acqua Felice. The anthropomorphous lion portrayed here is more reminiscent of German visual precedents. Jerome holds in his right hand a stone, the instrument of his penitence, and gazes at the crucifix in his left hand. On the ground in front of him lies a skull, referring to the

transitory nature of life on earth. The anemone blooming next to it has traditionally been connected with death; its colour symbolises the blood shed by Christ and the martyrs.[1] The two snails creeping up the stone bench, symbols of sloth and sin, point to the hermit's temptations, as does the lizard behind him, from antiquity a traditional ingredient of love potions and here perhaps suggestive of the lustful temptations that Jerome mentions in his writings.[2]

In Elsheimer's time, deserts were commonly thought to have impenetrable forests dangerous to humans. In his writings Jerome says that during his life as a hermit he was surrounded by nothing but scorpions and wild animals. In comparison with other, contemporary, portrayals of Saint Jerome, Elsheimer's representation is remarkable for its conception of the forest landscape as a closed space, above which the sky is barely discernible. Behind the saint is a dark grotto overgrown by plants, optically cutting the picture in two. The dividing line is formed by a brightly lit grapevine growing up the rock face, a vine being one of the oldest symbols of Christian faith (John 15:5). The light falling sharply from above strikes the hermit's naked back and puts space between him and the dark cave. The composition of this painting

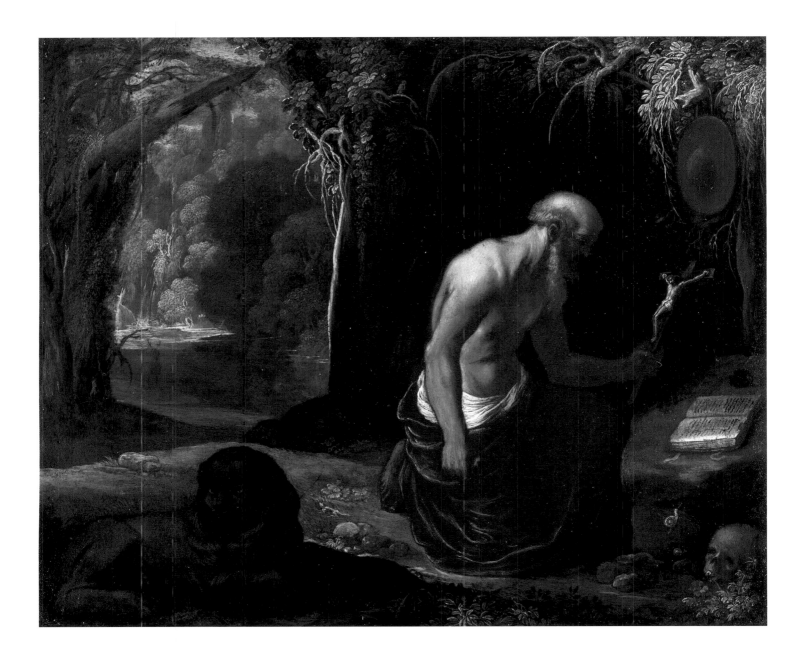

could have been inspired by Dürer's 1512 woodcut of *Saint Jerome in a Cave* (fig.79), which also shows the hermit in a grotto overgrown by vegetation,[3] although there the pile of rocks forms a window affording a view to a distant lake. Unlike Dürer, Elsheimer used the darkness of the grotto as a foil to the light in the forest, where he shows the scene's theological underpinnings. The picture shows the depths of a dense deciduous forest, across a lake whose surface is darkened by the shadows cast by tall trees. Standing completely in shadow at the water's edge is a hart, its gaze fixed on the opposite shore – lit by bright sunlight – where a waterfall gushes from the rock face. The reference to the biblical passage is not difficult to recognise: 'As the hart panteth after the water brooks, so panteth my soul after thee, O God' (Psalm 42). Moreover, the source springing from the rocks is, as frequently seen, symbolic of life everlasting.

With regard to its chronology, the painting offers several stylistic clues already observed by Waddingham. A Saint Jerome rendered in very similar fashion – in terms of colour, modelling and treatment of light – occurs in the foreground in the central depiction of

Elsheimer's *True Cross Altarpiece* in Frankfurt (cat.no.20a), which must have been executed around 1603–05. The rendering of the forest in changing light with the hart standing at the waterside is most closely related to Elsheimer's small paintings in Petworth House (cat.no.21), especially the small-scale, refined landscapes in the background of *Saint John the Baptist* and *Tobias and the Angel*. According to Andrews, these paintings can be dated to before 1605 because of their relationship to works by David Teniers the Elder. In Elsheimer's *Pietà* and *The Three Marys at the Tomb* (cat.nos.15, 16), which are very close in style, the hanging plants, whose leaves seem to move in the light, are the same as those seen in the grotto of *Saint Jerome*. Waddingham's dating of the piece to shortly before the *True Cross Altarpiece* is supported by its close formal correspondence to the *Pietà* and *The Three Marys at the Tomb*.

NOTES

1 L. Behling, *Die Pflanze in der mittelalterlichen Tafelmalerei*, Weimar, 1957, passim.
2 On the snail as a symbol of sloth, cf. Dittrich 2004, p.461; on the lizard as a symbol of sinfulness, cf. L. Stauch, in *RDK* IV, col. 931f.; Dittrich 2004, p.79.
3 *The Penitent Saint Jerome*, woodcut 1512 (Bartsch 113, Hollstein German, vol.229).

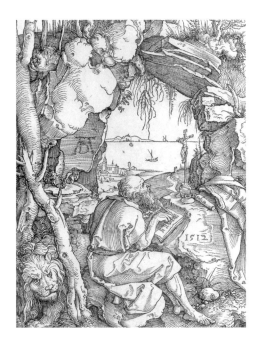

Fig.79
Albrecht Dürer,
Saint Jerome in a Cave, woodcut

18 Saint Lawrence Prepared for Martyrdom

Copper, 26.7 x 20.6 cm
London, The National Gallery, inv.no.1014

PROVENANCE Saarbrücken, Count Johann of Nassau (1603–1677); Antwerp, Diego Duarte Collection (1682); London, Goodall sale, 9 April 1772, lot 37; Wynn Ellis Collection; acquired 1876

LITERATURE Drost 1933, p.58; Weizsäcker 1936, vol.I, p.70ff.; Longhi 1943, p.45, n.31 (Lastman?); Weizsäcker 1952, no.37; Levey 1959, p.38f.; Andrews 1977, no.9; Andrews 1985, no.9; Bachner 1997, pp.249–53; Klessmann 2004, p.57f.

Lawrence, born in Spain and active as a deacon in Rome, was martyred in AD 258. The Pope had instructed him to distribute the church's treasures (precious vessels and money) – for which he as deacon was responsible – among the poor of Rome, and Lawrence refused to carry out the prefect's orders to hand them over to the city.[1] In the foreground stands, in accordance with the legend, the Emperor Decius (wearing a turban), who orders Lawrence to renounce Christianity. With a marble statue of Hercules towering above him, he looks threateningly at the young deacon, who is being undressed in preparation for his impending martyrdom – being roasted on a gridiron. A priest points the statue of the Roman god out to Lawrence; above them hovers an angel, holding the martyr's palm and pointing upwards to indicate the heavenly reward in store. In the background are the waiting spectators, among them a Roman officer on horseback, and unidentifiable Roman architec-

Fig.80
Albrecht Dürer,
The Flagellation of Christ,
Frankfurt,
Graphische Sammlung im Städelschen Kunstinstitut

ture. No precedents have so far been found for the atypical statue of Hercules; according to Andrews, it is more closely connected with late antique statues of Mercury. There is also no satisfactory explanation for the Latin inscription on the socle of the monument.[2]

Elsheimer's depiction may be counted among the foremost achievements of his early years. He did not rely on traditional portrayals of Lawrence's martyrdom, such as Titian's altarpiece in the Gesuiti in Venice, but rather expanded the story to include his own inventions. To begin with, it was unusual to choose not the martyrdom itself but the preparations leading up to it as the main subject, as Elsheimer did. According to Franziska Bachner's interpretation, Elsheimer accorded the heathen statue an additional role that goes beyond its customary association with the subject matter. The painter put Hercules' strength as a virtuous hero on a symbolic par with the spiritual strength of the martyr. When Hercules, wearing a garment soaked in Nessus' poisoned blood, suffers terrible torments, he chooses to die on the funeral pyre. The parallels to the martyrdom of Saint Lawrence are recognisable 'in the contempt for earthly torments to which Hercules, being burnt alive, bears witness on the funeral pyre'.[3]

The trio consisting of victim, accuser and pagan statue forms the dominant motif of the composition. Elsheimer's source of inspiration for the central figure of the Emperor Decius was obviously the figure of Pontius Pilate in Dürer's woodcut of *The Flagellation of Christ* from the series called 'the Large Passion' (fig.80).[4] Decius wears a costly brocade robe, largely similar to that worn by the angel in Elsheimer's *Holy Family* (cat.no.7).

The officer – dressed in red and wearing a plumed beret – who grabs Lawrence's garment is encountered in similar garments in Aeneas' entourage in Elsheimer's *Burning of Troy* in Munich (cat.no.10). The statue of Hercules and the ancient temples in the background in this painting show the the painter's first impressions of Rome after settling there. According to Levey, the angel swooping down with a palm branch was perhaps inspired by a fresco – executed by a member of Raphael's workshop in the Villa Magliana near Rome – of *The Martyrdom of Saint Cecilia*, which was also known through an engraving by Marcantonio Raimondi.[5] Elsheimer's painting offers no further clues as to its date, but the length of time between it and the similarly constructed *Stoning of Saint Stephen* (cat.no.19) cannot have been very great.

Early on, this unusual work led to a large number of copies and adaptations, prompted in part by the engraving made by Pieter Soutman,[6] the existence of which suggests that the original was in Antwerp from the second quarter of the seventeenth century, where it was later mentioned (before 1682) as hanging next to Elsheimer's *Aurora* in the collection of the art dealer Diego Duarte. It is nevertheless possible that the original *Saint Lawrence* ended up at some point in the collection of Count Johann of Nassau in Saarbrücken (as Sandrart records), even though the count was a staunch supporter of Protestantism. Rubens, whose Saint Lawrence altarpiece in Munich (painted around 1614) also betrays reminiscences of Elsheimer's work, could have become acquainted with the painting in Rome. The attention it attracted is evidenced by a hitherto unnoticed oval etching by an anonymous artist, who adopted the composition but moved the statue of Hercules to stage centre to assume the role of protagonist in this scene of martyrdom.[7]

NOTES

1 *Golden Legend*, vol.II, p.63ff.
2 Andrews 1977, p.143.
3 Bachner 1997, p.252.
4 *The Flagellation of Christ* (Bartsch 8; Hollstein German, vol.117); Koch 1977, p.162, no.89.
5 Bartsch 117.
6 Soutman, Hollstein, vol.XXVII, no.10; a summary of the known copies is to be found in Weizsäcker 1952 and Levey 1959.
7 Etching, 151 x 102 mm (oval), Amsterdam, Rijksprentenkabinet, inv.no.RP-P-2004-756. I am grateful to Christian T. Seifert for drawing my attention to this sheet.

19 The Stoning of Saint Stephen

Copper (silvered), 34.7 x 28.6 cm
Edinburgh, National Gallery of Scotland,
inv.no.NG 2281

PROVENANCE Rome, Paul Bril (before 1626);
his widow Ottavia Sbarra (1629); his daughter
Faustina Baiocco (1659); Cardinal Curzio Origo
(1712); Brunswick, Carl Wilhelm Ferdinand,
duke of Brunswick (around 1775–80);
Hamburg, private collection; Salisbury, the
Very Rev. George David Boyle, Dean of Salis-
bury (1828–1901); acquired 1965

LITERATURE Jost 1966, p.103ff.; H. Möhle,
in exh. cat. Berlin 1966, no.10; exh. cat. Frank-
furt 1966, no.21; C. Thompson and H. Brig-
stocke, *National Gallery of Scotland. Shorter
Catalogue*, Edinburgh, 1970, p.27; Andrews
1977, no.15; Andrews 1985, no.15;
K. Andrews, in exh. cat. Naples 1985, no.38;
Sello 1988, p.39ff.; Cocke 1991, p.112; Mai
1996, p.15f., passim; M.K. Komanecky, in exh.
cat. Phoenix/Kansas City/The Hague 1999,
no.20; Klessmann 2006

Stephen, one of the first seven deacons
appointed by the apostles and ordained
by Peter, was among the earliest martyrs
of Christendom. He aroused the wrath of
the high priests and elders in Jerusalem
by delivering a provocative sermon,
which caused such turmoil that he was
dragged out of the city and stoned to
death (Acts 6 and 7). Elsheimer's painting
shows Stephen kneeling on the paved
surface of a road, being hit by stones,
with blood streaming from his head. He
wears a deacon's dalmatic with an em-
broidered depiction of Christ carrying the
cross, which provides him with an exam-
ple to be followed as he faces his ordeal,
and looks up at a splendidly dressed
horseman wearing a turban. He is sur-
rounded by people throwing stones at

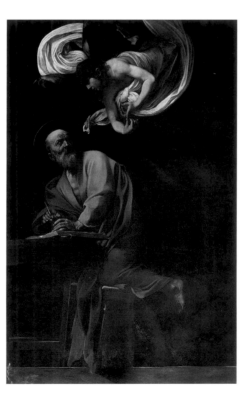

Fig.81
Caravaggio,
*The Inspiration
of Saint Matthew*,
Rome, Chiesa di
S. Luigi dei
Francesi

him. A ray of light, in which a number of
angels holding martyr's palms sweep
down from heaven, falls on the martyr;
God the Father and Christ are visible in
the clouds. The young man serving as a
repoussoir (depicted in shadow in the left
foreground), who wears a diadem and
sits on a fragment of an antique tomb
relief, is – according to Jost – Saul, one of
the witnesses to the execution (Acts 7:58).

In conceiving the composition
Elsheimer was possibly referring to a
composition by Raphael of the same
subject in one of his tapestries for the
Sistine Chapel (now in the Vatican
Museum).[1] Quite apart from this possibili-
ty, Elsheimer's painting is closely related
in style and composition to his earlier
Saint Lawrence Prepared for Martyrdom
(cat.no.18). In both compositions the
dramatic event is concentrated on the left,
with a large, upright figure closing off the
scene on the right. This figure forms a
stopping point for the viewer's gaze
before it shifts to the background, in
which ancient ruins and impressions of
Rome are recognisable, including (in
Cocke's view) the remains of the Temple
of Vespasian. Elsheimer also incorpor-
ated Roman sources in the figures: the
half-naked boy poised to throw a stone
behind Stephen resembles a figure in
Caravaggio's *Martyrdom of Saint
Matthew* in San Luigi dei Francesi, which
was painted at approximately the same
time. In the same church, Caravaggio's
altarpiece *The Inspiration of Saint
Matthew* (fig.81), in which an angel in
flowing robes sweeps down from heaven,
could have been the model for
Elsheimer's heavenly messenger.

Elsheimer based the standing stone-thrower on the right after the example of an antique statue of Marsyas (recognised by Jost), which he could have seen in Rome at the house of Camillo Capranica-Valle (fig.82),[2] a motif – quoted again in his *Realm of Minerva* (cat.no.32b) – that Raphael, too, used in the Stanza della Segnatura.

Elsheimer's *The Stoning of Saint Stephen*, though influenced by the proximity of the art of Caravaggio, still depends on the composition of his *Saint Lawrence*, in which the rigid isocephalism of the main figures stands in the way of spatial development. In style and narrative power the *The Stoning of Saint Stephen* functions as the prelude to the paintings of the *True Cross Altarpiece* (cat.no.20), which makes it justifiable to date it to around 1603–04, as Jost and Andrews propose. The wealth of invention and the dynamism of the multi-figured composition constitute Els-

heimer's debut as a true Baroque painter. His contemporaries – including Rubens, David Teniers the Elder, Pieter Lastman and Jan Pynas – admired this painting in Rome and later used many of its elements in their own works. Rubens copied a number of its background figures in a drawing (fig.82a), which Pieter Soutman published in an engraving, an astounding example of the high esteem in which Elsheimer's art was held in Antwerp.[3]

NOTES

1 Wohlfromm 1997, p.54f.; exh. cat. *Raffaello in Vaticano*, Città del Vaticano, Rome, 1984, no.92a.
2 *Marsyas*, Roman copy after a Greek original of the third century BC, Florence, Uffizi; cf. Bober/Rubinstein 1986, no.32; Cocke 1991, p.109.
3 The composition of Rubens's drawing has survived only in Soutman's engraving. Held 1986, p.78, no.31; A.-M. Logan, in *Master Drawings* 15, 1977, p.412; Hollstein, vol. XXVII, no.16); Van Gelder/Jost 1967, p.146ff.; Klessmann 2004, p.58.

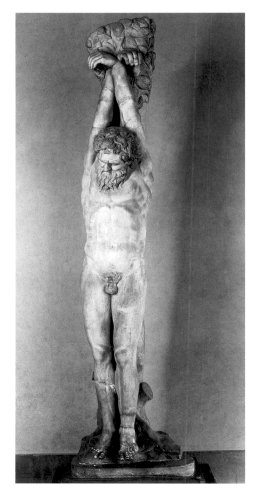

Fig.82a
Pieter Soutman after Rubens,
Figures after Elsheimer,
London, British Museum

Fig.82
The White Marsyas
(Roman copy after
a Greek original,
3rd century BC),
Florence, Uffizi

20 The Finding and Exaltation of the True Cross ('The Frankfurt Tabernacle')

Seven copper plates (silvered). Frankfurt am Main, Städel and Städelscher Museums-Verein

PROVENANCE Rome, Juan (Giovanni) Pérez Collection (1612); Florence, Grand Duke Cosimo II (1619); Grand Duke Ferdinand II (1626); Earl of Arundel (after 1626); Thomas Newport, Baron Torrington (after 1708); London, The Countess of Bradford (before 1735)

LITERATURE Martinez 1866, p.40f.; Weizsäcker 1936, p.162ff.; Orbaan 1927, p.158; Holzinger 1951, p.212ff.; Weizsäcker 1952, p.37ff., no.40 A; R. Longhi, 'Una traccia per Filippo Napoletano', *Paragone*, 8, 1957, no.95, p.47f.; Crinò 1965, p.575f.; Jost 1966, p.3ff.; J. Held, in exh. cat. Frankfurt 1966, nos.27, 28; Van Gelder/Jost 1967, vol.II, p.32f.; Waddingham 1972 B, p.60off.; Andrews 1977, p.146, no.16; Andrews 1979, p.168f.; Andrews 1985, no.16; Howarth 1985, p.71f.; Eich 1986, pp.31–59; Lenz 1989, p.36ff. (with bibliography); Von Henneberg 1999, p.36f.; Heussler 2006, pp.273–83, 368, no.21

These pictures, painted on silvered copper plates, were originally inlaid in a retable made of pear wood (now reconstructed), the shape of which is known from a reliable document dating from 1612. They represent the subject of the exaltation of the cross of Christ and its finding by the Empress Helena, a story which derives from medieval legend.[1]

Helena, the mother of the Roman emperor Constantine the Great, converted to the Christian faith after her son set the example in AD 312. Already advanced in years, she nevertheless resolved to travel to Jerusalem to visit its holy places. There she asked an old man by the name of Judas, who was the only one who could still remember, exactly where the cross of Christ once stood; she then arranged to have a temple built by the Emperor Hadrian on Golgotha demolished in order to carry out – with the help of the old man – an excavation of the site of the Crucifixion. Three wooden crosses were found, which were examined in the city in hopes of a sign from God. A dead youth was carried past (according to some reports it was the body of a virgin) and was touched with each cross in turn to determine which was the True Cross; the third cross brought the body to life, showing that this was the True Cross of Christ. Later, too, other miracles occurred, which confirmed the authenticity of the cross. The Persian king Chosroes II subsequently stole the cross during a military campaign, but in 629 the Byzantine emperor Heraclius succeeded in bringing it back to Jerusalem. When he was approaching the city on horseback, carrying the cross in the midst of a glittering procession, the gate to the city was suddenly blocked by falling stones. An angel appeared and reminded the ruler that Jesus was humble and would have ridden through the gate on an ass, foregoing all regal splendour. Heraclius took the warning to heart. Weeping, he divested himself of his insignia and, barefoot, carried the cross to the gate, which opened miraculously to admit him.

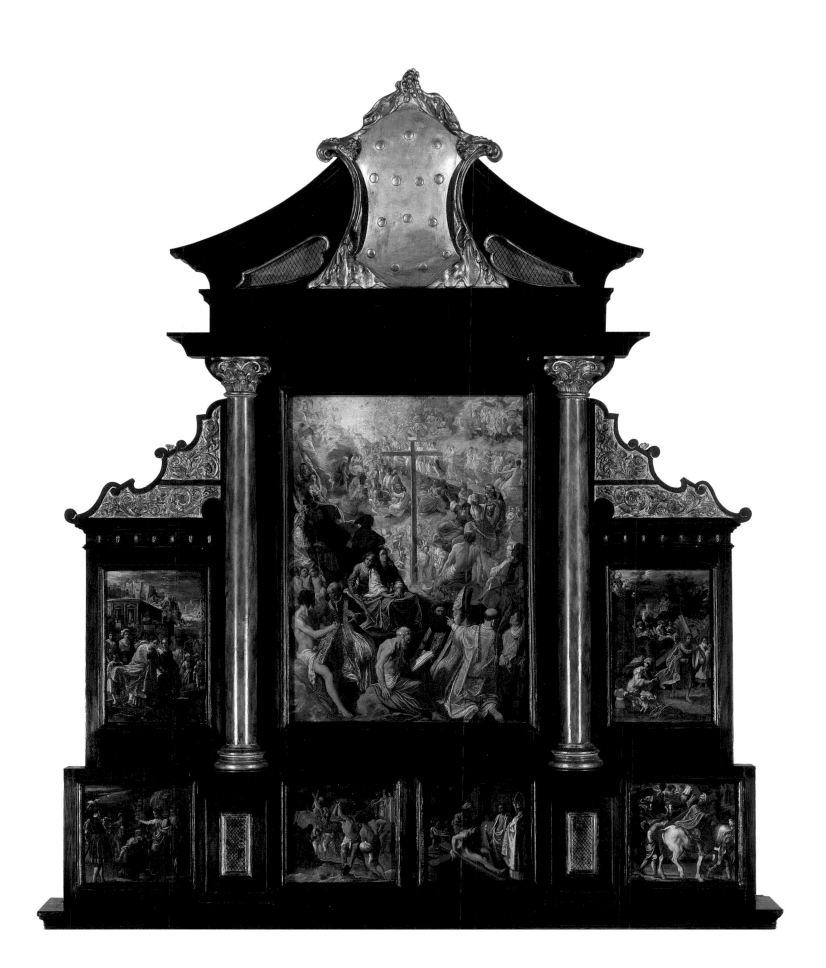

a) The Exaltation of the Cross

Copper (silvered), 48.5 x 35 cm, inv.no.2024

PROVENANCE Earl of Arundel (after 1626); Duke of Norfolk; sale London (Christie's), 11 February 1938, lot 83; London, art dealer Colnaghi (1938); acquired 1950

The central representation of the altarpiece combines two themes: the exaltation or worship of the cross, traditionally celebrated in the Roman Catholic Church on 14 September, and the coronation of the Virgin in heaven. The ceremony is attended by many saints, as well as by figures from the Old and New Testament. Rising up in the middle of the composition is the cross, the base of which unites the lower regions of martyrs and Fathers of the Church with the heavenly kingdom. Kneeling at the foot of the cross, surrounded by angels carrying the instruments of the passion, is the Empress Helena, whose pious efforts to find the cross are depicted on the side panels. To her right are the representatives of the Old Testament: Moses, Abraham, David, Daniel and Jonah. At the lower edge of

Fig.83
Johann
Rottenhammer,
The Coronation of the Virgin,
London, The
National Gallery

the picture, seated in the middle, is the half-naked Jerome, portrayed as a hermit and scholar engaged in studying the Bible; next to him, on the right, are the martyrs Stephen and Lawrence, as well as the saints Ambrose and Augustine. Ambrose was the first of the Latin Fathers of the Church to pay tribute to the empress's enterprise. To the left of Jerome are the martyr Sebastian and Saint Gregory, another Father of the Church; just behind them, to the right, sit Saint Catherine and Saint Mary Magdalene.[2] These two women recall those in Elsheimer's earlier painting of *The Three Marys at the Tomb* (cat.no.15), while Jerome occurs almost identically in a wooded landscape by Elsheimer (cat. no.17). Most of the saints in *The Exaltation of the Cross* are portrayed in pairs. In conceiving this complicated and thematically demanding composition, Elsheimer must have had in mind examples in the work of Titian, Veronese, Tintoretto and Rottenhammer. Elsheimer must also have been familiar with the *Paradise* by Francesco Bassano in the Gesù in Rome.[3] Andrews refers in particular to Tintoretto's *Paradise* (Paris, Louvre) and Rottenhammer's picture of *The Coronation of the Virgin*, which was in Rome until 1608 (fig.83).[4] This composition, painted around 1595, is dominated by the coronation of the Virgin, its large number of saints appearing in a circular arrangement on several levels. This differs, however, from the disposition of the figures in Elsheimer's composition, in which the erect cross and the flow of light serve to open up the view to heaven.

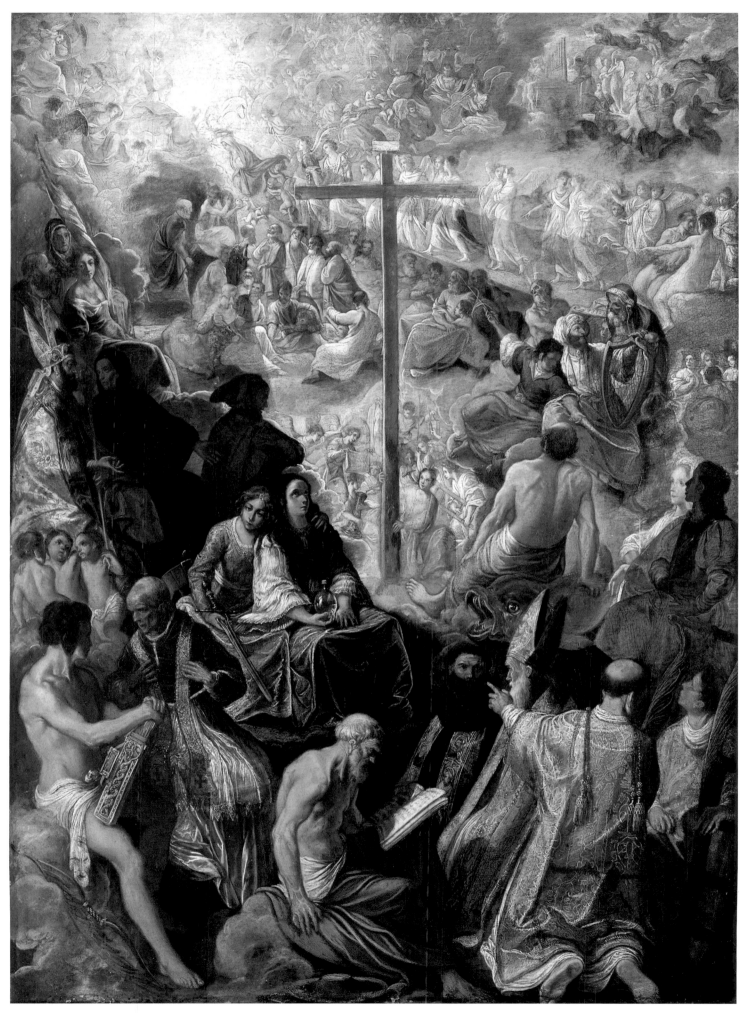

b) The Embarkation of the Empress Helena

Copper (silvered), 22.5 x 14.9 cm, inv.no.2131

PROVENANCE England, private collection (1970); acquired 1975

The empress, wearing a gold-coloured cloak carried by a page, walks along the carpet-covered gangway to a ship that is not within view. In the distance is a city built on hilly terrain, in front of which stands an archaising one-storey building, from whose windows, which are decorated with rugs, a few curious spectators watch the embarkation. The ruins in the background, according to Cocke, are those of the abbey of Santa Sabina on the Aventine, a motif also used by Rubens and Paul Bril.[5]

c) The Questioning of the Jew

Copper (silvered), 15 x 15.8 cm, inv.no.2142

PROVENANCE London, The Countess of Bradford (before 1735); Australia, private collection; sale London (Christie's), 4 October 1981, lot 99; acquired 1981

In the presence of an officer, the empress questions an old man kneeling before her, who has laid his turban on the ground. In the background are the ruins of an ancient edifice. The same officer in similar dress appears in Aeneas' entourage in Elsheimer's *Burning of Troy* in Munich (cat.no.10).

d) The Digging for the Cross

Copper (silvered), 14.7 x 16 cm, inv.no.2118

Provenance
London, The Countess of Bradford (before 1735); sale London (Christie's), 25 June 1971, lot 14; acquired 1971

Several men stand in a hole, digging with pickaxes and spades; in the background a cross that has been unearthed is carried up a ladder. The empress, accompanied by a bishop and an officer, observes the work in progress from a raised place on the right. The realistic depiction of an excavation site was rather unusual as the main subject of a panel intended for an altarpiece. Elsheimer presumably hoped by this means to underscore the miraculous nature of the event, which entailed finding the cross, snatching it from the darkness of the earth and thus rescuing it from oblivion. The man knuckling down to work with his spade could be based on a similar figure occurring in a Venetian work, Tintoretto's *Crucifixion* in the Scuola di San Rocco (fig.84),[6] a huge painting with many figures that seems in other ways as well to have been of great importance to Elsheimer's development.

There is a preliminary design connected with this panel, a carefully executed brush drawing by Elsheimer, which bears his name in an old inscription and which belonged, together with other drawings by Elsheimer or Hendrick Goudt, to the famous art collection of Valerius Röver in Delft (fig.85, cat.no.38) in 1731.[7] It proves to be the only surviving preparatory work for the *True Cross Altarpiece* and as such provides a remarkable record of the artist's working methods. It is not a preparatory study of the usual kind, but rather a finished work, made for transfer to the copper plate and of the same dimensions. The contours and parts of the inner modelling have been perforated, which demonstrates the means of transfer used by the painter (pouncing with charcoal dust). Although this technique was not new in Elsheimer's day and was also used later in the seventeenth century, the authenticity of the drawing has been cast into doubt, wrongly, not least because it is proof of this working method.[8] Despite the transfer of the main lines of the composition, details show that the painter – as Lenz observes[9] – made small corrections while executing the painting.

Fig.84
Tintoretto,
The Crucifixion (detail),
Venice, Scuola di San
Rocco

Fig.85
Elsheimer, *The Digging for the Cross*, Frankfurt, Graphische Sammlung im Städelschen Kunstinstitut

20 b

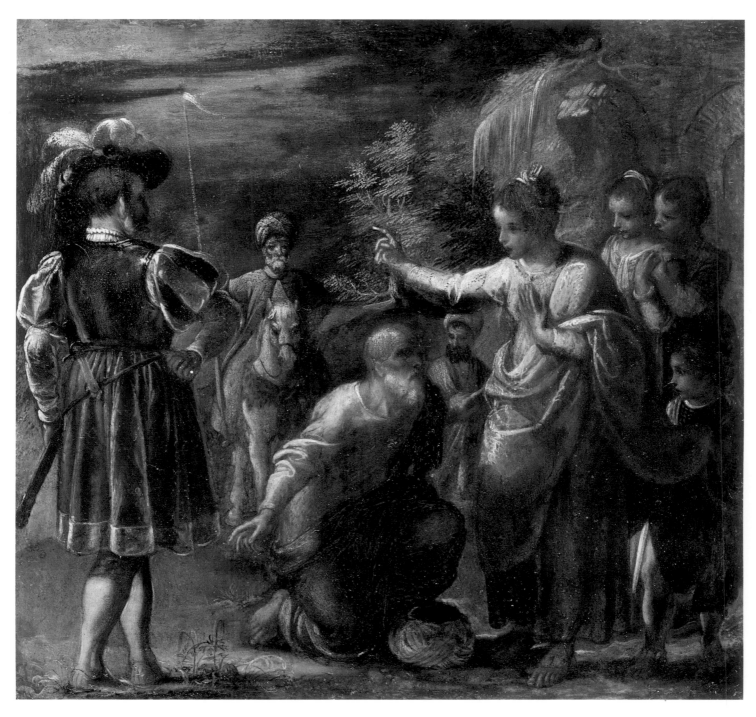

20 C

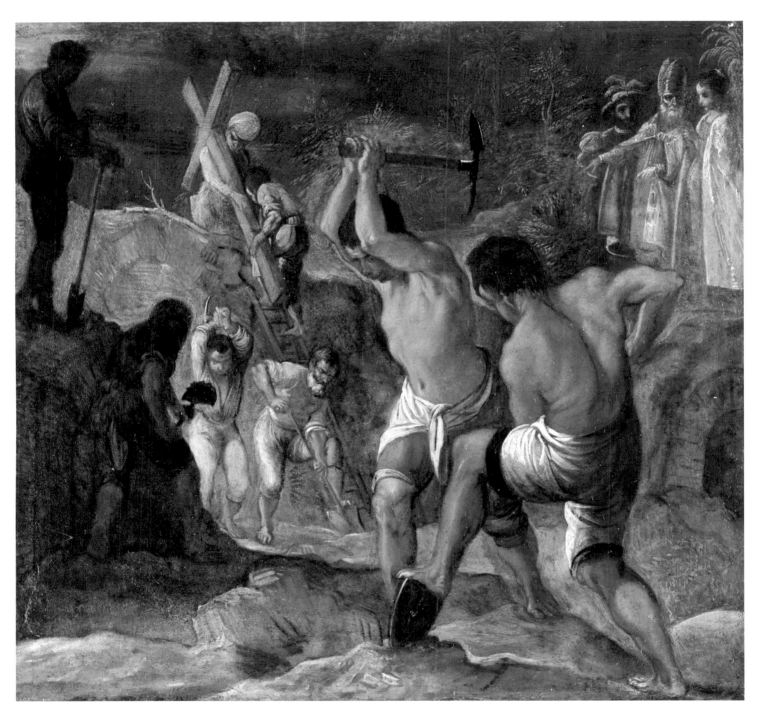

20 d

e) The Testing of the Cross

Copper (silvered), 14.7 x 16.2 cm, inv.no.2140

PROVENANCE London, The Countess of Bradford (before 1735); Australia, private collection; London, Bonham Collection sale, 13 July 1978; acquired 1978

In the darkness of a chapel, lit by a torch held by an acolyte, the naked body of a dead man is laid on a cross. The empress stands expectantly at the foot of the cross; beside her is a bishop, praying, whose ceremonial vestment (pluvial) is decorated with a depiction of the resurrected Christ and the doubting Thomas. A young woman leaning on the lid of the sarcophagus and two children observe the scene. The boy clinging to the pillar, who raises himself up to get a better look, is a motif typical of Veronese, here adopted by Elsheimer. The figure of the bishop with his back turned to the viewer can also be traced to impressions the painter received in Venice.

f) Heraclius on Horseback with the Cross

Copper (silvered), 14.8 x 15.8 cm, inv.no.2119

PROVENANCE Sale London (Christie's), 25 June 1971, lot 15; acquired 1971

The cross of Christ was stolen and taken to Persia. Here, the Byzantine emperor Heraclius brings it back to Jerusalem on a splendid white horse. He wears a costly turban, a cloak of gold brocade and golden shoes – his horse also sports imperial trappings – and looks back proudly at the spectators following his progress towards the city. Several angels and a bishop accompany him, although the role of this bishop is not entirely clear and therefore open to interpretation.[10] This is the only instance in Elsheimer's painted oeuvre that a noble horse and its rider, portrayed full length, take up almost the entire picture. Perhaps the painter was thinking of the monumental horsemen in Tintoretto's large *Crucifixion* in the Scuola di San Rocco in Venice.[11]

g) Emperor Heraclius' Entry into Jerusalem

Copper (silvered), 22.5 x 15.3 cm, inv.no.2054

PROVENANCE London, The Countess of Bradford (before 1735); London, Sir Alec Martin Collection (1936); acquired 1955

The emperor Heraclius, bareheaded and without shoes, carries the cross of Christ into the city. The impassable city gate, which will open for him miraculously, is not part of the picture. In accordance with an ancient tradition, he has wound a cloth around his hands so as not to touch the holy wood, a consideration he felt unnecessary – as Elsheimer showed – during his first, proud entry on horseback. Next to him walks a bearded old man, whose job it is to carry the turban with the emperor's crown. The emperor is followed by his mounted retinue. Spectators gaze down upon the procession from a vantage point high up on the rocks. In the left foreground a mother urges her children, who play with a dog, to be quiet, simultaneously pointing out to them the event taking place. This scene clarifies the intended formal correspondence between the two large side panels of the retable:[12] both rulers, the empress Helena and the emperor Heraclius, are on their way to the True Cross, and their actions set an example for their subjects to adhere to the true faith.

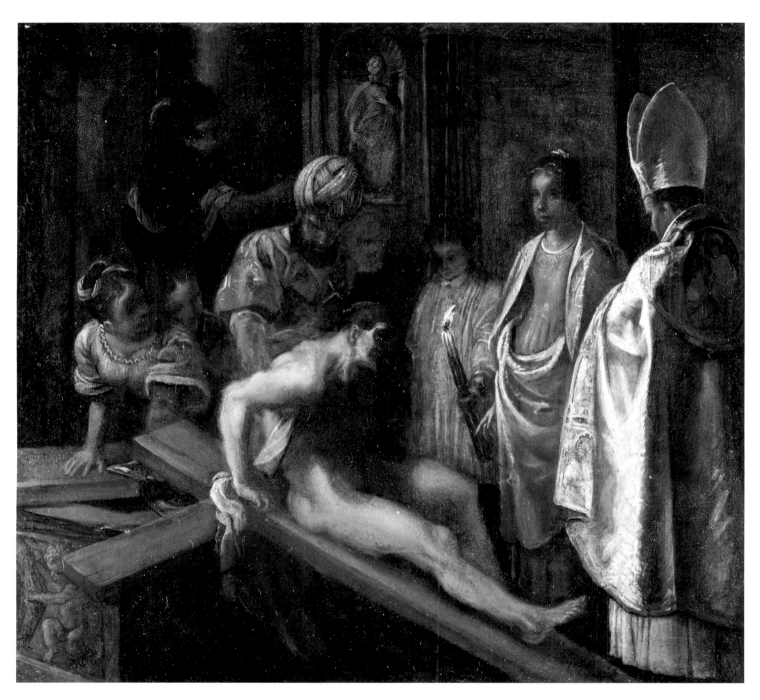

20 e

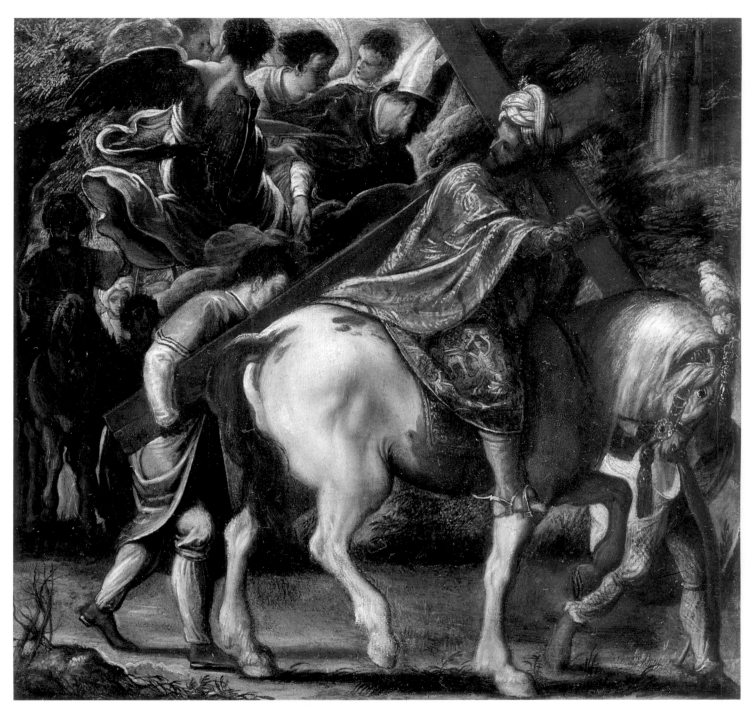

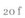

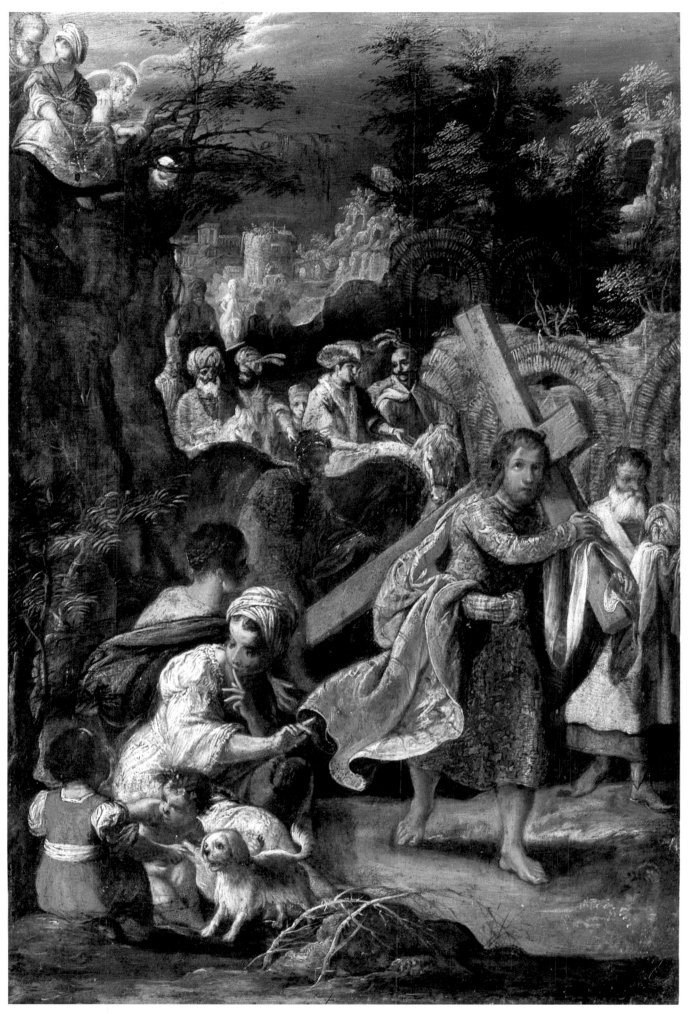

20 g

The theological programme of this altarpiece, intended for private devotion or a house chapel, marks it unmistakably as a commissioned work – Elsheimer's most important commission, as far as we know. Moreover, a number of contemporary documents pertaining to this work have survived, more than is the case with any of his other works. The documents give an exact description of the original altarpiece, but do not mention the name of the patron or when he commissioned the work.[13] Only in 1612, after Elsheimer's death, is there mention of Juan Pérez – a Spaniard living in Rome, who perhaps dealt in art but could not have been the patron in question – as the owner and also the vendor of the work. The acquisition of the altarpiece for the collection of Grand Duke Cosimo II in Florence, which finally came about in 1619 after negotiations had been broken off in 1612, was based on the expert opinion of the painters Agostino Tassi and Lodovico Cigoli, as well as on the advice of the famous Caravaggio collector Cardinal Francesco Maria del Monte. In Florence the panels were given a new frame of *pietra dura*, as shown by their entry in an inventory dated 19 May 1626, drawn up during the reign of Ferdinand II de' Medici. The sale and transfer of the retable to England cannot have taken place before this date.[14] We are indebted to the Spanish painter Jusepe Martinez (1600–1682),[15] who was staying in Rome in 1625, for the first words of admiration for Elsheimer's altarpiece, which he had viewed in the company of a 'famous painter' ('un pintor grande'), whose name he does not divulge, in an unnamed palace in Rome.[16] Martinez recorded his memories of this experience in his *Discursos practicables*, written around 1673 but first published in 1866. This discreet appraisal (and valuation?) could have been connected with the delivery of the altarpiece to the Earl of Arundel, who offered Grand Duke Cosimo II a portrait by Hans Holbein the Younger in exchange for it and was in fact a collector of Elsheimer's work.

NOTES

1 *Golden Legend*, vol.I, p.278ff.; vol.II, p.168ff.

2 On the theological background of the painting, cf. Eich 1986, p.45f., and Von Henneberg 1999, p.36; Heussler 2006.

3 Arslan 1960, vol.I, pp.204, 209.

4 Formerly Althorp, Collection of Earl Spencer: Rottenhammer, *The Coronation of the Virgin*, copper, 91.3 x 63.8 cm; I. Jost, 'Drei unerkannte Rottenhammer-Zeichnungen in den Uffizien', in *Album Discipulorum Prof. D.J.G. van Gelder*, Utrecht, 1963, pp.67–78; Schlichtenmaier 1988, p.81f., 205, no.G I 5.

5 W. Adler, *Corpus Rubenianum Ludwig Burchard XVIII. Landscapes and Hunting Scenes I: Landscapes*, London, 1982, p.39, cat.no.1.

6 Waddingham 1972 B, p.602.

7 Van Gelder/Jost 1967, p.32f.; Andrews 1977, no.41; Andrews 1985, no.41.

8 W. Hugelshofer, review of Möhle 1966, *Zeitschrift für Kunstgeschichte* 31, 1968, p.95.

9 Lenz 1989.

10 Holzinger 1972 (Bishop Quiriacus); Andrews (1977, p.147) is inclined to think – referring to Flavio Biondo's *Historiarum ab inclinatione Romani imperii*, Venice, 1483 – that this figure represents the patriarch Zacharias of Jerusalem, who was abducted by the Persians, together with the cross, and after being freed by Heraclius returned with him to Jerusalem. Cf. also Eich 1986, p.44; Von Henneberg 1999; Heussler 2006.

11 Kennedy connects the motif of the horseman to engravings by Dürer. G. Kennedy, 'Elsheimer: Two Predellas from the Frankfurt Tabernacle', *Burlington Magazine*, 113, 1971, pp.92–96.

12 Andrews considers their juxtaposition as a conscious separation of the earthly scenes of this representation from those of the life to come in the central panel. Andrews 1977, p.147.

13 Orbaan 1927; Crinò 1965. Andrews 1977, p.50, document 14; Lenz 1989, pp.38–44.

14 Guardaroba Medicea, Filza 409, no.117 (communicated by Marco Chiarini in a letter of April 1990); I am indebted to Michael Maek-Gérard for this reference. See also Gordenker's essay in this catalogue.

15 I. Gutiérrez Pastor, in *Turner Dictionary* 1996, vol.20, p.500.

16 Martinez 1866, p.40f.; Bode 1883, p.245ff.

21 Saints and Figures from the Old and New Testament

Series of eight copper panels (silvered),
each 9 x 7 cm
a) *Saint John the Baptist*, inv.no.PET.P.279
b) *Saint John the Evangelist*, inv.no.PET.P.274
c) *Saint Peter*, inv.no.PET.P.275
d) *Saint Paul*, inv.no.PET.P.276
e) *Saint Thomas Aquinas*, inv.no.PET.P.278
f) *Tobias and the Angel*, inv.no.PET.P.272
g) *Saint Anne with Mary*, inv.no.PET.P.277
h) *Saint Joseph with the Christ Child*,
inv.no.PET.P.273; Petworth House, The
Egremont Collection (The National Trust)

PROVENANCE York House, Collection of the
Duke of Buckingham (1635); Northumberland
House, Collection of the Duke of Northumber-
land (1671); Piccadilly, Egremont House
(1764); Petworth, Lord Leconsfield

LITERATURE Bode 1880, p.253f.; Bode 1883,
p.293; Drost 1933, p.58ff.; Weizsäcker 1936,
vol.I, p.112ff.; Weizsäcker 1952, pp.33, 220,
no.39; Waddingham 1972 B, p.606; Andrews
1977, no.17; Andrews 1985, no.17; A. Laing,
in exh. cat. London 1995, no.59

The eight panels, identical in format,
belong to a series that once consisted of at
least ten pieces and perhaps even more.
An additional panel is now preserved in
the Musée Fabre in Montpellier (cat.
no.22), and another, obviously lost, is
known only from a copy by Cornelis van
Poelenburch (fig.87). This last belongs to
a complete series of copies, preserved in
Florence, which Poelenburch produced
after Elsheimer's Petworth panels.[1]
Elsheimer's paintings must have served
to decorated a valuable piece of furniture,
into which they were inserted or inlaid,
though no one has yet succeeded in
determining the its exact appearance and
purpose. A Dutch cabinet made in the
seventeenth century – the so-called
Penshurst Cabinet in a private collection
in England (collection of Viscount De

L'Isle and Dudley) – is decorated with
copies of Elsheimer's paintings by
Cornelis van Poelenburch, and offers
some idea of the construction of this type
of furniture (fig.86).[2] Inside the Penshurst
Cabinet is a silver model of Saint Peter's
tomb in Rome and a relief depicting the
Resurrection, which suggests that the
cabinet was an object of personal devo-
tion. The theological context of the figures
portrayed in the Petworth series – the
choice was certainly in keeping with
the wishes of the unknown patron – has
not yet been clarified, particularly as
Elsheimer's panels portray not only
saints, but also figures from the Old
Testament.

The series of panels with single, stand-
ing figures in an unconfined space recalls
series of engravings by Martin Schon-
gauer and Albrecht Dürer,[3] and – as
Andrews suggests – could have been
inspired by them. The most astounding
thing about these tiny panels is the monu-
mentality of the figures, which are placed
very close to the front of the picture plane
and, unlike German precedents, are
shown before a deeply receding land-
scape, with only one exception. John the
Baptist, who carries a little lamb as his
attribute, stands in front of a distant
clearing in the woods. Deer and storks,
depicted on a miniature scale, are clearly
recognisable at the edge of a stretch of
water. The apostle Peter – displaying his
attribute, the keys – is also placed in a
woodland clearing, while the apostle Paul
stands on a hill, meditating and leaning
on his sword, which is his attribute. No
other picture in the Petworth series
exudes Dürer's spirit as strongly as this
one. The viewer looks down from a great

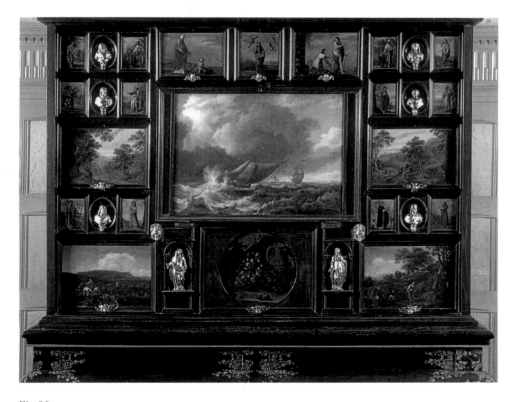

Fig.86
Cabinet with copies after
Elsheimer,
Penshurst, Collection of
Viscount De L'Isle and
Dudley

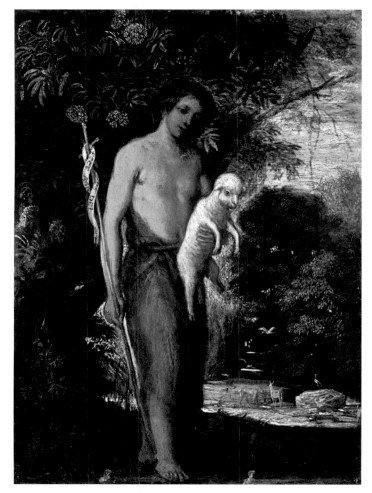

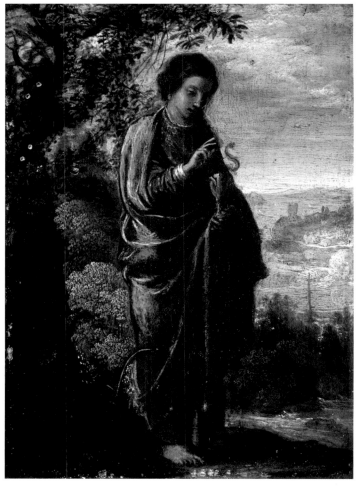

a) *Saint John the Baptist*

b) *Saint John the Evangelist*

c) *Saint Peter*

d) *Saint Paul*

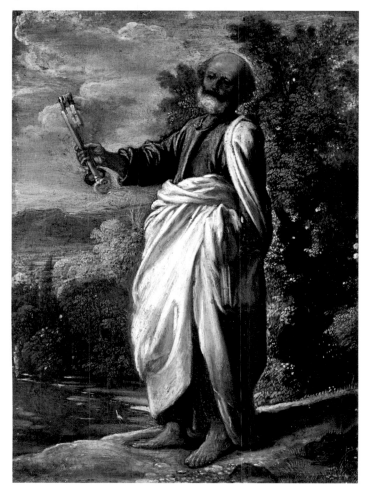

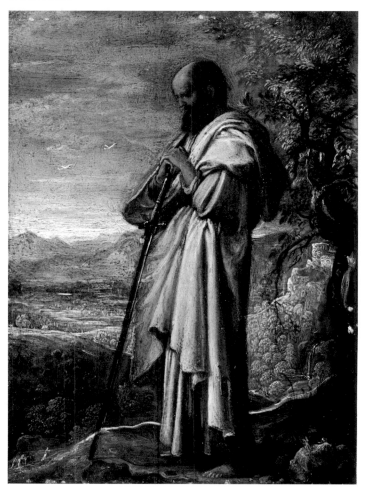

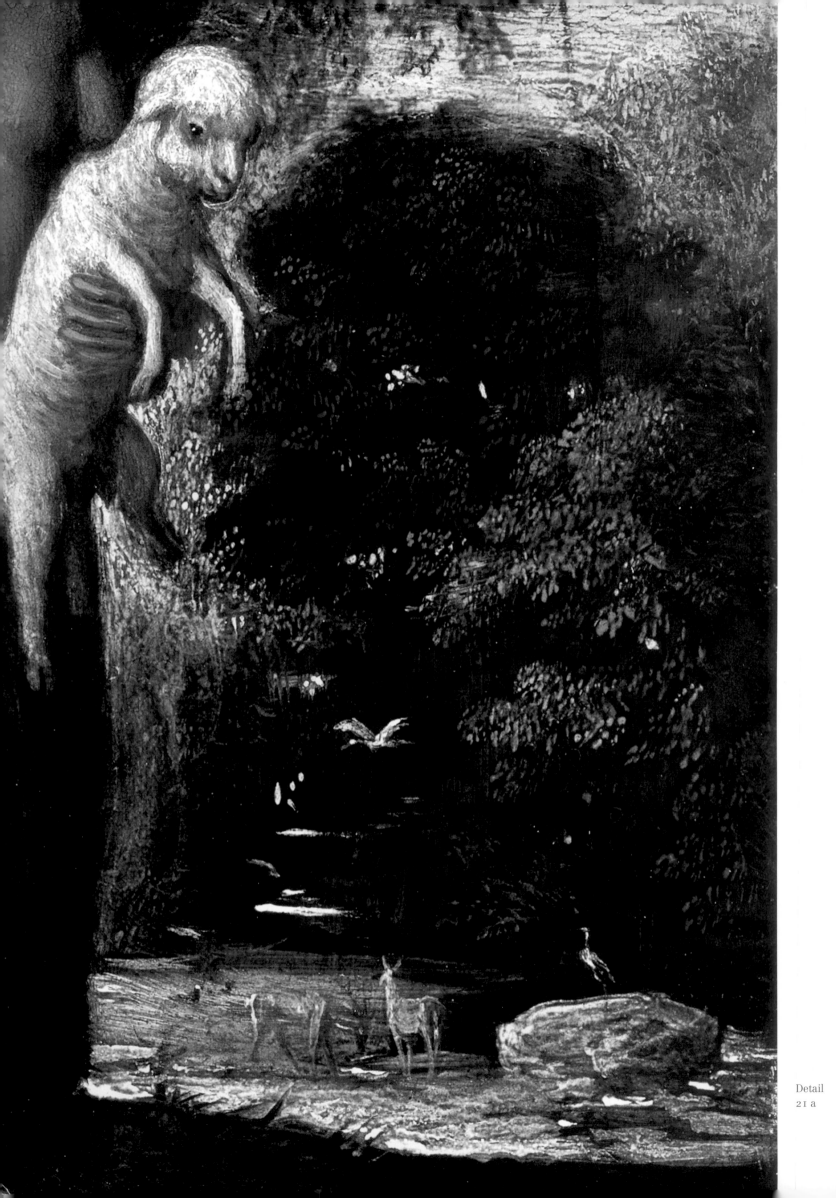

Detail
21 a

Detail
21 b

height over sunlit mountains, fortresses and valleys; in this context the storks flying in the sky undoubtedly symbolise love and faithfulness to Christ.[4] The panel preserved in Montpellier (cat.no.22) shows Saint Lawrence, recognisable by his martyr's palm and the gridiron on which he met his death, standing alone before a wide vista. His pluvial is embroidered with a depiction of Christ carrying the cross, an image that also decorates the deacon's dalmatic worn by the martyr Saint Stephen in the painting in Edinburgh (cat.no.19). Only one panel features an architectural motif, a monastery, as the backdrop to the figure, who wears the habit of the Dominican Order. According to Andrews, this is probably Saint Thomas Aquinas, holding a pen in his right hand – a reference to his important writings – and a model of a church in his left hand.

Three of the paintings portray pairs instead of single figures, each pair alluding to the protection of a child. To these may be added the lost panel, the composition of which survives in a copy by Van Poelenburch, portraying Abraham and Isaac (fig.87).[5] The panels with children perhaps suggest an orphanage or a school with which the unknown patron was connected in some way.[6] Joseph leads the boy Jesus by the hand, who looks the viewer in the eye, a scene reminiscent in composition and style of Annibale Carracci. The stormy sky and the dark natural backdrop are suggestive of the dangers they might encounter on their journey. This picture of the young Tobias with the archangel Raphael is Elsheimer's first version of the subject, with which he introduced to Roman painting one of his most cherished themes, one he was to take up again in two later variations (cat.nos.30, 34). Here the travellers pass by a river, into which a waterfall pours down from a rock. The fish Tobias has killed trails on the ground as he drags it along. His face, wearing a weary and

perhaps fearful expression, remains in shadow, whereas the angel, who holds the child's hand, looks at the viewer reassuringly. Although all these compositions by Elsheimer treat single figures or pairs of figures, the scenic nature of the tiny paintings is especially striking and foreshadows his later landscapes. Seen as a whole, the Petworth series will remain fragmentary until we know more about the patron's thematic (or decorative) programme, how many pictures there were originally, and how they were assembled to form a cohesive work of art. According to Andrews, the paintings – or parts of them – had probably been completed by 1605, for it was then that Elsheimer's pupil David Teniers the Elder, who returned to Antwerp that year, incorporated several of their motifs in a work of his own. Evidently the panels

Fig.87
Cornelis van
Poelenburch
after Elsheimer,
*Abraham and
Isaac*, Florence,
Palazzo Pitti

remained in Rome for the first three decades of the seventeenth century, since they were copied by Cornelis van Poelenburch, who lived in the city in the period 1617–25.[7] By the following decade, however, they seem to have been brought as panels – and no longer as part of a piece of furniture – to England, where (if their identification is correct) they were recorded in 1635 in the collection of the Duke of Buckingham in York House.[8]

NOTES

1 Cornelis van Poelenburch after Elsheimer, *Abraham and Isaac*, copper, 10 x 7 cm, Florence, Palazzo Pitti, cf. Florence 1979, p.417f., nos.P 1203, 1204; Andrews 1977, p.148, fig.64.
2 *Country Life*, 23 March 1912, p.438; Andrews 1977, p.148; A. Laing, in exh. cat. London 1995, p.216, no.6.
3 Schongauer (Hollstein German, vols.41–52); Dürer (Hollstein German, vols.45, 47–50).
4 Dittrich 2004, p.514.
5 Florence 1979, p.417f., no.P 1203.
6 Exh. cat. London 1995, p.162.
7 Bode 1883, p.286.
8 R. Davis, 'An Inventory of the Duke of Buckingham's Pictures, etc., at York House in 1635', *Burlington Magazine*, 10, 1906/07, p.382.

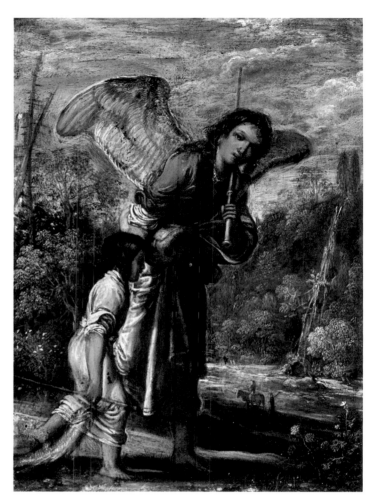

e) *Saint Thomas Aquinas*

f) *Tobias and the Angel*

g) *Saint Anne with Mary*

h) *Saint Joseph with the Christ Child*

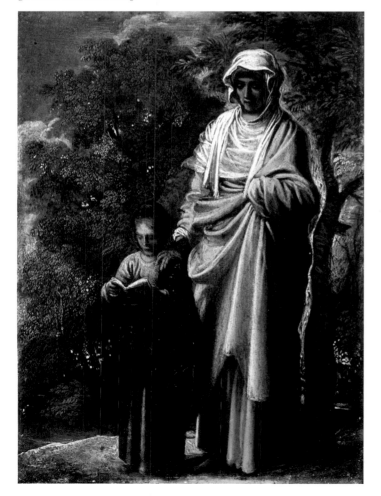

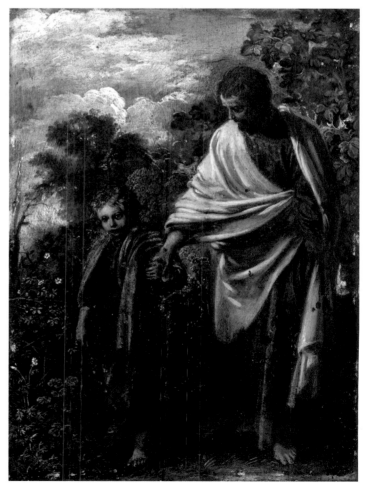

Detail
21 f

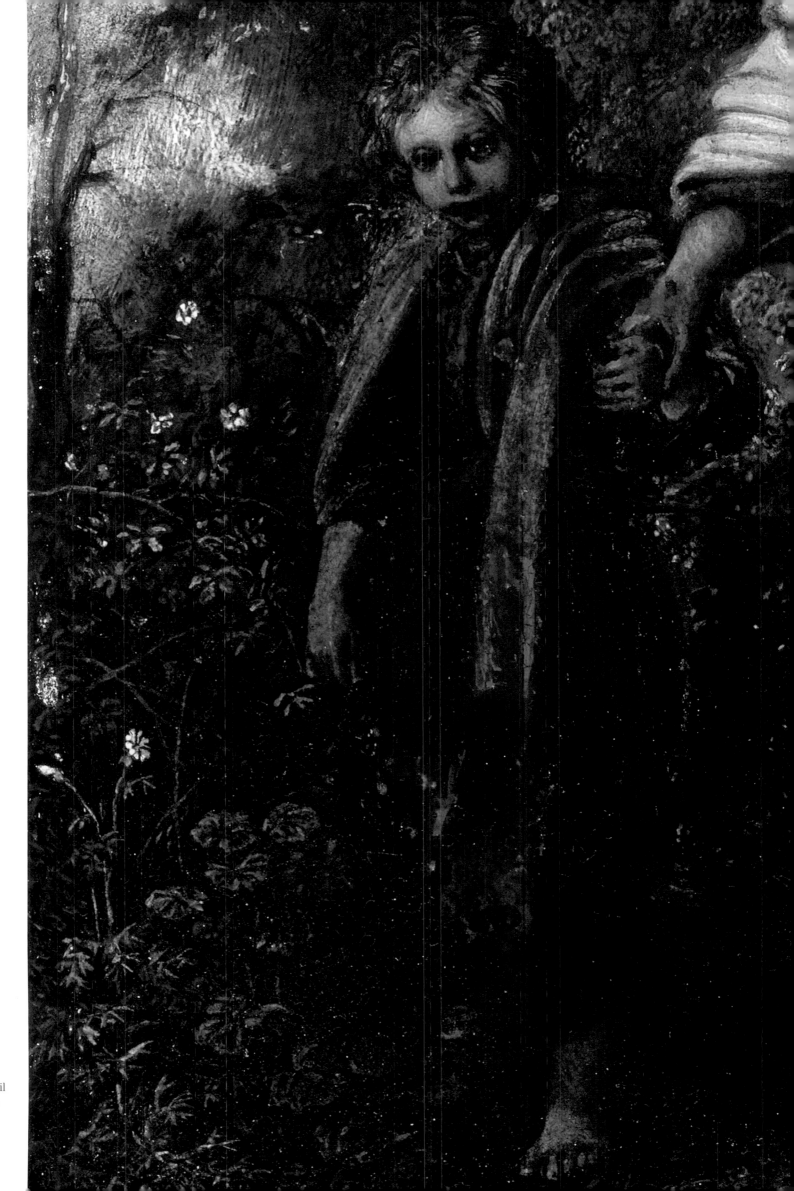

Detail
21 h

22 Saint Lawrence

Copper (silvered), 9 x 7 cm
Montpellier, Musée Fabre, inv.no.685
(Frankfurt and Edinburgh only)

PROVENANCE Montpellier, Francois-Xavier
Fabre Collection; acquired 1825

LITERATURE *Notice des Tableaux et objects
d'art exposés au Musée Fabre*, Montpellier,
1843, p.41, no.137; Bode 1883, p.289; Drost
1933, p.61f.; Weizsäcker 1936, vol.I, p.112ff.;
Weizsäcker 1952, p.36, no.39 J; J. Held, in
exh. cat. Frankfurt 1966, no.24; W.J. Müller, in
Hubala 1970, p.199; Andrews 1977, no.17;
Andrews 1985, no.17

This copper panel, reproduced in an
etching by Wenceslaus Hollar,[1] belongs to
the series of representations preserved at
Petworth House, which are discussed in
the previous entry. A copy preserved in
the Kunsthalle Karlsruhe is probably
identical with the painting –accurately
described by Sandrart – in the possession
of Abraham Mertens in Frankfurt am
Main.[2]

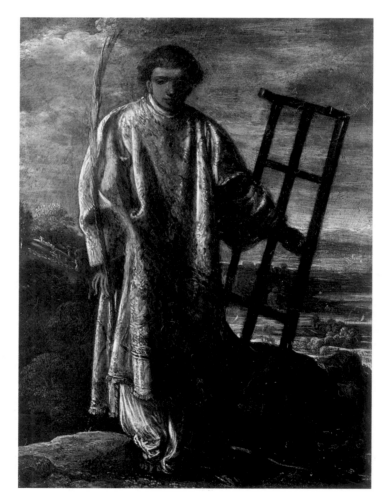

NOTES
 1 Parthey 170.
 2 Sandrart 1675, p.161; J. Lauts, *Staatliche
 Kunsthalle Karlsruhe. Katalog Alte Meister
 bis 1800*, Karlsruhe, 1966, p.111, no.164.

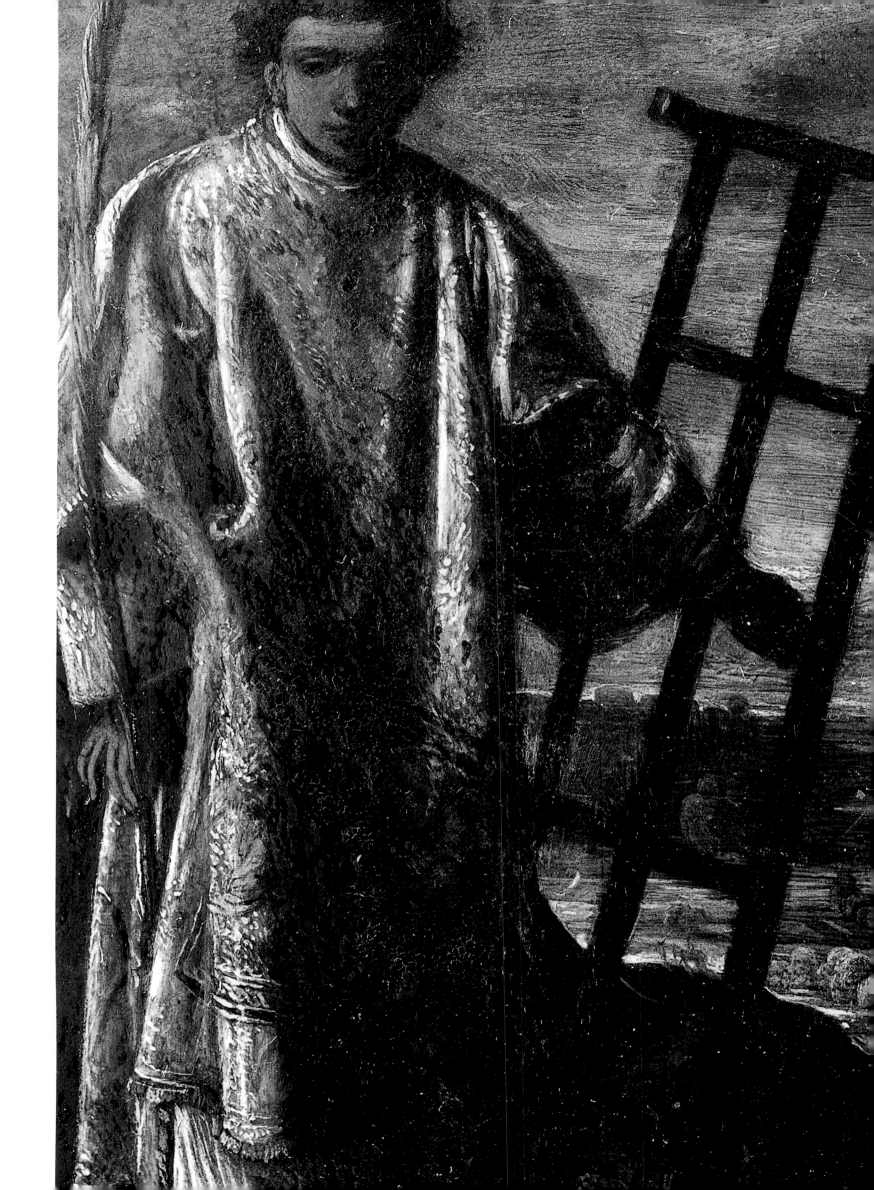

23 The Flight into Egypt

Fort Worth, Kimbell Art Museum,
inv.no.AP 1994.01
Copper (silvered), oval 9.8 x 7.6 cm

PROVENANCE (?) Paris, Chevalier de Querelles;
sale Paris (Martin), 6 November 1820, lot 94
(Elzeymer); Paris, Mr Gustave Rothan (before
1883); sale Paris (Georges Petit), 29–31 May
1890, lot 246; Paris, Eugène Féral Collection
(until 1901?); Jules Féral (c.1920); Mme Paule
Andral Collection (before 1956); sale Monaco
(Sotheby's), 22 February 1986, lot 249; New
York, Bob P. Haboldt; New York, Peter Sharp
(1986); sale London (Sotheby's), 13 January
1994, lot 67; New York, Bob P. Haboldt;
acquired 1994

LITERATURE Bode 1883, p.289; Weizsäcker
1952, p.102; K. Andrews, 'A rediscovered
Elsheimer', *Burlington Magazine*, 128, 1986,
pp.795–97; R. Klessmann, in exh. cat. *Land-
scape of the Bible. Sacred Scenes in European
Master Paintings*, edited by G. Pessach, Israel
Museum, Jerusalem 2000, no.18; F. Cappel-
letti, in exh. cat. London 2001 A, no.68

NOTES
1 On this subject, cf. W. Augustyn, in *RDK* IX,
 col. 1352ff.
2 Bassano del Grappa, Museo Civico, inv.no.6;
 exh. cat. London 1983, no.1.
3 I am particularly indebted to Nancy E.
 Edwards, who made her latest findings
 regarding the provenance of this painting
 available for this catalogue.
4 Museum Boijmans Van Beuningen,
 inv.no.1442; Freise 1911, p.35f.
5 Sale London (Sotheby's), 11 July 1979, lot
 256 (as Saraceni), cf. Andrews 1986, p.797;
 anonymous painter, copper, 14 x 21 cm
 (photograph RDK, Rottenhammer?). I am
 grateful to Christian T. Seifert for this
 reference.

After the birth of Jesus in Bethlehem,
Joseph was warned in a dream that
Herod was searching for the Christ Child
in order to kill him, and that he and his
family should flee to Egypt. There are only
three sentences in the Bible that tell of the
flight of the Holy Family (Matthew
2:13–15), but the story developed into a
popular theme in painting and was taken
up by many North European artists.
These painters drew inspiration from
numerous apocryphal texts which had
been used to enrich the biblical canon
since the Middle Ages.[1] The small panel
shows the high, densely wooded moun-
tains of the Alps – with mighty trees,
bright sunlight and clear blue sky – and in
the distance country folk with their live-
stock at the edge of a forest. At first glance
this seems to be an idyllic landscape with
travellers passing by, but a closer look
reveals the threatening situation in which
the wayfarers find themselves. Driven by
fears for the safety of their child, they
negotiate the perilous heights along a
narrow stone path, dangerously close to
the precipice, the depths of which can be
gauged from the scale of the tiny figures
in the distant valley. The travellers have
no eye for the beauty of nature, for it is all

they can do to concentrate on picking
their way across the rocks. They look
exhausted, especially the young mother,
whose head droops as she lets the ass
carry her and her child. The painter
emphasised the hardship of their journey
by depicting the ass's careful steps as it
seeks a foothold on the large rocks. It is
the minute rendering of the summery
landscape that actually focuses our atten-
tion on the perilous scene. In its composi-
tion and the poses of the figures, this
work displays a certain similarity to *The
Flight into Egypt* in an altarpiece by
Jacopo Bassano (fig.88),[2] which Els-
heimer could have seen on his way to
Venice. Bassano's representation differs
fundamentally from Elsheimer's port-
rayal, however, in its inclusion of three
young men who accompany the fugitives
and in the path taken by the wayfarers: a
safe enough road winding through the
landscape.

The present painting is closely related
stylistically[3] – as Andrews noted – to the
panels of the Petworth series, painted in
1605 (cat.no.21), and therefore could not
have been made much later. Its origin in
this period is confirmed by Pieter
Lastman's 1608 painting of the same
theme (now in Rotterdam),[4] which shows
a close dependence on Elsheimer's com-
position that would have required knowl-
edge of the painting itself (fig.146).
Lastman could have seen it during his
Roman sojourn, on a visit to Elsheimer's
studio. As far as we know, Lastman
returned to Holland before the winter of
1606, which gives us a *terminus ante
quem* for Elsheimer's *Flight into Egypt*.
Two repetitions of the picture, which
portray the landscape in a horizontal
format, testify to the interest taken in it
early on by Elsheimer's contemporaries.[5]

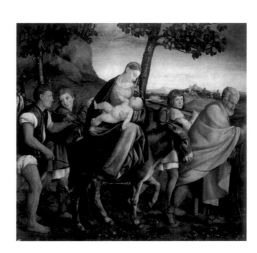

Fig.88
Jacopo Bassano, *The
Flight into Egypt*,
Bassano del Grappa,
Museo Civico

24 Mercury and Herse

Copper, 26.8 x 38.9 cm
Chatsworth, Devonshire Collection,
Chatsworth House Trust, Inv. PA64
(Frankfurt and Edinburgh only)

PROVENANCE Chatsworth, Duke of
Devonshire, 1761

LITERATURE R. and J. Dodsley, *London and its
Environs Described*, vol. II, London, 1761,
p.229 (Bril and Elsheimer); Waagen 1854,
vol.III, p.347 (Bril and Elsheimer); Andrews
1977, p.167, no.A 19 (Paul Bril); Andrews
1985, p.202, no.A 19 (Paul Bril); Pijl 1996,
p.228 (Bril and Elsheimer); Pijl 1998, p.664
(Bril and Elsheimer)

NOTES

1 Ovid *Metamorphoses*, II, lines 724–832.
2 Dittrich 2004, p.572.
3 Another oval format in Elsheimer's oeuvre,
in addition to *The Flight into Egypt* in Fort
Worth (cat.no.23) and *The Beheading of
Saint John the Baptist*, which has survived
in an engraving by Hendrick Goudt
(cat.no.28), is Elsheimer's painting of *Christ
on Gethsemane*, which was destroyed by a
fire in the Rotterdam Museum Boymans in
1864 (Bode 1883, p.289f.).
4 A. Emiliani, in exh. cat. Bologna 1962,
no.120; M. Chiarini, in Forence 1979,
p.439, no.P 1289.
5 R. and J. Dodsley, *London and its Environs
Described*, vol.II, London, 1761, p.229.

Mercury, the messenger of the gods,
sweeps down from the heavens and espies
the beautiful daughters of the king of
Athens – Herse, Pandrosos and Aglauros –
returning from the festival of Minerva with
flower-filled baskets on their heads.
Mercury instantly falls in love with Herse,
follows her home, and spends the night
with her.[1] The picture shows seven
women on a road that winds around the
foot of a high mountain with a city at the
top, in front of which stands a hill with the
temple of Minerva. The woman walking at
a slight remove from the others – she is
the only one who looks at the viewer – is
probably Herse, brought to the fore and
visually connected with Mercury in
heaven by an imaginary vertical line
running from her via the tower of the city
in the background straight up to the god.
The billy goats standing at the edge of the
road, which traditionally symbolise lust
(*luxuria* or *voluptas*),[2] refer to Mercury's
imminent amorous adventure.

The composition and technique can be
attributed without reservation to Paul
Bril. He created in the midst of the land-
scape a small stage, so to speak, for the
staffage, to be filled in by another hand.
The engraver Wenceslaus Hollar
(1607–1677) reproduced the scene –
featuring a group of women walking in an
outdoor setting – in an etching and named
Elsheimer as the inventor of the composi-
tion, which he had perhaps seen in the

collection of his employer Thomas
Howard (fig.89, cat.no. 56). The figures
correspond exactly to those of the present
painting, but this is not the case with the
landscape, which is visible in Hollar's
etching only in a small, oval section. It is
not known whether there was ever an
oval painting to which the etching corre-
sponded, or whether Wenceslaus Hollar,
taking the present painting as his exam-
ple, decided to focus on the group of
figures and reduce the amount of land-
scape visible in his etching. The latter is
probably the case, since no composition –
in the form of a copy or adaptation after
Elsheimer – corresponding to the etching
has yet surfaced. On the other hand, three
of the painter's works show that he also
used an oval format at times (cat.nos.23,
28).[3] A painting attributed to Jacob Pynas
in Florence shows the same group of
women,[4] as well as a few figures not
present in Hollar's etching which are in
fact present in Bril's landscape. This leads
to the supposition that the author of the
work in Florence knew Paul Bril's paint-
ing and perhaps, in view of Elsheimer's
importance, decided to include his group
of figures. As early as the eighteenth
century, the present painting was recor-
ded – possibly following older documen-
tation – as a collaborative work by Els-
heimer and Paul Bril.[5] Johann Faber
mentioned the possibility of collaboration
between the two artists, who were on
friendly terms, in 1627. Bril may be
considered the inventor of the landscape,
which can be dated to around 1605.
Elsheimer, as already established by
Waagen, might have created the group of
women for Bril's composition, which is
close in style to the figures in antique
dress of his *Il Contento* and *The Mocking
of Ceres* (cat.nos.25–27). If this is so, it is
the only surviving example of the collabo-
rative work – so far known only by tradi-
tion – that was produced by these two
artists.

Fig.89
Wenceslaus
Hollar,
*Mercury and
Herse*,
Frankfurt,
Graphische
Sammlung im
Städelschen
Kunstinstitut

25 Il Contento

Copper, 30.1 x 42 cm
Edinburgh, National Gallery of Scotland,
inv.no.NG 2312

PROVENANCE Rome, inventory of Elsheimer's
estate, 1610; (?) Rome, Collection of Cardinal
Odoardo Farnese (1615); Frankfurt a. M., Mr
Du Fay and heirs 1666–1734; Paris, Mr
Poullain 1780; Mr Langlier; Downton Castle,
Richard Payne Knight; W.M.P. Kincaid Lennox
(before 1953); acquired 1970

LITERATURE Sandrart 1675, p.161;
Weizsäcker 1936, pp.146ff., 346; Weizsäcker
1952, no.54 B; E.K. Waterhouse, 'Some Notes
on the Exhibition of "Works of Art from
Midland Houses"', *Burlington Magazine*, 95,
1953, p.306; Seilern 1955, p.56f.; D. Mahon
and D. Sutton, in exh. cat. London 1955, no.43;
F.G. Grossmann, in exh. cat. Manchester 1961,
no.158; Kuznetsow 1964, p.229f.; J. Held, in
exh. cat. Frankfurt 1966, no.42; Andrews 1971
(with bibliography); Hohl 1973, p.188;
Andrews 1977, p.28f., no.19; Andrews 1985,
p.27f., no.19; F. Cappelletti, in exh. cat.
London 2001 A, no.69; Baumstark 2005,
p.65ff.; Witte 2006

Fig.90
Adam Elsheimer, preparatory drawings for
Il Contento:
a) Paris, Musée du Louvre, Cabinet des Dessins
b) Edinburgh, National Gallery of Scotland
c) Paris, Musée du Louvre, Cabinet des Dessins

This subject, seldom treated in painting,
derives from antique fables (Lucian) and
writings of the Renaissance (Leon Battista
Alberti, Antonio Francesco Doni). How-
ever, the stimulus for Elsheimer's inven-
tion – recognised by Kuznetsow – was the
Spanish picaresque novel *Guzman de
Alfarache*, which was published in 1599
by Mateo Alemán in Madrid and ap-
peared in an Italian translation in 1606 in
Venice. The narrative set out in Alemán's
novel tells of Jupiter's complaint that the
people on Earth are irresponsible and
self-indulgent, worshipping only Con-
tento, the god of contentment and happi-
ness, and neglecting the other gods.
During a festival he bids Mercury to ab-
duct the god of happiness and to replace
him with his twin brother, Discontento,
dressed up in Contento's clothing.

The picture shows Jupiter – framed by
the columns of a temple – sweeping down
on a cloud and ordering Mercury to ab-
duct Contento. Hurrying past and protest-
ing are people from all walks of life –
including a naked courtesan carrying a
basket of pigeons – who try to prevent the
kidnapping by holding on to Contento's
clothes. Elsheimer chose to portray the
alternative also mentioned by the author
of the novel, namely that Contento could
have been a goddess. In the background a
great number of people are enjoying
sports, dancing and games. The members
of an emperor's retinue have assembled
inside the sumptuously decorated temple;

the tapestries display the double eagle,
the insignia of the Habsburg monarchs,
its connection of the ancient fable with the
modern age perhaps intended as a criti-
cism. That the moral claims of the theme
also permitted a Christian interpretation
is evidenced by several derivatives of the
painting, with scenes of Adam and Eve or
the Fall of Man in the background.[1]
Sandrart accurately described the paint-
ing, which he described as a masterpiece
when he saw it in Frankfurt in 1666, as
the abduction of Contento.

The theme, for which there were no
precedents in painting, must have pre-
sented Elsheimer with a true challenge.
This could only have been a commis-
sioned work, though no documents have
been found to substantiate this.
According to Witte's findings, the person
who commissioned *Il Contento* was
probably Cardinal Odoardo Farnese, who
– after the completion of the Galleria
Farnese by Annibale Carracci in 1601–04
– erected behind that building a *palaz-
zetto* for a collection of paintings that
would reflect his personal tastes.[2] It is
certainly no coincidence that for this
painting by Elsheimer (the only one in his
oeuvre to be thus distinguished) three
preparatory studies have been preserved
– there were possibly others – in which he
experimented mainly with the arrange-
ment of the figures in the foreground
(fig.90a-c, cat.nos.39–41). He was evi-
dently thinking of the friezes on antique

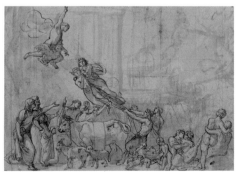
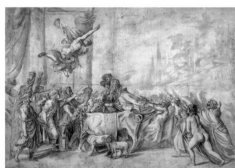
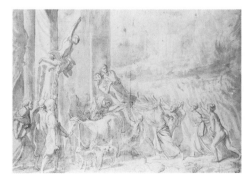

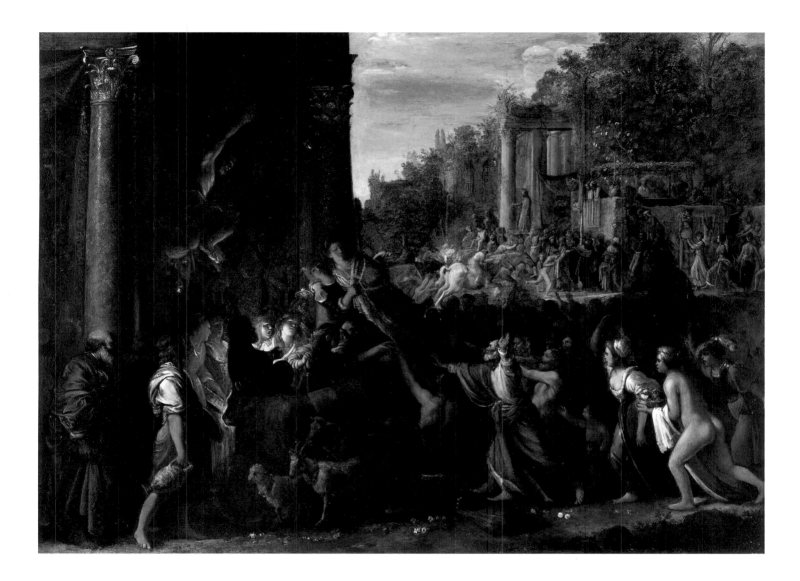

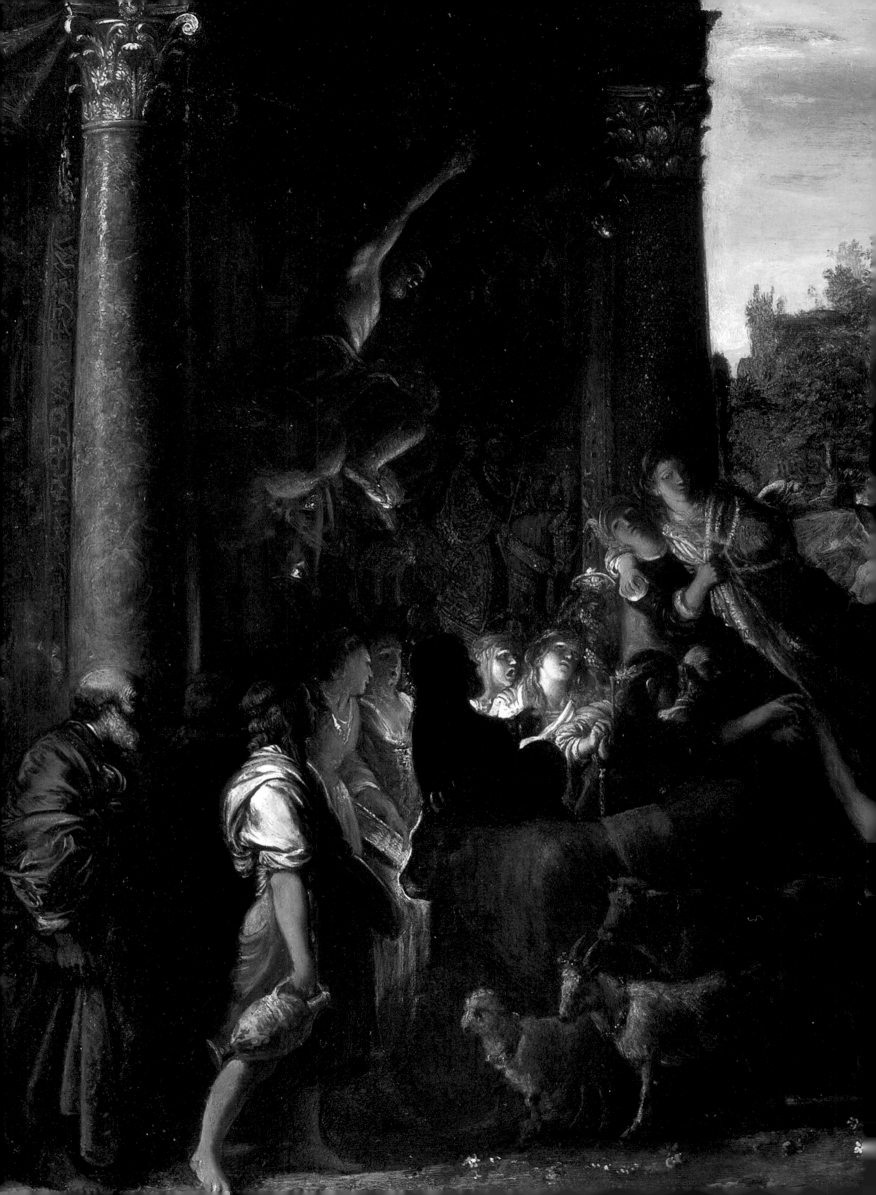

sculpture and the reliefs on Roman sarcophagi,[3] though he could also, as Andrews assumes, have been inspired by a engraving made on two plates previously thought to be by Cornelis Cort after Lambert Lombard, in which a Roman procession – with sacrificial animals and wildly gesturing participants – is depicted in similar fashion.[4]

The preliminary designs are pen and wash drawings – two in the Cabinet des Dessins in the Louvre and one in Edinburgh – which reveal various stages in the development of the composition.[5] The first drawing (cat.no.39), which consists mostly of contours drawn in pen and ink, portrays Jupiter flying down from heaven with his attribute, the eagle, but still without the hierarchic frame of columns. With his left hand he points at Mercury, who floats towards him holding Contento by the arm, which angry people naturally try to prevent. In the right foreground, children and partially naked amorous couples disport themselves, while on the left, priests and their helpers prepare to kill the sacrificial animals.

The second design (cat.no.40) was executed with more precision. Not only is it more detailed but it has also gained a few figures , particularly on the side of the priests, who hope to change the mind of

Mercury, bent on the abduction, with the help of garlanded virgins and an altar with sacrificial fire. But the amorous scenes sketched on the right in the first design, which Elsheimer perhaps borrowed from Agostino Carracci,[6] have been replaced with a new group of figures that includes a striking female nude. Jupiter, through the architecture behind him, has clearly been upgraded in stature. Elsheimer seems to have taken antique statues as examples for the robed figures and the line-up of sacrificial animals.

The third preparatory study (cat.no.41) is even closer to the composition of the final painting, although here, too, several figures are still missing. In the case of the naked woman rushing into the scene from the right, carrying her clothes, her companion – a priest or scholar – has been eliminated, perhaps because his presence in this context caused offence. In the painting, his place is taken by a soldier. This representation proves that there must have been other studies, and presumably also consultations with the patron, to whom these sheets were shown. But the significance of this sheet, with its cursorily applied washes, lies not so much in the depiction of detail as in the intention of the artist to clarify the

flow of light and the distribution of the chiaroscuro passages. These three drawings offer a unique glimpse of Elsheimer's working methods preparatory to painting. In two of the designs,[7] the figures' contours have been traced with a stylus, a method used to transfer a composition to another sheet or, in printmaking, to a copper plate. As ascertained by Andrews, Elsheimer adopted this method from engravers, using it to transfer his drawing or parts thereof to the picture's copper support after covering it with a light grey ground. Indeed, a grey underpainting is demonstrable in most of Elsheimer's paintings.

The dating of *Il Contento* can be inferred from its connection with Alemán's novel, the Italian translation of which appeared in 1606, which is therefore considered a *terminus post quem*. Andrews proposes a dating to around 1607 on stylistic grounds, although the painting was never completely finished. We cannot rule out the possibility that Elsheimer had begun to make studies for this composition earlier; his patron, after all, might have introduced him to the theme as soon as the original Spanish book was published. A painting by the Antwerp artist David Teniers the Elder (fig.91),[8] who worked for a time in Rome

Fig.91
David Teniers
the Elder,
*Saints Paul and
Barnabas at
Lystra*,
London art market
1992

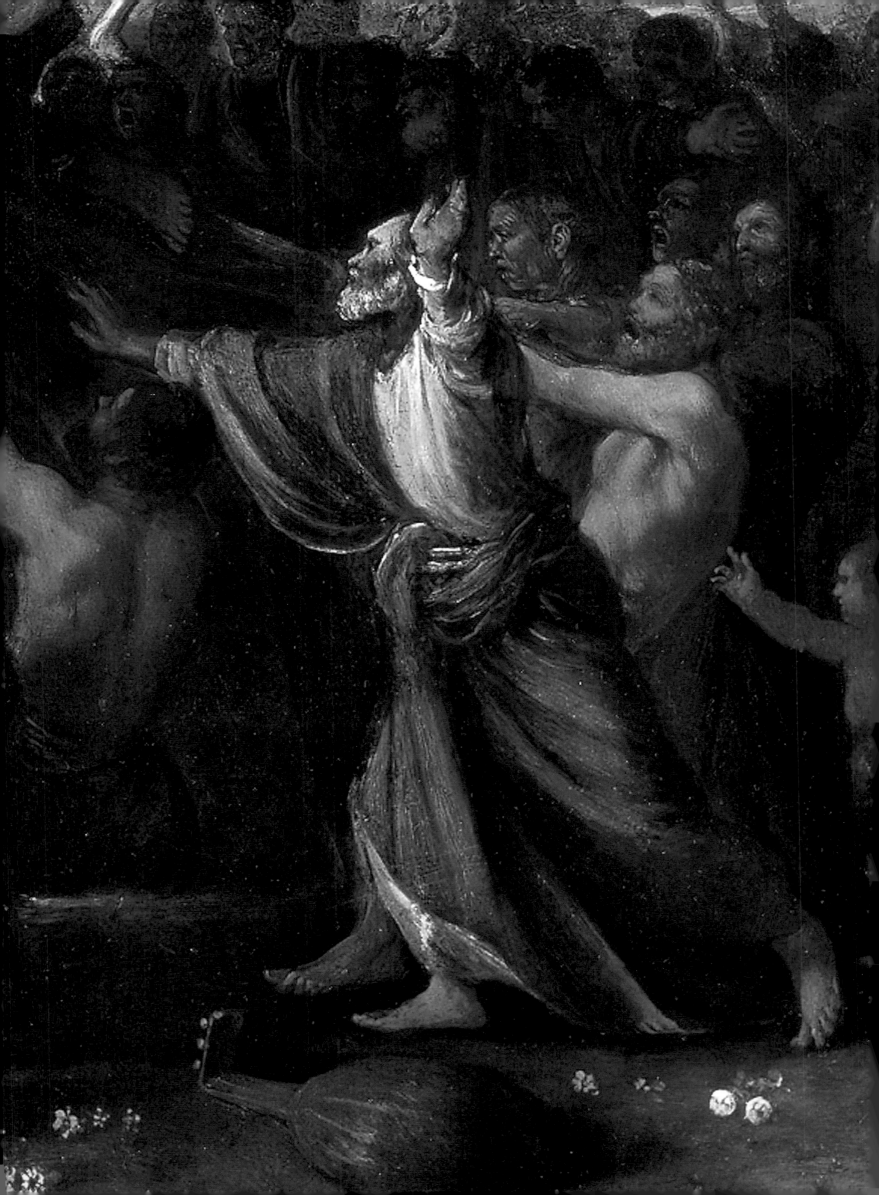

as a pupil in Elsheimer's studio, displays a number of motifs that occur in Elsheimer's preliminary drawing for *Il Contento* preserved in Edinburgh (cat.no.40), but which do not appear in the final painting. These include the decorated sacrificial bull with a cow standing behind it, a woman in a low-cut dress approaching from the right and carrying a bowl in her left hand, and a youth wearing a laurel wreath, carrying a jug and a bowl, adopted in reverse from Elsheimer's example. This proves that David Teniers the Elder studied the drawing closely, and – assuming he did not become acquainted with it later on in Antwerp, which is not very likely – could already have seen it in Rome in his master's studio. Teniers also borrowed elements from Elsheimer's *Stoning of Saint Stephen*, painted around 1603 (cat.no.19), as well as from the small panels in the Petworth series (cat.no. 21).[9] Considering that Teniers returned to Flanders at the end of 1605,[10] the only explanation could be that Elsheimer was already working on his designs for *Il Contento* in that year.

When Elsheimer died in December 1610, the painting was found unfinished in his studio – 'a copper on which is painted the god of contentment with many figures, unfinished' ('Un Rame dove è dipinto Il dio del Contento con molte figure non finito') – which means that it must never have been delivered to the person who commissioned it. The passages obviously completed by another hand – this involves a number of figures in the procession – were evidently painted soon after the winding-up of Elsheimer's estate. There are numerous copies and variants, including a drawn copy of the unfinished painting,[11] a drawing dated 1615, which, according to its inscription, was owned by Cardinal Odoardo Farnese,[12] a signed and dated (1617) gouache by Johann König in Munich (fig.162), as well as a copy attributed to Nicolaus Knüpfer in the Alte Pinakothek in Munich.[13] In the 1620s Rubens, who could have seen Elsheimer's unfinished picture in Rome, painted a *Sacrifice to Mars and Venus* (London), which includes a partial copy of *Il Contento*.[14] This raises the question as to whether Elsheimer's original was then in Antwerp. It was long considered lost, until Waterhouse rediscovered it in Downton Castle in 1953.

NOTES

1 Andrews 1971, p.3; Saxton 2005, pp.143, 144.
2 For more details, see Witte 2006.
3 Hohl names as a possible source the *Suovetaurilia* relief in the Louvre (MA 1096), which had been known in Rome since the sixteenth century. Hohl 1973, p.188; Bober/Rubinstein 1986, no.190; Witte 2006.
4 Cornelis Cort (rejected) after Lambert Lombard, *Roman Procession*, Hollstein, vol.V, nos.190, 191; *The New Hollstein*, under Cort, no.R 34.
5 Hohl wrongly disputed the authenticity of the preliminary drawings found by Andrews in Paris. Andrews 1977, nos.43, 45.
6 Andrews mentions Agostino Carracci's engraving *Mutual Love* (*Il reciproco Amore*; Bartsch 119; DeGrazia Bohlin 1979, no.191). Andrews 1971, p.9, no.1.
7 Andrews 1977, nos.44, 45.
8 David Teniers the Elder, *Paul and Barnabas in Lystra*, panel, 54 x 81 cm; Duverger/Vlieghe 1971, pp.44, 77, fig.30; sale London (Sotheby's), 1 April 1992, lot 34.
9 Van Gelder/Jost 1967, p.147f.
10 Duverger/Vlieghe 1971, p.19.
11 Present whereabouts unknown, formerly Utrecht, Mrs Ingrid van Gelder-Jost (Andrews 1971, fig.6).
12 On this subject, cf. Andrews 1971, p.19f.
13 R. van der Heyden, in *Alte Pinakothek München* 1983, p.275; Saxton 2005, p.142, no.48.
14 London, Courtauld Institute Gallery, cf. Seilern 1955, p.56f., no.30 (shortly after 1620); Andrews dates Rubens's *Contento* copy to around 1630, but points out that Rubens's lost *Rape of Proserpina* – known only through an engraving by Pieter Soutman, which he presumably made before 1620 – presupposes knowledge of Elsheimer's painting. Andrews 1971, p.20.

26 The Mocking of Ceres

138

Copper (silvered), 29.1 x 24 cm. Old inscription on the back: *Adam Elsh(ei)mer pinxit Rom(ae).* Milwaukee, Dr Alfred and Isabel Bader Collection

PROVENANCE (?) Leiden, Gerard Dou; (?) Kensington, Collection of George II; Gateshead, England, H.G. Binder Collection; London, private collection (before 1977); sale Munich (Neumeister), 7 December 1988, lot 406 (follower of Elsheimer); London, private collection; Billingshurst sale (Sotheby's Sussex), 20 May 1991, lot 123 (follower of Elsheimer); acquired 1991

LITERATURE Mahon 1949, p.350; Andrews 1977, p.152; A.-M. S. Logan, *The 'Cabinet' of the Brothers Gerard and Jan Reynst*, Amsterdam, 1979, p.82, no.94; Andrews 1985, p.188; Klessmann 1997, pp.239–48; Klessmann 2004, pp.59–62; Seifert 2005 A, p.103f.

NOTE

1 I am grateful to David de Witt in Kingston, Ontario, for providing me with a draft for a catalogue entry. I am also indebted to Alfred Bader and Emilie Gordenker for their verification of the provenance.

See the following catalogue entry.[1]

27 The Mocking of Ceres

Copper, 29.5 x 24.1 cm
Madrid, Museo del Prado, inv.no.2181

PROVENANCE Antwerp, Cornelis van der Geest
Collection (after 1611?); Antwerp, Peter Paul
Rubens Collection (before 1626); Rubens's
estate (1640); Philip IV of Spain (before 1645);
Madrid, Alcazar (1686)

LITERATURE Sandrart 1675, p.161; Bode
1883, p.294; Drost 1933, p.80; Weizsäcker
1936, p.183; Weizsäcker 1952, no.42; H.
Möhle, in exh. cat. Berlin 1966, no.12; exh. cat.
Frankfurt 1966, no.32; Waddingham 1967,
p.47; Krämer 1973, p.158f.; Andrews 1977,
no.23; Andrews 1985, no.23; Muller 1989,
p.101, no.32; Shawe-Taylor 1991, pp.207–19;
Sumowski 1992, p.187; exh. cat. Madrid 1992,
no.28; Klessmann 1997, p.241; exh. cat.
Munich 1998, no.266; K. Lohse Belkin, in exh.
cat. Antwerp 2004, no.4; Klessmann 2004,
p.59f.

Ceres, the goddess of fertility and agriculture, goes in search of her daughter Proserpina, who has been abducted by Pluto, the god of the underworld. In the course of her search, she comes to a hut at night, where she asks a woman by the name of Metanira for a drink. As she greedily empties the drinking-pot, a boy pokes fun at her. Angered by his insolence, the goddess turns the impertinent boy (called Abas or sometimes Stellio) into a lizard.[1]

Elsheimer portrayed the incident as a nocturnal scene, lit by various sources of light. In the middle of the picture stands Ceres, wrapped in a red cloak; she drinks from a pot, which she holds to her mouth with both hands. Her monumental pose resembles that of an antique sculpture, according to Weizsäcker an Attic statue of Athena that was formerly on display in the Palazzo Giustiniani in Rome (now in the Vatican Museum), which Elsheimer could have seen there.[2] Elsheimer's interest in archaeology reveals itself in some of his other paintings as well (cat.nos.19, 32). The torch laid across the wagon wheel next to Ceres refers to the fact that it was lit on Mount Etna at the

beginning of her wanderings. The moon and the stars, visible through the trees, help Ceres to recognise the changes from day to night. Visible in the background in the light of a fire, a peasant with his cattle watching a woman milking a cow refer to Ceres as the goddess of fertility and to her life-giving powers, as do the farming implements and the luxuriant vegetation behind her. The wagon parts lying on the left may perhaps be seen – as Shawe-Taylor suggests – as an allusion to the wrongdoing of Pluto, who abducted Proserpina to the underworld in a golden chariot pulled by four black horses,[3] and the dead branches of the tree above them could be a reference to the realm of the dead.

Elsheimer was the first to introduce this unusual theme to painting. Furthermore, he gave it a multi-layered interpretation that goes far beyond its simple presentation in the 1606 etching by Antonio Tempesta (fig.92).[4] The old woman has left her hut with a candle in her hand, in order to get a good look at the noble visitor. With her left hand she restrains the rambunctious boy, who stands completely naked, pointing with outstretched arm at the goddess. The depiction of these two women, whose meeting is disturbed by the boy, can be interpreted – according to Sello – on another level, namely as a portrayal of the three ages of life: childhood, youth and old age. It is owing to the light shed by the old woman's candle that Ceres becomes the target of Stellio's mocking words, which are underscored by his provocative pose. His floppy limbs and the reptilian smoothness of his body foreshadow his imminent metamorphosis into a lizard,[5] a creature that lives in the earth and belongs to the lower orders in the realm of Ceres. In a gouache made as a preparatory study for this painting, Elsheimer experimented with the representation of the completed metamorphosis, in which the peasant woman standing next to the

Fig.92
Antonio Tempesta,
Ceres, from
*Metamorphoseon
Ovidianarum*,
Amsterdam 1606

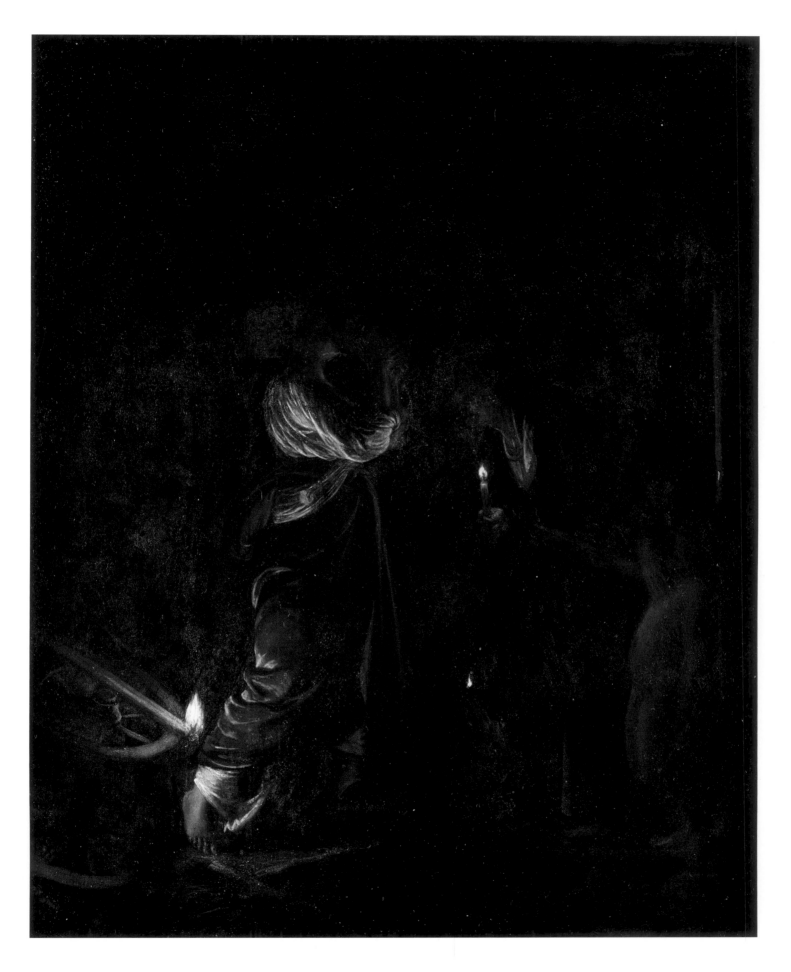

26

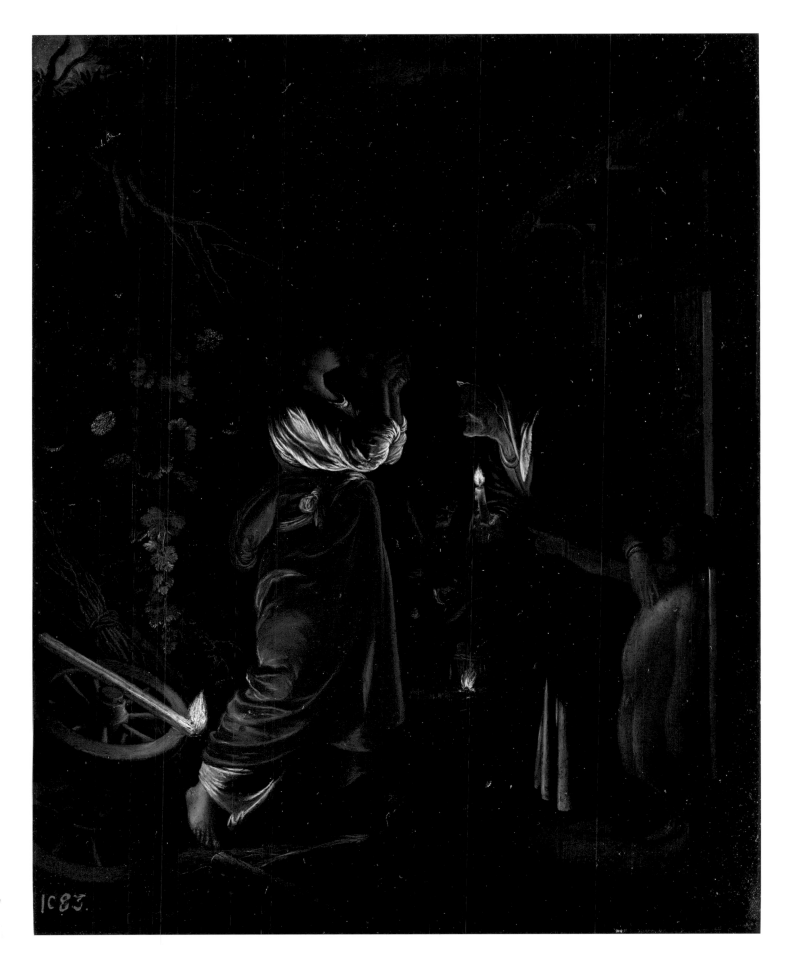

27

goddess points with horror at the lizard crawling on the ground before her (fig.93, cat.no. 43).[6]

Elsheimer had no precedents to draw upon for his painterly treatment of this theme from Ovid's *Metamorphoses*, and thus prepared it carefully in preliminary drawings. A gouache in Hamburg (fig.94, cat.no.42) shows his first draft: a nocturnal scene in which the goddess Ceres, sitting on the right in the corner, quenches her thirst like a peasant, while holding the burning torch in her lap, which seems rather risky. The other two figures of importance, the old woman offering her a drink and the impertinent Stellio, recede into the background. This version fails to convey the point of the story, which is undoubtedly why the artist found it unsatisfactory. For another attempt Elsheimer adopted the technique of etching, as a consequence of which he reversed the composition, assigning to the now-standing Ceres a central position

(fig.95).[7] The torch, henceforward lying on a wagon wheel at the left, illuminates the goddess as if she were a piece of sculpture, while the other figures benefit from two other sources of light. Looking closely at this etching – of which, significantly, only one impression is known (in Hamburg) – the coarse and hasty doodles of the etching needle show that Elsheimer was simply experimenting, with no other goal in mind than to find a solution to a painterly problem. He largely adopted the composition tested in the etching for his final painting.

The Mocking of Ceres – which according to Johann Faber caused a stir in Rome,[8] which must have been encouraged by Hendrick Goudt's masterly etching of 1610 (fig.96, cat.no.51) – is unique, even within Elsheimer's own oeuvre, and cannot easily be compared with his other paintings. The depiction of trees and plants is similar to that seen in his landscapes of *Apollo and Coronis* and the

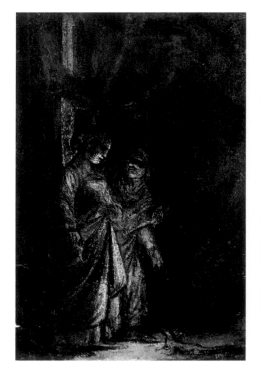

Fig.93
Adam Elsheimer, *Ceres Turns the Mocking Boy into a Lizard*, Vaduz, Wolfgang Ratjen Foundation

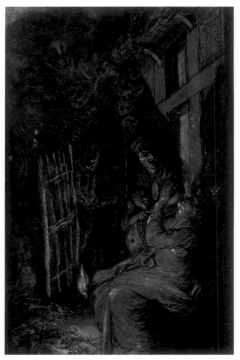

Fig.94
Adam Elsheimer, *The Mocking of Ceres*, Hamburg, Kunsthalle

'large Tobias' (cat.nos.31, 34), both of which can probably be dated to around 1607. The old woman, portrayed in profile, appears again – with only slight changes – in his painting of *Jupiter and Mercury in the House of Philemon and Baucis* in Dresden (cat.no.35). This seems to have been more or less finished by 1608, if we accept Andrews's supposition that Rubens saw the painting before his departure from Italy. According to convincing evidence put forward by Waddingham in 1967, a signed and dated picture by the Lindau painter Jakob Ernst Thomann von Hagelstein, *Judith Showing the Head of Holofernes* (fig.144), betrays a clear stylistic dependence on Elsheimer's *Mocking of Ceres* and therefore constitutes an important clue as to its dating.[9] The date on Thomann's painting was hitherto read as 1609 or 1607. The most recent research, however, carried out by Seifert, has yielded the date 1605, providing a *terminus ante quem* for the origin of Elsheimer's *Ceres*. The painting must therefore be seen, within the context of the artist's development, in the imme-

diate proximity of *Il Contento* (cat.no.25), which it resembles as regards the modelling of the figures and their antique dress.

The Mocking of Ceres is known from numerous versions originating as early as the seventeenth century.[10] Among these, the present painting – which was to be found in the collection of Peter Paul Rubens and, after his death, in that of Philip IV of Spain – must be assigned first place. Nevertheless, the authenticity of the painting, which is smoother in its handling than other works by Elsheimer, has long been a matter of dispute, and Andrews – like Drost and Weizsäcker before him – excludes it from Elsheimer's oeuvre. Their grounds, however, include the differences – both in detail and in the manner of painting – to the engraving by Hendrick Goudt, whose graphic reproductions are always very reliable. The most striking difference is the head of the boy, depicted in profile, who looks at the viewer in both Goudt's engraving and Elsheimer's etching. Examination of the painting under infrared light, recently carried out in Madrid,[11] revealed old

damage at the right edge of the picture: lacunae in the paint surface, which strongly affected the boy's head, restored later on. It is quite possible that his head was originally turned towards the viewer, as it is in the engraving. When and by whom the restoration was carried out can no longer be ascertained. If these findings argue in favour of this version's being the original, they still do not dispel the doubts raised by the manner of painting, which is cursory in places, a trait not otherwise seen in Elsheimer's work. This is true of the woman's hand, attempting to restrain Stellio, and also of the boy's body and the wagon wheels lying on the ground.

The Mocking of Ceres in the collection of Alfred and Isabel Bader (cat.no.26), a painting that corresponds exactly in composition and format to the one in the Prado, is very difficult to judge because of the heavy damage it has sustained. When it surfaced about thirty years ago on the English art market, Andrews took it to be an unfinished copy, in which he discovered passages of exceptionally high quality, as well as corrections which he

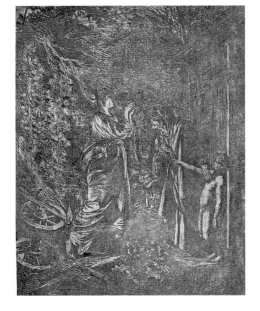

Fig.95
Adam Elsheimer,
The Mocking of Ceres,
Hamburg,
Kunsthalle

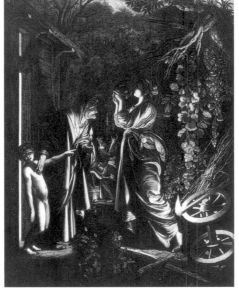

Fig.96
Hendrick Goudt,
The Mocking of Ceres,
Frankfurt, Graphische Sammlung
im Städelschen Kunstinstitut

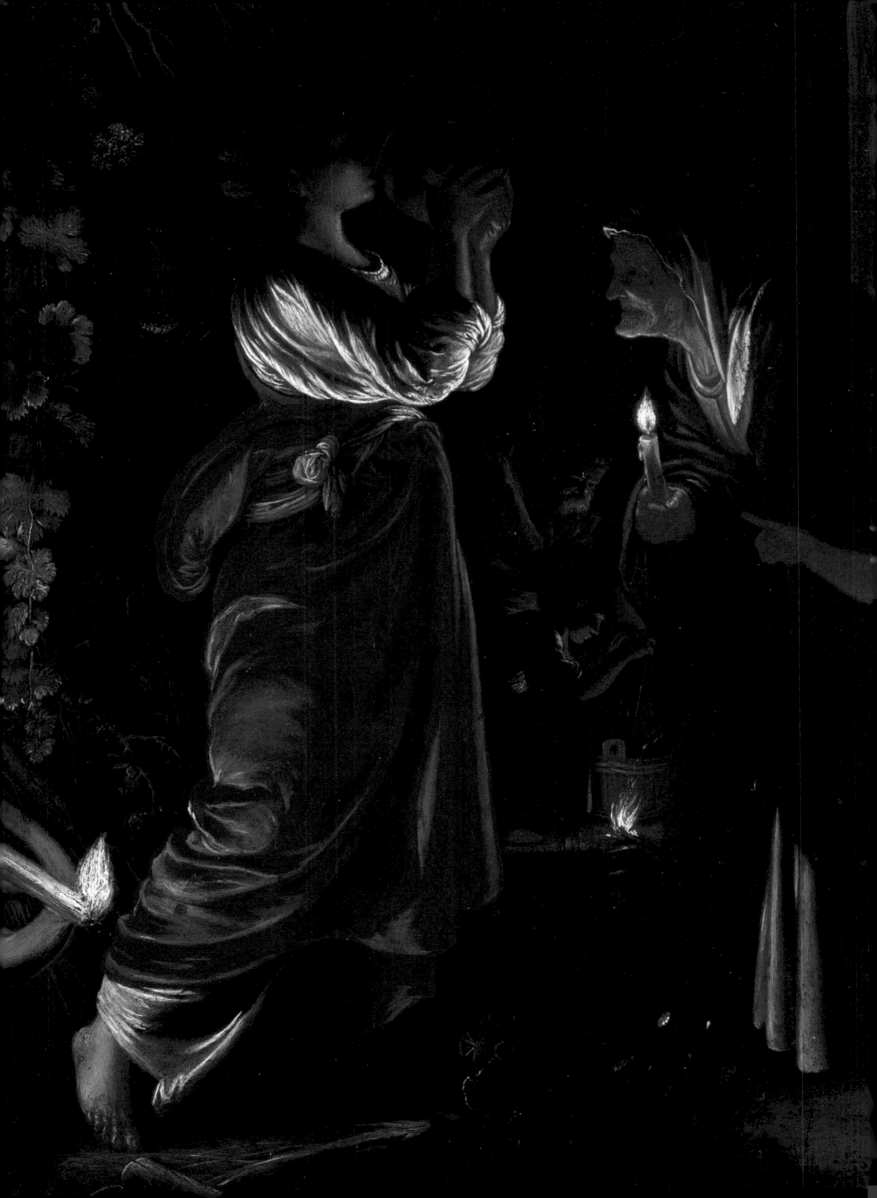

found inexplicable at the time.[12] Research carried out in 1991 at the owner's behest into the technical aspects of the painting, whose paint surface had been destroyed in places (apparently by fire), led to the conclusion that it cannot be a copy, since clearly recognisable pentimenti show it to be Elsheimer's original version (fig.97). The changes reveal that Stellio was initially painted in a transitional pose. He was supposed to tiptoe into the picture from the right, one leg outstretched, moving towards the goddess. This movement was accompanied by the glance directed at Ceres by Stellio, whom the painter planned to depict in profile. His right foot was approximately at the place now occupied by the foot of the old woman. The motif of the boy sneaking into the scene was then eliminated in favour of a standing, deliberately provocative pose. Further pentimenti are to be found in the contours of the woman's back and in the dress of Ceres, where the cloth slung around her waist was later knotted. These are changes that

reflect stages of development during the painting's execution – corrections undertaken during the working process, which only the maker of the painting could conceive and carry out. The painting, which like others by his hand is painted on a silvered copper plate, has an old inscription on the back, 'Adam Elsh(ei)mer pinxit Romae', which certainly dates from the seventeenth century (fig.98).[13] Further examination of the inscription has yet to be undertaken, but it could have been written by the hand that was responsible for the inscription on the back of *Aurora* (cat.no.29) and was perhaps applied when the painting was in the possession of Hendrick Goudt.

NOTES

1 Ovid *Metamorphoses*, V, lines 446–461.
2 Rome, Vatican Museum: *Athena*, marble, Attic, copy from the time of imperial Rome.
3 Shawe-Taylor 1991.
4 Tempesta, *Metamorphoseon Ovidianarum*, Amsterdam, 1606, no.48.
5 L. Stauch, in *RDK* IV, col. 932.
6 Vaduz, Wolfgang Ratjen Foundation; Andrews 1977, no.51.
7 Hind 1926, p.24; Andrews 1977, no.56; Andrews 1985, no.56.
8 Faber 1628, p.748; Andrews 1977, p.153.
9 Waddingham 1967.
10 Cf. Weizsäcker 1952, p.41f.; Andrews 1977, p.153.
11 Undertaken in 2004. I am greatly indebted to Alejandro Vergara and Teresa Posada Kubissa for allowing me to take part in the research done on the painting in the Prado's workshop, and for kindly providing the photographic material.
12 Andrews 1977, p.152.
13 Weizsäcker compared the inscriptions on the backs of other paintings and recognised the same words and writing seen in the inscriptions on the back of the *Aurora* in Brunswick, the *Latona* in Cologne and the *Flight into Egypt* in Munich (cat.nos.29, 33, 36). Weizsäcker 1936.

Fig.97
Adam Elsheimer,
The Mocking of Ceres
(diagram of the pentimenti), Milwaukee,
Dr Alfred and Isabel
Bader Collection

Fig.98
Adam Elsheimer,
The Mocking of Ceres
(inscription on the back), Milwaukee,
Dr Alfred and Isabel
Bader Collection

Detail 27

28 The Beheading of Saint John the Baptist

Copper, 24.5 x 20 cm
Mr and Mrs Edward D. Baker

PROVENANCE Vienna, private collection; sale
Vienna (Dorotheum), 5 October 2005, lot 405
(circle of Elsheimer)

LITERATURE On Elsheimer's original:
Andrews 1977, p.162, under no.48; Andrews
1985, p.199, under no.48; Baldriga 2002,
p.181f.

The preacher John the Baptist, impris-
oned by Herod Antipas, was executed as
the result of a promise made by the king
to his stepdaughter Salome (Matthew
14:3–11 and Mark 6: 21–28). The present
painting, a copy of a lost work by
Elsheimer, shows Salome standing next
to the body in a dark room lit only by a
torch. She accepts the head of the mur-
dered man on a dish; behind her stands
the executioner, his upper body naked,
holding his sword.

An engraving by Hendrick Goudt
which bears the monogram HG
(cat.no.49), as well as that of Elsheimer

(AE), shows the composition of the lost
painting in oval format and reversed. It
was Goudt's customary practice to re-
verse the image, a characteristic of all the
engravings by his hand. The figures
themselves also prove, however, that the
composition of the original was the other
way around. In the engraving, the officer
supervising the execution wears his
sword, which is normally worn on the
left, on the right; similarly, the execution-
er, contrary to custom, holds his sword in
his left hand. Goudt's engraving, which is
of lesser quality than his other, larger
works, appears to have been the first one
he made in Rome after the work of his
master.[1] In preparation for his painting,
Elsheimer made a preliminary design in
gouache, in which he mainly sought to
experiment with the contrasts inherent in
nocturnal illumination (fig.99, cat.no.44).
The drawing, which has one more figure
than the painting, shows a man holding
the head of John the Baptist and posing
with one foot on the decapitated body.
Elsheimer eliminated this brutal motif
and replaced it with the figure of an
officer, seen from the back, which pushes
the presentation of the head to Salome to

the middle plane. The splendidly dressed
officer in rear view is reminiscent of his
counterpart in *The Questioning of the Jew*
in Elsheimer's *True Cross Altarpiece*
(cat.no.20c).

The copies of the painting that have
surfaced so far (fig.100), as well as the
1646 etching by Wenceslaus Hollar, are
all based – with one exception – on the
engraving by Hendrick Goudt. The endur-
ing admiration for Elsheimer's composi-
tion is evidenced by a 1732 painting by
Adam Oeser, *The Artist in his Workshop*
(Weimar), in which a seventeenth-century
copy of Elsheimer's representation (cop-
per, 65 x 52 cm) has been inserted into
the panel standing on the easel, produc-
ing a picture within a picture.[2]

The present painting – an unreversed
though rectangular copy, which recently
surfaced at a sale in Vienna – helps us to
visualise the connection with Elsheimer's
lost original, which appears to be related
in its figural conception to both *Il Con-
tento* (cat.no.25) and *The Mocking of
Ceres* (cat.no.27). Elsheimer's design is
closely linked in terms of style to his
gouache of *Ceres* (cat.no.42), which can
be dated to around 1605.

NOTES

1 Seifert, in his contribution to this catalogue,
 points out the existence of two states of the
 engraving and an artist's proof.
2 Weimar, Staatliche Kunstsammlungen, no.G
 33; other copies are to be found in
 Copenhagen (Statens Museum, no.559,
 copper, 14.7 x 10.8 cm), England (private
 collection, this fact kindly communicated by
 Emilie Gordenker) and formerly in the
 collection of Mrs Frieda Greiner in Leonberg
 near Stuttgart, Germany (72 x 70 cm).

Fig.99
Adam Elsheimer, *The Beheading of Saint John
the Baptist*, Chatsworth, Trustees of the
Chatsworth Settlement

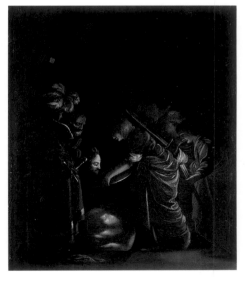

Fig.100
Copy after Adam Elsheimer, *The Beheading of
Saint John the Baptist*, Copenhagen, Statens
Museum for Kunst

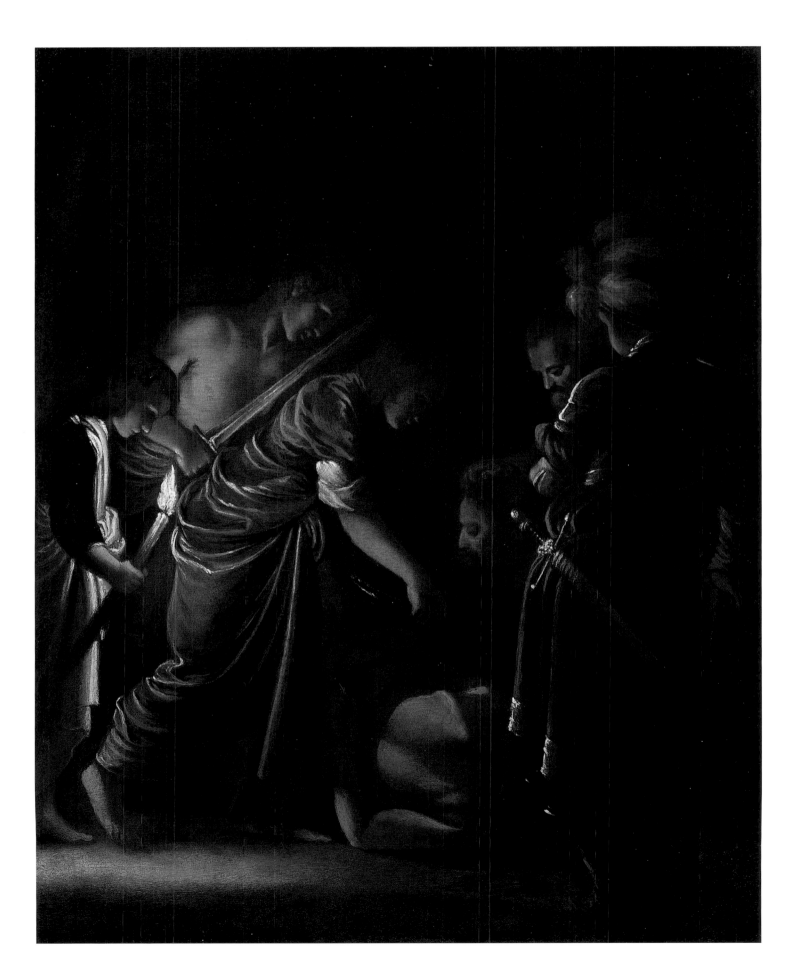

29 Aurora

Copper, 17 x 22.5 cm. Inscribed on the back:
Adam Elsehimer fecit Romae.
Brunswick, Herzog Anton Ulrich-Museum,
inv.no.550

PROVENANCE Utrecht, Hendrick Goudt
(1611–1648?); Antwerp, Diego Duarte Collec-
tion (1683); before 1737 in the gallery of
paintings at Salzdahlum; since 1815 in the
ducal museum at Brunswick

LITERATURE Sandrart 1675, pp.161, 180; C.N.
Eberlein, *Verzeichniß der Herzoglichen Bilder-
Galerie zu Salzthalen*, Brunswick, 1776,
p.104; Bode 1883, p.282; Drost 1933, p.104;
Weizsäcker 1936, pp.246–49; Weizsäcker
1952, no.59; A. Emiliani, in exh. cat. Bologna
1962, p.314, no.121; exh. cat. Frankfurt 1966,
p.37, no.39; K. Nicolaus, 'Elsheimers "Aurora"
im Lichte naturwissenschaftlicher Unter-
suchungen', *Maltechnik/Restauro*, 80, 1974,
pp.98–106; Adriani 1977, p.2; Andrews 1977,
p.148, no.18; Andrews 1985, p.183, no.18;
Klessmann 1987, pp.158–71; Jacoby 1989,
p.112ff. (with bibliography); P. Cavazzini, in
exh. cat. London 2001 A, no.80; Klessmann
2006

The traditional title of this work can be
traced to the inscription on an engraving
(fig.101, cat.no.53) made in 1613 by
Hendrick Goudt after this painting, which
was in his possession at the time. It shows
a view from a wooded hill overlooking the
Roman Campagna lit by the rising sun.
The building on the right recalls the Villa
of Maecenas in the Anio Valley below
Tivoli.[1] Elsheimer recorded the same view
of the valley in a pen and ink drawing,
which shows a mule train being led
across the ridge of the hill (fig.102),
presumably a study from nature which he
later used for the painting.[2] The painting
was begun as a history piece, but this idea
was abandoned for unknown reasons
before completion; as far as we know, it is
the only work to which Elsheimer made
substantial changes in the thematic
conception. Knut Nicolaus discovered the
first version with the help of infrared
reflectography (fig.103, 104),[3] making it
possible to identify its subject: the lovers
Acis and Galatea hiding at the edge of a
wood during their flight from the one-
eyed giant Polyphemus.[4] The artist decid-
ed to eliminate the group of figures he
had already finished painting in the left
foreground and to cover them with a dark
knot of trees. This correction clearly

displays the hand of Elsheimer, which
means that he painted over this passage
himself and that *Aurora*, in its present
state – apart from the figure walking on
the left – can be considered an original
and homogeneous landscape painting
without additions by another hand.

Elsheimer decided against a new
conception with figures. This part of the
picture, which old damage and retouches
make extremely difficult to judge, was
probably left unfinished, as happened
with other of the painter's works.[5] It has
been suggested – wrongly and confusingly
– that another hand was involved. The
shepherd emerging from the darkness
was not painted by Elsheimer. This figure
(together with another one, half covered),
rendered on a considerably smaller scale
than those in the first version, were
probably added later on in Holland by
Hendrick Goudt, who must have been an
eye-witness to Elsheimer's change of
plan. When producing the engraving in
1613, Goudt abbreviated the view in the
painting at the top and on the left-hand
side by approximately the width of the
added figure. Perhaps he lacked the
courage to take responsibility for his own
additions to the painting. By giving the
engraving the title of *Aurora*, he steered

Fig.101
Hendrick Goudt,
Aurora,
Frankfurt,
Graphische Sammlung
im Städelschen
Kunstinstitut

Fig.102
Adam Elsheimer,
*Large Campagna Landscape
with a Mule Train*,
Berlin, Staatliche Museen,
Kupferstichkabinett

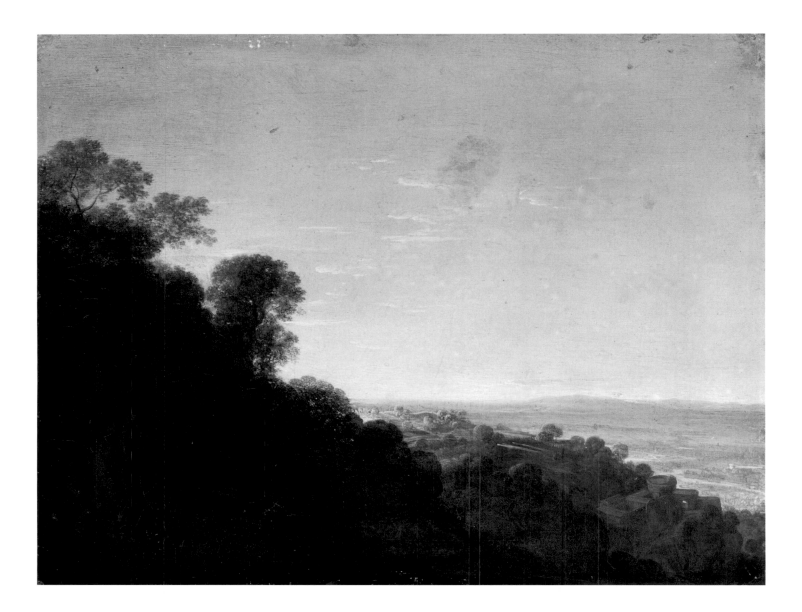

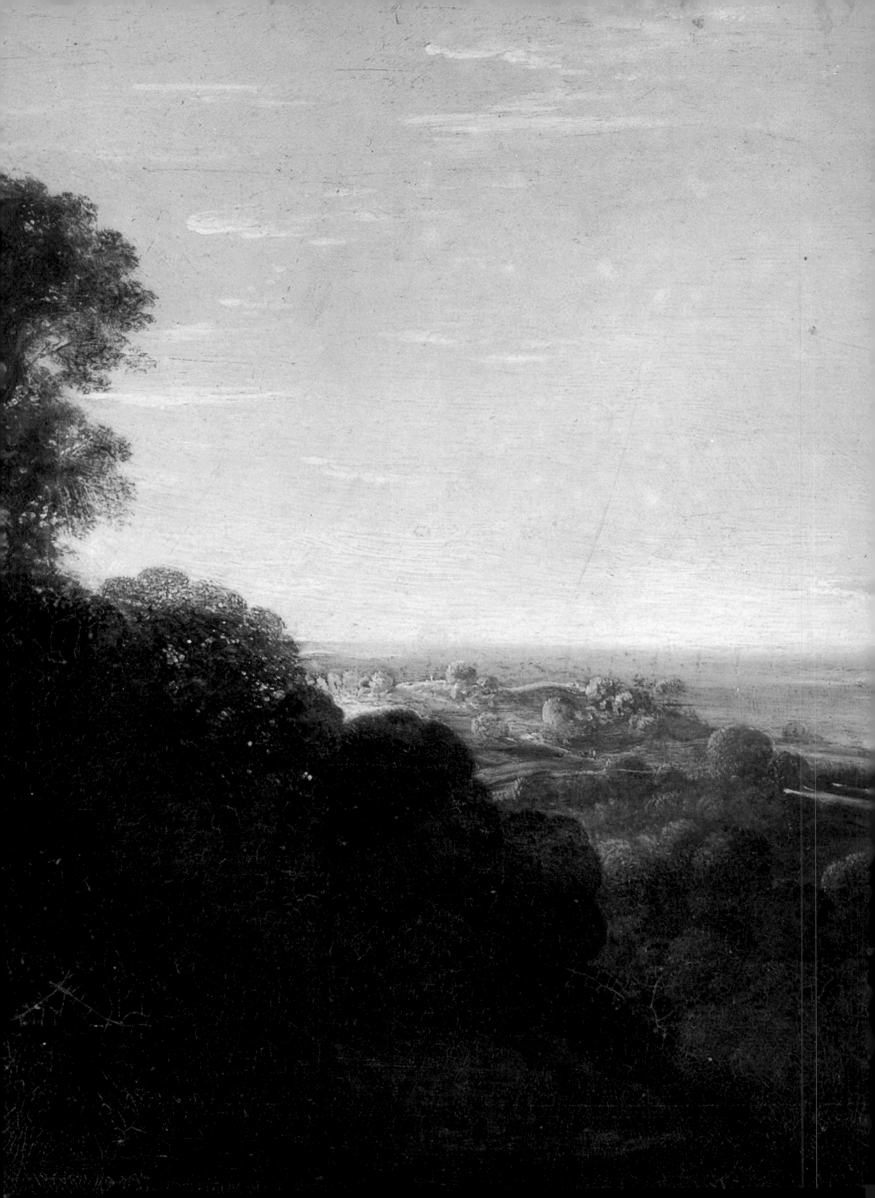

the viewer's attention towards the rising sun on the horizon, thereby preserving the memory of the tragic love story that Elsheimer abandoned, since it was Aurora, the goddess of the dawn, who spoiled the lovers' happiness.[6] It is these cautious corrections that turned Goudt's masterly 1613 engraving of Elsheimer's deserted but nonetheless atmospheric landscape into an important catalyst to the distinctively Dutch developments in landscape painting.[7]

Andrews's suggestion of dating *Aurora* to around 1606 is convincing, also in its assumption that Elsheimer had already attempted to depict similar views from an elevated vantage point of a sun-filled, distant landscape as well as the atmospheric conditions peculiar to the various times of the day. This is confirmed by the Petworth series, which he painted around 1605, as well as by his small-scale *Fight into Egypt* (cat.no.23). What is new, however, is the step the painter took towards a panorama-like opening of the view and to the elevation of the grandeur of the landscape to the status of main subject. Elsheimer's development in the portrayal of nature also shows, however, how close *Aurora* is both in style and in time to the later, nocturnal *Flight into Egypt* (cat.no.36), a proximity that is especially visible in the shape of the tree-tops against the light, the transparency of the darkness and the delicacy of the moving clouds. The painter's next step, however, led to the landscape with the 'small Tobias' (cat.no.30), to a composition like that of the first version of *Aurora*, whose spatial dimension is also defined by a prominent group of figures.

NOTES

1 Andrews 1977, p.149; Weizsäcker 1936, p.246f.; Jacoby 1989, p.113.
2 Berlin, Kupferstichkabinet, inv.no.KdZ 2237; Möhle 1966, no.21; Andrews 1972, p.598; Andrews 1977, no.42: Andrews 1985, no.42.
3 Nicolaus 1974.
4 Ovid *Metamorphoses*, XIII, lines 750–898.
5 The paintings that remained unfinished are *The Conversion of Saul*, Frankfurt am Main, the *Pietà*, Brunswick, *Il Contento*, Edinburgh (cat.nos.4, 16, 25).
6 Pauly/Wissowa, vol.V (1905), col.2669.
7 Blankert 1965, p.18f.; Stechow 1966, p.24f.; Freedberg 1980, p.42.

Fig.104
Adam Elsheimer,
Aurora (infrared photograph, detail),
Brunswick,
Herzog Anton
Ulrich-Museum

Fig.103
Adam Elsheimer,
Aurora (infrared photograph),
Brunswick,
Herzog Anton
Ulrich-Museum

30 Tobias and the Angel ('the small Tobias')

Copper, 12.4 x 19.2 cm
Frankfurt, Historisches Museum, inv.no.B 789

PROVENANCE Perhaps in the possession of the
Cologne painter Johann Jacob Schmitz (1724–
1801); Mainz, K.L. Goedecker Collection;
acquired 1886

LITERATURE Sandrart 1675, p.160; Weiz-
säcker 1936, p.120; Bothe 1939, pp.12, 18,
86f.; Holzinger 1951, p.210; Weizsäcker 1952,
no.8; W. Prinz, *Gemälde des Historischen
Museums Frankfurt am Main*, Frankfurt, 1957,
p.90f.; H. Möhle, in exh. cat. Berlin 1966,
no.11; J. Held, in exh. cat. Frankfurt 1966,
no.5; Waddingham 1972 B, p.610; Andrews
1977, no.20; Andrews 1985, no.20; K.
Andrews, in exh. cat. Naples 1985, no.39;
Sumowski 1992, p.145ff.; Bachner 1997,
pp.253–56

Tobias journeyed from Nineveh to Media
in the company of his guardian, the
archangel Raphael, and his little dog.
While washing on the shore of the River
Tigris, Tobias was attacked by a great fish
that put him in fear of his life. On the
angel's instructions he pulled the fish by
its fins onto land, killed it and removed its
heart, liver and gall. He later used these
fish guts to exorcise a demon that had
bewitched his wife and to restore his
father's sight (Tobit 6:2–7, Apocrypha).
The painter gave the theme his own
interpretation by portraying Tobias as a
young boy seemingly incapable of under-
taking such a long journey. Raphael has
always been seen as the protector of
travellers, especially young ones. Tobias,
carrying the dead fish under his arm, is
led by the angel, who holds his arm to
guide him across the stones in the water.
The frogs sitting on the pair's perilous
path are symbols of uncleanliness and
evil. Described in the Book of Revelation
(16:13–14) as 'unclean spirits', they are
used here metaphorically to represent the
sinful world.[1] The fish Tobias carries
under his arm is no longer a threat and
serves here merely as his attribute. The

present work is less a history painting
than a representation of a guardian angel,
also indicated by the caption to Goudt's
engraving.

Elsheimer's poetic depiction of the
journey and his atmospheric rendering of
nature represent a new vision of land-
scape which, according to Sandrart,
caused a stir in Rome. The composition
became widely known, not only through
the many engravings and etchings made
after it, but also through the great num-
ber of copies and adaptations.[2] Els-
heimer's original painting, now in
Frankfurt am Main, was not recognised
as such until quite late, even though it
corresponds exactly to Hendrick Goudt's
1608 engraving (fig.105, cat.no.50).[3] It is
generally referred to as the 'small Tobias',
to distinguish it from Elsheimer's later
painting of the subject, of which the
composition of the lost original is pre-
served only in a copy in Copenhagen
(cat.no.34) and in a 1613 engraving by
Hendrick Goudt (cat.no.54). Despite the
outward similarity of their compositions,
Elsheimer's two versions display consid-
erable differences in thematic concept.
The 'small Tobias' depicts the popular
pious notion of a guardian angel, whereas
the 'large Tobias' is a religious history
painting that follows exactly the biblical
passage on which it is based.

Elsheimer had previously treated the
theme in one of his paintings in the
Petworth series (cat.no.21) and could
therefore use that composition as his
starting point. His preparatory work for
the 'small Tobias' probably included a
gouache (fig.106, cat.no.45), executed in

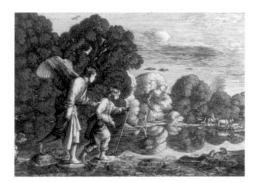

Fig.105
Hendrick Goudt,
Tobias and the Angel,
Frankfurt, Graphische
Sammlung im
Städelschen Kunst-
institut

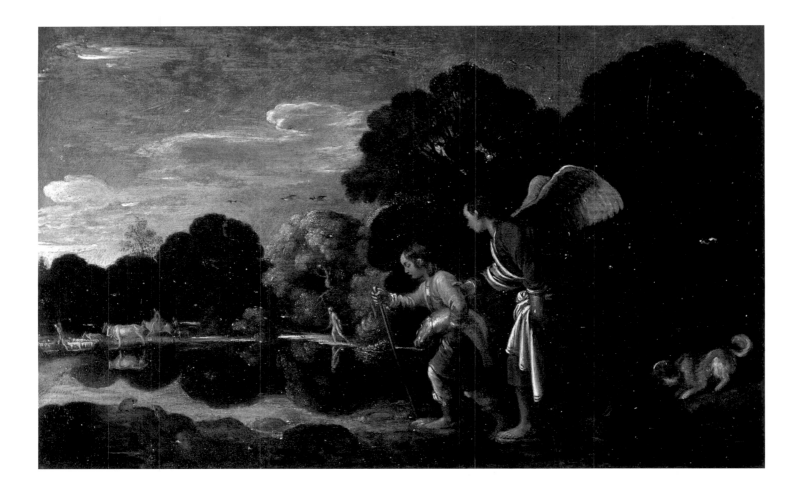

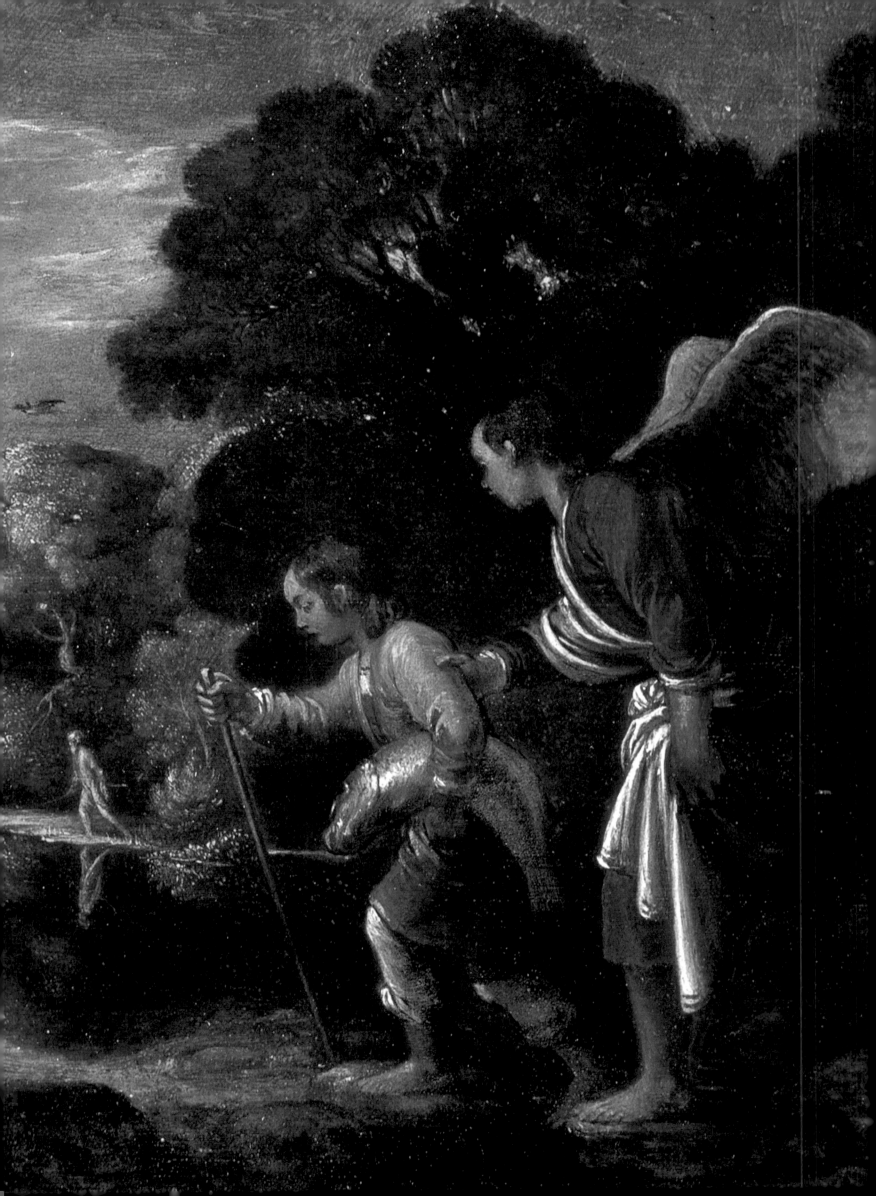

a painterly manner, in which he experimented with an alternative pose for the boy, as well as an etching (fig.107, cat.no.46), in which he strove to resolve the contrasts of light and dark in coarse strokes. In neither of these sheets did he depict such details as the dog, the frogs or the animals passing by in the background, so it is unlikely that they were produced after the completion of the painting.[4] The fact that the engraving by Hendrick Goudt was published in 1608 means that the painting must have been finished at the latest in the previous year. The Amsterdam painter Pieter Lastman, who lived in Rome from the autumn of 1602 until the winter of 1606–07, appears to have studied Elsheimer's *Tobias* closely, as indicated by his 1613 painting of the same theme in Leeuwarden (fig.108).[5] If, as Seifert assumes, Lastman became familiar with Elsheimer's painting while still in Rome, it must have been nearly finished in 1606 before Lastman's departure from Italy.[6]

Fig.106
Adam Elsheimer,
Tobias and the Angel,
Berlin,
Staatliche Museen,
Kupferstichkabinett

Fig.107
Adam Elsheimer,
Tobias and the Angel,
Frankfurt, Graphische Sammlung im Städelschen Kunstinstitut

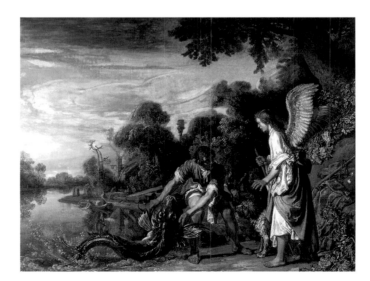

Fig.108
Pieter Lastman,
Tobias Catches the Fish,
Leeuwarden,
Stichting Museum het Princessehof

NOTES
1 Dittrich 2004, p.160.
2 Weizsäcker and Andrews provide lists.
3 On this subject, see Andrews 1977, p.150.
4 On this subject, see Klessmann 2006 A.
5 Leeuwarden, Stichting Museum het Princessehof; exh. cat. Amsterdam 1991, no.3.
6 Seifert 2006.

31 Apollo and Coronis

Copper, 17.4 x 21.6 cm
Liverpool, Walker Art Gallery, inv.no.10329

PROVENANCE Thomas Newport, Baron
Torrington (after 1708); Countess of Bradford
(before 1735); Sir Paul Methuen (1672–1757);
London, Paul Ayshford, 4th Baron Methuen;
Corsham House; sale London (Christie's), 13
May 1920, lot 17; Lord Methuen; acquired by
the museum in 1982

LITERATURE Sandrart 1675, p.160; T. Martyn,
The English Connoisseur, London, 1766, vol.I,
p.31; G.F. Waagen, *Works of Art and Artists in
England*, London, 1838, vol.III, p.105; Bode
1883, p.294; Drost 1933, p.85; Weizsäcker
1936, p.140ff.; Holzinger 1951, p.218; Weiz-
säcker 1952, no.49 A; D. Mahon and D. Sutton,
in exh. cat. London 1955, no.42; exh. cat.
Frankfurt 1966, no.35; Andrews 1977, no.21;
Morris/Evans 1984, pp.3–6; Andrews 1985,
no.21; M.R. Nappi, in exh. cat. Brussels/Rome
1995, no.83; P. Cavazzini, in exh. cat. London
2001 A, no.77

The princess Coronis, Apollo's pregnant
lover, was unfaithful to him. In his anger
Apollo slayed his beloved with an arrow.
Immediately regretting this rash act, he
tried in vain to bring her back to life with
healing herbs. In view of the preparations
necessary for the burning of the body, he
resolved to save his unborn child and
proceeded to remove it from her womb.
In this way Asclepius, the god of medi-
cine, who was nursed by the centaur
Chiron, was born.[1] Elsheimer chose as his
main subject the naked, pregnant
Coronis, on whom bright sunlight falls.
Even though she lies lifeless beneath a
tree, with the blood-stained arrow at her
feet, she does not give the impression of
being dead. The position of her arms and
the pink tone of her flesh reveal a woman

still capable of giving birth to a living
being. Above her, the climbing plant with
luminous blossoms underscores her
fertility, while at the same time the
branches of a dead tree that hang down
into the picture symbolise her death. This
refers metaphorically to the uncertain
outcome of all decisions, here alluding to
Apollo's regrettable act.[2] Behind Coronis,
Apollo, bent with grief at the loss of his
beloved, picks healing herbs. He is
dressed – rather unusually for a god of
antiquity – in a cloak richly decorated
with embroidered motifs, one of which is
a raven, which – as Holzinger observes –
is an allusion to the crow that had
brought Apollo the news of Coronis' un-
faithfulness.[3] The elegant robe is similar
to that worn by the goddess Juno in a lost
painting by Elsheimer, the composition of
which has survived in an etching by
Wenceslaus Hollar (cat.no.32c). The
painter, who was the son of a tailor, had a
penchant – frequently seen in his paint-
ings – for rendering sumptuous clothing.

The affair of Apollo and Coronis was
rarely depicted in art, and in the few
cases when it was – as in the engraving by
Crispijn de Passe the Elder – the focus
was on the fatal arrow shot by the jealous
god (fig.109).[4] This portrayal by
Elsheimer of the episode in which Apollo
regrets his actions and tries to revive his
beloved seems to be one of a kind. The
subject of this painting was long thought
(also by Sandrart) to be *The Death of
Procris*, because that is the title of an

Fig.109
Crispijn de Passe the
Elder, *Apollo and
Coronis*, engraving

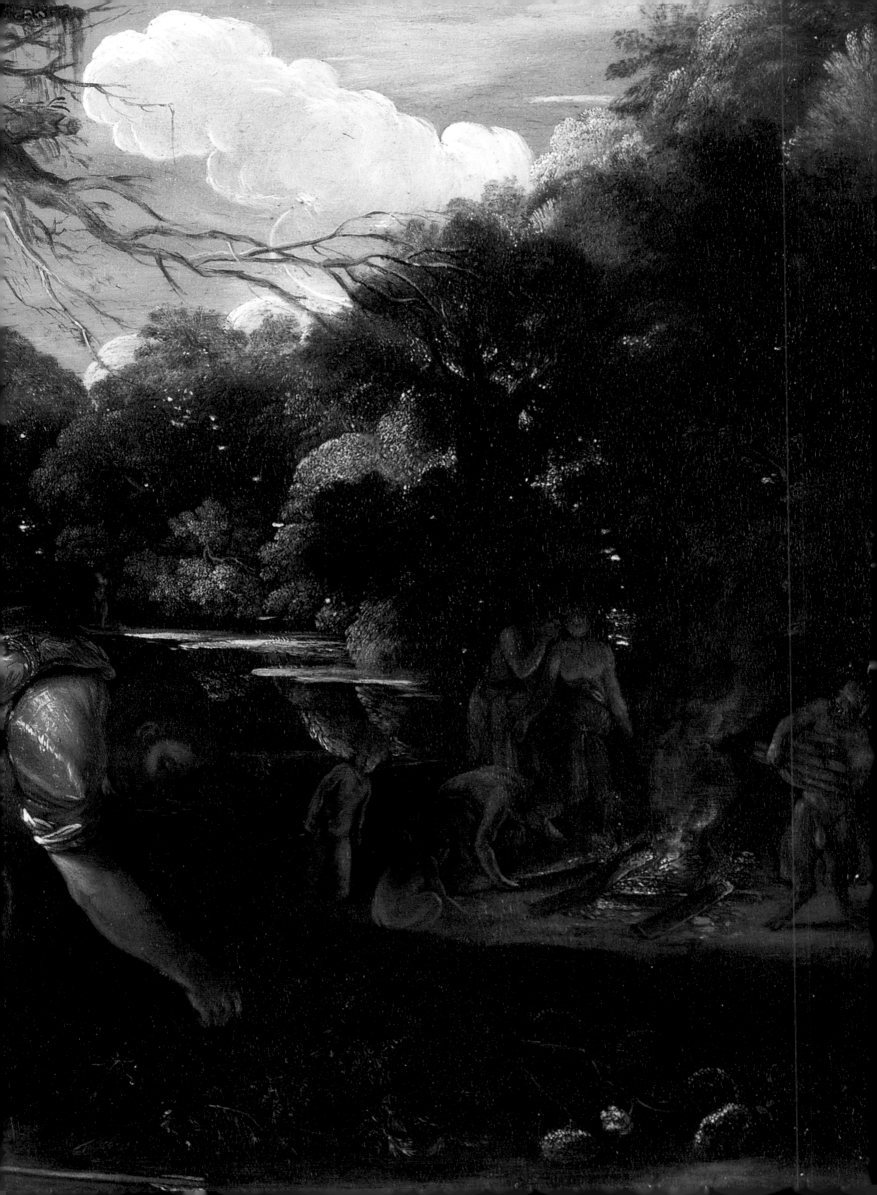

engraving made after it by Magdalena de Passe (fig.110).[5] Holzinger was the first to notice the very similar sequence of events in the two stories from the *Metamorphoses*, and gave convincing reasons for his identification of the theme as *Apollo and Coronis*.[6] The emphasis placed on the pregnant body, the elegant cloak worn by the god as he searches for healing plants, and the funeral pyre must relate to the fate of Coronis. It cannot be ascertained whether the differing interpretation of the scene in Magdalena de Passe's engraving was intentional or merely erroneous. The Utrecht artist must have known the story of Coronis, since, as mentioned above, her father, who was also her teacher, had treated the theme in an engraving.

The figure of Coronis was, as Andrews assumes, inspired by a sleeping Bacchant in Titian's *Bacchanal of the Andrians* in Madrid (fig.52), which in Elsheimer's day was in the possession of the Roman family of Aldobrandini.[7] Weizsäcker names the Roman statue of *The Sleeping Ariadne* as a possible example (Vatican Museum).[8] Stylistically Elsheimer's painting is closely related to his *Realm of Venus* (cat.no.32 a), which is similarly composed with the nude resting in the left foreground and the large tree-tops that close off the pictorial space. The rendering of the background is reminiscent of the landscape in the 'small Tobias', namely the silhouette of the forest and its reflection in the lake (cat.no.30). This picture has a *terminus ante quem* in the 1608

engraving by Hendrick Goudt, so *Apollo and Coronis* must have originated at approximately the same time.

Numerous versions of the painting are known, but only the present one can be attributed with certainty to Elsheimer. The painter's mentality and the circumstances of his life make it extremely unlikely that he produced copies of his own works. The repetitions, lists of which were published by both Weizsäcker and Andrews, are sometimes of high quality, the ones most worthy of mention being in Augsburg, Städtische Kunstsammlungen (formerly Georg Schäfer Collection) and in the J.H.S. Lucas-Scudamore Collection, Kentchurch Court, Hereford.[9] In the case of several of the copies, Morris and Evans have rightly pointed out the formal correspondence of their supports and measurements, as well as their manner of painting and technique: 'It seems plausible that more than one of them were executed in the same workshop.'[10] It is conceivable that other artists made copies after Elsheimer's original in Rome during the artist's lifetime. The painting used by Magdalena de Passe for her engraving, which is probably the one now in Liverpool, could have been taken by Hendrick Goudt from Rome to Utrecht, where De Passe had been active since 1611.[11]

NOTES

1 Ovid *Metamorphoses*, II, lines 542–632.
2 The warning to consider the life-or-death consequences of a decision seriously is expressed in Netherlandish emblem books. Roemer Visscher depicts in his emblem 'Keur baert angst' ('Choice breeds fear') a dead tree next to a blossoming tree. Roemer Visscher, *Sinnepoppen*, Amsterdam, 1614, no.46. Cf. E. de Jongh, *Tot lering en Vermaak. Betekenissen van Hollandse genrevoorstellingen uit de zeventiende eeuw*, exh. cat., Rijksmuseum, Amsterdam, 1976, p.88; P.C. Sutton, 'Introduction' to exh. cat. Amsterdam/ Boston/Philadelphia 1987, p.15.
3 Holzinger 1951, p.218 recognises even more details that can be connected with Apollo in the cloak's embroidery.
4 Hollstein, vol.XV, p.287; Veldman 2001.
5 Hollstein, vol.XVI, no.5; Veldman 2001, p.288.
6 Holzinger 1951.
7 Titian, *The Bacchanal of the Andrians*, Tietze 1936, no.45.
8 Weizsäcker 1936, p.140: *Ariadne*, Roman copy after a Hellenistic original, Rome, Vatican Museum, Galleria delle Statue; Bober/Rubinstein 1986, no.79.
9 Augsburg 1984, p.71, no.L 804; Andrews 1977, no.21 A; Morris/Evans 1984, p.4; *Works of Art from Midland Houses*, exh. cat., Birmingham Museum and Art Gallery, Birmingham, 1953, no.147.
10 Morris/Evans 1984, p.5.
11 Veldman 2001, p.199f.; Lavin assumes that the similarity to the portrayal of the story of Cephalus and Procris in the Farnesina contributed to the picture's mistaken identity. Lavin 1955, p.286.

Fig.110
Magdalena de Passe after Adam Elsheimer, *Apollo and Coronis*, engraving

32 The Three Realms of the World

a) *The Realm of Venus*, copper, 8.7 x 14.6 cm
Cambridge, Fitzwilliam Museum, inv. no. 532
b) *The Realm of Minerva*, copper, 8.7 x 14.6 cm
Cambridge, Fitzwilliam Museum, inv. no.539
c) *The Realm of Juno*
Lost, but the composition has survived in an
etching by Wenceslaus Hollar (Parthey 269;
Andrews 1977, no.22c)

PROVENANCE Thomas Howard, Earl of Arundel
(before 1646); London, the Countess of
Bradford (before 1735, only cat.no.28 a and b);
Robert Grave; sale London (Christie's), 12 May
1827, lot 42 (to Daniel Messman); bequeathed
to the museum in 1834

LITERATURE Bode 1883, p.291; Drost 1933,
p.93f.; Weizsäcker 1936, pp.136ff., 192f.; Hoff
1939, p.59f.; Weizsäcker 1952, p.51, nos.34
and 35;: *Catalogue of Paintings: Fitzwilliam
Museum Cambridge*, Cambridge, 1960, vol.I,
p.201ff.; Krämer 1973, p.156; Andrews 1977,
p.36f., no.22; Andrews 1985, p.36ff., no.22

These two paintings belong to what was
originally a three-part series, which
probably served to decorate a valuable
cabinet. The third piece, *The Realm of
Juno*, must be considered lost, though it is
known through a print by Wenceslaus
Hollar, who made etchings of all three
paintings in 1646, when they were in the
collection of Thomas Howard, Earl of
Arundel (cat.nos.57–59).[1]

The series of paintings portrays the
theme of the *Vita Triplex*, the three
modes of life: the sensual, the active and
the contemplative, which were ruled over
by the three goddesses portrayed. Venus,
who embodies the sensual life, lies naked
on a red cloak in a summery landscape, in
which lovers and satyrs frolic. Bright
sunlight falls on the spherical tree-tops. In
the foreground Amor carries a basket
filled with roses. The painting's poor state
of preservation makes it impossible to

discern all the details visible in
Wenceslaus Hollar's etching and in old
copies (figs.111, 112).[2] Such lost details
include a pair of doves sweeping down
from heaven, familiar as the attribute of
Venus but now missing in the painting.[3]

The brightness of the realm of Venus
contrasts sharply with the dark realm
ruled by Minerva, patroness of the arts.
The goddess wears a helmet and carries a
spear; the owl, her attribute, sits next to
her on a lute resting on the floor.
Minerva, sitting in a melancholy pose at a
table and resting one foot on a sphere,
seems scarcely to notice what the men in
the room are doing. By the light of oil
lamps and candles, two artists work on
depictions of a naked model, hanging –
like Marsyas – from the ceiling.[4] In front of
a bookcase, four scientists are engrossed
in work involving a globe, a pair of com-
passes and large tomes. The light hits the
faces and objects only in a few places, the
darkness of the cramped room exudes an
atmosphere of melancholy, expressive of
life's toil and trouble and the uncertainty
of success. The motif of the meditating
Minerva, which recalls Dürer's
Melancholia, is reflected in the attitudes
of the despairing artists in Elsheimer's
drawing in Munich, which conveys a
similarly gloomy atmosphere (fig.113).[5]

In comparison, the third, lost painting

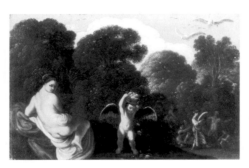

Fig.111
Wenceslaus Hollar,
*The Realm of
Venus*,
Frankfurt,
Graphische
Sammlung im
Städelschen
Kunstinstitut

Fig.112
Copy after Adam
Elsheimer,
*The Realm of
Venus*,
Vienna, Gemälde-
galerie der
Akademie der
bildenden Künste

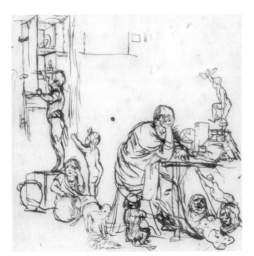

Fig.113
Adam Elsheimer,
The Artist in Despair,
Munich, Staatliche
Graphische
Sammlung

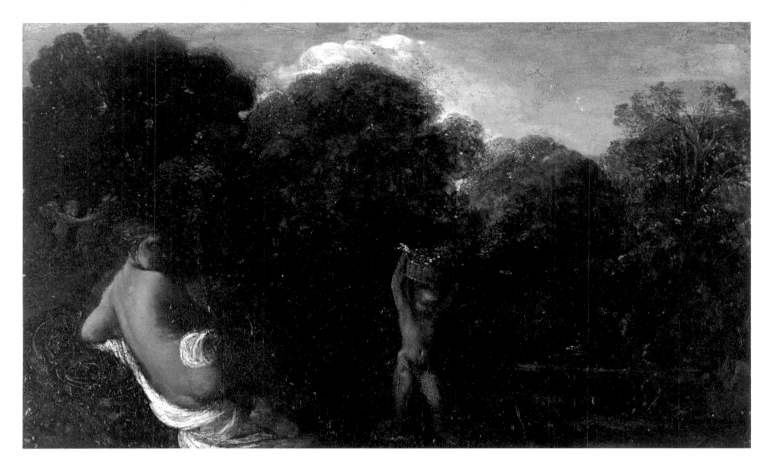

32 a

NOTES

1 Parthey 270–72. The 1735 inventory of the collection of the Countess of Bradford does not list *The Realm of Juno*, so by that time it had already been separated from the other two paintings in the series.

2 Andrews 1977, fig.126. The painting in Vienna, illustrated in fig.112, is a good copy.

3 Research recently carried out into the painting technique, for which I thank Mr David Scrase, indicates that the doves are now invisible to the naked eye, but can be proved by looking at the ground.

4 Elsheimer had already used an antique Marsyas figure as an example in *The Stoning of Saint Stephen* (cat.no.19). Cf. fig.82.

5 Sumowski 1995; *Zehn Meisterzeichnungen. Neuzugänge der Graphischen Sammlung*, exh. cat. edited by T. Falk/T. Vignau-Wilberg, Neue Pinakothek, Munich, 1996, p.27f.; Thielemann 2006.

6 Weizsäcker 1936, see Literature.

7 Parthey 114; Andrews 1977, p.166, A 18 (rejected works).

8 Pen and brown ink and grey wash, 205 x 166 mm (pricked for transfer). Sale Amsterdam (Sotheby's), 8 November 2000, lot 16 (as Elsheimer). For the reference to this drawing, the original of which I do not know, I am grateful to Christian T. Seifert.

9 Andrews 1977, no.34.

of the series, *The Realm of Juno* (fig.114), is much more down-to-earth, more orderly (thanks to the arcades of the building) and cooler in its composition and treatment of light. The monumental figure of Juno, the patroness of trade – sumptuously dressed and holding a sceptre in her right hand – sits on a throne and looks down at the viewer. Behind her are numerous workmen, busy loading goods, who seem tiny in relation to the high, spacious Renaissance hall, which resembles Raphael's Villa Madama.[6] A remarkable feature of this composition is the dominance of the architecture that takes up a large part of the picture, quite unusual considering Elsheimer's other known works. That the artist presumably made studies of Roman architecture is apparent from an etching by Wenceslaus Hollar depicting *The Healing at the Pool of Bethesda*, which records Elsheimer as the inventor

(fig.115).[7] Elsheimer's authorship of this composition is generally rejected, also by Andrews, and yet the rendering of the temple of Bethesda is unquestionably close, not only in its architectural components and the treatment of light but also in its low viewpoint, to the palace of Juno. If the lost *Realm of Juno*, which we also know only through an etching by Hollar, was indeed a painting by Elsheimer's hand – and that is scarcely in doubt – then the *Bethesda* should also be attributed to him. This seems to be confirmed by a recently discovered pen and wash drawing, used by Hollar as a model for this etching, which can perhaps also be attributed to Elsheimer (fig.116).[8] In any case, the loose manner of sketching seen in the small figures – if compared, for example, with the painter's sheet of figure studies in Berlin[9] – is completely in keeping with Elsheimer's style of drawing.

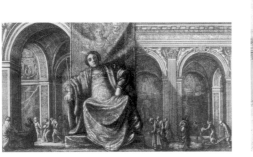

Fig.114
Wenceslaus Hollar,
The Realm of Juno,
Frankfurt, Graphische
Sammlung im Städelschen
Kunstinstitut

Fig.115
Wenceslaus Hollar,
*The Healing at the Pool
of Bethesda*,
Graphische Sammlung
im Städelschen Kunst-
institut

Fig.116
Attributed to Adam
Elsheimer,
A Temple Courtyard (*The
Pool of Bethesda*),
Amsterdam
art market 2000

32 b

33 Latona and the Lycian Peasants

Copper, 16.9 x 22.7 cm. Old inscription on the back: *Adam Elseh...r fecit Romae.* Cologne, Wallraf-Richartz-Museum – Fondation Corboud, inv.no. Dep.586

PROVENANCE Earl of Arundel; Holland, Arundel's widow (c.1647, inventory 1655); Arundel's son William Howard, Viscount Stafford, sold in Utrecht 1662; Bethmann-Hollweg Collection (before 1935); Düsseldorf, Galerie Stern; Paris/New York, Mr Jean Lambert; Montreal, Dominion Gallery Dr. Max Stern (before 1952); sale London (Sotheby's), 16 April 1980, lot 94; London, Lucerne Gallery, David Barcley Ltd.; acquired 1992

LITERATURE Weizsäcker 1936, p.347, no.4 (as Roman landscape); Weizsäcker 1952, p.58f., no.56; K. Andrews, 'Elsheimer's Latona uncovered', *Burlington Magazine*, 123, 1981, pp.350–53; Andrews 1985, no.21 A; A. Repp-Eckert, in *I Bamboccianti. Niederländische Malerrebellen im Rom des Barock*, exh. cat. edited by D.A. Levine and E. Mai, Wallraf-Richartz-Museum, Cologne; Centraal Museum, Utrecht, 1991, no.13

NOTES

1 Ovid *Metamorphoses*, VI, lines 317–81.
2 Cf. Andrews 1985, p.187; Burghley House, Lady Exeter Collection.
3 Weizsäcker saw the painting before 1936 on the Düsseldorf art market, but its thick overpainting led him to believe it was a replica of the painting engraved by Hollar.

Latona, travelling with her twins Apollo and Diana, stops, exhausted and thirsty, to drink at a lake in Lycia. She is mocked, however, by peasants working on the shore who prevent her from drinking. She punishes them by turning them into frogs.[1] The painting shows the mother with her children, sitting on the ground. In front of her stands a jeering peasant with outstretched arms; another, squatting on the shore, looks at her defiantly as he churns up the marshy water to make it undrinkable. Unlike other seventeenth-century artists who portrayed this theme, Elsheimer refrained from showing the peasants already metamorphosed into frogs.

The painting – previously known only through a 1649 etching by Wenceslaus Hollar (fig.117, cat.no.60) and a copy, attributed to Cornelis van Poelenburch,[2]

in a private collection in England (fig.118) – was long considered lost.[3] It was not rediscovered until about thirty years ago, after the removal of disturbing overpainting underneath which the seriously damaged original was long hidden. The composition draws the eye past the group of figures, to the right and across the water, focusing on a steep, densely wooded hill lying in shadow on the opposite shore, before moving on to the distant landscape with rolling, sunlit hills. The broad pictorial space and the treatment of light are comparable to the landscape in the 'large Tobias' in Copenhagen (cat.no.34), while its atmosphere corresponds closely to that of *Apollo and Coronis* and *The Realm of Venus* (cat.nos.31, 32a). It can, therefore, be assumed that *Latona* originated at approximately the same time, in 1607–08.

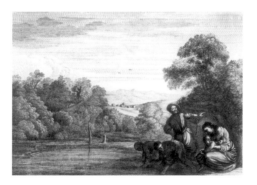

Fig.117
Wenceslaus Hollar, *Latona*, Frankfurt, Graphische Sammlung im Städelschen Kunstinstitut

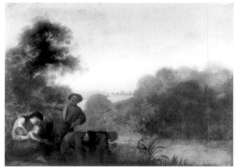

Fig.118
Cornelis van Poelenburch after Adam Elsheimer, *Latona and the Lycian Peasants*, Burghley House, Lady Exeter Collection

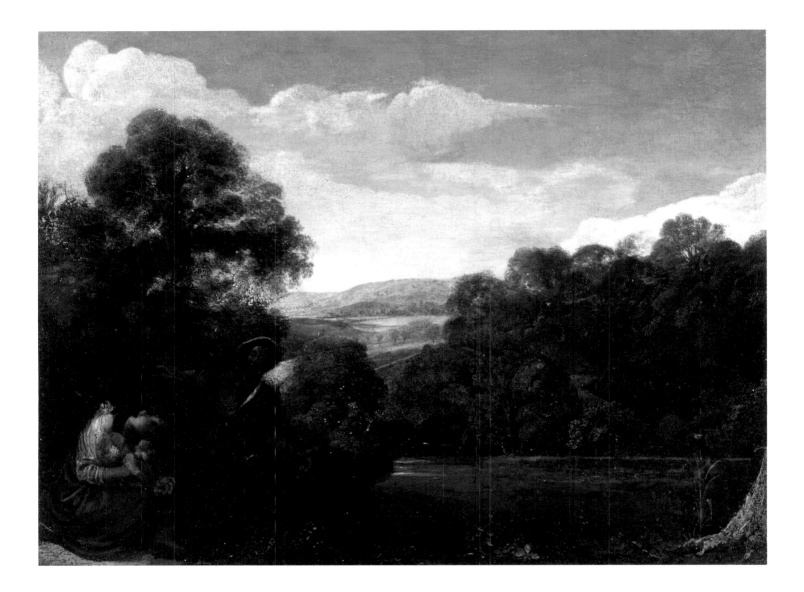

34 Tobias and the Angel ('the large Tobias')

Copper, 21 x 27 cm
Copenhagen, Statens Museum for Kunst,
inv.no.207 (Sp. 745)

PROVENANCE Acquired through G. Morell
1760; Schloss Fredensborg; Schloss
Christiansborg (1827)

LITERATURE E. Schenk zu Schweinsberg, 'Ein
Beitrag zu Adam Elsheimer', *Städel-Jahrbuch*
3/4, 1924, p.91; Drost 1933, p.85ff.;
Weizsäcker 1936, p.123; *Royal Museum of
Fine Arts. Catalogue of Old Foreign Paintings*,
edited by L.S., Copenhagen, 1951, p.87;
Weizsäcker 1952, p.13f., no.9; exh. cat.
Frankfurt 1966, no.7; Andrews 1977, no.25;
Andrews 1985, no.25, Sello 1988, p.30f.;
Sumowski 1992, p.145ff.; Seifert 2006

This painting, generally known as the
'large Tobias', is a faithful copy of the lost
original by Elsheimer, which Hendrick
Goudt, its owner from 1611, reproduced
in an engraving in 1613 (fig.119, cat.
no. 54). After Goudt's death in 1648, the
painting remained in Holland, where it
was in the collection of the Utrecht town
councillor Johann Heunrius in 1669.[1]
Here it was first recorded as the 'large
Tobias', which implies knowledge of the
'small' one. From Utrecht it made its way
via 's Hertogenbosch to Leiden, where the
art dealer and frame-maker Carel de
Moor bought it in 1673 for the huge sum
of 700 guilders.[2] Since then there has
been no trace of the original painting.

Here Elsheimer portrayed Tobias as a
youth – in contrast to his earlier, smaller
depiction in Frankfurt (cat.no.30) – drag-
ging a large fish and turning slightly
towards the viewer. His right arm is in a
sling, obviously the result of his struggle
with the aggressive fish (for more on this
subject, see cat.no.30). His heavenly
companion, the archangel Raphael,
carries a staff – symbolising his task of
guiding his young charge on his travels –
and follows Tobias, without touching him.
The travellers' path leads through a
densely wooded mountain landscape,
notable for its profusion of flowers. The

plants are rendered with greater accuracy
than is usually the case with Elsheimer.
The low-growing, leafy plant in the
middle foreground could be rhubarb,
behind which poppies bloom, both known
since antiquity for their medicinal proper-
ties. The tree above the figures is full of
white blossoms whose large, plate-like
shape is reminiscent of eucalyptus,[3]
which would be unexpected here, since it
is native to Australia and was still un-
known to other parts of the world in the
seventeenth century. Elsheimer's paint-
ing, however, more or less took shape
under the eyes of a prominent botanist,
his friend Dr Johann Faber, and it is in
this light that the surprising occurrence of
this tree should be examined. Portuguese
ships had probably landed on the coasts
of Australia as early as the sixteenth
century, and Dutch seafarers had certain-
ly done so, for they had been sending out
expeditions since 1595 from their posts in
Java. The discoverer of Australia is con-
sidered to be the Dutchman Willem Jansz
(1571–1638), who landed on the north
coast of the unknown continent in 1605,
to be followed shortly by other voyagers.
It is not known when news of his discov-
ery reached Rome, or the impact it made,
but we may assume that the flora of this
recently discovered continent were a

Fig.119
Hendrick Goudt,
*Tobias and the
Angel*,
Frankfurt,
Graphische
Sammlung im
Städelschen
Kunstinstitut

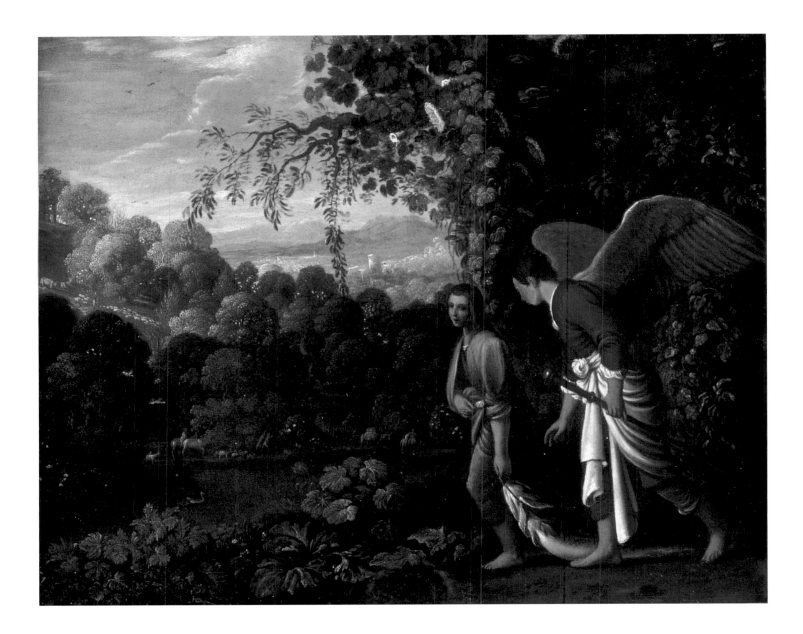

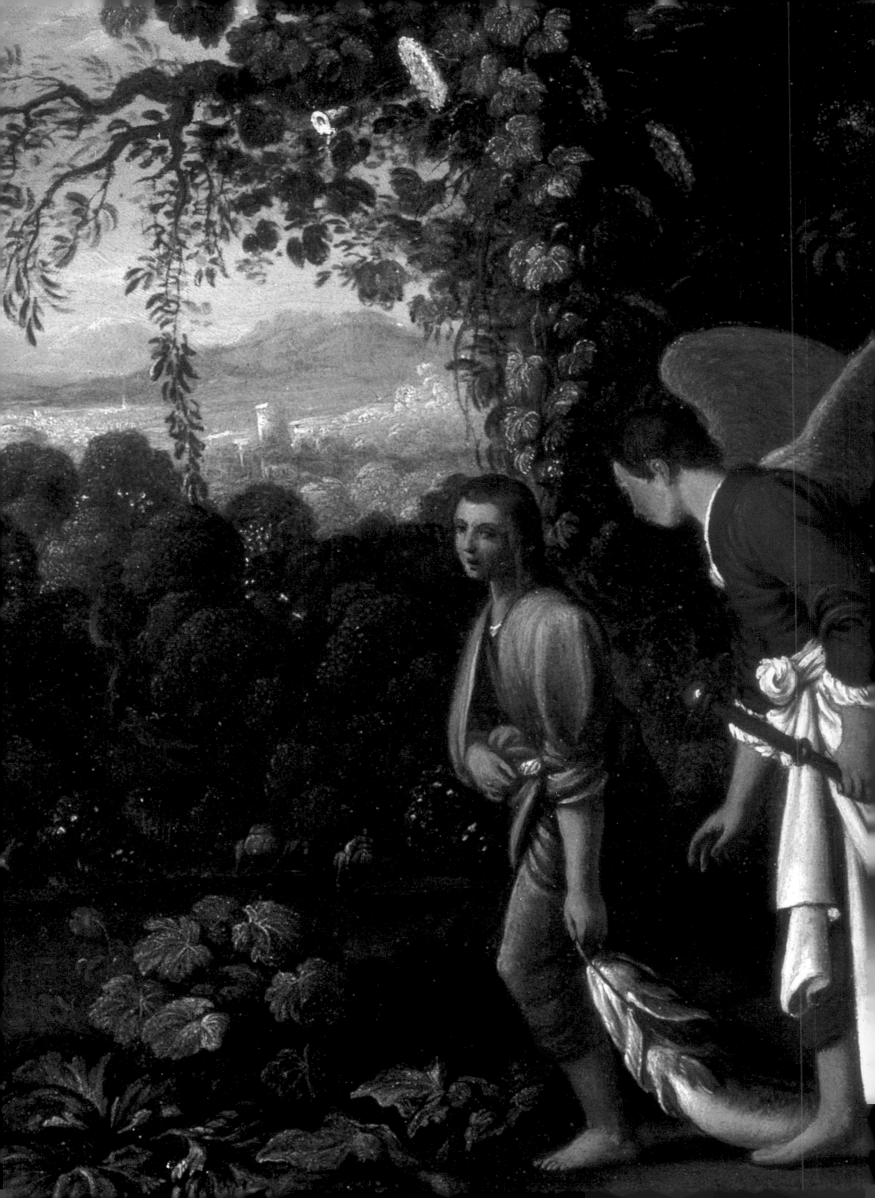

matter of great interest to Faber. His publications and the writings left at his death reveal that he kept up a world-wide correspondence for the purpose of obtaining the very latest botanical and zoological information.[4] The oil extracted from eucalyptus trees served as a remedy for fever and respiratory illnesses. The variety of medicinal plants Elsheimer rendered so precisely in the context of the story of Tobias perhaps relate to the ancients' use of the fish, whose guts Tobias removes, acting on the angel's instructions, for later use in curing his wife and restoring his father's sight.

It can be assumed that the botanical details in Elsheimer's *Tobias* were included at the request of an interested patron, or even his friend Dr Faber. In this new form of narrative Elsheimer speaks in a matter of fact tone that clearly differs from the fairy-tale character of the Frankfurt painting. As similar as the two versions appear at first glance, they are, however, fundamentally different in terms of subject matter. The 'large Tobias' is not, as is usually assumed, a variation of a successful picture undertaken for financial reasons, but rather the treatment of the same theme from a fresh perspective. The Tobias in the Frankfurt painting is a child in need of protection, who is not in a position – as the biblical schedule dictates – to marry a few weeks later. The 'large Tobias', on the other hand, is a true history painting, whose realistic interpretation does justice to the biblical source. It is possible that Pieter Lastman looked to this work for inspiration for the painting he made in 1613 in Amsterdam of the same subject, in which the threat unfolding on the shores of the River Tigris is given great prominence (fig.108).[5] Elsheimer shows the youth with his injured arm in a sling, having survived his dangerous battle with the great fish, making his way through the forest and dragging the dead fish. He has no need of a dog or a walking stick, relying only on his faith in God – stronger than ever on this journey in foreign parts – which is symbolised by the angel following close on his heels.

It is not known who made this copy, but a possible candidate is Johann König, who was in Rome from 1610 to 1614 and probably met Elsheimer there.[6] If this attribution is correct, König must have seen Elsheimer's original in Rome, since from 1611 it was with Hendrick Goudt in Utrecht and no longer accessible to König. A copy by a later hand, which differs in detail from Goudt's engraving, is in the National Gallery in London (fig.120).[7]

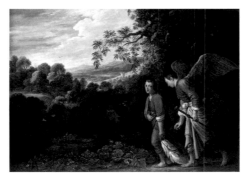

Fig.120
Copy after Adam Elsheimer, *Tobias and the Angel*, London, The National Gallery

NOTES

1 On this subject, cf. Seifert 2006.
2 A. Bredius, *Künstler-Inventare. Urkunden zur Geschichte der holländischen Kunst des 16., 17. und 18. Jahrhunderts*, The Hague, 1919, vol.VI, p.2180 k.
3 I am indebted to Mrs Eva Schmidbauer of the Botanical Gardens in Munich for her invaluable advice.
4 Huemer 1996, p.7.
5 Leeuwarden, Stichting Museum het Princessehof; exh. cat. Amsterdam 1991, no.3; Seifert assumes that Lastman was already inspired in Rome by Elsheimer's 'small Tobias', and has demonstrated that Lastman took a gurnard as his model, which also suggests the involvement of Elsheimer's friend Dr Faber, whose collection contained a skeleton of this fish. Seifert 2006.
6 The attribution of the Copenhagen painting to Johann König was already suggested in the 1922 catalogue of the Statens Museum (no. 125).
7 Levey 1959, p.40, no.1424.

35 Jupiter and Mercury in the House of Philemon and Baucis

Copper, 16.9 x 22.4 cm
Dresden, Staatliche Kunstsammlungen,
Gemäldegalerie, inv.no.1977

PROVENANCE Utrecht, Hendrick Goudt (1611);
Amsterdam, Johan van de Capelle Collection
(inventory of 13 August 1680, no.52); The
Hague, Grave van Wassenaer d'Obdam sale,
19 August 1750, lot 104; Huistenray; acquired
for the Dresden Museum before 1754

LITERATURE Sandrart 1675, p.161; Bode
1883, p.277; Drost 1933, p.94f.; Weizsäcker
1936, p.195; Holzinger 1951, p.209;
Weizsäcker 1952, no.43; Möhle 1966, no.11;
exh. cat. Frankfurt 1966, no.38; Andrews
1977, no.24; Andrews 1985, no.24;
Monkiewicz 1988, pp.93–101; exh. cat. Munich
1998, no.268

Philemon and Baucis, an aged couple living in Phrygia, give shelter in their poor hut to two travellers who have been turned away from other houses. They are prepared to give the strangers hospitality, and even offer to kill their only goose for the occasion. The strangers are in fact Jupiter and Mercury, who show their gratitude by turning the hut into a temple and by granting the old couple their wish, which is to live out their lives as priests of the temple.[1] The painting shows a windowless room constructed of rough timber, which is lit by only two oil lamps, the brighter one serving to light the table at which their distinguished guests are seated. It is, moreover, the only place in the room where a picture could show to advantage. This proves to be a representation of the story of Mercury and Argus,[2] which portrays the unhappy ending of one of Jupiter's many love affairs. Goethe took note of this playful allusion, referring to it with pleasure and admiration.[3]

Elsheimer treated this unusual subject in an extremely free and anecdotal manner. Jupiter and Mercury are seated expectantly, Baucis busies herself with sheets and blankets, preparing a bed for them, and Philemon carries in the food. Their casual poses make them practically unrecognisable as gods of antiquity; the painter portrays them as seen through the eyes of the unwitting old couple. What is really happening here is clarified by Elsheimer's use of light, which shows Jupiter as though under a baldachin in heavenly brightness. Baucis, transfixed, gazes at Jupiter, suddenly realising who he is. It was not without reason that the painter modelled Baucis after the figure of the old woman in *The Mocking of Ceres* (cat.nos.26, 27), who holds a candle in order to serve the goddess, for this too is a moment of recognition. The close connection of the subjects, as well as the similar treatment of light in these two scenes, has led to the widely held idea that the two paintings originated in close succession. Andrews assumed that Rubens, who adopted motifs from *Philemon and Baucis*, became acquainted with it in Elsheimer's studio, before his departure from Rome in October 1608. The portrayal of Ceres, however, appears to have been painted as early as 1605, since that is the date on Thomann von Hagelstein's picture of *Judith Showing the Head of Holofernes* (fig.144), which – as

Fig.121
Adam Elsheimer,
*Jupiter and
Mercury in the
House of Philemon
and Baucis*,
Berlin,
Staatliche Museen,
Kupferstichkabinett

ascertained by Seifert – bears witness to the influence of Elsheimer's *The Mocking of Ceres*.[4] We must, therefore, assume that an interval of two to three years elapsed between these two paintings, a period in which Elsheimer was turning to a softer and more tonal manner.

Two drawings by Elsheimer that are closely connected with the Dresden painting must have been preparatory designs for it. A tiny pen and ink drawing in Berlin, trimmed on the left-hand side (fig.121), can be considered the *prima idea*.[5] It shows Philemon, who approaches the guests, sitting at a table on the right, as though to ask how he can be of service to them. A related gouache in Warsaw (fig.122, cat.no.47), the composition of which is similar, moves the scene to a dark room with a low, timbered ceiling. On the table in the middle stands an oil lamp, its bright light striking Jupiter but even more so Philemon, who holds a basket under his arm. The figures

cast shadows on the ceiling and the walls. Using the sketchy brush technique of this gouache, which resembles that of *The Mocking of Ceres* in Hamburg (cat.no.42), Elsheimer explored the painterly form and handling of light appropriate to the scene. In the final painting he revised the arrangement of the figures, by swapping the sides and directing the lamplight mainly at the wall behind Jupiter. The brightness now radiates from the gods, who will change the poor lives of Philemon and Baucis. Elsheimer's attempts to come to terms with this theme were probably witnessed by Hendrick Goudt, who lived in the painter's household, since he made drawings of a similar composition that are closely related to Elsheimer's invention.[6] After the artist's death, Goudt took possession of the painting and in 1612 produced an engraving after it, though without mention of Elsheimer's name (fig.123, cat.no.52).

NOTES

1 Ovid, *Metamorphoses*, VIII, lines 621–96.
2 Ovid, *Metamorphoses*, I, lines 668–721.
3 J.W. Goethe, 'Nach Falconet und über Falconet' (1776), in *Werke*, I, vol.37, Weimar, 1896, p.319.
4 Seifert 2006.
5 Möhle 1966, no.11; Andrews 1977, no.46.
6 Möhle 1966, no.11; London, British Museum, inv.no.1920-11-16-11 (Elsheimer), Möhle 1966, p.73, fig.G62 (Goudt); Möhle 1966, no.43 (London, Lady Robertson), art market London, Day & Faber, exhibited in *Master Drawings in London*, 3–9 July 2004, no.7 as Hendrick Goudt.

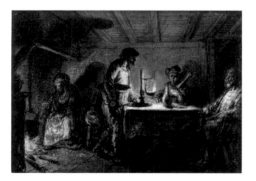

Fig.122
Adam Elsheimer,
*Jupiter and Mercury
in the House of
Philemon and Baucis*,
Warsaw, Muzeum
Narodowe

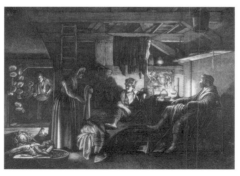

Fig.123
Hendrick Goudt,
*Jupiter and Mercury
in the House of
Philemon and Baucis*,
Frankfurt, Graphische
Sammlung im Städelschen
Kunstinstitut

173

36 The Flight into Egypt

Copper, 31 x 41 cm. Inscribed on the back: *Adam Elsheimer fecit Romae 1609*; below this another, barely legible inscription, which could possibly be the artist's signature. Munich, Bayerische Staatsgemäldesammlungen, Alte Pinakothek, inv.no.216

PROVENANCE Rome, inventory of Elsheimer's estate, 1610; Utrecht, Hendrick Goudt (from 1611); Düsseldorf and Mannheim, Elector Palatine Johann Wilhelm; Munich, Königliche Sammlung since 1813

LITERATURE Sandrart 1675, p.162; Drost 1933, p.112; Weizsäcker 1936, p.252; Weizsäcker 1952, no.13; exh. cat. Frankfurt 1966, no.9; Stechow 1966, p.174f.; W.J. Müller, in Hubala 1970, p.200; Andrews 1972, p.597; Ottani Cavina 1976, p.139; K. Andrews, 'Letter to the Editor', *Burlington Magazine*, 118, 1976, p.595; Adriani 1977, p.23; Andrews 1977, no.26; Andrews 1985, no.26; Sello 1988, p.68ff.; M. Levey, 'Adam Elsheimer. The Kindness of Strangers', *Art News*, 91, no. 2, 1992, p.43f.; Howard 1992, pp.212–24; exh. cat. Munich 1998, no.180; Neumeister 2003, p.277f.; M. Dekiert, in exh. cat. Munich 2005, no.1; Klessmann 2006; Thielemann 2006

Unlike Elsheimer's first work on this subject (cf. cat.no.23), in which the dangers of the fugitives' perilous path are underscored by their contrast to the summery expanse of nature in the background, the dominant motif of this painting is the poetic atmosphere of the landscape. Despite the darkness of night, the landscape exudes a peace and calm that nevertheless does justice to the biblical story. The Latin caption to the engraving, made by Hendrick Goudt after the painting in 1613, reads: 'In darkness flees the light of the world, and wondrously the ruler of the world hides at the tyrant Pharaoh's.' The family's dark isolation is not a cause for concern, since there are all manner of auspicious signs indicating that God himself is watching over them. The ass, carrying Mary and the Christ Child on its back, finds its way through the darkness alone. Even though the beast must cross a stream, Joseph does not have to lead it by the reins, as he traditionally does. He lags behind, the torch in his left hand, to be near the child. This new pictorial idea took shape only in a second stage (fig.56),[1] after Elsheimer had abandoned a previous rendering showing Joseph leading the party (fig.124).[2] The night sky is dotted with countless stars, its closeness to the earthly travellers revealing itself in the shining disc of the moon,

which is reflected in the water. At the same time the trail of the Milky Way is visible at the upper left, falling off towards the middle of the picture and thereby focusing attention on the family. Since the Middle Ages, the Milky Way had also been known as 'Jacob's Street',[3] referring to the Hebrew patriarch Jacob, who dreamed of a ladder going up to heaven, with angels climbing up and down, and God looking down from on high (Genesis 28). Elsheimer included the motif of 'Jacob's Street' as a way of showing that the Holy Family was under the guidance of God. This idea is also expressed by the black silhouette of the woods rising up behind them, beyond which the firmament extends into infinity.[4]

The extent of the nocturnal landscape is determined by three sources of light, which are of thematic as well as spatial significance. Elsheimer made use of this device in other pictures as well, as seen in *The Mocking of Ceres* and *The Realm of Minerva* (cat.nos.27, 32). The Holy Family, who occupy the centre of the composition, have only the meagre light from the torch in Joseph's hand, a dim glow that lights up the face of the child and may be understood as symbolic of Christ's humility. The full moon in the distance and the sparkling splendour of the stars testify to the presence of God. The third source of light is the flaring fire, around which the shepherds and their animals have gathered. The Holy Family's path leads in the direction of this fire, which cannot have been intended only as painterly enrichment.[5] In this context it seems natural to think of the shepherds in the field who experienced the angel's nocturnal annunciation of the birth of Jesus (Luke 2:7–14). The sparks flying out of the fire float up to heaven, where they seem to join the stars.

The sky, which takes up about half of the composition, divided diagonally, opens up to mysterious depths that bestow a nearly cosmic significance on the inconspicuous family. In the upper

Fig.124 Adam Elsheimer, *The Flight into Egypt* (infrared photograph), Munich, Bayerische Staatsgemäldesammlungen, Alte Pinakothek

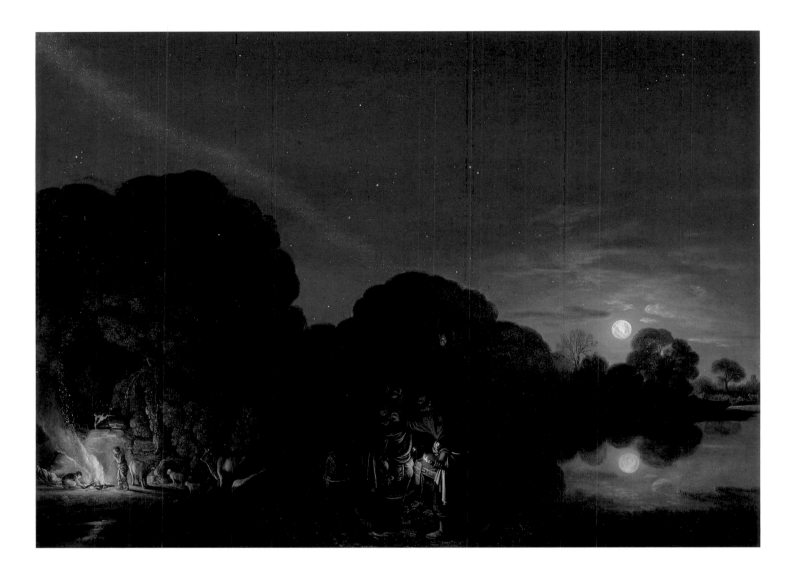

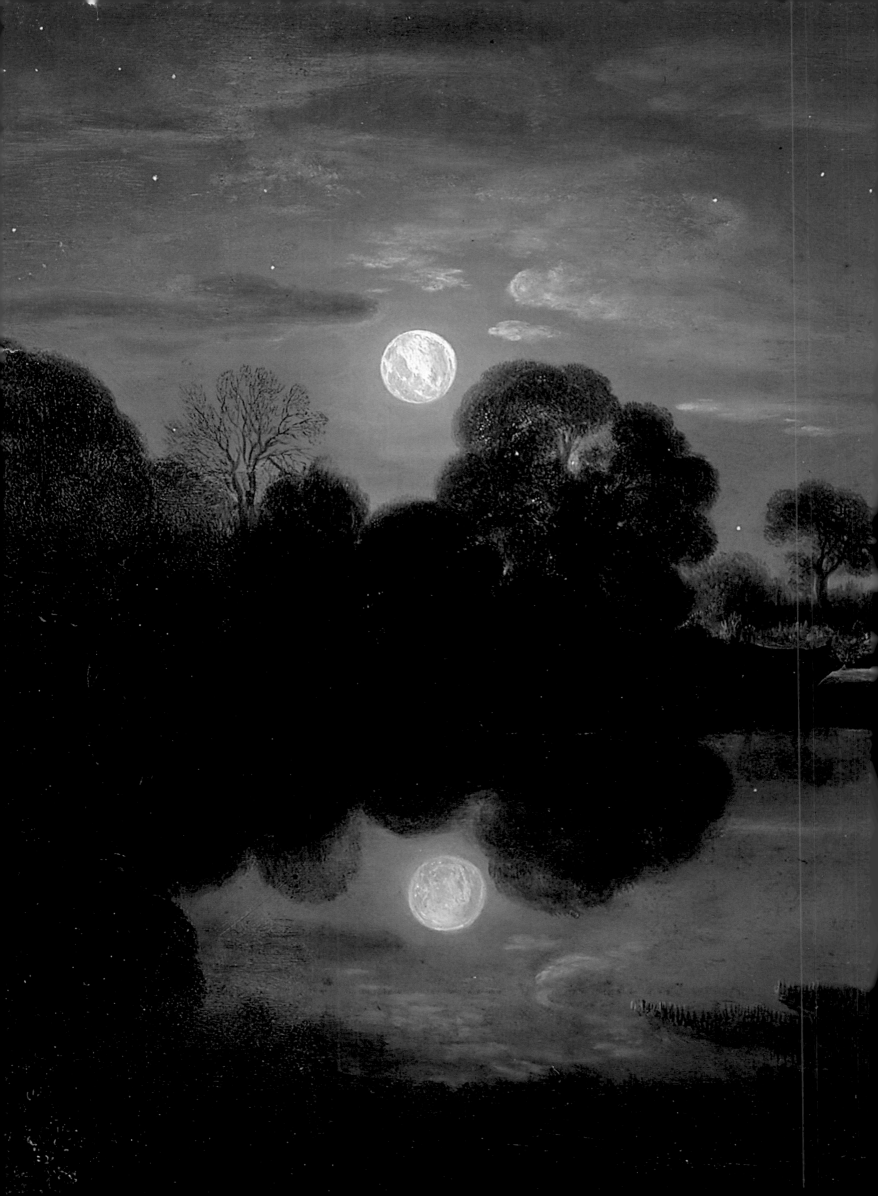

right-hand corner of the picture is the constellation of the Great Bear, in particular the Plough. The Bear belongs to the circle of Diana, known since antiquity as the goddess of the moon and especially of chastity, as well as the protectress of virginity.[6] Boccaccio compares Diana with the Virgin Mary as a shining example of chastity. Presumably Elsheimer, too, wished to convey with his strikingly exact rendering of the constellation the heavenly calling and the purity of the Virgin. Moreover, it is possible that this landscape, in which heaven and earth meet, was also meant to portray the mysterious effects of the Four Elements: air dipping into water and fire touching earth.

This painting by Elsheimer represents 'the first true moonlit night scene in European painting'.[7] The view to the ocean of stars conveys an idea of the infinite depths of the universe; indeed, it is no coincidence that the painting originated in the same decade that witnessed the unprecedented advances in astronomy made by Kepler and Galileo. This fascinating rendering of the starry sky has raised the question, indeed provoked controversy, as to whether Elsheimer intended to depict a particular configuration of stars and whether the picture thus reflects Galileo's research on the Milky Way, which was published in 1610.[8] Andrews correctly rejected this theory, even though Elsheimer was probably acquainted with Galileo, who was also active as an artist. In fact, the painting only depicts phenomena that a talented painter like Elsheimer could observe with his own eyes, for which knowledge of specific writings on astronomy was not at all necessary. Nevertheless, it may be assumed that the circle of scholars that had congregated in Rome around Johann Faber and the natural scientist Federico Cesi, with whom Elsheimer was in close contact, had heightened his awareness of astronomy and opened his eyes to cosmic phenomena. As Thielemann has ascertained, several telescopes – built after a prototype developed by Cesi independently of Galileo – were available in Rome in the summer of 1609, and Elsheimer could have had the opportunity to observe things for himself.[9] This is evidence of the correctness of the date – 1609 – on the back of the painting. Even so, an exact rendering of scientific findings cannot have been Elsheimer's primary aim in painting this nocturnal scene.

The discussion raging in recent years as to the astronomical relevance of Elsheimer's depiction has diverted attention from several unanswered questions of iconology that testify to the complexity of the painting. Numerous copies and adaptations, lists of which have been compiled by both Weizsäcker and Andrews, reveal that the message conveyed by Elsheimer's *Flight into Egypt* – as evidenced by Rubens's painting in Kassel – was a highly appealing one. The adaptations include the *Landscape with Jacob's Dream* by Johann König, who could have seen the much-admired nocturnal piece only in 1610–11 in Rome (fig. 163). No copyist, however, was capable of attaining the unique effect of Elsheimer's starry sky.

NOTES

1 The drawing reproduced here – executed in pen and brown ink and attributed to Elsheimer – which was recently at a Paris art dealer's (Galerie Terrades 2005), 72 x 94 mm (inscribed at lower left in old handwriting 'Jan Liven'), could be connected with Elsheimer's change of concept, as evidenced by the corrections made to the pose of Mary and her mount.
2 Restoration of the painting carried out in 2005 revealed that Joseph was originally leading the ass and was visible behind its head. I am grateful to Veronika Poll-Frommel and Marcus Dekiert for allowing me to participate in their research.
3 The expression 'Jacob's Street' (*Jacobsstraße*) was also used by Sandrart in his description of the painting.
4 Sello 1988.
5 Levey 1992.
6 L. Ettlinger, in *RDK* III, col. 1431.
7 Sello 1998.
8 Ottani Cavina 1976.
9 Thielemann 2006.

37 Self-portrait

Canvas, 63.7 x 48 cm
Florence, Galleria degli Uffizi, inv.no.1784
(Frankfurt and Edinburgh only)

PROVENANCE Rome, inventory of Elsheimer's
estate, 1610; Rome, Accademia di San Luca;
Florence, Cosimo III de' Medici (1697);
Cardinal Leopoldo de' Medici; Florence,
Uffizi (1704)

LITERATURE Baglione 1642, p.101; Bode
1883, p.263; Weizsäcker 1936, p.92f.;
Weizsäcker 1952, p.84f., no.83 (Saraceni?);
J. Held, in exh. cat. Frankfurt 1966, no.54
(circle of Elsheimer); Bauch 1967, p.93 (circle
of Saraceni); K. Andrews, 'Elsheimer's
Portrait', in *Album Amicorum J. G. van Gelder*,
The Hague, 1973, p.1ff.; Andrews 1977, no.26
A; Lenz 1978, p.167; Krämer 1978, p.325,
no.5 (not Elsheimer); Florence 1979, p.864;
Andrews 1985, no.26 A; Rapp 1989, p.131,
no.14 (not Elsheimer); C. Whitfield, in exh. cat.
London 2001 A, no.52

The painting shows the artist as a half-
length figure, wearing dark, formal cloth-
ing with a white collar, holding a brush
and palette in his left hand, his right hand
invisible. He looks at the viewer with a
serious, probing expression. It is the only
autonomous portrait and the only picture
painted on canvas in a larger format by
Elsheimer that is known. It therefore
occupies a unique place in his oeuvre, its
singularity also having raised doubts as to

Fig.125
Simon Frisius and
Hendrick Hondius,
*Portrait of Adam
Elsheimer*,
Frankfurt,
Graphische Sammlung
im Städelschen
Kunstinstitut

NOTES
1 Weizsäcker 1952, p.132; Van
 Mander/Miedema 1994, p.442.
2 Parthey 1397.
3 There is no known documentation confirm-
 ing Elsheimer's admission to the academy,
 but records show that he began paying
 membership fees in 1607. Cf. Andrews
 1977, p.47, doc. 6.

its authenticity. There is no question that
the features are those of Elsheimer, since
the painting served as the basis for a
portrait engraving published by Hendrick
Hondius and Simon Frisius the year
Elsheimer died (fig.125, cat.no.48). The
engraving belongs to an extensive series
of artists' portraits appearing under the
title *Pictorum aliquot celebrium prae-
cipue Germaniae inferioris effigies* in
1610 in The Hague. The seventy-two
artists are portrayed three-quarter-length
in largely the same pose, often in front of
a wall with an opening that affords an
outdoor view. In Elsheimer's engraved
portrait a large city with Roman motifs
and two dignified men in historical dress
looking over the windowsill into the pain-
ter's studio appear in the background.
Andrews suggested that these figures
represent Dürer and Holbein, who found
in Elsheimer an artist capable of carrying
on in their tradition. The inscription on
the sheet refers, according to Andrews, to
the few lines devoted to Elsheimer by
Karel van Mander (in his *Schilder-Boeck*,
in his biography of Johann Rottenham-
mer 'and some others'),[1] in which he
describes the painter's habit of sitting in
churches and 'gazing continually at the
works of ingenious masters'. We have no
idea how either Frisius or Hondius, who

had been active in The Hague from 1597
– neither appears to have travelled to Italy
– became acquainted at such an early
date with the painting that was still in
Elsheimer's possession at the time of his
death in 1610. Perhaps they had seen a
drawn copy of it. The portrait etching of
Elsheimer made by Wenceslaus Hollar in
1649 is based on the same examplar.[2]

The present painting was made for the
Accademia di San Luca, as confirmed by
a weak copy preserved there (fig.43),
which bears the date 1606, the year the
painter was elected to the Roman aca-
demy.[3] It accords with the academy's
custom of requiring its members to supply
a portrait of themselves in a specified
format. Elsheimer's self-portrait, prob-
ably identical with the one mentioned in
the inventory of his estate drawn up after
his death in 1610, was apparently handed
over to the academy only after his death.
Its presence there was recorded by
Baglione in 1642. In 1697 the portrait
made its way, perhaps in company with
other portraits sold at the time, to
Florence, to the Grand Duke Cosimo III
de' Medici, who owned an important
collection of self-portraits.

The quality of Elsheimer's painting has
always been underestimated, probably
because its style is so different from the
small-scale paintings on copper that he
usually produced. Even though it displays
all the formal characteristics of a self-
portrait, its status as such was doubted
and it was even attributed to other artists.
The painting owes its rehabilitation to
Andrews, who was the first to recognise
in it the characteristic features of the
artist's style and to affirm its value as a
historical document. Elsheimer is not
likely to have painted any other portraits,
though this has not been proven. The
present painting presumably originated
in the period between 1606 (the year
Elsheimer became a member of the
academy) and around 1608; otherwise its
use for the engraving produced by Frisius
before 1610 is difficult to explain.

Drawings, Gouaches and Etchings by Elsheimer

These sheets served as preparatory studies.

38 The Digging for the Cross

Pen and wash, 156 x 155 mm.
Contours pricked for transfer. Old
inscription: *AElsheimer inv. fec.*
Frankfurt a. M., Graphische
Sammlung im Städelschen
Kunstinstitut, inv.no.16736
(Frankfurt and Edinburgh only)

LITERATURE Weizsäcker 1952,
no.40 B; Crinò 1965, p.575; Möhle
1966, no.B2; Van Gelder/Jost 1967,
II, p.32; Andrews 1977, no.41;
Andrews 1985, no.41
See cat.no.20 for commentary.

39 Il Contento

Pen and wash over black chalk,
239 x 330 mm
Paris, Musée du Louvre, Cabinet des
Dessins, inv.no.33.953
(not exhibited)

LITERATURE Formerly thought to be
anonymous French, seventeenth
century
Andrews 1971, p.7f.; Andrews 1977,
no.43; Andrews 1985, no.43
See cat.no.25 for commentary.

40 Il Contento

Pen and wash over black chalk,
288 x 374 mm. Two sheets joined
together. Contours indented for
transfer.
Edinburgh, National Gallery of
Scotland, inv.no.RSA 298
(Frankfurt and Edinburgh only)

LITERATURE Andrews 1971, p.9f.;
Andrews 1977, no.44; Andrews
1985, no.44
See cat.no.25 for commentary.

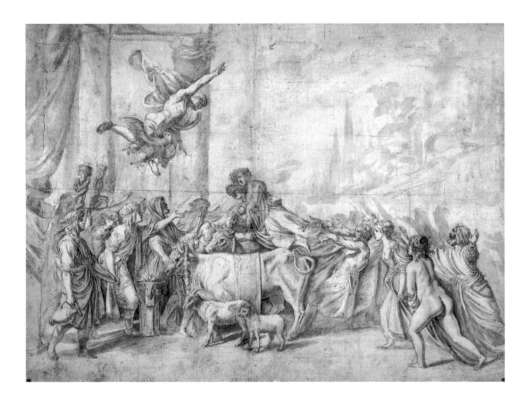

41 Il Contento

Pen and wash, 264 x 417 mm.
Contours indented for transfer.
Paris, Musée du Louvre, Cabinet des
Dessins, inv.no.18657
(Frankfurt and Edinburgh only)

LITERATURE Demonts 1938, vol.II,
no.558 (as school or manner of
Adam Elsheimer); Andrews 1971,
p.11f.; Andrews 1977, no.45;
Andrews 1985, no.45
See cat.no.25 for commentary.

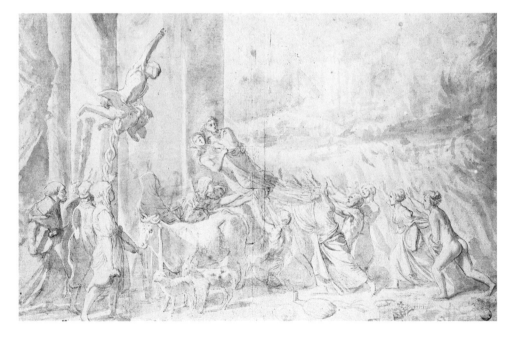

42 The Mocking of Ceres

Gouache, 159 x 104 mm. Inscribed
on the lintel by a later hand: *AVE*.
Hamburg, Kunsthalle,
inv.no.1927-105
(Frankfurt only)

LITERATURE Möhle 1966, no.37;
Andrews 1977, no.50; Andrews
1985, no.50
See cat.no.27 for commentary.

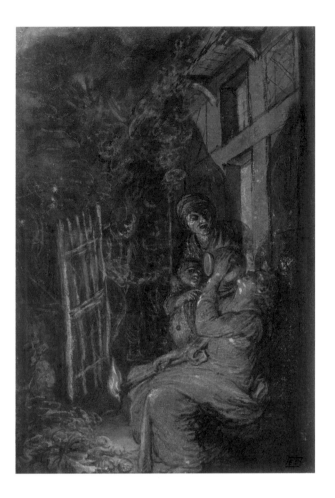

43 Ceres Turns the Mocking Boy into a Lizard

Gouache, 110 x 68 mm. Nineteenth-
century inscription on the verso: *A.
Elsheimer f geb. Frankfurt 1574.*
Vaduz, Wolfgang Ratjen Foundation
(Frankfurt and Edinburgh only)

LITERATURE Andrews 1977, no.51;
Andrews 1985, no.51
See cat.no.27 for commentary.

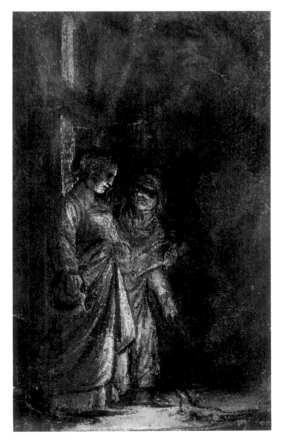

44 The Beheading of John the Baptist

Gouache, 78 x 67 mm
Chatsworth, Trustees of the
Chatsworth Settlement, inv.no.851 C
(Frankfurt and Edinburgh only)

LITERATURE Möhle 1966, no.45;
Andrews 1977, no.48; Andrews
1985, no.48; M. Jaffe, *The
Devonshire Collection of Northern
European Drawings*, 5 volumes,
London/Turin 2002, vol. 4, p.476,
no.1536
See cat.no.28 for commentary.

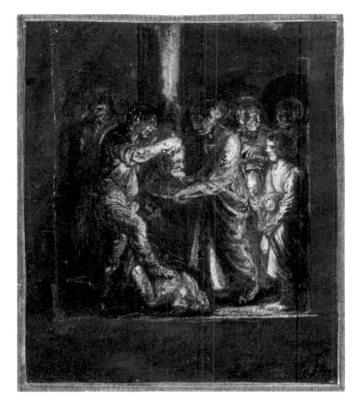

45 Tobias and the Angel

Gouache, 70 x 95 mm
Berlin, Staatliche Museen,
Kupferstichkabinett, inv.no.KdZ
8498
(Frankfurt and Edinburgh only)

LITERATURE Möhle 1966, no.44;
Andrews 1977, no.47; Andrews
1985, no.47
See cat.no.30 for commentary.

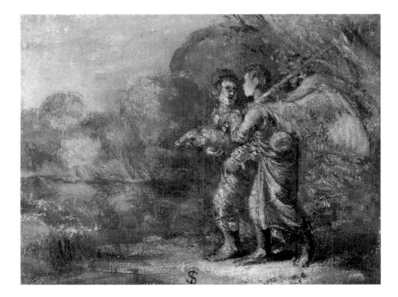

46 Tobias and the Angel

Etching, 92 x 146 mm
Frankfurt a. M., Graphische
Sammlung im Städelschen
Kunstinstitut
(Frankfurt only)

LITERATURE Hollstein, vol.VI, no.8;
Andrews 1977, no.58; Andrews
1985, no.58
See cat.no.30 for commentary.

47 Jupiter and Mercury in the House of Philemon and Baucis

Gouache, 102 x 160 mm. Laid down
on another sheet with the inscrip-
tion: *Adam Elseimer* (19. Jh.).
Warsaw, Muzeum Narodowe,
inv.no.146603 /17 MNW
(Frankfurt and Edinburgh only)

LITERATURE Monkiewicz 1988,
pp.93–105; exh. cat. Washington
1993, no.23
See cat.no.35 for commentary.

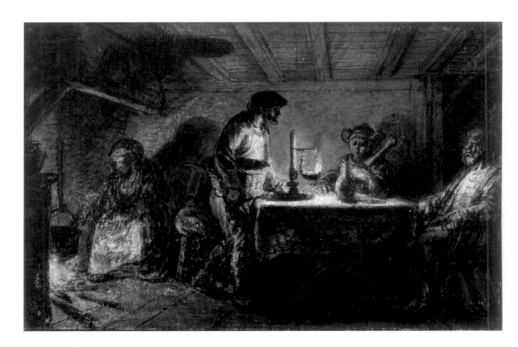

Engravings and Etchings after Elsheimer

SIMON FRISIUS
(c.1580–before 1628);
HENDRICK HONDIUS
(1573–after 1648)

48 Portrait of Adam Elsheimer

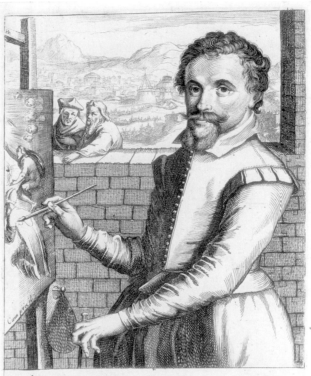

Engraving, 209 x 123 mm,
inscribed *HH*
From *Pictorum Aliquot Celeberium
praecipue ...* The Hague (c.1610)
Frankfurt a. M., Graphische
Sammlung im Städelschen
Kunstinstitut, 49693
(Frankfurt only)

LITERATURE Nagler, vol.VI, 280;
Nagler Monogr, vol.III, 1034;
Hollstein, vol.VII, p.32; N. Orenstein,
The New Hollstein: Hendrick
Hondius, Amsterdam 1994, p.90
See cat.no.37 for commentary.

HENDRICK GOUDT
(1580/85–1648)

49 Salome Receiving the Head of Saint John

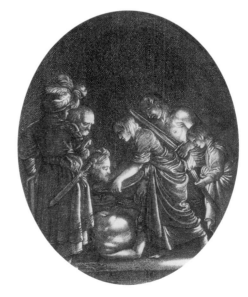

Engraving, oval, 65 x 53 mm,
inscribed *AE* and *HG*
London, The British Museum,
inv.nos. F-3-94; S4961; S4962

LITERATURE Hollstein, vol.VIII, no.4
See cat.no.28 for commentary.

HENDRICK GOUDT

50 Tobias and the Angel

1608
Engraving, 132 x 189 mm, inscribed
AEhlsheimer pinxit and *HGoudt skulpt. 1608*
London, The British Museum,
inv.nos. S4957, 1868-8-22-796

LITERATURE Hollstein, vol.VIII, no.1
See cat.no.30 for commentary.

51 The Mocking of Ceres

Engraving, 315 x 235mm, inscribed
AEhlsheimer pinxit and *HGoudt skulpsit Romae 1610*
Edinburgh, National Gallery of
Scotland, inv.no.P2686

LITERATURE Hollstein, vol.VIII, no.5
See cat.no.26 for commentary.

52 Jupiter and Mercury in the House of Philemon and Baucis

Engraving, 204 x 222 mm, inscribed
HGoudt 1612
Edinburgh, National Gallery of
Scotland, inv.no.P2769

LITERATURE Hollstein, vol.VIII, no.6
See cat.no.35 for commentary.

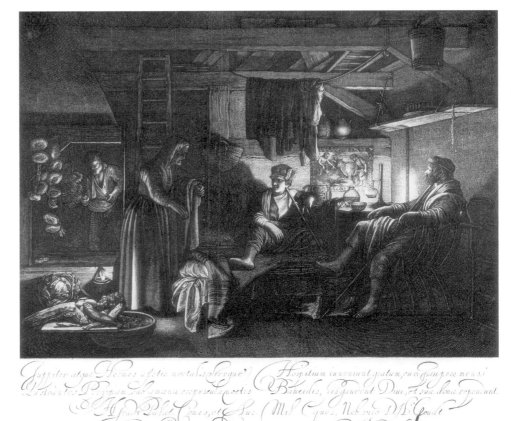

53 Aurora

Engraving, 165 x 187 mm, inscribed
HGoudt 1613
London, The British Museum,
inv.no. F.3-104

LITERATURE Hollstein, vol.VIII, no.7
See cat.no.29 for commentary.

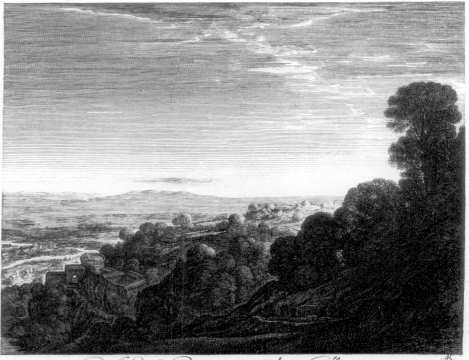

HENDRICK GOUDT

54 Tobias and the Angel

1613
Engraving, 260 x 272 mm,
inscribed *HGoudt 1613*
London, The British Museum,
inv.no. F3-100

LITERATURE Hollstein, vol.VIII,
no.2
See cat.no.34 for commentary.

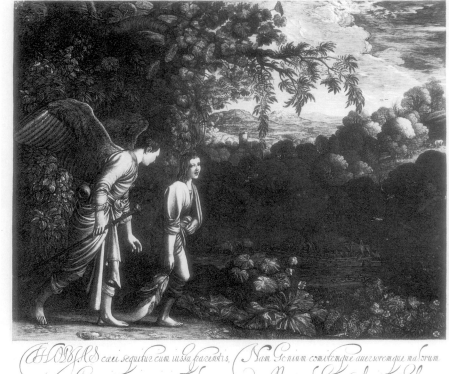

55 The Flight into Egypt

Engraving, 350 x 398 mm,
inscribed *HGoudt 1613*
Edinburgh, National Gallery of
Scotland, inv.no.P2773

LITERATURE Hollstein, vol.VIII,
no.3
See cat.no.36 for commentary.

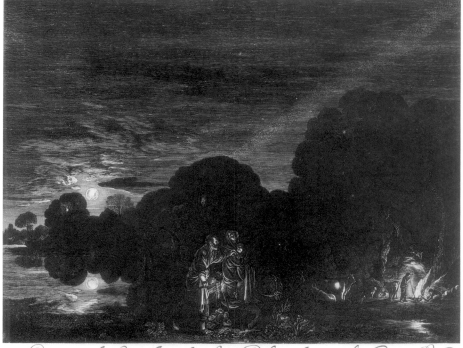

WENCESLAUS HOLLAR
(1607–1677)

56 Mercury and Herse

Etching, oval, 80 x 98 mm
London, The British Museum,
inv.nos. 1977u.376(1),
1850-2-23-227

LITERATURE Parthey 268
See cat.no.24 for commentary.

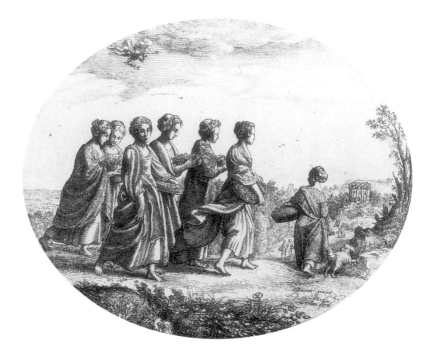

57 The Realm of Venus

Etching, 95 x 150 mm
Edinburgh, National Gallery of
Scotland, inv.no.P2714B

LITERATURE Parthey 271
See cat.no.32 for commentary.

WENCESLAUS HOLLAR

58 The Realm of Minerva

Etching, 95 x 148 mm
Edinburgh, National Gallery of
Scotland, inv.no.P2714A

LITERATURE Parthey 270
See cat.no.32 for commentary.

59 The Realm of Juno

Etching, 91 x 173 mm
Edinburgh, National Gallery of
Scotland, inv.no.P2714C

LITERATURE Parthey 269
See cat.no.32 for commentary.

60 Landscape with Latona

Etching, 171 x 231 mm
London, The British Museum,
inv.no. 1977 u. 376(6)

LITERATURE Parthey 272
See cat.no.33 for commentary.

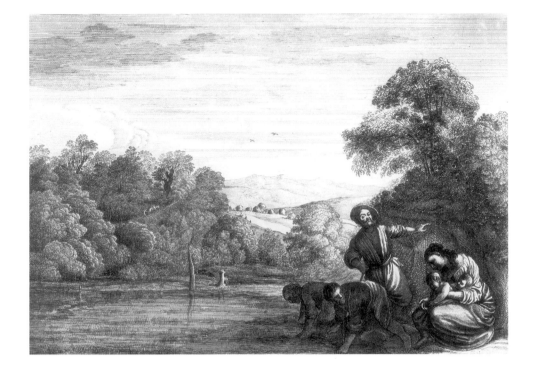

Hidden Treasures:
Collecting Elsheimer's Paintings in Britain

EMILIE E.S. GORDENKER

Giulio Mancini, a near contemporary of Adam Elsheimer, wrote a short passage about the artist shortly after his death. Mancini remarked: 'One sees little of his work because he produced little and this little is in the hands of princes and those persons who, in order that they should not be taken from them, keep them hidden'.[1]

Had he been better informed about the whereabouts of Elsheimer's paintings, Mancini might have known that a surprising number were probably already squirrelled away in Britain, and more would follow. Some 360 years later, Keith Andrews (to whom this exhibition is dedicated) remarked: 'It is astonishing to note how many of the extant works were at one time in British collections, or are still there.'[2] The appendix to this essay lays out the provenance, as we know it, of paintings by Elsheimer that are in Britain or were there for a notable period. Some of the early history of the works is based on educated guesses, but has only been included when there is a good chance of accuracy. The analysis shows that of Elsheimer's surviving works, more than half found their way to Britain and more than a quarter were already there in the seventeenth century. This essay endeavours to explain why.

In the first decades of the seventeenth century, a small but significant group of British connoisseurs were forming some of the most spectacular collections in Europe. This came as a surprise to some Continental visitors, such as the artist Peter Paul Rubens. During his visit to England between 1629 and 1630, Rubens wrote to his friend, the eminent French antiquarian Nicolas-Claude Fabri de Peiresc: 'I certainly haven't encountered the barbarity in this island that one might presuppose from its climate, so far removed from Italian elegance. Rather, I confess that as concerns excellent pictures by the hands of first-class masters, I have never seen so large a group all together, as in the royal household, in that of the late Duke of Buckingham, and at the residence of the Earl of Arundel'[3]

The three collectors whom Rubens singled out – Charles I, the Duke of Buckingham, and the Earl of Arundel – were among Elsheimer's foremost devotees and established the artist's reputation in Britain.[4]

Facing page:
detail cat.no.19

Arundel

Thomas Howard, second Earl of Arundel (1585–1646) played the most significant role as a collector of Elsheimer's works – certainly in Britain, but arguably in Europe as a whole.[5] Although we know that Arundel's collection must have been remarkable for its size and quality, no records of its content have survived. What is certain, however, is that Arundel was an extraordinarily committed and knowledgeable collector with a broad sweep of interests. He had a network of diplomats and agents who kept him informed and through whom he bought deliberately and judiciously, driving a hard bargain for what he wanted. Arundel was a keen collector of antiquities and formed an impressive library of books on painting and architecture. Daniel Mytens's portraits of Arundel and his wife, Aletheia Talbot (d. 1654),[6] show the couple seated before the gallery in their London property, Arundel House, which was designed by Arundel's friend and travelling companion, the great architect Inigo Jones (figs.126, 127). Although the view in Mytens's portrait is almost certainly imaginary, the fact that the sculptures appear so prominently speaks volumes about Arundel's pride in his collection and his interest in antiquities.

Fig.126
Daniel Mytens, *Thomas Howard, Second Earl of Arundel*, 1618, Arundel Castle

Fig.127
Daniel Mytens, *Aletheia Talbot, Countess of Arundel*, 1618, Arundel Castle

Fig.128
Sir Anthony
van Dyck,
*Thomas Howard,
Second Earl of
Arundel,*
*c.*1620–21,
Los Angeles,
J. Paul Getty
Museum

Along with antiquities, Arundel collected drawings, prints and paintings. What we know about Arundel's pictures derives from two main sources. He commissioned from the artists Wenceslaus Hollar, Peter van den Borcht and Lucas Vorsterman a remarkable group of prints reproducing works in his collection. Although this project was never completed, it does allow us to trace certain pictures to Arundel. An inventory of pictures and works of art taken in Amsterdam in 1655, after the countess's death, lists 799 works.[7] The attributions should be taken with some scepticism, and we know that the list is far from complete, because paintings recorded in the prints by Hollar and Van den Borcht do not always appear. Nevertheless, the inventory gives an idea of Arundel's taste in pictures and demonstrates that this must have been one of the greatest collections in Europe.[8]

The largest group of Arundel's paintings were by Venetian artists, including an astonishing thirty-seven assumed to be by Titian. Notably, and much more unusually for English collectors, Arundel had a particular interest in German painting. The 1655 inventory lists no less than forty-four works by Holbein and sixteen paintings and watercolours by Dürer. His taste for German art must have been remarkable for the time – so much so that his personal secretary Edward Walker noted that Arundel's paintings 'were numerous and of the most excellent Masters, having more of that exquisite Painter Hans Holben than are in the World besides. And he had the Honour to be the first Person of Quality that set a Value on them in our Nation'.[9]

Although the names Dürer and Holbein appear frequently in early sale catalogues and inventories, Arundel's collection also included more unusual names, such as Albrecht Altdorfer, Lucas Cranach and Hans Sebald Beham, which indicates a real interest in German art.[10]

Arundel took an interest in work by living artists, too. In his own day, he was recognised as a connoisseur with a keen eye for contemporary, and particularly Northern art.[11] Rubens himself praised Arundel as 'a supporter of our art'.[12] The 1655 inventory includes several paintings by Johann Rottenhammer, Paul Bril and David Teniers, Elsheimer's Flemish contemporaries working in Rome. Arundel also patronised Anthony van Dyck, who painted his portrait during his first visit to England, in 1620–21 (fig.128), and he was responsible for bringing Hollar and Van der Borcht to England to illustrate his collection.

We know that Arundel certainly owned three paintings by Elsheimer before 1646, because dated prints by Hollar after the pictures survive with an inscription stating explicitly that they were in Arundel's collection. These are *The Realm of Venus* (cat.no.32a), *The Realm of Minerva* (cat.no.32b) and *The Realm of Juno*, now known only through Hollar's etching (cat.no.59). Additionally, the 1655 inventory of the Countess of Arundel lists a '*Latona*' by Elsheimer (cat.no.33).[13] By the Restoration, Arundel's grandson, Thomas Howard, fifth Duke of Norfolk (1627–1677), had inherited a good portion of his collection. Norfolk owned several works by Elsheimer, and it is likely these were at one time in Arundel's possession. All of Norfolk's Elsheimers are now in Frankfurt: *Jacob's Dream* (cat.no.4), *The Conversion of Saul* (cat.no.5) and the central and upper right sections of *The Finding and Exaltation of the True Cross* (cat.no. 20a,b). The altarpiece has a particularly intriguing history. The central panel was certainly in the collection of the Duke of Norfolk. The other paintings that made up the altarpiece all have an English provenance, which suggests that they were very probably together in England at one time, and may have been in Arundel's collection.[14] It has even been suggested that Arundel acquired the altarpiece as a trade with Duke Cosimo II of Florence for a portrait by Holbein of Sir Richard Southwell (fig.129), which entered the Medici collection in 1621.[15] Desperate to have a top quality Holbein, Cosimo could have bought the altarpiece deliberately as a bargaining chip, because he knew of Arundel's interest in Elsheimer through his agents in London. It is unlikely, however, that the trade took place, as the altarpiece is documented in the collection of Carlo de' Medici on 19 May 1626.[16] In any event, if all the works from the Duke of Norfolk's collection were originally Arundel's, then he would have owned roughly one-fifth of Elsheimer's paintings before the middle of the

seventeenth century, by far the most of any early collector.

Why would Elsheimer's little paintings have appealed so much to Arundel? He was almost certainly aware of Elsheimer through his network of English diplomats and agents. When Arundel was in Rome in 1614, Elsheimer was no longer alive and his studio no longer existed, but Elsheimer's widow might have been able to direct Arundel to her late husband's paintings.[17] Arundel was also in close touch by letter with a group of well-informed scholars and painters. One of these was Rubens, who lamented Elsheimer's death in a letter of 1611, writing that he 'had no equal in small figures, in landscapes, and in many other studies'.[18] In the same letter, Rubens encouraged the artist's widow to send a *Flight into Egypt* for sale to Antwerp, where there were 'countless numbers of people interested in works of small size' and even offered to take care of the painting if no immediate buyer was found.[19] Later, Rubens himself bought four of Elsheimer's paintings.[20] It quite possible that Rubens communicated his enthusiasm directly to Arundel.

A knowledgeable and distinguished connoisseur, Arundel would have been more than capable of recognising the great quality and originality of Elsheimer's paintings. For that reason alone, it is not surprising that he would have been interested, but Elsheimer's paintings combined ingredients that seem tailored to Arundel's tastes. Arundel, as we have seen, had a particular interest in German art. The detailed renderings and smooth surfaces that characterise the portraits of Holbein have an echo in Elsheimer's highly wrought surfaces, albeit on a much smaller scale, and Altdorfer's landscapes are an important precedent for those of Elsheimer. Arundel also collected works by Elsheimer's Flemish contemporaries working in Italy, and he must have seen that Elsheimer was the most original landscape painter of the group. A widely read intellectual, Arundel would have appreciated the erudition of Elsheimer's references. He would almost certainly have recognised the relatively obscure source for *Il Contento*, the picaresque novel *Guzman de Alfarache* by Alemán. And for a collector of small, jewel-like objects – Arundel owned a famous group of antique gems – the tiny format and brilliant finish of Elsheimer's paintings must have had great appeal.

Buckingham

The meteoric rise of the courtier and royal favourite George Villiers, first Duke of Buckingham (1592–1628) enabled him to put together a world-class art collection.[21] In the short period from his arrival at the court of James VI and I in 1614 to his assassination in 1628, Buckingham acquired a staggering amount of property

Fig. 129
Hans Holbein,
Sir Richard Southwell, 1536.
Florence, Galleria degli Uffizi

and become an important patron of the visual and dramatic arts.[22] He bought rapidly and in bulk, often using intermediaries. Sir Balthasar Gerbier, an art agent, miniature painter, architect, and close friend of Rubens, played a crucial role in the formation of Buckingham's collection.[23] In 1625, Gerber told Buckingham: 'Sometimes when I am contemplating the treasure of rarities which your excellency has in so short a time amassed, I cannot but feel astonishment in the midst of my joy; for out of all the amateurs and princes and kings there is not one who has collected in forty years as many pictures as your excellency has collected in five!'[24] Indeed, he seems to have assembled his painting collection in ten years, from 1618 and 1628, with most of the objects being in place by 1626.[25]

Buckingham's collection is well documented. His residence York House (later Buckingham House) on the River Thames was used for official functions and displaying most of his picture collection. Unlike Arundel, Buckingham had little interest in prints, drawings or German art. He focused his attention on sculpture and paintings by or attributed to Italian and Flemish artists and, like many of his contemporaries, he had a taste for Venetian paintings. Buckingham was introduced to great picture collections in London, Paris and The Hague, and perhaps most importantly in Madrid. When the future Charles I travelled to the Spanish court in 1623 with the intent of securing the hand of the Infanta, Buckingham accompanied him. Although the mission was not a success, Buckingham and Charles were deeply impressed by Philip IV's court and its astounding picture collection. Buckingham so

admired Titian's portrait of Charles V riding at Mühlberg that he had a copy painted for the hall of York House. He later commissioned a portrait of himself on horseback by Rubens.[26] The painting was destroyed in 1945, but an oil sketch for it survives (fig. 130).

Buckingham's collection, while selected and acquired in a manner different from that of Arundel, nevertheless followed the trend set by other prominent contemporary collectors in its concentration on Italian and Flemish paintings, statues and rare curiosities. While Arundel developed a deep and abiding intellectual interest in his collection, Buckingham might very well have had another agenda aside from the personal enjoyment of the objects he owned: to advance his cultural power and prestige by equalling if not surpassing the great art collectors of his day.[27] Although his interests diverged from those of Arundel, it is possible that he was tempted to acquire paintings by his rival's favourite, Elsheimer. Gerbier, who tapped into the same circle of contacts and agents, could easily have helped steer Buckingham to his prize.

Buckingham certainly owned the delightful series of eight paintings, each showing a saint or biblical figure in a landscape, now in Petworth (cat.no.21). The series was documented in a posthumous inventory taken at York House in 1635 as 'Ensen Hamor – Eight little pieces', where they were kept in 'My ladyes Redd Closett' along with a great number of other pictures, many of which are described as 'little', by Italian and Northern painters.[28] Given the description of the room and the reference to many of the works as 'little', this must have been a cabinet room, containing precious objects and small-scale works.

Fig. 130
Peter Paul Rubens,
George Villiers, First Duke of Buckingham on Horseback, 1625, Fort Worth, Kimbell Art Museum

Although the early history of Buckingham's group of paintings is uncertain, it might well have shared a similar fate to *The Exaltation of the True Cross*, acquired from Juan Pérez in Rome in 1619 by Cosimo II for the Grand-Ducal collections in Florence.[29] The original series, larger than the present eight, must have been broken up before reaching England in 1635, because at least one copper has a different provenance.[30] Algernon Percy, tenth Earl of Northumberland bought the group from the widowed Duchess of Buckingham during the Civil War, and placed them together in one frame.[31] Although small in format, these little paintings have had an influence far beyond their size – they were copied already in Elsheimer's lifetime and the landscape backgrounds made an impact on other artists, such as David Teniers[32] – and must have been amongst the highlights of Buckingham's collection.

Charles I

The third great seventeenth-century collector of Elsheimer's paintings, Charles I (1600–1649), formed the greatest collection of art of any British monarch (fig. 131).[33] From his older brother, Henry Frederick, Prince of Wales, the young Charles would have learned about antique medals and other precious objects. Charles's education coincided with the rise of the Duke of Buckingham, who became an influential figure in the future king's life and the formation of his tastes. The mission to Madrid in 1623 deeply impressed Charles, as it had Buckingham, and must have encouraged his penchant for Italian painting. In terms of its scale and ambition, the collection that Charles ultimately put together was in line with those on the Continent formed in the last decades of the sixteenth century.[34] Like his Continental predecessors, Charles had a special gallery built for his treasures in Whitehall. It was designed by the Surveyor of the King's Pictures, Inigo Jones.

In 1639, Abraham van der Doort, a Dutch artist and the first Surveyor drew up an inventory of the king's collection.[35] From this list, we know that Charles owned at least one work by Elsheimer, the very early painting *The Witch* (cat.no.1), which he received as a gift from the British Ambassador in Spain, Sir Arthur Hopton (1588–1650).[36] Hopton first arrived in Madrid in July 1629 as secretary to Sir Francis Cottington and, after Cottington left in 1630, remained as resident agent until in 1636. He returned to Spain as resident ambassador in 1638, and remained until he was recalled in 1645. Hopton probably acquired the work during his travels on the Continent in 1629 or 1635, and gave it to Charles before 1639.

Another painting by Elsheimer in the royal collection, *The Adoration of the Magi* (cat.no.6), arrived by a different route. Its early history is uncertain, but it was documented in Buckingham House by 1821. The painting could possibly have been acquired by Charles I from Karel Oldrago, a Flemish painter who lived in Rome and who probably dealt in paintings.[37] We know that Oldrago owned an *Adoration of the Magi* (quite possibly cat.no.6), as well as *The Conversion of Saul* (cat.no.4) which probably then passed to Arundel's collection, but no documentation has come to light to prove that Charles bought directly from him. A painting of a very similar description was documented at Kensington Palace in 1697. At some point in its history, the picture was believed to be by Johann Rottenhammer and, given this attribution, it could be the one listed in the 'Water-Closet' at Windsor Castle in the reign of George II as 'Rottenhamer. The Wisemen offering by Rottenhamer' with a note 'these are very good of their kind'.[38]

Fig.131
Anthony
van Dyck,
*Charles I
in Three Views*,
Windsor Castle,
The Royal
Collection

Elsheimer's Paintings in Seventeenth-Century British Collections

That *The Adoration of the Magi* might have found its way to a 'Water-Closet' at Windsor today might seem amusing, yet to some extent it makes a point about how Elsheimer's small paintings would have fitted into the grand collections being formed at the beginning of the seventeenth century in Britain. Elsheimer's paintings were suitable for a 'cabinet of curiosities' – a place in which rare, small-scale and sometimes exotic objects were kept, more often for private study than for public display.[39] Early forms of the cabinet were the fourteenth-century French *estudes* and the fifteenth- and sixteenth-century Italian *studioli*, both terms meaning 'study'. In about 1550, the word *Kunstkammer* ('chamber of art') was introduced in connection with Emperor Ferdinand I's collection of paintings, rare objects, games and natural history specimens in a self-contained location in Vienna. Soon after, the term *Wunderkammer* ('chamber of marvels') appeared in the chronicle of the Grafen von Zimmern of 1564–66 to describe a room containing rare natural history specimens, with an emphasis on the abnormal. In 1565, Samuel von Quiccheberg defined both terms, calling the former a close chamber filled with objects fashioned with art and the latter a collection of marvellous things. In the late sixteenth century, the terms were combined into *Kunst- und Wunderkammer*, a term that is still generally used to describe an all-embracing collection that held prized and wondrous objects, both man-made and from the natural world. In the later sixteenth century, a *Kunst- and Wunderkammer* was established in almost every court in Germany, and perhaps the finest was that of Rudolf II

in Prague. Rudolf's brother, Archduke Albert, established one in Brussels (fig.132). During the seventeenth century, the *Kunstkammer* became in integral part of royal patronage, as well as a status symbol for the well-off middle classes and, in Catholic countries, for monasteries and church dignitaries. Although they remained comprehensive, embracing rare objects from the natural and artistic worlds, the seventeenth-century *Kunstkammer* placed perhaps more emphasis on precious materials and smaller objects than earlier ones had.

In Britain, cabinets were formed along the general lines of the great *Kunstkammern* of the rest of Europe. Unlike their Continental counterparts, however, British noble cabinets tended to focus more on fine art than on natural history, exotic rarities and other 'curiosities'.[40] Paintings in these cabinets tended to be small and precious, and it is in this context that Elsheimer's works were placed. Most of Charles I's collection was held in the private apartments, or 'Privie Lodgings' as they were called.[41] The inventory of 1639 mentions a 'new erected Cabbonnett' in the Privie Lodgings, where Charles installed seventy-three of his smaller pictures, alongside reliefs, sculptures and miniatures, as well as books of special artistic interest. Elsheimer's *The Witch* was kept in this cabinet. We have seen that Buckingham's series of little landscapes was listed in 'My ladyes Redd Closett', along with other small-scale works. Although we have no information about the exact scheme of Arundel House, Arundel may very well also have displayed his Elsheimers with other small works in a cabinet. It was not only the small scale of Elsheimer's paintings, but their rarity and precious quality that must have made them particularly well-suited to the early seventeenth-century British cabinet.

Fig.132
Jan Brueghel
and Peter Paul
Rubens,
*The Sense of
Sight*,
Madrid,
Museo del Prado

The three great early British collectors of Elsheimer's paintings went about acquiring works of art in a different manner and had distinct taste. Nevertheless, there are significant overlaps. All three men modelled their collections on a similar mixture of theoretical writings and what they had seen in the courts of Italy and Spain and in the Netherlands.[42] They were part of the same network of advisers and friends: the names of Rubens, the architect Inigo Jones, and the agents Dudley Carleton and Balthasar Gerbier, as well as others, recur in relation to all three men. Their taste in painting, although not identical, was often comparable. While they may have prized Venetian history paintings over others, they all collected small-scale works appropriate for a cabinet. These early collectors not only brought a critical number of Elsheimer's paintings to Britain, but established a taste and admiration for them that was to last in Britain until the present day.

Elsheimer's paintings – whether in versions we now believe to have been copies or originals – continued to appear in some of the most important British collections throughout the seventeenth century. Arundel owned what we now know was a copy of the *Saint Christopher* (see cat.no.13). It was given to Charles I, and recorded as an Elsheimer in the inventory of 1639.[43] The picture was sold in 1649 with most of the rest of Charles's collection, but was eventually bought back by Queen Mary. Although now considered a copy, it must have been a valuable gift to the king, and is a

tangible demonstration of Arundel's and Charles's shared admiration for the artist. *The Mocking of Ceres* (cat.no.26), until recently thought to be a copy but now believed to be the damaged original, was part of a group of pictures known as the 'Dutch Gift', given to Charles II at the Restoration of the monarchy in 1660.[44] A *Jupiter and Mercury in the House of Philemon and Baucis* (a copy of cat.no.35) turned up in the 1682 sale of the painter and consummate collector, Sir Peter Lely as 'Elsheimer: a curious small piece being the history of Philemon and Baucis …'.[45]

British Collectors of Elsheimer after the Seventeenth Century

Great British collectors in subsequent centuries continued to covet Elsheimer's paintings. A group of pictures, including several from Arundel's collection, found their way into the collection of Thomas Newport, Baron Torrington (1655–1719). Documented in Torrington's house in 1715 and again in Lady Torrington's house in 1719 were: *The Realm of Venus* and *The Realm of Minerva* (cat.no.32a,b), two of the series of three from Arundel's collection and reproduced by Hollar; the four smallest panels from the lower register of 'The Frankfurt Tabernacle' (cat.no.20); 'A Naked Woman sleeping with other Figures', which must be the *Apollo and Coronis* (cat.no.31); and a *Stoning of Saint Stephen*, which is probably not the Edinburgh picture

(cat.no.19) but possibly a version of it currently on loan to the Wallraf-Richartz Museum in Cologne.[46]

Torrington almost certainly inherited his paintings from his father, Francis Newport, first Earl of Bradford (1619–1708). The first Earl of Bradford was a formidable collector, with a particular interest in the paintings of Van Dyck.[47] He bought several works from the sale of the collection and studio contents of Sir Peter Lely in 1682[48] and continued to build his collection in subsequent years. The famous diarist, John Evelyn, remarked in 1685 that he 'has some excellent pictures'.[49] Upon Torrington's death in 1719, the collection must have passed to his brother, Richard Newport, second Earl of Bradford (1644–1723), whose widow Mary Wilbraham (1661–1737) brought the collection to her family's house, Weston Park, in 1735.[50] Weston Park was celebrated, not only for its glorious Palladian architecture, but for the rich collection of paintings kept there. By this time, the Bradford collection included pictures by the desirable Italian painters Bassano, Giorgione, Veronese, Titian and Guido Reni, but also many Northern cabinet pictures by artists such as Johann Rottenhammer, Paul Bril, Cornelis van Poelenburch and Jan Brueghel the Elder.

Sir Paul Methuen (1672–1757), British ambassador in Lisbon, Madrid and Turin, formed an important collection of pictures, which had works then attributed to Titian, Tintoretto and Veronese, as well as major paintings by Northern artists Van Dyck, Rubens, Gérard de Lairesse, Jan Both and Holbein.[51] As Methuen died childless, his cousin (also named Paul Methuen) inherited the pictures, which he installed at Corsham Court.

Methuen's busy career took him to the great artistic centres of Europe. In 1715, he was appointed ambassador to Spain. It was possibly during this visit, but more likely when he had returned to England, that Methuen bought *Saint Paul on Malta* (cat.no.9).[52] The early history of the painting is largely a matter of speculation. A 'Shipwreck of St. Pablo, small, by the hand of Adam' was in the collection of Giovanni Battista Crescenzi, a Roman painter who was in Madrid as Spanish agent and architect to the King of Spain. An undated document in the Public Record Office states that Crescenzi gave a group of paintings to Sir Dudley Carleton, the English ambassador in Venice and a figure we have encountered before, in relation to Arundel.[53] It has been suggested that Crescenzi's paintings may have been offered to James VI and I for presentation to the Earl of Somerset and that, after Somerset's disgrace, the collection made its way into the hands of Arundel. It is not certain, however, that the *Saint Paul on Malta* was among these works. Another possibility could be that Crescenzi offered part of his collection to Charles I, with Sir Francis Cottington in Spain and Dudley Carleton in England

acting as intermediaries.[54] An inscription on the reverse of the painting, however, indicates that it was bought in Antwerp. So, if Methuen acquired the work during a diplomatic mission to Spain, the painting would have gone from Crescenzi to Antwerp, possibly via the Arundel collection, and then back to Madrid before finally reaching England. It has been suggested that Rubens, who was in Spain on a diplomatic mission between August 1628 and April 1629, might have alerted Cottington to Crescenzi's collection and might also have been the reason for its presence in Antwerp. Whichever scenario is the correct one, the picture's history brings out the close ties between the small group of collectors vying for Elsheimer's paintings. Methuen acquired a second painting by Elsheimer, the *Apollo and Coronis*, which is recorded in his London house in Grosvenor Street before his death in 1757.[55]

Later in the eighteenth century, Richard Payne Knight (1751–1824) acquired *Il Contento* (cat.no.25). Knight, a controversial figure and voracious collector, was one of the leading figures of the Enlightenment (fig.133). He was educated at home, and instead of attending university travelled to France and Italy in 1772 and 1773. These early experiences must have contributed to his interest in classical history and archaeology as well as to his independent, even iconoclastic, taste and opinions on art. Knight was elected to the Society of Dilettanti in 1781 and became a founding member of the British Institution in 1805. His bequest of bronzes, gems and Old Master drawings is one of the cornerstones of the British Museum's collection.[56] Knight built a superb house on land he inherited at Downton in Herefordshire, and furnished it with his splendid collection of art and antiquities.

Elsheimer's *Il Contento* (cat.no.25) is documented as having been at Downton in the eighteenth century. The originality of the picture's composition and the close observation of the figures and landscape background must have suited Knight's taste in pictures. He believed that painting could only be perfected by the study of nature, and not through theoretical or academic study. According to Nicholas Penny, 'for Knight the great achievements of paintings had been those of the artist working independently, gaining an intuitive feeling for his materials and developing original and even idiosyncratic methods of imitation'.[57] On the basis of these criteria, Knight held the rather unconventional view for his time that Rembrandt and other Dutch painters were on a par with Italian Renaissance artists. Knight's collection of paintings, while not as impressive as his drawings, reflected his originality as a thinker. Most of his pictures were cabinet sized, possibly because of a limited budget, but also because he objected to large works on theoretical grounds.[58] *Il Contento*, with its small scale, original composition and closely observed detail, fitted well into Knight's picture

Fig.133
Sir Thomas
Lawrence,
*Richard Payne
Knight*,
The University
of Manchester,
Whitworth Art
Gallery

collection. The painting also must have dovetailed with the rest of Knight's holdings and interests: the obscure text with its references to Roman gods might well have appealed to his love for antiquity; the highly wrought surface has a jewel-like quality that probably appealed to a collector of ancient gems; and the ruined temple in the background could have reminded Knight of expeditions to Italy.

The remaining paintings listed in the appendix arrived in Britain in various ways and for different reasons. *The Baptism of Christ* (cat.no.8), which eventually found its way to the National Gallery in London, was in the collection of the painter Sir Joshua Reynolds in the eighteenth century, suggesting that Elsheimer continued to appeal to painters and collectors alike. *Judith and Holofernes* (cat.no.14) was amongst a group of pictures captured from Joseph Bonaparte in Spain by the first Duke of Wellington in 1813. Wellington tried to return the booty to the Spanish king, who graciously refused, so the collection, including the painting by Elsheimer, remained intact. The Wellcome Institute for the History of Medicine purchased *Saint Elizabeth Tending the Sick* (cat.no.2) in 1928, probably for its subject matter of the saint caring for the sick in a hospital. Only much later did the correct attribution emerge.[59]

Conclusion

That Elsheimer's pictures were so highly prized in Britain practically from the time they were painted must be testament to more than a passing vogue. In the seventeenth century, collectors would have appreciated the small, precious objects as appropriate for their burgeoning cabinets. Elsheimer's landscapes suited English taste, particularly in the seventeenth century, when collectors admired Roman *vedute* and ruins.[60] For erudite collectors, such as Arundel and Knight, Elsheimer's novel treatment of narrative must have had particular appeal. Once in Britain, Elsheimer's works tended to remain in the country, often in great collections, such as those of Methuen, Bradford and Knight.

Elsheimer's paintings have always had the appeal of being precious. In his exhaustive account of paintings in British collections, the nineteenth-century German writer Gustav Friedrich Waagen singled out Elsheimer's paintings, often praising them and repeatedly calling his work 'rare'.[61] Waagen saw the *Saint Paul on Malta* (cat.no.9) in the collection of Paul Methuen, for example, and wrote an enthusiastic response: 'A small rich picture, in which the tendency to the fantastic, the art of lighting, and the conscientious solidity of execution belonging to this rare master, are seen in a great degree'.[62] Perhaps because he was German, Waagen's repeated remarks about the rarity of Elsheimer's paintings suggests a certain astonishment at finding them in Britain. And yet, had he known the long ties between British collectors and Elsheimer's paintings, he would not have been surprised. Waagen was not the first to note the rarity of Elsheimer's work. Mancini, quoted at the beginning of this essay, commented that Elsheimer produced few works. In 1642, Giovanni Baglione noted: 'One does not see his works in public, because he painted little, and in such a size that in any public exhibition they would have remained unnoticed'.[63] Although Baglione correctly identified the scarcity of his works, he could have had no way of knowing that now, more than 350 years after he published his book, roughly half of Elsheimer's works are in Britain and are all accessible by the public. Although small, Elsheimer's paintings are far from unnoticed, and remain some of the most prized possessions in British collections.

NOTES

My thanks to Alfred Bader, Xanthe Brooke, Michael Clarke, Susan Foister, David Howarth, Rüdiger Klessmann, Alastair Laing and Nicholas Penny for assistance with this essay.

1 Mancini, *Considerazioni*, vol.I, p.228. Translation from Andrews 1977, p.52.

2 Andrews 1977, p.10.

3 The letter was dated 9 August 1629. In Rooses/Ruelens 1887–1909, vol.V, p.152.

4 Andrews remarked, 'Collectors of Elsheimer's works appeared early on the scene and nowhere more persistently than [in Britain], headed by Thomas Howard, Earl of Arundel'. Andrews 1977, p.10. On collections formed in the first part of the seventeenth century in England, see Brown 1995; Howarth 1997; Chaney 2003. On Rubens in England, see F. Donovan, *Rubens and England*, New Haven and London, 2004.

5 For information about Arundel's life and activities as a collector, see Hervey 1921; Howarth 1984; D. Jaffe *et al.*, 'The Earl and Countess of Arundel: Renaissance Collectors', *Apollo*, 144, August 1996, pp.3–35; White 1995; Howarth 2002; entry by R. Malcolm Smuts in the *Dictionary of National Biography*, Oxford, 2004.

6 Although Aletheia's role as a collector is not known with any certainty, she undoubtedly contributed to the collection as well. See D. Howarth, 'The Patronage and Collection of Aletheia, Countess of Arundel, 1606–1654', *Journal of the History of Collections*, 10, 1998, pp.125–37; E.V. Chew, 'The Countess of Arundel and Tart Hall', in Chaney 2003, pp.285–314.

7 For a transcription of the original, see Cust/Cox 1911, pp.282–86 and 323–25. See also Hervey 1921, appendix V, pp.472–500.

8 The inventory lists only a few drawings, including a famous album of studies by Leonardo da Vinci (now in Windsor Castle), but he must have he had more. White 1995, pp.25–26.

9 E. Walker, *Historical Discourses upon Several Occasions*, edited by H. Clopton, London, 1705, p.222.

10 It is possible that a good portion of his German paintings might have been a by-product of an embassy that Arundel undertook to Germany in 1612. On Arundel's interest in German art, see S. Foister, ' "My foolish curiosity": Holbein in the Collection of the Earl of Arundel', *Apollo* 144, August 1996, pp.51–56.

11 White 1995, pp.27–28.

12 Francesco Vercellini (?) to Arundel, Antwerp, 17 July 1620. Quoted in Hervey 1921, p.175.

13 See Cust/Cox 1911, p.286.

14 Andrews 1985, p.181.

15 Dated 1536, now in the Uffizi, Florence. For this and the following discussion, see Howarth 1985, pp.71–72 and note 32, p.233; Howarth 2002, pp.76–77.

16 Florence, Uffizi, Guardaroba Medicea, Filza 409, N.117.

17 Howarth claims that Arundel may have had access to Elsheimer's studio when he was in Rome in 1614, where he could have bought directly from the widow. But the studio was no longer in existence in 1614 and the widow remarried in 1611. Howarth 2002, p.77.

18 Letter to Johann Faber dated 14 January 1611. Reprinted in Ruelens/Rooses 1887–1909, vol.VI, p.327. The entire letter appears on pp.327–28; it is translated and reprinted in Andrews 1977, p.51.

19 Recently, it has been suggested that Rubens recalled the central panel of the *Exaltation of the True Cross* when composing his own altarpiece for Santa Maria in Vallicella, the *Madonna Adored by Angels* of 1608: Von Henneberg 1999.

20 For Rubens as a collector, see Muller 1989 and exh. cat. Antwerp 2004 A, esp. pp.98–101.

21 The main biography of Buckingham is R. Lockyer, *Buckingham: the life and political career of George Villiers, first Duke of Buckingham, 1592–1628*, London, 1981. For a brief version with extensive bibliography, see the same author's entry in the *Dictionary of National Biography*, Oxford, 2004.

22 On Buckingham as a collector of art, see P. McEvansoneya, 'Italian Paintings in the Buckingham Collection', in Chaney 2003, pp.315–35.

23 For new information on Gerbier's activities as a dealer, see D. Howarth, 'Rubens and Philip IV: a Reappraisal', in *Sponsors of the Past. Flemish Art and Patronage 1550–1700*, edited by H. Vlieghe and K. Van der Sighelen, Turnhout, 2004, pp.47–60.

24 Letter dated 8 February 1624–25. Cited in G. Goodman, *The Court of King James the First*, edited by J.S. Brewer, London, 1839, vol.2, pp.369–70.

25 McEvansoneya 2003, p.318.

26 He also owned major paintings by Rubens, including the *Cimon and Iphegenia*, *Head of the Medusa*, and *Angelica and the Hermit* now all in the Kunsthistorisches Museum, Vienna.

27 McEvansoneya 2003, pp.319–20, 325–26.

28 The inventory is transcribed in its entirety in S. Jervis, 'Furniture for the First Duke of Buckingham', *Furniture History*, 33, 1997, pp.57–74. The Elsheimer paintings were omitted from the earlier publication of this inventory by R. Davies, 'An Inventory of the Duke of Buckingham's Pictures &c. at York House in 1635', *Burlington Magazine*, 10, 1907, pp.376–82.

29 Laing 1995, p.162.

30 See cat.no.21 for a discussion of the original series and their purpose.

31 For a complete discussion, see Laing 1995, p.163.

32 Andrews 1977, no.17, p.148.

33 On Charles I as a collector, see MacGregor 1989; Brown 1995; Howarth 1997.

34 Lightbown 1989, p.63 and *passim*.

35 Millar 1958–60. On the role of the Surveyor, see O. Millar, 'Caring for The Queen's Pictures: Surveyors Past and Present', in London, National Gallery, *The Queen's Pictures: Royal Collectors Through the Centuries*, 1991, pp.14–27.

36 Millar 1958–60, no.5, p.77.

37 Cropper/Panofsky-Soergel 1984, pp.473–88.

38 Andrews (1977) did not accept the attribution to Elsheimer. See cat.no.5.

39 There is an extensive literature on 'cabinets of curiosities'. The classic book on the subject is J. von Schlosser's *Die Kunst- und Wunderkammern der Spätrenaissance*, Leipzig, 1908. For their relation specifically to British collectors, see MacGregor 1985, pp.147–58. For a recent publication with bibliography, see P. Mauries, *Cabinets of Curiosities*, London, 2002. The following discussion draws on all these sources.

40 MacGregor 1985, p.147.

41 Lightbown 1989, p.70.

42 Exh. cat. Antwerp 2004 A, pp.29–30.

43 The copy is at Windsor Castle, inv.no.2963. Copper, 230 x 164 mm. For complete provenance, see Andrews 1977, no.5(a), p.141. Millar 1958–60, p.90, no.75.

44 Klessmann 1997, pp.239–48. On its inclusion in the 'Dutch Gift', see Mahon 1949, p.350.

45 Andrews 1977, no.24(a), p.154.

46 The pictures are listed in *A Catalogue of the Pictures of the Hon^able Tho. Newport Esq. at his House in Surrey Street* (this inventory must have been taken between the death of

his father, Francis Newport, first Earl of Bradford, in 1708 and his own elevation to the peerage on 25 June 1715). They also appear in *A Catalogue of the Pictures of the R:^t Hon:^able Ann Lady Torrington at her house in Twittnam, taken 9^th Nov:^e 1719*, which contains: *A Catalogue of the pictures at the Lady Torrington's house in London*. These documents are at Weston Park. Given the fact that the Edinburgh *The Stoning of Saint Stephen* was still on the Continent in 1712 and again in 1775–80, it is unlikely that it was the version in the Bradford collection, which remained there until 1762.

47 Nicholas Penny has very kindly shared his unpublished research on the Bradford collection, which I use here.

48 British Library Add. MSS 16174, Executor's Account book 1679–91, fol. 39r. Cited in Penny's unpublished manuscript.

49 Evelyn singled out Sir Anthony van Dyck's *Portrait of Sir Thomas Hanmer* as the most noteworthy in the collection. The entry is dated 24 January 1685. See *The Diary of John Evelyn*, edited by E.S. de Beer, Oxford, 1955, vol.IV, p.412.

50 Documented in *A Catalogue of Pictures belonging to the R:^t Hon:^able the Countess of Bradford, which were sent down from London to Weston in Staffordshire June 1735*. Staffordshire Record Office D1287/4/3.

51 On Methuen and the collection, see T. Borenius, *A Catalogue of the Pictures at Corsham Court*, London, 1939, especially the 'Introduction', pp.ix–xv.

52 Although Methuen certainly bought three copies by Spanish artists of works by Titian, Veronese and Tintoretto during his tenure in Spain, no other paintings are known to have been bought by him then. Most of his purchases were between 1722 and 1754, mostly at auction in England. Written communication from James Methuen-Campbell, 2 November 2005.

53 Documented in a letter in the public Record Office: P.R.O., C.S.P. (Dom.) Jas. I, LXXVIII, 107. Cited and discussed in K. Andrews, 'Elsheimer's "Latona" Uncovered', *Burlington Magazine*, 123, June 1981, p.353.

54 Shakeshaft 1981.

55 The contents of the first Sir Paul Methuen's collection at Grosvenor House are recorded in *London and its environs described. Containing an account of whatever is most remarkable for grandeur, elegance, curiosity or use, in the city and in the country twenty miles round it. Comprehending also whatever is most material in the history and anitquities of this great metropolis*, London, 1761, vol.III, pp.83–100.

56 On Knight and his collection, see Clarke/Penny 1982.

57 Clarke/Penny 1982, p.91.

58 It has been suggested that the small size of his London house at Soho Square might have been a factor, but *Il Contento* has only ever been documented at Downton. Clarke/Penny 1982, p.109.

59 Andrews 1979, pp.168–79.

60 On British taste for landscape paintings, see H.V.S. and M. Ogden, *English Taste in Landscape in the Seventeenth Century*, Ann Arbor, 1955.

61 Waagen 1854; Waagen 1857. Waagen mentions Elsheimer nine times in his publications, five times calling him a 'rare master'.

62 Waagen 1857, p.394.

63 Baglione 1642. For entire passage and translation, see Andrews 1977, pp.52–53.

Detail cat.no.14

Appendix: Provenance of Elsheimer Paintings that are or were in Britain for a substantial period[1]

First ownership in Britain is indicated in *italics*.

Title and Date	Current Location	Provenance	Date in Britain
Saints and Figures from the Old and New Testaments (cat.no.21)	Petworth House, National Trust	*George Villiers, 1st Duke of Buckingham* at York House, 1635; Duke of Northumberland, Northumberland House, 1671: 'eight little pictures in one Frame by Elshammer'...; by descent to Lord Leconsfield, Petworth	Before 1628; documented in 1635[2]
The Witch (cat.no.1)	Collection of HM The Queen, Hampton Court	*Sir Arthur Hopton (c.1588–1650)*; Charles I	In collection of Charles I before 1639[3]
The Realm of Venus (cat.no.32a)	Fitzwilliam Museum, Cambridge	*Thomas Howard, 2nd Earl of Arundel*; Thomas Newport, Baron Torrington (1654/55–1719) between 1708 and 1715;[4] Mary Wilbraham, Countess of Bradford (1661–1737) m. Richard Newport, 2nd Earl of Bradford (1644–1723) in 1735;[5] Robert Grave; sale, Christie's, 12 May 1827, lot 42; bought Daniel Messman; bequeathed to the Fitzwilliam Museum 1834	Before 1646[6]
The Realm of Minerva (cat.no.32b)	Fitzwilliam Museum, Cambridge	*Thomas Howard, 2nd Earl of Arundel*; Thomas Newport, Baron Torrington (1654/55–1719) between 1708 and 1715[7]; Mary Wilbraham, Countess of Bradford (1661–1737) m. Richard Newport, 2nd Earl of Bradford (1644–1723) in 1735; Robert Grave; sale, Christie's, 12 May 1827, lot 42; bought Daniel Messman; bequeathed to the Fitzwilliam Museum 1834	As above
The Realm of Juno (cat no.59)	Lost	*Thomas Howard, 2nd Earl of Arundel*	As above
The Finding and Exaltation of the True Cross ('The Frankfurt Tabernacle') *The Exaltation of the Cross*; *The Embarkation of the Empress Helena*; *The Questioning of the Jew*; *The Digging for the Cross*; *The Testing of the Cross*; *Heraclius on Horseback with the Cross*; *Emperor Heraclius' Entry into Jerusalem* (cat.no.20 a-f)	Städelscher Kunstverein, on loan to the Städel, Frankfurt	Juan (Giovanni) Pérez in Rome by 1612; Grand Duke Cosimo II of Florence; *Earl of Arundel?*; (c-f) Thomas Newport, Baron Torrington (1654/55–1719) between 1708 and 1715[8]; Mary Wilbraham, Countess of Bradford (1661–1737) m. Richard Newport, 2nd Earl of Bradford (1644–1723) in 1735; (2, 5) Thomas Newport, 4th and last Earl of Newport (d. 1762); (a,g) Duke of Norfolk; sale, Christie's, 11 February 1938, lots 83 and 84, as 'The Resurrection' and 'Christ carrying the Cross'; bought Colnaghi; acquired by the Städel 1951 and 1955 respectively; (d,f) sale, Christie's, 25 June 1971, lots 14 and 15; (b) acquired from private collection; (e) sale Christie's 10 April 1981, lot 99 from Australian private collection, acquired by the Städel	Possibly exchanged for Hans Holbein the Younger's *Portrait of Sir Richard Southwell* (now Uffizi, Florence) by the Earl of Arundel, but no earlier than 19 May 1626.[9] The central panel in the collection of the Duke of Norfolk by 1660.[10] When the altarpiece was broken up is not clear, but the fact that all the panels ended up in England is a strong indication that they came together.

Title and Date	Current Location	Provenance	Date in Britain
Jacob's Dream (cat.no.5)	Städel, Frankfurt	Collection Karel Oldrago (Uldurago), Rome, from before 1619 to 1639 or later;[11] *Duke of Norfolk*; sale, Christie's, London 11 February 1938, lot 84; bought Matthiesen (together with *Conversion of Saul*)	Probably acquired by the Earl of Arundel before 1646; in the collection of the Duke of Norfolk by 1660
The Conversion of Saul (cat no. 4)	Städel, Frankfurt	Collection Karel Oldrago (Uldurago), Rome, from before 1619 to 1639 or later;[12] *Duke of Norfolk*; sale, Christie's, London 11 February 1938, lot 84; bought Matthiesen (together with *Jacob's Dream*)	Probably acquired by the Earl of Arundel before 1646; in the collection of the Duke of Norfolk by 1660
The Mocking of Ceres (cat.no.26)	Collection Alfred and Isabel Bader, Milwaukee	Possibly[2] collection Gerrit Dou, Leiden;[13] *Charles II* (as part of 'Dutch Gift' of 1660);[14] Collection of H.G. Binder, Gateshead, England; sale, Munich, Neumeister, 7 December 1988, lot 406 (as Follower of Elsheimer); London, private collection; sale, Billingshurst (Sotheby's, Sussex), 20 May 1991, lot 123 (as Follower of Adam Elsheimer); Collection of Alfred and Isabel Bader, Milwaukee	Sent to Charles II as part of 'Dutch Gift' in 1660
The Adoration of the Magi (cat.no.6)	Collection of HM The Queen, Hampton Court	Possibly collection Karel Oldrago (Uldurago), Rome, from before 1619 to 1635 or later;[15] *Royal collection*, possibly no. 48 at Kensington in 1697, 'A Small piece 3 Kings coming to Worship' (BM Harl MS 7025); possibly in the Water-Closet at Windsor in the reign of George II: 'Rottenhamer. The Wisemen offering by Rottenhamer' (Vertue, inv., *Windsor*, f. 8) with a note 'these are very good of their kind'; Buckingham House, June 1821: 'A Painting – The Wise Mens offering on Copper – said to be by Margin Roter 11 inches by 8½ inches in a Metal Frame', which survives (Jutsham, *Receipts*, f. 141); later at Windsor (1839); sent to Hampton Court in 1904.[16]	Possibly bought by Charles I from Oldrago; possibly recorded at Kensington in 1697; definitely in Buckingham House by 1821
Saint Paul on Malta (cat.no.9)	The National Gallery, London	Possibly the 'Shipwreck of St. Pablo, small, by the hand of Adam' from James Baptista Cresentio (G.B. Crescenzi), given to and endorsed by Dudley Carleton *c.*1614, but more likely in 1630–31 to Sir Francis Cottington for *Charles I*;[17] Sir Paul Methuen (1672–1757), probably 1722–54, Grosvenor Street, London;[18] bequeathed to his cousin Paul Methuen, moved to Corsham House[19] (known as Corsham Court from *c.*1845); sale, Christie's, 14 May 1920, lot 16; bought Walter Burns; presented to the National Gallery in 1920	Possibly bought for Charles I; definitely recorded mid-18th century
Apollo and Coronis (cat.no.31)	Walker Art Gallery, Liverpool	*Thomas Newport, Baron Torrington (1654/55–1719)* between 1708 and 1715;[20] Mary Wilbraham, Countess of Bradford (1661–1737) m. Richard Newport, 2nd Earl of Bradford (1644–1723) in 1735; Sir Paul Methuen (1672–1757), probably 1722–54, Grosvenor Street, London;[21] bequeathed to his cousin Paul Methuen, moved to Corsham House (known as Corsham Court from *c.*1845); sale, Christie's, 14 May 1920, lot 17;[22] bought back by Lord Methuen; by descent to Paul Ayshford, 4th Baron Methuen (d. 1974); (accepted by HM Govt. from his executors in 1979 and allocated to) the Walker Art Gallery in 1982	Between 1708 and 1715

Title and Date	Current Location	Provenance	Date in Britain
The Baptism of Christ (cat.no.8)	The National Gallery, London	Collection Karel Oldrago (Uldurago), Rome, from before 1619 to 1635 or later; possibly J. Schuckborough decd. and others sale, Christie's, *London 1 March 1771*, lot 59, 'The Baptising our Saviour, Elshamer' – unsold at £3; sale, Christie's, London 27 March 1779, lot 70 (second day); bought Shriber; Sir Joshua Reynolds; sale, Christie's, London 27 March 1795, lot 27 (fourth day); bought Dermer; probably Booth sale, Christie's, London 25 April 1812, lot 132; bought Bowden; George Smith sale, Christie's, London, 27 May 1882, lot 16; bought Wagner; Henry Wagner; presented to the National Gallery, 1924	Before 1771
Saint Lawrence Prepared for Martyrdom (cat.no.18)	National Gallery, London	Possibly Diego Duarte collection, Antwerp, 1682 [as Frans Francken made a copy of the painting (Aschaffenburg) and Pieter Soutman engraved it, it is likely that it was in Antwerp in the second quarter of the 17th century,[23] but Sandrart reports seeing it in the collection of Count Johann von Nassau (Saarbrücken, probably around 1635)]; sale S. Feitama, Amsterdam, 16 October 1758, lot 64; sale Eversdijk, the Hague, 28 May 1766, lot 29; *Goodall sale, London, 9 April 1772, no. 37*; Wynn Ellis; bequeathed to the National Gallery in 1876	Between 1766 and 1772
Il Contento (cat.no.25)	National Gallery of Scotland, Edinburgh	Inventory of 1610, fol. 861r; possibly in collection of Cardinal Odoardo Farnese, 1615; du Fay, Frankfurt 1666–1734; till 1780 M. Poullain, Receveur Général des Domaines du Roi, Paris; Poullain Sale, Paris, 20 March 1781, lot 21; bought Langlier; *Richard Payne Knight, Downton Castle*; then by descent to Major Kincaid Lennox; acquired in lieu of death duties by the National Gallery of Scotland 1970	Between 1781 and 1808[24]
Judith and Holofernes (cat.no.14)	Wellington Museum, Apsley House, London	P.P. Rubens (listed in Inventory of 1640); bought from his estate by Don Francisco de Rochas for King Philip IV of Spain; La Granja, collection of Isabella Farnese, wife of Philip V, 1746; La Granja 1774; *the painting was captured 1813 by 1st Duke of Wellington*[25]	1813
The Stoning of Saint Stephen (cat.no.19)	National Gallery of Scotland, Edinburgh	Paul Bril (1626); by inheritance to his widow Ottavia Sbarra (1629); by descent to the daughter Faustina Baiocco (1659); Cardinal Curzio Origo (1712); Herzog von Braunschweig, *c.*1775–80; sold by him to a merchant in Hamburg; *The Very Rev. G.D. Boyle, Dean of Salisbury (1828–1901)*; by descent to the last owner, from whom it was purchased by the National Gallery of Scotland	Before 1901
Saint Elizabeth Tending the Sick (cat.no.2)	The Wellcome Institute for the History of Medicine, London	January 1927 in the collection of Professor Paul Stolz, Hammelburg, Germany; bought by the firm P. de Boer, Amsterdam; bought by the dealer R.W. de Vries, Amsterdam; sale Lempertz, Cologne 1 December 1927, lot 63 (as Elsheimer), unsold; sale A. Mak, Amsterdam 5 June 1928, lot 173 (as Elsheimer), unsold; *1928 purchased from R.W. de Vries by the Wellcome Institute for the History of Medicine*	1928

Note:
Eighteen paintings are included in this list (counting the Petworth series of saints and the Frankfurt altarpiece as one). This represents about half the number of accepted and surviving works – thirty-four (including for the present purposes the lost *Realm of Juno*, but not the *Mercury and Herse*, by Paul Bril with figures by Elsheimer).

NOTES

1 Unless indicated otherwise, provenance information derives from Andrews 1977.

2 As 'Eight little pieces – Enson Hamor *[sic]*' in the collection of the Duke of Buckingham at York House in 1635. See R. Davies, 'An Inventory of the Duke of Buckingham's Pictuers, etc., at York House in 1635', *Burlington Magazine*, 10 (1906/07), p.382. For subsequent provenance with bibliography, see Laing, in exh. cat. London 1995, p.163. For a complete transcription of Buckingham's inventory, see S. Jervis, 'Furniture for the First Duke of Buckingham', *Furniture History* 33, 1997, pp.48–74.

3 In Millar 1958-1960, p.77.

4 The pictures are listed in *A Catalogue of the Pictures of the Hon^able Tho. Newport Esq. at his House in Surrey Street* (this inventory would have been taken between the death of his father, Francis Newport, first Earl of Bradford, in 1708 and his own elevation to the peerage on 25 June 1715). They also appear in *A Catalogue of the Pictures of the R.^t Hon.^able Ann Lady Torrington at her house in Twittnam, taken 9^th Nov.^r 1719*, which contains: *A Catalogue of the pictures at the Lady Torrington's house in London*. Both documents are at Weston Park. Other pictures to appear in this list are: *The Realm of Minerva*, four of the panels from the *Altarpiece of the True Cross* (*The Questioning of the Jew, The Digging for the Cross, The Testing of the Cross, Heraclius on Horseback with the Cross*); *Apollo and Coronis* and a version of *The Stoning of Saint Stephen*, but probably not the picture in the National Gallery of Scotland. My thanks to Thea Randall at the Staffordshire Records Office for verifying the information in these catalogues.

5 Documented in *A Catalogue of Pictures belonging to the R.^t Hon.^able the Countess of Bradford, which were sent down from London to Weston in Staffordshire June 1735*. Staffordshire Record Office D1287/4/3.

6 An etching by Wenceslaus Hollar after the painting, recording it as in the Arundel collection, is dated 1646.

7 See notes to *The Realm of Venus*, above.

8 See notes to *The Realm of Venus*, above.

9 The altarpiece is documented in the collection of Carlo de' Medici, uncle of Ferdinando II de' Medici, on 19 May 1626. Florence, Uffizi, Guardaroba Medicea, Filza 409, no.117.

10 See Howarth 1985, pp.71–72; Howarth 2002, pp.76–77.

11 Cropper/Panofsky-Soergel 1984, esp. p.479.

12 Cropper/Panofsky-Soergel 1984, esp. p.480.

13 Christian Ludwig von Hagedorn, *Lettre à un Amateur de la Peinture* (Dresden, [1755], p.179): 'Gerard Dow ne dedaignoit point de copier le Tableau de Ceres, quand l'orginal devoit passer en Angleterre, où il fut malheureusement consumé, dit-on, dans un incendie arrivé â White-hall'. Cited in Mahon 1949, p.350.

14 For documentation, see Mahon 1949, p.350.

15 Cropper/Panofsky-Soergel 1984, esp. p.480.

16 Waddingham 1972 B, p.601.

17 Shakeshaft 1981, p.551.

18 Written communication from James Methuen-Campbell, 2 November 2005.

19 The earliest this painting and the *Apollo and Coronis* could have been moved is *c.*1765, but they could have remained until the house in Grosvenor Street was sold in *c.*1768. First recorded at Corsham in 1806. James Methuen-Campbell, as above in note 18.

20 See notes to *The Realm of Venus*, above.

21 See notes to *St Paul on Malta*, above.

22 My thanks to Marijke Booth of Christie's for verifying the correct date of this sale.

23 G. Dogaer, 'De inventaris van Diego Duarte', *Jaarboek van het Koninklijk Museum voor Schone Kunsten*, 1971, p.212, no.105.

24 In 1808, Richard Payne Knight gave up Downton Castle to his brother. On the assumption that the great connoisseur bought *Il Contento* and given that it was at Downton Castle, the picture must have been acquired between the date of its sale to Langlier and 1808.

25 C.M. Kauffmann, *Catalogue of the Paintings in the Wellington Museum*, London, 1982, no.45.

Adam Elsheimer's Artistic Circle in Rome

CHRISTIAN TICO SEIFERT

Adam Elsheimer's oeuvre spans a creative period of less than ten years. Even before his untimely death in Rome, his fame and his art had spread throughout Europe with unusual rapidity. Karel van Mander (1548–1606) already refers to him in his *Schilder-Boeck* (published in 1604, but written chiefly in 1603) as an 'outstanding German painter' and a 'skilful master', praising his 'attractively invented compositions on copper plates'.[1] Several Dutch and German painters were in Rome during those years and had close contact with Elsheimer there; upon their return, they introduced his art to the world north of the Alps. It was primarily through the efforts of these artists that Adam Elsheimer's works made a substantial impact on European art. His artistic circle has, therefore, frequently been discussed only in connection with the history of his influence. Yet it is difficult to judge Elsheimer's direct artistic influence in Rome. Very few of the works certain to have been painted by his 'mit-Compagnen'[2] – fellow artists – during his lifetime and in his immediate vicinity have survived. The majority of comparisons undertaken to date are based on works produced after these artists returned to the Low Countries. With the exception of Carlo Saraceni, the contemporary reception of Elsheimer's art in Rome has hardly been investigated.[3]

Based on contemporary sources and selected works, this essay endeavours to take a closer look at Elsheimer's artistic circle in Rome. The chief focus will be on the travels of his 'mit-Compagnen' to Rome, their contact with Elsheimer and the artistic interaction they enjoyed. In this context, it will also be relevant to ask whether an Elsheimer workshop might have existed.

From Venice to Rome –
Johann Rottenhammer and Paul Bril

Adam Elsheimer was in Munich in 1598, as demonstrated by a sheet of an *album amicorum* entitled *A Painter Presented to Mercury* (fig.7).[4] He subsequently travelled to Venice; his time there, it should be noted, has only been deduced from his works and is not documented.[5] Elsheimer had arrived in Rome by April of the Holy Year of 1600, which can be proved by the signature on his drawing *Neptune and Triton* (fig.13)[6] and an entry of 21 April 1600 in the *album amicorum* of Abel Prasch of Augsburg.[7]

The connection between Munich and Rome by way of Venice is reminiscent of Johann Rottenhammer (1564–1625), a native of Munich who settled in Venice following a sojourn in Rome (1593–94).[8] In the period around 1600, Rottenhammer had contact with Paul Bril (1553/54–1626) in Rome, with whom he collaborated repeatedly.[9] His figural painting was thus also known in Rome (fig.134). Carlo Ridolfi describes the two artists' collaboration in his *Maraviglie dell'Arte* (1648): 'A number of gentlemen had him [Rottenhammer] make figures on copper [and] then sent them to Bril in Rome [who] supplied the landscape.'[10] Rottenhammer continued to collaborate with Bril even after he had once again settled in Augsburg in 1606. A letter dated 9 November 1617 from the art dealer Philipp Hainhofer (1578–1647) of Augsburg to Duke Philipp II of Pomerania-Stettin (1573–1618) proves this.[11] Having trained as an artist in Antwerp, Bril had taken up permanent residence in Rome before 1580, achieving considerable success in that city and remaining there until his death in 1626. Elsheimer must have had close contact with Bril fairly early on, as he chose

Fig.134
Johann
Rottenhammer,
*Rest on the Flight
into Egypt*,
1597,
Schwerin,
Staatliches
Museum

Facing page:
detail fig.146

him to act as a witness to his marriage in 1606.[12] It is entirely possible that Rottenhammer brought the two into contact with one another.

Rome – Paul Bril, Johann Faber and Peter Paul Rubens

In Rome, Bril gave Elsheimer access to the circle around Johann Faber of Bamberg (1574–1629), a physician and papal botanist. Faber was also one of Elsheimer's marriage witnesses in 1606.[13] He was a friend of Peter Paul Rubens (1577–1640) and Federico Cesi (1585–1630), who founded the Accademia dei Lincei in 1603.[14] In his *Animalia Mexicana* (1628) Faber describes his friendly relationship with Elsheimer, who was 'formerly a regular visitor and guest in my house'.[15] Faber proudly goes on to report that he himself possessed some 'original paintings by Elsheimer, in truth few'.[16]

In the same treatise Faber also makes reference to the artistic relationship between Bril and Adam Elsheimer. He describes Bril as having emulated Elsheimer's '*maniera* … for the past twenty years' (from around 1606–08).[17] This statement, however, fails to take into account the influence exerted by Bril on Elsheimer during the latter's early years in Rome.

Elsheimer made use of Bril's painting style and motifs particularly in his landscape backgrounds, as can be seen when Bril's *Landscape with the Flight into Egypt* (fig. 135)[18] of *c.*1600 is compared with Elsheimer's small panel of the same theme, presumably painted around 1605 (cat.no.23).

On the other hand, Luuk Pijl has related the figures in Bril's 1606 painting *Landscape with Mercury and Battus* (fig. 136) to Elsheimer.[19] Here, Bril integrated the figures into a landscape for which he had already made preliminary drawings in 1603.[20] Pijl also recognised the same group – Mercury, Battus and the cow – in the painting of an unknown master from the circle of Cornelis van Poelenburch (1594/95–1667) (fig. 137).[21] Recently, Pijl has discovered yet another version of this composition (fig. 138) in a private collection in England.[22] This figural group must have originated in a now lost work by Elsheimer that inspired Bril, as well as other painters, to copy it.

Either Faber or Bril will also have introduced Elsheimer to Rubens, who was in Rome in 1601–02 and between 1606 and 1608. Rubens made use of Elsheimer's works on several occasions, for example on a sheet of sketches containing two studies (fig. 139) after *Saint Christopher* (cat.no.13),[23] in a painting that is a partial copy of *Il Contento* (fig. 140, cf. cat.no.25)[24] and in his *Judith Slaying Holofernes*, which has

Fig. 135
Paul Bril,
Landscape with the Flight into Egypt,
Private Collection

Fig. 136
Paul Bril,
Landscape with Mercury and Battus,
Turin, Galleria Sabauda

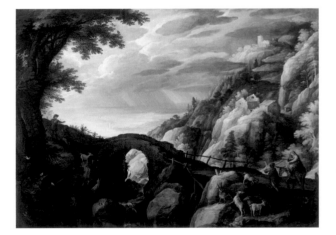

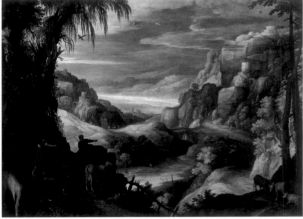

Fig. 137
Circle of Cornelis van Poelenburch,
Mercury and Battus,
Frankfurt, Städelsches Kunstinstitut und Städtische Galerie

Fig. 138
Circle of Adam Elsheimer,
Mercury and Battus, England,
Private Collection

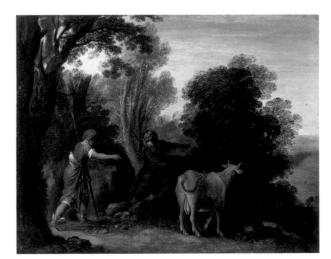

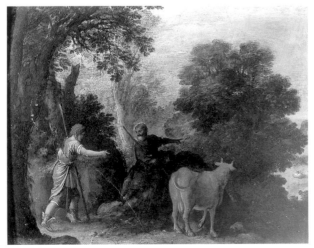

survived only in copies and in an engraving (fig.25) by
Cornelis Galle I (1576–1650).[25] After Elsheimer's
death, Rubens wrote a grief-stricken letter to Faber in
Rome, which testifies to his friendship with the painter
who died so young.[26]

David Teniers the Elder

It is possible that, like Elsheimer, David Teniers the
Elder (1582–1649) went to Rome in 1600. In his book
Het Gulden Cabinet van de Edele Vry Schilder-Const
(1662), Cornelis de Bie (1627–c.1715) relates that
Teniers had initially been a pupil of Rubens and subse-
quently went to Italy, where he 'lived with Adam of
Frankfurt, called Elsheimer, for ten years'.[27] If Teniers
was apprenticed to Rubens in Antwerp, this must have
been between Rubens's admission as master to the
painters' guild and Teniers's departure for Italy, be-
tween 1598 and 1600. This training would have fol-
lowed Teniers's first apprenticeship to his older
brother Juriaan, which he began in 1595.[28] De Bie was
unreliably informed about the duration of Teniers's
possible stay with Elsheimer. Having arrived in Rome
around 1600, Teniers the Elder is documented as a
member of the Antwerp painters' guild as early as
1605.[29] He thus could not have lived in Rome for more
than five years. De Bie's claim that Teniers lived with
Elsheimer is not supported by any other source, but
can, nevertheless, be interpreted as an indication of
personal contact between the two painters.

We know of no works by Teniers produced in Rome.
Motifs from paintings by Elsheimer, however, are to be
found in several of his later works. Teniers's *The
Stoning of Saint Stephen*, for example, known only in
an engraving by Egbert van Panderen (c.1581–c.1637)
(fig.141), clearly refers to Elsheimer's painting of the
same subject (cat.no.19). Van Panderen's engraving
presumably dates from between 1606 and 1609; the
original will thus have been an early work by Teniers.[30]
Teniers also used the group of two equestrian figures
in armour from the same Elsheimer painting in the
background of his *Adoration of the Magi*.[31] This work
has been attributed on the basis of a further signed
version, presumably dated 1609 (fig.142), which also
contains figures from Elsheimer's *Stoning of Saint
Stephen*.[32] The painting *Saint Paul's Shipwreck in
Malta*, based on Elsheimer's picture (cat.no.9) of the
same subject, can thus be attributed to Teniers as
well.[33] The figural group and the landscape in Teniers's
Landscape with Tobias and the Angel (fig.143)[34] were
evidently based on Elsheimer's *Tobias and the Angel*
(cat.no.21) from the series of depictions of saints in
Petworth.[35]

Fig.139 Peter Paul Rubens
after Adam Elsheimer,
Studies of Saint Christopher,
London, The British Museum

Fig.141 Egbert van Panderen
after David Teniers the Elder,
The Stoning of Saint Stephen,
engraving

Fig.140
Peter Paul
Rubens after
Adam Elsheimer,
*Sacrifice to
Mars and Venus*,
London,
Courtauld
Institute Galleries
– The Princess
Gate Collection

Fig.142
David Teniers
the Elder,
*The Adoration
of the Magi*,
London art
market 1995

Teniers apparently had the opportunity to study Elsheimer's paintings closely. Accordingly, they must have been completed before 1605 and accessible to Teniers in Rome. This should be taken into account when considering De Bie's statement that Teniers had lived with Elsheimer.

The 'mit-Compagnen' Jan Pynas, Pieter Lastman and Jakob Ernst Thomann von Hagelstein

Joachim von Sandrart (1606–1688) provides the most detailed information we have of Elsheimer's artistic circle in his *Teutsche Academie der Bau- Bild- und*

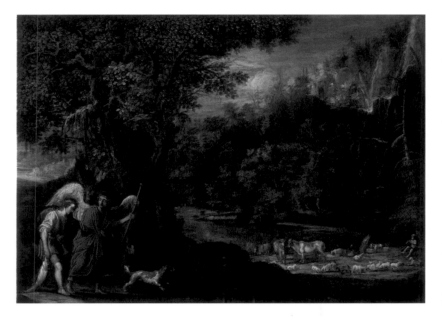

Mahlerey-Künste (1675).[36] In his biography of Elsheimer he mentions Jan Pynas (1581–1631) and Pieter Lastman (1583–1633), two painters from Amsterdam, as well as Jakob Ernst Thomann von Hagelstein of Lindau (1588–1653).[37] On the basis of Sandrart's descriptions it can be surmised that Elsheimer and these artists had 'studien gepflogen' and 'in den Landschaften … sich geübet' ('undertaken studies and practised landscapes' together).[38]

According to Sandrart, Thomann von Hagelstein went to Rome in 1605.[39] He painted his *Judith Showing the Head of Holofernes* (fig.144) in Rome the same year.[40] This *Judith* is the only work whose attribution to Thomann von Hagelstein is substantiated by a signature and date. More importantly, however, it is also the only surviving painting by one of Elsheimer's 'mit-Compagnen' definitely known to have been executed in Rome during the Frankfurt painter's lifetime. Wolfgang Wegner and Rüdiger Klessmann have both pointed out the close relationship of Thomann von Hagelstein's painting to Elsheimer's *Judith and Holofernes* (cat.no.14) and *The Mocking of Ceres* (cat.nos.26, 27).[41] The date on Thomann von Hagelstein's work was initially read as '1609', then as '1607'. An examination of the signature with the aid of a microscope has shown that the final fragmentary digit of the date can logically only be completed to form a '5', making the date of Thomann von Hagelstein's painting '1605'.[42] Unless we assume that Thomann von Hagelstein's work preceded Elsheimer's *The Mocking of Ceres* and was the source of the obvious similarities between the two paintings – the depiction of the scene

Fig.143
Attributed to
David Teniers the
Elder,
*Landscape with
Tobias and the
Angel,*
Paris, Institut
Néerlandais,
Collection Frits
Lugt

Fig.144
Jakob Ernst
Thomann von
Hagelstein,
*Judith Showing
the Head of
Holofernes,*
Friedrichshafen,
Zeppelin Museum

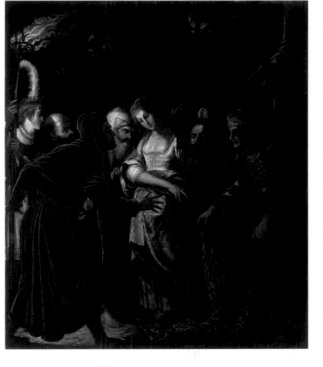

Fig.145
Attributed to Jakob Ernst Thomann von Hagelstein, *Ecce Homo*, Private Collection

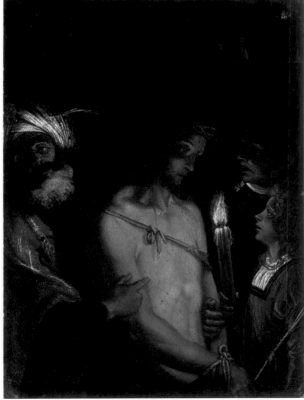

as a moonlit nocturne with torchlight, the figure of the old woman – the dating of Elsheimer's work must now be accepted as 1605 or earlier.[43] Thomann von Hagelstein evidently left Rome soon after Elsheimer's death, is known to have been in Naples in 1613,[44] and returned to his native town of Lindau on Lake Constance in 1614 – earlier than scholars have previously assumed.[45]

Taking Thomann von Hagelstein's *Judith Showing the Head of Holofernes* as a point of departure, more works can be attributed to him, such as an *Ecce Homo* (fig.145).[46] With regard to this painting, both Christian Lenz and, most recently, Rüdiger Klessmann have suggested that Thomann von Hagelstein might possibly be regarded as an Elsheimer copyist.[47] If so, the *Ecce Homo* would also have been painted before the artist left Rome, between 1605 and 1610.

Presumably in the autumn of 1602, Lastman travelled from Amsterdam, first to Venice and then to Rome. It is not known when he arrived there, but information supplied by Sandrart in his biography of Thomann von Hagelstein leads to the conclusion that Lastman was in the city before 1605.[48] His presence in Rome is substantiated by a signed drawing, *View of the Palatine*, dated 1606.[49] Neither archival sources documenting Lastman's stay in Italy nor any paintings from that period of his career are known.

Lastman's intense study of Elsheimer's art is more clearly evident in the early years following his sojourn in Italy than in his later work.[50] The *Flight into Egypt* (fig.146),[51] dated 1608, and the *Rest on the Flight into Egypt* (fig.147)[52] of the same period provide defininte proof of Lastman's acquaintance with works by Elsheimer. Also worth mentioning in this context is the grisaille *Christ on the Mount of Olives* (fig.148) painted by Lastman in *c.*1607–08.[53] This panel served as the model for an engraving by Pieter's younger brother Claes Lastman (1586–1625) (fig.149).[54] The inscription refers to Pieter Lastman as the inventor and cites the year 1608. The grisaille and the image size of the engraving are nearly identical, the print being a mirror image of the painting. Lastman's grisaille may very well have been related to a transverse oval painting of Gethsemane by Elsheimer in the collection of the Museum Boijmans in Rotterdam until 1864, when it was destroyed in a fire.[55] Carel Vosmaer's description of this work suggests certain similarities to Lastman's grisaille in the composition and figures. Of Elsheimer's nocturnes, *The Mocking of Ceres* (cat.nos.26, 27) is most comparable. Although the lighting in Elsheimer's painting is different, the garments are modelled in similar fashion. The heavy fabric of the cloaks forms deep, strongly shaded, straight vertical folds which billow at the curves. Other comparable elements are the gnarled tree with the dried-up branches and the hanging plants with large leaves near the left edge as

well as the repoussoir. In its choice of subject and manner of execution, in its rendering as a nocturne and even in the figures themselves, Lastman's grisaille *Christ on the Mount of Olives* of 1607–08 indicates close study of Elsheimer's Roman works.

No scholarly attention has been devoted to the possibility that Claes Lastman accompanied his older brother Pieter on his travels to Italy. Claes Lastman

Fig.146
Pieter Lastman,
*The Flight
into Egypt*,
Rotterdam,
Museum
Boijmans Van
Beuningen

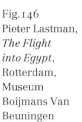

Fig.147
Pieter Lastman,
*The Rest on the
Flight into Egypt*,
Berlin, Staatliche
Museen,
Gemäldegalerie

Fig.148 Pieter
Lastman, *Christ
on the Mount of
Olives*, Stuttgart,
Staatsgalerie

Fig.149 Claes
Lastman after
Pieter Lastman,
*Christ on the
Mount of Olives*

GVIDO DE BOLOGNA PINXIT.

NICOLA LASTMAN SCVLP. ET EXC.

D. Petrus Romæ in Crucem agitur : iuxta imaginem in Ecclesia Triumfontium D.Pauli in via Ostiensi depictam.

Fig.151
Jan Pynas,
The Raising of Lazarus,
Aschaffenburg,
Bayerische
Staatsgemälde-
sammlungen

Fig.152
Jan Pynas,
Jacob's Dream,
Amsterdam,
Rijksprenten-
kabinet

Fig.150
Claes Lastman
after Guido Reni,
*The Crucifixion
of Saint Peter*,
engraving

produced an engraving (fig.150), which he also printed himself, after *The Crucifixion of Saint Peter* by Guido Reni (1575–1642), but in reverse.[56] It is one of the earliest engraved reproductions of a work by Reni. Commissioned by Cardinal Pietro Aldobrandini (1571–1621), Reni executed the altarpiece in 1604–05 for the Church of San Paolo alle Tre Fontane in Rome, where it remained until the eighteenth century.[57] Pieter Lastman could conceivably have supplied his brother with a faithful detailed drawing after Reni's work and informed him of its location, mentioned in the inscription. It is more likely, however, that Claes Lastman himself was in Rome. The plague that raged in Amsterdam in 1602, the death of his father and the decision of Pieter to travel to Italy could have inspired Claes to accompany his brother, although, to date, we have no documentary evidence of this. We also do not know where Claes Lastman received his training. The suggestion that he learned the art of engraving in Rome under Hendrick Goudt is no more than speculation, but certainly an appealing idea.

Pieter Lastman was certainly back in Amsterdam by 1 March 1607.[58] Just ten days after that date, the painter Jan Pynas was first documented back in Amsterdam after his trip to Italy. In view of this, and the fact that Sandrart describes the two artists as having been in Rome together, it appears likely that

Lastman and Jan Pynas returned from Italy – and probably undertook the entire journey – together.[59]

The painter Jan Tengnagel (1584–1635) of Amsterdam, who married a sister of Jan Pynas in 1611 and maintained close relations to his brothers-in-law and Lastman, could well have accompanied them or met them in Rome. According to a statement by Tengnagel himself which appears in a legal document, he was in Rome in the summer of 1608.[60] The works that are certainly known to have been executed by Tengnagel bear no obvious relation to Elsheimer's compositions, but two are thought to be early paintings by Tengnagel carried out in Rome, and could well have emerged from the circle around Elsheimer.[61]

The influence of Elsheimer is particularly evident in Jan Pynas's *The Raising of Lazarus* (fig.151).[62] The date on the oak panel has frequently been cited as '1605', but should be read as '1609'.[63] In view of the fact that oak was virtually never used in Rome as a painting support, Jan Pynas would have to have returned to Holland as early as 1605. This is highly unlikely, however, because (as mentioned above) he is not documented back in Amsterdam until 1607, and there is no evidence of any dated works before that year.

It was in Rome that Jan Pynas executed the etching *Jacob's Dream* (fig.152).[64] The attribution of this work

to Jan Pynas is based on comparison with the artist's drawings. A drawing showing a mirror image of the same composition, but marred by colouring added later, could well be a preliminary drawing by Jan Pynas for his etching.[65] The date on the etching was reworked, making the last two digits virtually illegible, and the work has accordingly been attributed by different scholars to the years 1600, 1602 and 1605. Peter Schatborn regarded 1605 as the most likely to be correct, rightly so in my opinion.[66] Kurt Bauch suggested that Pynas must have executed the etching when he was in Rome in Elsheimer's circle.[67] The landscape background with the trees, the lone figure on the narrow bank and the reflections in the water are all reminiscent of Elsheimer's 'small Tobias' (cat.no.30). The clumsy handling of the etching needle and the shallow etching of the plate, moreover, exhibit similar technical defects to those in Elsheimer's own etching of the 'small Tobias' (cat.no.46).[68] Jan Pynas is not known to have made any other etchings. Owing to this, and to the fact that there are only two impressions of *Jacob's Dream*, it appears that this work might possibly have been an artistic experiment regarded by the artist as a failure and therefore not carried further. Yet Jan Pynas must also have executed paintings in Rome. In 1629, the year in which Bril's widow Ottavia Sbarra died, her estate included a fairly large landscape painting by 'Pinas', in all likelihood Jan Pynas.[69]

Documents from the time of Elsheimer's death make reference to numerous unfinished paintings in his estate, among them works on canvas.[70] Elsheimer is only known to have used canvas for his self-portrait for the Roman Accademia di San Luca (cat.no.37). It remains a mystery whether the canvases documented in his estate were by Elsheimer himself, Goudt or other painters. Had the landscape painting by Jan Pynas owned by Bril's widow – in view of its size, presumably painted on canvas – been painted in Elsheimer's workshop?[71]

One of Jan Pynas's earliest paintings is the recently rediscovered *The Liberation of Saint Peter* (fig. 153).[72] A small oak panel, it clearly shows the influence of both Elsheimer and Caravaggio, and was engraved by Claes Lastman in 1609 (fig. 154).[73] The existence of several other copies suggests that it was a highly appreciated work of art. Somewhat unusually, two engravings were made in Rome after Lastman's work: one printed in the workshop of Hendrik van Schoel (?–1622);[74] the other presumably engraved by Jean LeClerc (c.1587– 1633), an artist known to have lived in Rome in the house of Carlo Saraceni in 1617.[75] Saraceni, for his part, may well have become acquainted with the circle of Elsheimer around 1605. It is conceivable that Jan Pynas maintained contact with these artists in Rome after his return to Amsterdam. He may even have taken Claes Lastman's engraving to

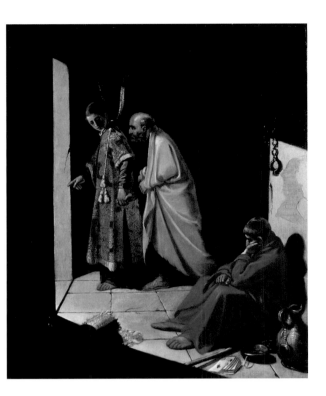

Fig. 153
Jan Pynas, *The Liberation of Saint Peter*, Amsterdam, Museum het Rembrandthuis

Fig. 154
Claes Lastman after Jan Pynas, *The Liberation of Saint Peter*

Rome himself when he visited the city a second time in 1617. The drawing *Laban Searching for Idols in Rachel's Baggage*, signed and dated 1617, and bearing the inscription 'Roma', testifies to Jan Pynas's second sojourn there.[76] The engravings made in Rome after his *Liberation of Saint Peter* had an influence on works produced in Italy. It is possible, for example, that Giovanni Battista Caracciolo (1578–1635) was familiar with one of them and that his painting of the same subject reflects that knowledge. As has been pointed out by Kurt Bauch, the work's influence is particularly evident in the painting by Johann Heinrich Schönfeld (1609–1684), the *Liberation of Saint Peter*, which was executed in Naples in c.1643–44.

Carlo Saraceni

The Venetian Carlo Saraceni (1579–1620) was already in Rome from about 1598, and is sure to have become acquainted with Elsheimer's works. There is, however, no documentary evidence of contact between the two artists. Echoes of Elsheimer's art can be seen in a relatively small group of works attributed to Saraceni's early Roman period,[77] of which key works are the six copper plates depicting mythological scenes (fig.155) known to have been in the possession of the Farnese in Parma in 1680.[78] Rüdiger Klessmann has noted that Saraceni must have seen Elsheimer's *Aurora* (cat.no.29) in his workshop before painting the *The Abandoned Ariadne*.[79] Anna Ottani Cavina has pointed out a close correspondence – in terms of motif – between a print by Magdalena de Passe dated 1623[80] after Jacob Pynas's painting *Salmacis and Hermaphroditus*[81] and Saraceni's painting of the same subject from the Farnese series. As a result, Ottani Cavina thought that Jacob Pynas must have been directly acquainted with the series. Assuming (like her fellow scholars at the time) that Jacob Pynas had first travelled in Italy in 1605–08, Ottani Cavina attributed the Farnese series to a period before Jacob Pynas's return to Amsterdam, *c.* 1606-07.[82] This presumed *terminus ante quem* no longer applies, however, since Dudok van Heel has proved that Jacob Pynas was not

born until 1592–93.[83] Keith Andrews's speculation that the series was painted jointly by Saraceni and Jacob Pynas must be rejected for the same reason.[84] Furthermore, there is no visible difference between the painting style and technique of the landscapes and that of the figures.

It is possible, however, that Saraceni had contact with Jan Pynas, as well as Pieter and perhaps even Claes Lastman, in Rome in 1605. It could hardly have been a coincidence that LeClerc, known to have lived in Saraceni's house from 1617, came into possession of Claes Lastman's engraving after Jan Pynas's painting *The Liberation of Saint Peter* (figs.153, 154).[85] In 1617 (as mentioned above) Jan Pynas was in Rome again, where LeClerc also engraved works by Saraceni in 1619. Jan Pynas and Saraceni presumably knew one another from the first Roman sojourn of Elsheimer's Amsterdam 'mit-Compagnen'. This would also help explain how Jacob Pynas after 1617 became acquainted not only with Elsheimer's, but also with Saraceni's works.

Jacob Pynas

The frequently repeated assumption that Jacob Pynas (1592/93–after 1650) travelled with his brother Jan in Italy and was in Rome in 1605 has never been proved and is inaccurate. As demonstrated by Dudok van Heel, Jacob Pynas was not born until 1592/93, and is hardly likely to have been in Rome at the age of twelve.[86]

When Elsheimer's oeuvre was re-evaluated, particularly after the 1966 exhibition of his work in Frankfurt, a substantial number of the paintings were attributed to Jacob Pynas.[87] Today many of these attributions appear arbitrary, not least because they were not made on the basis of comparison with signed works certainly by Jacob Pynas.

The first known signed and dated work by the younger Pynas brother is his 1616 painting *Royalty is Restored to Nebuchadnezzar* (fig.156), which corresponds closely to works by Jan Pynas and Pieter Lastman.[88] Nevertheless, paintings such as the *Landscape with Mercury and Battus*[89] dated 1618, or *Joseph Being Thrown into a Pit by His Brothers* (fig.157)[90] indicate that Jacob Pynas was familiar with Elsheimer's works. A particularly good example is the painting *Salmacis and Hermaphroditus*, mentioned above, which Magdalena de Passe's engraving of 1623 proves is by Jacob Pynas.[91] Yet although these works would seem to confirm Jacob Pynas's acquaintance with Elsheimer's art, and ultimately also with that of Saraceni, they do not necessarily lead to the conclusion that he was ever in Rome.

Fig.155
Carlo Saraceni,
Six Episodes
from the
Metamorphoses
of Ovid: The
Flight of Icarus;
The Fall of
Icarus; *The*
Burial of Icarus;
The Rape of
Ganymede;
Ariadne
Abandoned;
Salmacis and
Hermaphroditus,
Naples, Museo
Capodimonte

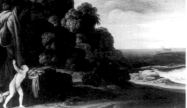

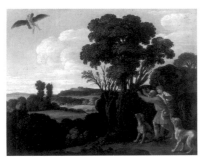

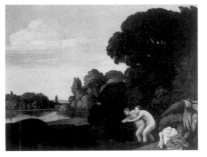

Jacob Pynas might have accompanied his brother Jan on his second, shorter journey to Rome in 1617, but, to date, there is no proof that he did.[92] Moreover, in that year Jacob Pynas painted *The Stoning of Saint Stephen* (fig.158), significantly on an oak panel.[93] Other signed and dated paintings by him of the years 1616 (*Royalty is Restored to Nebuchadnezzar*) and 1618 (*Landscape with Mercury and Battus*) were also painted on oak.[94] Jacob Pynas is, therefore, unlikely to have travelled to Rome during this period. Naturally, he could have been in Italy at an earlier or later date, but there is no basis for that assumption and no documentary evidence for it. We must, then, presume that Jacob Pynas acquired his knowledge of Elsheimer's works primarily from his brother, as well as from Lastman and from originals, copies and prints that he could have seen in Holland.

Hendrick Goudt

Hendrick Goudt (1583–1648) was closer to Elsheimer than any other artist. Their personal relationship was evidently quite complicated; even contemporary sources provide divergent accounts of it. This essay is not the place to consider that relationship in detail.[95]

The *Stato d'anime* (census of inhabitants) of the parish of San Lorenzo in Lucina in Rome documents Goudt's residence in Elsheimer's household in 1607 and 1609.[96] Goudt is thought to have come from The Hague, where he may have trained as an engraver under Simon Frisius (*c.* 1580–1629), and been influenced by the works of Jacques de Gheyn II (1565–1629) and Hendrick Goltzius (1558–1617).[97] The inscriptions on his engravings indicate that Goudt learned calligraphy from Jan van de Velde I (1569–1623) in Rotterdam. He was the only artist apart from Goltzius to whom Van de Velde dedicated a page in his *Spieghel der Schrijfkonste* (1605).[98] By this time Goudt may already have been in Rome. He is generally assumed to have arrived there in 1604, though the sources provide no evidence to that effect.

Goudt's engraving after Elsheimer's 'small Tobias' (cat.no.50) is dated 1608 and is considered by most scholars to be the earliest of Goudt's seven engravings.[99] Nevertheless, it is worth considering the possibility that the *Salome Receiving the Head of Saint John* (cat.no.49) preceded it. The *Beheading* is Goudt's smallest, least ambitious engraving, and is preserved in an unfinished trial proof as well as in two states, which might possibly indicate a long genesis. Both artists' monograms are inscribed on the work.[100] Goudt's print is after a lost painting by Elsheimer of which a copy has recently emerged (cat.no.28).[101] On the basis of the dramatic execution of the lighting, the original painting would seem to date from around

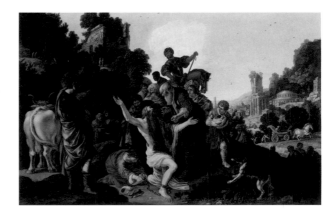

Fig.156
Jacob Pynas,
Royalty is Restored to Nebuchadnezzar,
Munich, Alte Pinakothek

Fig.157
Jacob Pynas,
Joseph Being Thrown into a Pit by His Brothers,
Dresden, Gemäldegalerie Alte Meister

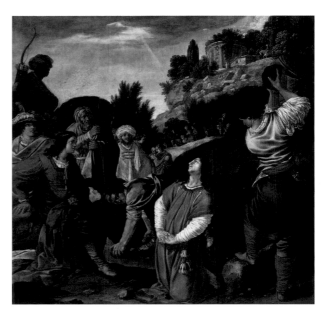

Fig.158
Jacob Pynas,
The Stoning of Saint Stephen,
Kingston, Ontario, Collection of the Agnes Etherington Art Centre, Queen's University, Gift of Dr Alfred and Isabel Bader, 1983

1603–05, the same period as *Judith and Holofernes* (cat.no.14) and *The Mocking of Ceres* (cat.nos.26, 27). In 1629, one impression of Goudt's *Saint John the Baptist* and one of the 'small Tobias', framed in ebony and printed on silk ('raso'), were in the estate of Elsheimer's friend Faber.[102] Irene Baldriga has shown that the Roman scholar Cassiano dal Pozzo (1588–1657) acquired these collectors' items – referred to as 'print on white silk' – from Faber's estate.[103] Until now, it has not been noticed that dal Pozzo also purchased

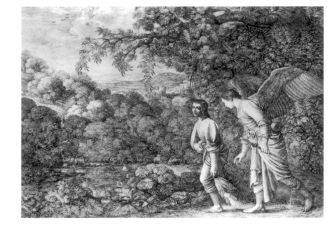

Fig.159
Hendrick Goudt,
*Tobias and the
Angel*,
New York, The
Pierpont Morgan
Library

Fig.160
Attributed to
Hendrick Goudt,
*Philemon and
Baucis*,
Private Collection

an impression of *The Mocking of Ceres* on silk, which must also have been among Faber's possessions, on the same occasion.[104] Such precious prints were frequently given to the patron who commissioned the engraving.[105] As documented in correspondence from the year 1609, Faber sent Goudt's engravings *Salome Receiving the Head of Saint John* (cat.no.49) and 'small Tobias' (cat.no.50) to several friends, including the merchant and scholar Marcus Welser (1558–1614) of Augsburg. Faber can thus be regarded as a supporter – if not the initiator – of Goudt's engravings after Elsheimer's paintings.[106] Furthermore, as Baldriga has proposed, it is conceivable that he also owned Elsheimer's painting 'small Tobias' and sold it before his death (it is not listed in the estate inventory); Baldriga's suggestion, however, cannot be supported with documentary evidence.[107]

On the basis of Sandrart's description, Goudt is thought to have been an ambitious dealer who took on Elsheimer's works and sold them, acting virtually as an exclusive agent. It is also worth considering the possibility that he aimed to distribute them to the public even more effectively by means of his exquisitely engraved reproductions.[108] Elsheimer's endeavours at etching have an almost experimental character, and the results are less than satisfactory. His etching of the

'small Tobias' (cat.no.46) is rare,[109] and only one impression of *The Mocking of Ceres* (fig.95) is known to have survived.[110] Goudt, on the other hand, engraved the 'small Tobias' (cat.no.50) in Rome in 1608 and *The Mocking of Ceres* in 1610. Masterfully executed, Goudt's engravings after Elsheimer's works also testify to his own artistic skill. The same is true of two drawings by Goudt after Elsheimer's 'small Tobias'[111] and 'large Tobias' (fig.159).[112] The highly detailed and elaborate works are drawn on parchment with pen and ink and can be compared to the splendid Dutch 'Federkunststücke' (virtuoso pen drawings) produced by such artists as Goltzius. Both the costly material and the detailed execution support the assumption that they were more than mere 'first steps in the preparation of the engravings', as suggested by Félice Stampfle.[113] These drawings are to be regarded both as copies and as works of art in their own right, and *final* preparatory steps for the engravings, if at all. Perhaps the 'small sketch on parchment' kept by Elsheimer in a small leather-bound case in his atelier (according to the 1610 inventory) was just such a 'Federkunststück', though it might also have been a gouache.[114]

It is uncertain whether Goudt was active as a painter as well. In the Roman *stato d'anime* of 1607 he is listed as a painter ('pictore').[115] In 1611, upon returning to Utrecht, he was admitted to the painters' guild as an engraver (*plaatsnyder*).[116] Weizsäcker was the first to draw attention to a painting of *Philemon and Baucis* (fig.160), which he thought might be by Goudt.[117] From the eighteenth century, it was in a Swedish private collection, and has only recently been sold at auction.[118] Weizsäcker identified the work as a painting sold in The Hague in 1725 attributed to Goudt, which depicted the same subject, had almost the same dimensions and was described as 'a little candlelight [a nocturne with artificial lighting] depicting the history of Baucis and Philemon'.[119] Indeed, the two probably are one and the same picture; it is Goudt's authorship of the work that remains doubtful, as pointed out by Andrews.[120] The composition was presumably developed from Goudt's engraving of *Jupiter and Mercury in the House of Philemon and Baucis* (cat.no.52) combined with elements from works by Elsheimer. The full moon and the figure of Philemon by the fire, for example, are reminiscent of *The Flight into Egypt* (cat. nos.36, 55), also engraved by Goudt. It is thus hardly surprising that the painting was associated with Goudt's name nearly eighty years after his death.

On 17 December 1610, shortly after Elsheimer's death, Goudt was registered as a witness in the legal announcement of the preparation of an inventory of the Frankfurt artist's estate. Goudt no longer belonged to Elsheimer's household at this time, but lived in a house nearby.[121] He must have left Rome quite soon thereafter, as he was admitted to the painters' guild of

Utrecht in 1611, as discussed above. He took the plates of his engravings back to Holland with him, as well as an unknown number of Elsheimer's paintings, some of which he reproduced as engravings.[122] In the period that followed, his own collection and the seven engravings contributed substantially to the vast circulation of Elsheimer's art throughout Europe.

Johann König

Johann König (1586–1642) had already spent several years in Italy before he arrived in Rome in 1610. According to Buchheit and Oldenbourg, König's earliest work, a sheet from an *album amicorum* (formerly in the Derschau Collection, present whereabouts unknown) was inscribed 'Augsburg 1605'.[123] König's copy of Veronese's *Marriage at Cana* was produced in Venice as early as 1607,[124] indicating that he had probably arrived in the City of Canals in 1606–07. Hainhofer, mentioned above, recounts that König worked on a 'miniature' after Veronese's painting for 'a whole year'.[125] Painted on parchment in the unusually large folio format and framed in ebony, the work (which unfortunately is no longer traceable) was sent by Hainhofer to the Duke of Pomerania in 1610.[126]

The same letter from Hainhofer also provides evidence that König had arrived in Rome from Venice in September 1610.[127] In view of the fact that Adam Elsheimer did not die until 11 December 1610, König could still have encountered him there. Paintings such as the recently auctioned *Landscape with John the Baptist* (fig. 161) clearly indicate that König must have been well acquainted with works by Elsheimer.[128] This small work might be the one Henrich Sebastian Hüsgen (1745–1807) saw in the Frankfurt collection of Johann Friedrich Ettling. Hüsgen described it in 1780, recounting that it originally bore a signature by König.[129] That signature was later removed and the painting sold as a work by Elsheimer.[130] Hüsgen's remarks allude to the possibility that König copied Elsheimer's paintings in Rome.[131]

König must have begun his copy (fig. 162) of Elsheimer's *Il Contento* (cat.no.25) – completed in gouache on parchment in 1617 for Duke Maximilian I of Bavaria (1573–1651) – while he was still in Rome.[132] König had already produced a considerable number of miniatures in Rome, at least three of which have survived.[133] Hainhofer makes frequent mention of such works by König, some made to order, some for sale on commission.[134] In 1612 he reported that, as a miniaturist, König was 'swamped with work'.[135] Yet König also painted on copper during his sojourn in Italy.[136] Rüdiger Klessmann has suggested that König's painting *Landscape with Jacob's Dream* (fig. 163) might possibly have originated in Rome.[137] In December

1613 Hainhofer wrote that König wanted to return to Germany.[138] König must have left Rome soon thereafter, for on 7 April 1614 he relinquished his citizenship of his native town of Nuremberg and on 25 May 1614 he received the right to practise the profession of painter in Augsburg.[139]

It remains to be noted that the contact between the artists discussed above with Adam Elsheimer is either confirmed by contemporary sources or assumed on the basis of the work of the artists. The exception is Jacob Pynas, who presumably became acquainted with works by Elsheimer only indirectly in Holland. The extent to which Elsheimer's 'mit-Compagnen' might have been active in his workshop or acted as copyists of his works in Rome can, at present, not be known for certain. Sandrart's account suggests that the 'mit-Compagnen' studied together rather than sharing a workshop. The only artist certain to have worked in

Fig. 161
Johann König,
Landscape with John the Baptist,
London art market 2004

Fig. 162
Johann König after Adam Elsheimer,
Il Contento,
Munich,
Residenzmuseum

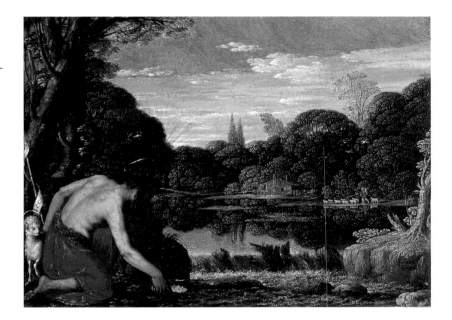

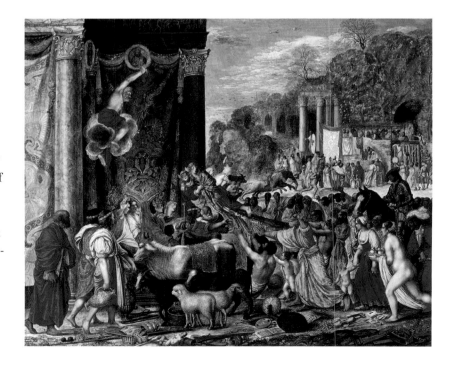

Fig.163
Johann König,
*Landscape with
Jacob's Dream*,
Paris, Collection
Frits Lugt,
Institut
Néerlandais

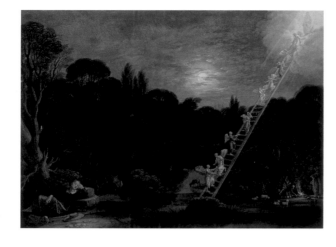

Elsheimer's studio was Goudt, as demonstrated by contemporary sources and his works. Only De Bie states that Teniers lived with Elsheimer. As to the other painters from the north, it remains uncertain whether they merely worked *with* Elsheimer or actually *in his workshop*. Every one of these painters, however, took something of Elsheimer's art back home with them and – in Antwerp, Amsterdam, Utrecht, Augsburg and elsewhere – developed it into his own individual style. In that way the 'mit-Compagnen' spread Elsheimer's art and narrative style, and provided a breakthrough for the development of history and landscape painting in the north.

NOTES

I am sincerely indebted to Rüdiger Klessmann for the generosity with which he shared his wealth of knowledge about Adam Elsheimer and his artistic circle for intensive discussions, critique and interest. I am grateful to Dirk Blübaum (Friedrichshafen) for his help in connection with Thomann von Hagelstein, Marten Jan Bok (Utrecht) for a conversation about Goudt and unpublished material, Bas Dudok van Heel (Amsterdam) for critical discussions on Pieter Lastman and the Pynas brothers, Charles Dumas (The Hague) for his support at RKD (Netherlands Institute for Art History) and Luuk Pijl (Dokkum) for a wealth of information concerning Bril. An expanded discussion of some of the works in this essay can be found in the German edition of this catalogue, which includes a section of entries on paintings by Elsheimer's contemporaries in Rome.

1 '… een uytnemende Hooghduytsch Schilder … een constigh werckman … Hy is wonderlijcke[n] aerdigh in te schilderen fraey inventien op coper platen.' Van Mander 1604, fol.296 r.
2 Sandrart uses this expression, literally 'co-companions', for artists in Elsheimer's direct vicinity in Rome; Sandrart 1675, p.163.
3 Cf. for example Orazio Borgianni (1578–1616), *Saint Christopher*, canvas, 104 x 78 cm, signed/dated 1615, Edinburgh, National Gallery of Scotland, inv.no.NG 48; Klessmann 2004, p.56. For Elsheimer's reception in Italy cf. also Longhi 1965 and Chiarini 1989/90.
4 Pen and black ink, washed in grey, 87 x 143 mm, signed *Adamus Ehlsheimer/ von Franckfurtt 98*, Braunschweig, Herzog Anton Ulrich-Museum, inv.no.070; Andrews 1985, p.193, no.30, pl.13.
5 Gronert 2003.
6 Pen and black ink, washed, 104 x 153 mm, signed: *Adam Ehlsheim/ in Roma 1600.*, Dresden, Kupferstichkabinett, inv.no.C 2310; Andrews 1985, p.194, no.32, pl.16.
7 'Adamus Ehlsheimer von Franckfurt dem Ehrenvesten und wolgelärtenn M. Abel Praschen … Roma den 21 Aprilis Anno '600', Andrews 1985, p.47, doc.2.
8 For Bril's sojourn in Rome cf. Hochmann 2003.
9 Pijl 1998; Pijl 1999.
10 '… alcuni Signori gli [Rottenhammer] faceuan fare figure in rame, mandandole poscia à Paulo Brillo à Roma acciò vi facesse il paese', Ridolfi 1648, vol.2, p.76; Pijl 1998, p.660, note 7; Pijl 1999, p.81f.
11 'Alss Paul Brill schreibt, so ist das ornament beim Rothen-[ha]mer fertig … und hab Ich dem Brillen geschrieben, er soll das st[ück]len per via di Mantoua oder di ven[ezi]a nur strachss herauss schücken, und nit warten, biss andere mehr darzue kommen, Rothenhamer ist, weil ich auss ware, an der hizigen krankhait gelegen, aber nun widerumb was besser auf worden', Hainhofer/Doering 1894, p.284, no.141 (9 November 1617).
12 Andrews 1985, p.47, doc.4.
13 Andrews 1985, p.47, doc.4.
14 Baldriga 2002, on Faber esp. pp.171–233.
15 'Adamo Elsheimer da Francoforte, che fu già frequentatore assiduo ed ospite di casa mia …', Faber 1628, p.748, quoted from Baldriga 2002, p.173, cf. Andrews 1985, p.188.
16 '… i quadretti originali di Elsheimer che, in verità pochi, conservo in casa mia', Faber 1628, p.748, quoted from Baldriga 2002, p.174, cf. Andrews 1985, p.188.
17 'Paolo Bril … avendo seguito la maniera di Adamo, ci ha lasciato negli ultimi venti anni, in questo genere d'arte pittorica che in Italia si chiama *paesaggio*, tali opere', Faber 1628, p.748, quoted from Baldriga 2002, p.174, cf. Andrews 1985, p.188.

18 Copper, 26.7 x 35 cm, signed at bottom left *PA.BR[IL]*, private collection; Laurie B. Harwood, in exh. cat. London 2001 A, p.68f., no.1, w/ ill.

19 Copper, 26.5 x 39 cm, signed and dated 1606, Turin, Galleria Sabauda, inv.no.323; L. Pijl, in exh. cat. Brussels/Rome 1995, pp.94–96, no.31, w/ ill.

20 Wood Ruby 1999, p.91f., 212f., no.37, 37a, ill.38, 39.

21 Copper, 12.4 x 16.4 cm, Frankfurt, Städelsches Kunstinstitut, inv.no.1676; Weizsäcker 1952, p.86, no.85 (as 'in der Art des [in the manner of] Cornelis Poelenburgh'); Waddingham 1972 B, p.610 (as 'Poelenburch studio in Italy'). There is a companion piece to this painting: *Pan Pursuing Syrinx*, copper, 12.4 x 16.4 cm, Frankfurt, Städelsches Kunstinstitut, inv.no.1677; Weizsäcker 1952, p.86, no.86 (as 'in der Art des [in the manner of] Cornelis Poelenburgh').

22 Copper, 11.5 x 16.5 cm, private collection, England. First published in the German version of this catalogue, no.A 3, by Luuk Pijl.

23 Pen and brown ink, 267 x 166 mm, London, British Museum, inv.no.Gg. 2-231; J. Rowlands, in exh. cat. London 1977, p.63, no.59, ill.; Klessmann 2004, p.56.

24 Canvas on wood, 47.8 x 60.8 cm, London, Courtauld Institute Galleries – The Princess Gate Collection, inv.no.30; H. Braham, in exh. cat. London 1981, p.55, no.78, ill.

25 Engraving, 542 x 374 mm, inscr. *Cornelius Galle sculp et excud.*; K. Renger, in exh. cat. Göttingen/Hannover/Nuremberg 1977, pp.44–46, no.21, ill.11.

26 Andrews 1985, p.50f., doc.18b; Baldriga 2002, p.293f. (there erroneously dated 14 January 1614 instead of 1611). For Rubens and Elsheimer in Rome cf. also Von Henneberg 1999, Baumstark 2005.

27 'Desen David Teniers is Discipel gheweest vanden Edelen ende Constrijcken Petrus Paulus Rubbens, ende daer naer in Italien komende heeft thien jaren ghewoont by Adam van Franckfort ghenoempt Elsenhamer', De Bie 1661, p.140; cf. Sandrart 1675, p.181; Houbraken 1753, vol.1, p.114f.

28 Duverger/Vlieghe 1971, p.18f.

29 '1605. Rekeninghe gedaen in presentie van dekens ende ouders van der cameren bij Robbert de Nole ende hier na volgende meesters die hy ontfangen heeft in der busboech gestelt. In den eersten Davidt Tenier schilder.' ('1605. Statement taken in the presence of the deans and elders of the guild by Robert de Nole and the masters listed below, whom he received [and] registered in the cashbook. Firstly David Teniers [the Elder] painter'), Antwerp, Koninklijke Academie voor Schone Kunsten, Het Bussenboeck van de S. Lucasgulde, Armenbus, rekening 243, fol.47; Casteels 1961, p.239, no.52 (quotation).

30 Inscr : *David Teniers inuent. Egbert van Panderen sculp. Theod. Galle excud.*; Hollstein, vol.XV, p.91, no.14; Van Gelder/Jost 1966/67, p.150; Duverger/Vlieghe 1971, p.41f., ill.11; Klessmann 2004, p.58.

31 Wood, 51.5 x 84 cm, Aachen, Suermondt-Museum; Van Gelder/Jost 1966/67, pp.147–49, ill.8; Waddingham 1970, pp.59–61, ill.2; Duverger/Vlieghe 1971, p.47, ill.46; Andrews 1984, pp.152–54, ill.5.

32 Wood, 63 x 47.7 cm, signed at bottom left *DAVID TENIERS ANNO 16[0?]9*, whereabouts unknown (last documented in London auction [Sotheby's], July 5, 1995, no.153, ill.); Van Gelder/Jost 1966/67, p.148f., ill.9; Waddingham 1970, p.60f., ill.4; Duverger/Vlieghe 1971, p.47, ill.45; Andrews 1984, pp.152–55, ill.6.

33 Wood. 54.5 x 83 cm, St. Petersburg, Hermitage, inv.no.692; Van Gelder/Jost 1966/67, p.150; Waddingham 1970, p.61, ill.5; Duverger/Vlieghe 1971, p.44f., ill.31.

34 Copper, 27.5 x 38 cm, Paris, Collection Frits Lugt, Institut Néerlandais; Andrews 1985, p.29f., 183, under no.17, ill.33.

35 Waddingham 1972 B, p.606, note 23; Andrews 1977, p.30; Andrews 1985, p.30.

36 Sandrart 1675, p.163 (quotation).

37 Sandrart 1675, pp.160–163.

38 Sandrart 1675, p.163 (quotation).

39 For Thomann von Hagelstein cf. most recently Seifert 2005 A.

40 Copper, 41.2 x 36.9 cm, signed on base of column: *?ET* [in ligature] *160[5]*, Friedrichshafen, Zeppelin-Museum, inv.no.ZM 1963/5/M; Seifert 2005 A. pp.103–05, ill.

41 Wegner 1969, pp.178, 186, note 6; Klessmann 2006.

42 J. Held, in exh. cat. Frankfurt 1966, p.70, no.105

43 Waddingham 1967, p.48, note 7, who cited the opinion of Wolfgang Wegner; Wegner 1969, p.178, 186, note 5.

44 My thanks to Peter Vogel (Institut für Technologie der Malerei, Staatliche Akademie der Bildenden Künste, Stuttgart), who carried out the technical investigation and the reconstruction.

45 Lenz 1978, p.167, dated 'um die Mitte des Jahrzehnts' (around the middle of the decade).

46 On 13 May 1613, 'Giacomo Thoma, a German and actually from Constance, domiciled in Naples in the Strada di Monte Calvario, painter of approximately 24 years of age', ('Iacomo Thoma, todesco e proprio di Costanza, domiciliato a Napoli nella strada di Monte Calvario, pittore di anni 24 circa') witnessed the marriage of his colleague Francesco Nomé (1593–1640); Causa 1956, p.32f. (quotation); cf. Longhi 1957, p.43.

47 In 1614 Thoman von Hagelstein is mentioned as a member of the 'Sünfzen', a society of leading families of the Lindau patriciate: 'Herr Jacob Ernnst Doma zalldt Ao: [16]14. 4 [fl]', Stadtarchiv Lindau, Reichsstädtische Akten 115,2; cf. Stolze 1956, p.245, no.56d. My thanks to Rosmarie Massong (Hergatz). On the basis of Sandrart's account it has been assumed until now that Thoman von Hagelstein returned in c.1620.

48 Copper, 19.3 x 14.3 cm, private collection; Seifert 2005 A, p.106, ill.

49 Lenz 1978, p.168; Klessmann 2006.

50 Sandrart 1675, p.163.

51 Pen and brown ink over pencil, brown and grey wash, 164 x 230 mm, inscr.: *Roma 1606 Lastman f:*, private collection, Germany; P. Schatborn, in exh. cat. Amsterdam 1991, p.146f., no.26, ill.

52 For Lastman's reception of Elsheimer's art cf. Seifert 2006.

53 Wood, 29 x 25.5 cm, signed at bottom centre: *PLM* [in ligature] *1608*, Rotterdam, Museum Boijmans Van Beuningen, inv.no.1442; Freise 1911, p.54f., 107, no.58, ill.6.

54 Oak, 31.2 x 51.2 cm, signed at bottom left: *PL* [in ligature], Berlin, Gemäldegalerie, inv.no.747; Freise 1911, p.55f., 111, no.59, ill.5.

55 Wood, 35 x 29 cm, Stuttgart, Staatsgalerie, inv.no.LS 201 (as copy after Pieter Lastman); Bauch 1951, p.234f., ill.16; A. Waiboer, in exh. cat. Dublin 2005, p.55, no.9, w/ ill.

56 380 x 295 mm (plate), 345 x 290 mm (image size), inscr. *Petr. Lastman inuen: Nicola Petri. sculp: Ao, 1608.*; Hollstein, vol.X, p.34, no.3; Judson 1964, p.141, note 4, ill.3.

57 Vosmaer 1863, p.102f.; Freise 1911, p.107; Seifert 2006.

58 470 x 287 mm, signed: *GVIDO DE BOLOGNA / PINXIT./ NICOLA LASTMAN / SCVLP. ET EXC.*, inscr.: *D. Petrus Romæ in Crucem agitur: iuxta imaginem in Ecclesia Triumfontium [!] D. Pauli in via Ostiensi depictam.*; Hollstein, vol.X, p.34, no.5; V. Birke, in exh. cat. Vienna 1988, p.50f., no.3.; Seifert 2006.

59 Pepper 1984, p.215f., no.17, pl.17.

60 Dudok van Heel 1991 B, p.6.

61 Bredius 1935, p.253; Seifert 2006.

62 'Dat hy getuyge [Tengnagel] in den Somer van den jaer 1608 is geweest binnen Romen', Schneider 1921, p.23. For Tengnagel cf. M. J. Bok, 'Jan Tengnagel', in exh. cat. Amsterdam 1993, p.318f.; Seifert 2005 B.

63 *The Liberation of Saint Peter*, copper, 22.7 x 18 cm, private collection (presently on loan to the Museum Het Rembrandthuis, Amsterdam); exh. cat. Leiden 1968, p.31, no.46, ill.46 (as Jan Tengnagel); I have not been able to find the monogram 'JT' referred to there. Wegner 1969, p.188, note 34, ill.8 attributed the work to Thomann von Hagelstein with reservations. *Marriage of Saint Catherine*, copper, 26.7 x 21.4 cm, whereabouts unknown (last documented in art dealership Jack Kilgore & Co. Inc., New York, 1999), A. Tümpel, in exh. cat. Amsterdam 1991, p.43f., 46, ill.34 (as Jan Tengnagel). In my opinion, neither of the two paintings is by Tengnagel.

64 Oak, 45 x 60 cm, signed on narrow edge of the lid of the tomb covering slab *J. Pijnas f[e]c 1609*, Aschaffenburg, Bayerische Staatsgemäldesammlungen, inv.no.6499; E. Brochhagen/P. Eikemeier, in Aschaffenburg 1975, p.151f., ill.20.

65 Bode 1883, p.344, as well as Drost 1933, p.179 and Van Gelder 1953, p.278.

66 153 x 205 mm (sheet), 152 x 203 mm (image size), dated at bottom right: *160[5?]*; C. Ackley, in exh. cat. Boston 1981, p.37f., no.20, ill.20. The Amsterdam impression is printed on non-Italian (perhaps Basle?) paper (my thanks to Jaco Rutgers), cf. Bruyn 1997, p.174, note 13.

67 Brush and black ink, coloured at a later date, 147 x 211 mm, Dresden, Kupferstichkabinett, inv.no.C 1427; C. Ackley, in exh. cat. Boston 1981, p.37, note 1.

68 Schatborn 1996, p.39, cf. C. Ackley, in exh. cat. Boston 1981, p.37, note 2.

69 Bauch 1960, pp.126, 128, ill.90.

70 92 x 146 mm; Andrews 1985, p.202, no.58, pl.10.

71 'Due quadri di paesi di palmi 4 [= 103.2 cm], uno viene da Pinas, l'altro [name missing] di valuta ...', Bodart 1970, p.12.

72 Andrews 1972, pp.598–600.

73 See note 71.

74 Wood, 35.2 x 29.6 cm, Amsterdam, Museum Het Rembrandthuis. First published in the German edition of this catalogue, no.A 11.

75 380 x 297 mm, inscr. *Jan Pinas Inuentor Nicola Lastman. sculp.*; Hollstein, vol.X, p.34, no.4, ill.

76 144 x 90 mm, inscr.: *Jan Pinas in: H. van Schoel ex.*

77 233 x 220 mm; Pariset 1935, pp.245, 247f., ill.7; cf. Weigert/Préaud 1976, p.425f. (as not by LeClerc). For LeClerc cf. M. Sylvestre, in *Turner Dictionary* 1996, vol.19, p.35, on his joint workshop with Saraceni, cf. Ottani Cavina 1968, p.69f., 89–91.

78 Pen and brown ink, grey wash over minimal black chalk, 183 x 244 mm, signed and dated b.r. *Jan Pynas fc Roma 1617*, Amsterdam, Rijksprentenkabinet, inv.no.RP-T-1911-87; P. Schatborn, in exh. cat. Amsterdam 1998, vol.1, p.128, no.279, vol.2, p.152, ill.279.

79 Canvas, 310 x 207 cm, Naples, Pio Monte della Misericordia; S. Causa, in exh. cat. Naples 1991, p.216f., no.1.7., ill.

80 Canvas, 74.5 x 62 cm, Galleria Nazionale d'Arte Antica – Palazzo Corsini, inv.no.16; Pée 1971, p.116f., no.38, ill.45, cf. Bauch 1935 A, p.150, note 2.

81 Ottani Cavina 1968, pp.22-32, Ottani Cavina 1976.

82 Copper, 45 x 54 cm (inv.no.151–153), 41 x 53 cm (inv.no.154), Naples, Museo Capodimonte, inv.no.151–154; Ottani Cavina 1968, p.108f., nos.40-43, ill.53-55, 58; Bertini 1987, p.247, no.270-75, p.291, nos.39-45.

83 Klessmann 1987, p.162; cf. Klessmann's essay in this catalogue.

84 204 x 228 mm; Hollstein, vol.XVI, p.214, no.7; Veldman 2001, pp.287, 428, note 358, 359.

85 Copper, 16 x 21 cm, fragments of a signature (?) at bottom right, whereabouts unknown (London auction [Sotheby's], 3 July 1991, no.102, w/ ill.); Klessmann 2004, p.64; Klessmann 2006.

86 Ottani Cavina 1968, p.63, note 25; A. Ottani Cavina, in exh. cat. New York 1985, p.192.

87 See note 90.

88 Andrews 1985, pp.24, 45, note 11, cf. also A. Ottani Cavina, in exh. cat. New York 1985, p.192.

89 See note 75.

90 Dudok van Heel/Giskes 1984, p.17f., cf. also A. Tümpel, in exh. cat. Sacramento 1974, p.67; Keyes 1980, p.147; Andrews 1985, pp.24, 42.

91 Van Gelder/Jost 1966/67, p.145f.; Oehler 1967; Waddingham 1972 B, pp.606–609; Andrews 1985, p.202, no.A 10, A 13.

92 Oak, 73 x 122.5 cm, signed at bottom right: *Jacob p.f. 16[1]6*, Munich, Alte Pinakothek, inv.no.13151; E. Brochhagen/P. Eikemeier, in Munich 1973, p.53f.

93 Wood, 38.7 x 52.7 cm, signed at bottom right: *1618 JACP* [in ligature], private collection, New York; Oehler 1967, pp.148, 159, ill.7; P.C. Sutton, in exh. cat. Amsterdam/Boston/Philadelphia 1987, p.423f., no.75, pl.12.

94 Copper, 22.4 x 27.4 cm, signed at centre: *JACP* [in ligature]*f. A 16 [31?]*, Dresden, Gemäldegalerie Alte Meister, inv.no.1547A; A. Mayer-Meintschel/A. Lasius, in exh. cat. Dresden 1992, p.307, ill.

95 See notes 84, 85.

96 Schatborn 1997, p.3. Jan Pynas's second journey to Italy must have taken place between 10 October 1616 and 2 December 1617 as he is mentioned in legal documents in Amsterdam on those dates; Dudok van Heel/Giskes 1984, p.33, note 23, p.37.

97 Oak, 73 x 73.2 cm, signed at bottom left: *Jac. p.f Ano 1617*, Agnes Etherington Art Center, Kingston, Ontario (CAN), inv.no.26-001.

98 See notes 92, 93.

99 Andrews 1985, pp.40–42. Cf. also Klessmann essay in this catalogue.

100 Sandrart 1675 (1925), p.180; Andrews 1985, p.47, doc.5 (1607), 9 (1609).

101 K. Andrews, in Turner Dictionary 1996, vol.13 (1996), p.222f.

102 'A Mons[ieur] H. Gout, Gentil-homme Hollandois', Van de Velde 1605, n.p.

103 Andrews 1985, p.41.

104 The initials 'HG' (in ligature) used by Goudt are similar to those of Hendrick Goltzius. It is worth considering whether Goudt was thus referring to an artist whom he admired and with whom he also competed.

105 My thanks to Luuk Pijl (Dokkum) who called my attention to this picture.

106 '12. Item dui altri quadretti parimenti piccolini, ... et l'altro la decollatione di Sto. Giovanni Battista in vaso [raso] incorniciati di ebbano ... 34. Item un altro quadretto piccolino parimente di vaso [raso] di grandezza di un palmo incirca rappresentante l'historia di Tobia in corniciato d'ebbano', Weizsäcker 1952, p.212, no.12, p.214, no.34; Baldriga 2002, p.285, no.12 (quotation), p.287, no.34 (quotation). My thanks to Andreas Thielemann (Rome) for calling the publication by Irene Baldriga and the erroneous reading of 'raso' to my attention.

107 'Un altro quadretto d'un palmo con altra stampa pur in raso bianco d'un Tobia; Un altro quadretto d'un mezzo palmo dentrovi una stampetta ornata in raso bianco

d'una decollat.[io]ne di S: Gio:[vanni] bat[tis]ta incornicia-
ta d'ebano ma rotta in piu lati', Baldriga 2002, pp.182,
291 (quotation).

108 'Un quadretto di due palmi incorniciato similm.[en]te di
pero con una stampa di raso bianco di Cerere', Baldriga
2002, p.290 (quotation). There is no corresponding entry
to be found in Faber's inventory, but immediately before
'small Tobias' it says: '33. Item un quadretto in vaso
[raso] di grandezza di un palmo et mezzo in circa rap-
pressentante una notte, incorniciato di nero et profilato di
bianco', Baldriga 2002, p.287, no.33. This nocturnal
scene ('notte') is presumably identical to the *The Mocking
of Ceres* purchased by dal Pozzo. An impression of
Goudt's *The Mocking of Ceres* on silk was on the London
art market in 1978, Mendez 1978, n.p., no.17, w/ ill.

109 M. Bury, in exh. cat. London 2001 B, p.48. Hollstein,
vol.VII, p.151, proves the existence of two impressions of
Goudt's engraving after Elsheimer's 'small Tobias' on silk
(Seydlitz Collection 1912 and Oettingen Collection 1937).

110 Baldriga 2002, p.177, 181–183. Elsheimer's contacts in
Rome with the circle around Johann Faber and the
Accademia dei Lincei, and Faber's contact with the
Augsburg Johann Rottenhammer and Marcus Welser as
well as Philipp Hainhofer, can not be examined in this
context, but would be well worth further study.

111 Baldriga 2002, p 182, 188–90.

112 '... und [Goudt] kaufft nicht allein alles, was von seiner
[Elsheimer's] Hand war, auf, sondern liess ihn etliche
Jahr lang vor sich allein mahlen und bezahlte seine
Arbeit gar theur', Sandrart 1675, p.180.

113 92 x 146 mm; Andrews 1985, p.202, no.58, pl.10.

114 314 x 233 mm (sheet), 284 x 227 mm (image size);
Andrews 1985, p.201, no.56, pl.8.

115 Pen and brown ink on parchment, 114 x 182 mm, Paris,
Musée du Petit Palais, Collection Dutuit, inv.no.D Dut
1116.

116 Pen and brown ink on parchment, 192 x 250 mm, signed:
HGo... [H and G in ligature], New York, Pierpont Morgan
Library, inv.no.I, 146a. On these two drawings cf.
Stampfle 1983 and Klessmann 1987, p.170, note 22.

117 Stampfle 1983, p.257.

118 'un quadretto in carta pecora abozzato', Andrews 1972,
p.600.

119 Andrews 1985, p.47, doc.5.

120 Weizsäcker 1928, p.112.

121 Weizsäcker 1939.

122 Copper, 22.5 x 26.2 cm, private collection, Germany
(previously London auction [Sotheby's], Dec. 13, 2001.
no.26, ill.). My thanks to George Gordon (London) for
information on and a slide of the painting.

123 Auction Vrouwe van S[in]te. Annaland, The Hague, 6
November 1725 (L. 340), no.26 ('Een kaersligtje, ver-
beeldende de Historie van Bauces ende Philemon, door
H: Goudt, groot acht duim en een half hoog, tien duim en
een quart breedt.' [corresponds to 21.9 x 26.4 cm]);
Weizsäcker 1939, p.185, note 4, erroneously as no.16; in
addition with the price quotation of 'f. 40'. My thanks to
Marten Jan Bok (Utrecht) for a copy of the auction cata-
logue.

124 Andrews 1985, p.41, ill.59.

125 Andrews 1972, pp.596, 599.

126 On the fate of the printing plates, cf. Klessmann 1987,
p.168f., note 7.

127 Buchheit/Oldenbourg 1921, p.6.

128 Canvas, 115 x 171.5 cm, signed at bottom right: *Joan
König Fe Venezia 1607*, whereabouts unknown (last
documented in Cologne auction [Lempertz], 27–29
November 1969, no.120, w/ ill.); Waddingham 1972 B,
p.610, note 51 (erroneously as no.121).

129 'miniatur ... ein gantzes jar', Hainhofer/Doering 1894,
p.39 (quotations). Cf. above p.209f.

130 'auf bürgament gemahlet von aim folio blat die
Cananeische hochzeit vom Hanss König. in ebeno einge-
fast', Hainhofer/Doering 1894, p.44, no.14a. 'Folio
format' refers to a height of 35–45 cm.

131 '... so hab ich bey Wolf Diederich thorn ain Cananeische
hochzeit vom Hanss König (welcher an ietzo zu Rom ist)
von miniatur in Venedig gemahlet ersehn ...',
Hainhofer/Doering 1894, p.39, no.14 (9-19 September
1610); cf. Strieder 1966, p.89.

132 Copper, 8.5 x 12.3 cm, signed at bottom right *Johann./
König. f*, whereabouts unknown (last documented in
London auction [Sotheby's], Dec. 8, 2004, no.39, ill.
[£352,800].

133 'Ich habe dieses an einem recht vortrefflichen Bildgen im
Etlingischen Cabinet gesehen, wo ein unvergleichlicher
heil.[iger] Johannes in der Wuesten im Vorgrund kniet,
im Hintergrund aber Hirten das Vieh treiben ...', Hüsgen
1780, p.25; cf. Hüsgen 1790, p.85.

134 Hüsgen 1780, p.25f.; cf. Hüsgen 1790, p.85f. On the
reproduction I consulted of the *Landscape with John the
Baptist*, König's signature indeed appears to have been
retraced in places. The signature may, therefore, once
have been overpainted.

135 Waddingham 1972 B, p.610.

136 Tempera on parchment, 14 x 18 cm signed at bottom
left: *Iohan: König/ Norimbe: Fecit/ 1617*, inscription on
sheet of paper next to lute: *R 233./ K'p?] 20*, Munich,
Residenzmuseum, inv.no.189; Buchheit/Oldenbourg
1921, pp.4–6, 13, no.33, pl.18.

137 *Orpheus among the Animals*, gouache on parchment, 25
x 37 cm, signed: *Joan: König/f./ in Roma/ 1613*, Munich,
Residenzmuseum, inv.no.192; *Marriage at Cana*,
gouache on parchment, 14.7 x 18 cm, signed: *Io: König:f.
in Roma*, Munich, Residenzmuseum, inv.no.190;
Buchheit/Oldenbourg 1921, p.13, nos. 30, 31, pl.16, 17
and *Let the Children Come to Me*, gouache on paper on
oak, 19.5 x 14.9 cm, signed: *Joan: König Fecit Roma
[1613?]*, Berlin, Gemäldegalerie, inv.no.M. 205; B.
Burock, in exh. cat. Berlin 1986, pp.87–89, ill.; exh. cat.
Berlin 1996, pp.67, 207, ill.483.

138 'König erbeuth sich gleichsfahls auf mein begeren eine
schöne flucht Christi in Aegipten von miniatur zuuerferti-
gen, dem schreib Ich wan er wass schöns habe so Ihme
nit apostiert, mög er michs sehen lassen, den preiss
darbei visieren, so wölle Ich mich alss dan bald darübert
erkleren, vnd die prouision darbei verschaffen',
Hainhofer/Doering 1894, p.90, no.28 (5 January 1611);
cf. ibid., p.144, no.49 (8 June 1611).

139 'vberhauffte arbeit', Hainhofer/Doering 1894, p.208
(quotation), no.78 (8 February 1612); cf. ibid., p.204,
no.73 (28 December 1611).

140 'ein schon kupfferlin van hanss Künig. darob Judicium
paridis', Hainhofer/Doering 1894, p.233, no.92 (6 June
1612).

141 Copper, 20 x 28.5 cm, signed on the stone: *Jo: König /
fecit*, Paris, Collection Frits Lugt, Institut Néerlandais,
inv.no.6380, Dekiert 2005, p.41f., ill.10; Klessmann
2006.

142 'König möchte her kommen, hette auch gerne wider
arbait', Hainhofer/Doering 1894, p.252, no.112 (4
December 1612).

143 Strieder 1966, p.89; Tacke 2001, p.490.

Appendix

Biographies of Painters in
Elsheimer's Circle

Bibliography

Lenders

Index

Biographies of Painters in Elsheimer's Circle

Paul Bril (1553/54–1626)

Paul Bril was born in 1553 or 1554, presumably in Breda, and received his early training from his father. In 1574 or 1576 he travelled to Italy, where he initially collaborated with his brother Matthijs (1547/50–1583) on large frescoes. There is documentary evidence of his presence in Rome from 1582, and in the years that followed he received numerous papal commissions. It was not until 1590 that he turned his attention to small easel paintings. Bril served as a witness at Adam Elsheimer's marriage ceremony in 1606. He occupied high-ranking offices in the Accademia di San Luca and enjoyed great esteem at the time of his death in Rome on 7 October 1626.

LITERATURE Van Mander 1604, fol.291v.–292r.; Sandrart 1675, p.150 f.; L. Pijl, in AKL, vol.14, pp.228–230 (with bibliography)

Hendrick Goudt (1583–1648)

Hendrick Goudt was born in 1583, presumably in The Hague, where he is thought to have received training as an engraver from Simon Frisius (c.1580–1629). He also learned calligraphy in Rotterdam from Jan van de Velde I (1569–1623). Around 1604 Goudt went to Rome, where he lived in the house of Adam Elsheimer. He is documented there in 1607 and 1609; most probably he lived there until later in 1609 or 1610. He was admitted to the painters' guild of Utrecht in 1611. Beginning in approximately 1620, Goudt suffered from a severe mental illness; he was declared legally incompetent in 1625 and died in Utrecht in a state of mental derangement in 1648.

LITERATURE Sandrart 1675, p.180 f.; Reitlinger 1921; Weizsäcker 1928; Swillens 1931; Weizsäcker 1939; Ten Hove 1944; Swillens 1946; Hoek 1970; Stampfle 1983; K. Andrews in GDA, vol.13, p.222 f.; Gerszi 2000

Johann König (1586–1642)

Johann König was christened on 21 October 1586 in Nuremberg. He may have received his training in Augsburg. He was in Venice in 1607 and, by September 1610, in Rome, where he might still have been able to encounter Adam Elsheimer. He became a master painter in Augsburg in 1614; in 1623 he was appointed to the Great Council there. He presumably left Augsburg in 1629. He was buried in Nuremberg on 10 March 1642.

LITERATURE Hüsgen 1780, 25 f.; R.A. Peltzer in Thieme/Becker, vol.21, pp.154–156; Drost 1933, pp.160–165; Strieder 1966; H. Seifertová in GDA, vol.18, p.225; Tacke 2001, pp.488–490

Pieter Lastman (1583–1633)

Pieter Lastman was born in Amsterdam in 1583 and received his training there from Gerrit Pietersz. (1566–after 1608). He was in Italy from 1602 or 1603 to 1606 or 07. In Rome he belonged to the inner circle around Adam Elsheimer. Following his return to Amsterdam he was the most important and influential history painter of his generation. His pupils included Jan Lievens (1607–1674) and Rembrandt (1606–1669). Pieter Lastman was buried in his native city on 4 April 1635.

LITERATURE Van Mander 1604, fol. 293v.; Sandrart 1675, pp.160, 163; Freise 1911; Amsterdam 1991; Dudok van Heel 1991 A; Dudok van Heel 1991 B

Jacob Pynas (1592/93–after 1650)

Jacob Pynas was born in Amsterdam in 1592 or 1593. He therefore cannot have been in Rome with his brother Jan in 1605, as has been assumed in the past. It is possible that he accompanied Jan on the latter's journey to Italy in 1617. His knowledge of Elsheimer's art is evident in his works. In Holland he led a restless life and was active in The Hague, Leiden, Haarlem, Alkmaar, and Delft. He died in Amsterdam some time after 1650.

LITERATURE Schrevelius 1648, pp.290, 384; Houbraken 1718 vol.1, pp.214, 254; Bauch 1936; Bauch 1937; Oehler 1967; A. Tümpel in Sacramento 1974, pp.26–31; Dudok van Heel/Giskes 1984; A. Tümpel in Amsterdam 1991, pp.17–27; Schatborn 1997; B.L. Brown in London 2001 A, p.382

Jan Pynas (1581–1631)

Jan Pynas was born in Alkmaar in 1581; his family moved to Amsterdam in 1590. He was presumably in Italy with Pieter Lastman until 1606 or 07, including a stay in Rome, where he had contact with Elsheimer. Following his return to Amsterdam he was active as a history painter. Jan Pynas was in Rome once again in 1617, possibly in the company of his younger brother Jacob. He was buried in Amsterdam in 1631.

LITERATURE Sandrart 1675, pp.160, 163; Houbraken 1718. vol.1, pp.132, 214 f.; Bauch 1935 A; Bauch 1935 B; Bredius 1935; A. Tümpel in Sacramento 1974, pp.23–26; Dudok van Heel/Giskes 1984; A. Tümpel in Amsterdam 1991, pp.27–33; Schatborn 1996

Johann Rottenhammer (1564–1625)

Johann (also known as Hans) Rottenhammer was born in Munich in 1564 and received his training there from Hans Donauer (c.1521–1596). He travelled to Italy in 1588; the documentary evidence indicates that he was initially in Treviso (1589), then in Venice (c.1591), Rome (c.1593–94) and subsequently back in Venice. There he ran a workshop, which Adam Elsheimer may have visited. He returned to Germany in 1606 and settled in Augsburg, where he was immediately granted major commissions, some from abroad. Rottenhammer died in Augsburg on 14 August 1625.

LITERATURE
Van Mander 1604, fol. 296r.; Ridolfi 1648, vol.2, p.76f.; Sandrart 1675, pp.152–54; Peltzer 1916; Schlichtenmaier 1988; K. Andrews in GDA vol.27, pp.227–29; Hochmann 2003

Carlo Saraceni (1579–1620)

Carlo Saraceni was born in Venice in 1579 and went to Rome around 1598. There he was initially influenced by Adam Elsheimer's art, but he later came under the sway of Caravaggio, the Carracci and Domenichino. In 1619 Carlo Saraceni returned to Venice, where he died in June 1620.

LITERATURE Mancini, *Considerazioni*, vol.I, p.254 f.; Baglione 1642, pp.145–47; Ottani Cavina 1968; J.J. Chvostal in GDA vol.27 (1996), pp.815–17

David Teniers the Elder (1582–1649)

David Teniers the Elder was born in Antwerp in 1582 and received his training there from his older brother Juriaan (1572–1615). He travelled to Rome presumably around 1600 and became acquainted with Adam Elsheimer's art. In 1605 he is registered as a master in the painters' guild of Antwerp. In the following years, Teniers painted both small-scale works under Elsheimer's influence as well as large-scale altarpieces based on works by Rubens. Teniers died in Antwerp on 29 July 1649. His son David Teniers the Younger (1610–1690) was also a painter.

LITERATURE De Bie 1661, pp.140–42; Sandrart 1675, p.181; K. Zoege von Manteuffel in Thieme/ Becker vol.32, p.527; Van Gelder/Jost 1966/67, pp.147–52; Waddingham 1970; Duverger/Vlieghe 1971; Andrews 1984; H. Vlieghe in GDA vol.30, p.460 f

Jakob Ernst Thomann von Hagelstein (1588–1653)

Jakob Ernst Thomann von Hagelstein was born in Lindau in 1588. It is possible that he received his training in Kempten and Constance. In 1605 he had contact with Elsheimer in Rome, and he is documented in Naples in 1613 and back in Lindau in 1614. He served as Imperial Master of Provisions from 1625 and was presumably no longer active as a painter. He was appointed Imperial Master-General of Provisions in 1634; in 1649 he was elected to the council of the City of Lindau. He died there on 2 October 1653.

LITERATURE Sandrart 1675, pp.160, 163; N. Lieb in Thieme/Becker, vol.33, p.57 f.; Wegner 1969; Seifert 2005 A

Bibliography

AKL
Saur Allgemeines Künstler-Lexikon. Die bildenden Künstler aller Zeiten und Völker, Leipzig and Munich, 1992–

Adriani 1977
G. Adriani, *Deutsche Malerei im 17. Jahrhundert*, Cologne, 1977

Amsterdam 1998
M. Schapelhouman and P. Schatborn, *Dutch Drawings of the Seventeenth Century in the Rijksmuseum Amsterdam. Artists born between 1580 and 1600*, 2 vols., Amsterdam, 1998

Andrews 1971
K. Andrews, *Adam Elsheimer: Il Contento*, Edinburgh, 1971

Andrews 1972
K. Andrews, 'The Elsheimer Inventory and other Documents', *Burlington Magazine*, 114, 1972, pp.595–600

Andrews 1973
K. Andrews, 'Elsheimer and Dürer: an attempt towards a clarification of Elsheimer's early work', *Münchner Jahrbuch der bildenden Kunst*, 24, 1973, pp.159–74

Andrews 1973 A
K. Andrews, 'Elsheimer's Portrait', in *Album Amicorum J. G. van Gelder*, edited by J. Bruyn *et al.*, The Hague 1973, pp.1–4

Andrews 1977
K. Andrews, *Adam Elsheimer: Paintings, Drawings, Prints*, Oxford, 1977

Andrews 1979
K. Andrews, 'Once more Elsheimer', *Burlington Magazine*, 121, 1979, pp.168–72

Andrews 1981
K. Andrews, 'Das Problem der Elsheimer-Gouachen', *Kunstgeschichtliche Gesellschaft zu Berlin. Sitzungsberichte*, 28/29, October 1979–May 1981, pp.23–25

Andrews 1984
K. Andrews, 'Bemerkungen zu einer Anbetung der Könige in Göttingen', *Niederdeutsche Beiträge zur Kunstgeschichte*, 23, 1984, pp.149–56

Andrews 1985
K. Andrews, *Adam Elsheimer. Werkverzeichnis der Gemälde, Zeichnungen und Radierungen*, Munich, 1985

Andrews 1986
K. Andrews, 'A Rediscovered Elsheimer', *Burlington Magazine*, 128, 1986, pp.795–797

Andrews 1996
K. Andrews, 'Adam Elsheimer', in *Turner Dictionary 1996*, vol.10, pp.156–61

Arslan 1960
E. Arslan, *I Bassano*, 2 vols., Milan, 1960

Aschaffenburg 1975
Bayerische Staatsgemäldesammlungen, *Galerie Aschaffenburg. Katalog*, edited by E. Steingräber, 2nd edition, Munich, 1975

Augsburg 1984
Bayerische Staatsgemäldesammlungen, *Städtische Kunstsammlungen Augsburg*, vol.2: *Deutsche Barockgalerie. Katalog der Gemälde*, compiled by G. Krämer, 2nd edition, Augsburg, 1984

Bachner 1997
F. Bachner, 'Gleichartigkeit und Gegensatz. Zur Figurenbildung bei Adam Elsheimer', *Städel-Jahrbuch*, NF 16, 1997, pp.249–53

Baglione 1642
G. Baglione, *Le vite de' pittori, scultori, architetti ...*, Rome, 1642

Von Baldass 1938/43
L. von Baldass, 'Studien über Jacob Pynas', *Belvedere: illustrierte Zeitschrift für Kunstsammler*, 13, 1938/43, pp.154–58

Baldriga 2002
I. Baldriga, *L'occhio della Lince. I primi lincei fra arte, scienza e collezionismo 1603–1630. Accademia Nazionale de Lincei. Storia dell' Accademia dei Lincei*, studi 3, Rome, 2002

Bartsch (+ No.)
A. Bartsch, *Le Peintre-Graveur*, 22 vols., Vienna, 1808–21

Bartsch Illustrated
The Illustrated Bartsch, edited by W.L. Straussand and J.T. Spike, New York, 1978-

Bauch 1935 A
K. Bauch, 'Beiträge zum Werk der Vorläufer Rembrandts I. Die Gemälde des Jan Pynas', *Oud Holland*, 52, 1935, pp.145–158

Bauch 1935 B
K. Bauch, 'Beiträge zum Werk der Vorläufer Rembrandts II. Die Zeichnungen von Jan Pynas', *Oud Holland*, 52, 1935, pp.193–204

Bauch 1936
K. Bauch, 'Beiträge zum Werk der Vorläufer Rembrandts III. Die Gemälde des Jakob Pynas', *Oud Holland*, 53, 1936, pp.79–88

Bauch 1937
K. Bauch, 'Beiträge zum Werk der Vorläufer Rembrandts IV. Handzeichnungen von Jakob Pynas', *Oud Holland*, 54, 1937, pp.241–52

Bauch 1951
K. Bauch, 'Frühwerke Pieter Lastmans, Münchner Jahrbuch der bildenden Kunst', *Neue Folge*, 2, 1951, pp.225–37

Bauch 1953
K. Bauch, 'Aus Caravaggios Umkreis, *Mitteilungen des Kunsthistorischen Institutes in Florenz*, 7, 1953–56, pp.227–38

Bauch 1960
K. Bauch, *Der frühe Rembrandt und seine Zeit. Studien zur geschichtlichen Bedeutung seines Frühstils*, Berlin, 1960

Bauch 1967
K. Bauch, 'Die Elsheimer-Ausstellung in Frankfurt', *Kunstchronik*, 20, 1967, pp.57–66, 89–93

Baudi di Vesme 1886
A. Baudi di Vesme, *Sull'acquisto fatto da Carlo Emanuele III Re di Sardegna della quareria del principe Eugenio di Savoia*, in *Miscellanea di Storia italiana*, X/25, Turin, 1886

Baumstark 2005
R. Baumstark, 'Römische Weggefährten: Rubens und Elsheimer', in Munich 2005, pp.50–75

Bellini 1975
P. Bellini, 'Printmakers and Dealers in Italy during the 16th and 17th centuries', *Print Collector*, 13, 1975, pp.17–45

Berger 1993
A. Berger, 'Die Tafelgemälde Paul Brils', in *Kunstgeschichte*, vol.12, Münster and Hamburg, 1993

Berlin 1986
I. Geismeierand and B. Burock, *Miniaturen. Staatliche Museen zu Berlin. Gemäldegalerie. Katalog*, vol.II, Berlin, 1986

Berlin 1996
Gemäldegalerie Berlin. Gesamtverzeichnis, Berlin, 1996

Bertini 1987
G. Bertini, *La Galleria del Duca di Parma. Storia di una collezione*, Bologna, 1987

Bialostocki 1972
J. Bialostocki, *Die Geburt der modernen Landschaftsmalerei*, in Dresden 1972, pp.13–18

De Bie 1661
C. de Bie, *Het Gulden Cabinet vande edel vry Schilder Const ...*, Antwerp, 1661 (reprint Soest 1971)

Biermann 1914
Deutsches Barock und Rokoko. Herausgegeben im Anschluß an die Jahrhundert-Ausstellung Deutscher Kunst 1650–1800 Darmstadt 1914, 2 vols., edited by G. Biermann, Leipzig, 1914

Blankert 1965
A. Blankert, *Nederlandse 17e eeuwse italianiserende landschapschilders*, exh. cat., Centraal Museum, Utrecht, 1965

Bober/Rubinstein 1986
P.P. Bober and R. Rubinstein, *Renaissance Artists and Antique Sculpture. A Handbook of Sources*, Oxford, 1986

Bodart 1970
D. Bodart, 'Les tableaux de la succession de Paul Bril', in *Mélanges d'archéologie et d'histoire de l'art offerts au professeur Jacques Lavalleye* (Université de Louvain. Receuil de travaux d'histoire et de philologie, 4e série, 45), Louvain, 1970, pp.1–14

Bode 1880
W. Bode, 'Adam Elsheimer, der römische Maler deutscher Nation', *Jahrbuch der preußischen Kunstsammlungen*, 1, 1880, pp.51–78, 245–62

Bode 1883
W. Bode, *Studien zur Geschichte der holländischen Malerei*, Braunschweig, 1883

Bode 1920
W. Bode, *Adam Elsheimer, der römische Maler deutscher Nation*, Munich, 1920

Bothe 1939
Friedrich Bothe, *Adam Elsheimer, der Maler von Frankfurt. Neue Forschungen über seine Jugendzeit*, Frankfurt, 1939

Bredius 1915–1921
A. Bredius, *Künstler-Inventare. Urkunden zur Geschichte der holländischen Kunst des 16., 17. und 18. Jahrhunderts. Quellenstudien zur holländischen Kunstgeschichte V–XI*, 7 vols., The Hague, 1915–21

Bredius 1935
A. Bredius, 'Aanteekeningen omtrent de schilders Jan en Jacob Symonsz Pynas', *Oud Holland*, 52, 1935, pp.252–58

Brejon de Lavergnée 1989
A. Brejon de Lavergnée, 'Pittori stranieri in Italia', in *La Pittura in Italia, Il Seicento II*, edited by M. Gregori, E. Schleier, Milan, 1989, pp.531–58

Brown 1995
J. Brown, *Kings and Connoisseurs*, New Haven and London, 1995

Brunner 1977
H. Brunner, *Die Kunstschätze der Münchner Residenzgalerie*, edited by A. Miller, Munich, 1977

Bruyn 1997
J. Bruyn, 'François Venant. Enige aanvullingen', *Oud Holland*, 111, 1997, pp.163–76

Buchheit/Oldenbourg 1921
H. Buchheit and R. Oldenbourg, *Das Miniaturenkabinett der Münchener Residenz*, Munich, 1921

Burchard/d'Hulst 1963
L. Burchard and R.-A. d'Hulst, *Rubens Drawings*, 2 vols., Brussels, 1963

Bys 1719
R. Bys, *Fürtrefflicher Gemähld- und Bilder-Schatz [1719]. Die Gemäldesammlung des Lothar Franz von Schönborn in Pommersfelden*, edited and compiled by K. Bott, Weimar, 1997

Casteels 1961
M. Casteels, 'De beeldhouwers De Nole te Kamerijk, te Utrecht en te Antwerpen', *Verhandelingen van de Koninklijke Vlaamse Academie voor Wetenschappen, Letteren en Schone Kunsten van België. Klasse der Schone Kunsten*, essay no.16, Brussels, 1961

Causa 1956
R. Causa, *Francesco Nomé detto Monsù Desiderio, Paragone*, 7, no.75, 1956, pp.30–46

De Caulibvs *Meditaciones*
Iohannis de Cavlibvs, *Meditaciones vite Christi*, compiled by M. Stalling-Taney (CCCM, vol.CLIII), Turnhout, 1997

Chaney 2003
The Evolution of English Collecting: Receptions of Italian Art in the Tudor and Stuart Periods, Studies in British Art, 12, edited by E. Chaney, New Haven and London, 2003

Chiarini 1989/90
M. Chiarini, 'Adam Elsheimer e i pittri fiorentini del primo Seicento', *Prospettiva*, 57–60 (Scritti in ricordo di Giovanni Previtali II), 1989/90, pp.205–12

Christiansen 1986
K. Christiansen, 'Caravaggio and "L' emsepio davanti del naturale"', *Art Bulletin*, 68, 1986, pp.421–45

Clarke/Penny 1982
The Arrogant Connoisseur: Richard Payne Knight 1751–1824, edited by M. Clarke and N. Penny, Manchester, 1982

Cocke 1991
R. Cocke, 'St Jerome and the Egyptian Lion: A note on Elsheimer, Rome and the Campagna', *Zeitschrift für Kunstgeschichte*, 54, 1991, pp.107–17

Crinò 1965
A.M. Crinò, 'An Unpublished Document on the Frame of Adam Elsheimer's Tabernacle', *Burlington Magazine*, 107, 1965, pp.575–76

Cropper/Panofsky-Soergel 1984
E. Cropper and G. Panofsky-Soergel, 'New Elsheimer Inventories from the Seventeenth Century', *Burlington Magazine*, 126, 1984, pp.473–87

Cust/Cox 1911
L. Cust and M. Cox, 'Notes on the Collections formed by Thomas Howard', *Burlington Magazine*, 19, 1911, pp.282–86, 323–25

Davidson Reid 1993
J. Davidson Reid, *The Oxford Guide to Classical Mythology in the Arts. 1300–1990s*, 2 vols., New York and Oxford, 1993

DeGrazia Bohlin 1979
D. DeGrazia Bohlin, *Prints and related Drawings by the Carracci Familiy. A Catalogue Raisonné*, Washington, 1979

Dekiert 2005
M. Dekiert, '"… Ein Werk, das in allen Theilen zugleich und in einem jeden besonderlich ganz unvergleichlich ist …" Adam Elsheimers Flucht nach Ägypten – Werk und Wirkung', in Munich 2005, pp.20–49

Demonts 1938
L. Demonts, *Musée du Louvre. Inventaire Général des*

Dessins des Ècoles du Nord. Ècoles Allemandes et Suisses, Paris, 1938

The Hague 1978
A. Blankert, *Museum Bredius. Catalogus van de schilderijen en tekeningen*, The Hague, 1978

Dittrich 2004
S. and L. Dittrich, *Lexikon der Tiersymbole. Tiere als Sinnbilder in der Malerei des 14. bis 17. Jahrhunderts*, Petersberg, 2004

Dresden 1992
Gemäldegalerie Dresden. Alte Meister. Katalog der ausgestellten Werke, Dresden and Leipzig, 1992

Drost 1926
W. Drost, 'Barockmalerei in den germanischen Ländern', in *Handbuch der Kunstwissenschaft*, Wildpark and Potsdam, 1926

Drost 1933
W. Drost, *Adam Elsheimer und sein Kreis*, Potsdam, 1933

Drost 1957
W. Drost, *Adam Elsheimer als Zeichner. Goudts Nachahmungen und Elsheimers Weiterleben bei Rembrandt. Ein Beitrag zur Strukturforschung*, Stuttgart, 1957

Dudok van Heel/Giskes 1984
S.A.C. Dudok van Heel and J.H. Giskes, 'Noord-Nederlandse Pre-Rembrandtisten en Zuid-Nederlandse muziekinstrumentenmakers. De schilders Pynas en de luit- en citermakers Burlon en Coop', *Jaarboek Amstelodamum*, 67, 1984, pp.13–37

Dudok van Heel 1991 A
S.A.C. Dudok van Heel, 'De familie van de schilder Pieter Lastman (1583–1633). Een vermaard leermeester van Rembrandt van Rijn', *Jaarboek Centraalbureau voor Genealogie*, 45, 1991, pp.110–32

Dudok van Heel 1991 B
S.A.C. Dudok van Heel, 'Pieter Lastman (1583–1633). Een schilder in de Sint Anthonisbreestraat', *Kroniek van Het Rembrandthuis*, 1991, no.2, pp.2–15

Duverger/Vlieghe 1971
E. Duverger and H. Vlieghe, *David Teniers der Ältere*, Utrecht, 1971

Eich 1986
P. Eich, 'Das Kreuzretabel Adam Elsheimers im Städelschen Kunstinstitut zu Frankfurt am Main', in *Spiegelungen*, edited by W. Knopp, Mainz, 1986, pp.31–59

Elsheimer 2006
Adam Elsheimer in Rome. Werk – Kontext – Wirkung, edited by S. Gronert and A. Thielemann *et al.*, Rome and Munich, 2006 (forthcoming)

Errera 1920
I. Errera, *Répertoire des peintures datées*, Brussels and Paris, 1920

Ertz 1979
K. Ertz, *Jan Brueghel d. Ä. Die Gemälde mit kritischem Oeuvrekatalog*, Cologne, 1979

Faber 1628
Joannis Fabri Lincei Bambergensis, medici et professoris Romani, … Animalia Mexicana descriptionibus scholiisque exposita, Rome, 1628

Faggin 1965
G.T. Faggin, 'Per Paolo Bril', *Paragone*, 16, no.185/5, 1965, pp.21–35

Florence 1979
Gli Uffizi. Catalogo Generale, edited by L. Berti, Florence, 1979

Florence 1989
M. Chiarini, *Galerie e musei statali di Firenze. I dipinti Olandesi del Seicento e del Settecento*, Rome, 1989

Frankfurt 1995
J. Sander and B. Brinkmann, 'Niederländische Gemälde vor 1800 im Städel', in *Niederländische Gemälde vor 1800 in bedeutenden Sammlungen. Illustriertes Gesamtverzeichnis*, edited by G. Holland, vol.1, Frankfurt, 1995

Freedberg 1980
D. Freedberg, *Dutch Landscape Prints of the Seventeenth Century*, London, 1980

Freedberg 1983
S.J. Freedberg, *Circa 1600: A Revolution of Style in Italian Painting*, Cambridge, Mass., 1983

Freedberg 2002
D. Freedberg, *The Eye of the Lynx. Galileo, His friends, and the Beginnings of Modern Natural History*, Chicago, 2002

Freise 1911
K. Freise, 'Pieter Lastman, sein Leben und seine Kunst. Ein Beitrag zur Geschichte der Holländischen Malerei im XVII. Jahrhundert', *Kunstwissenschaftliche Studien*, 5, Leipzig 1911

Van Gelder 1953
J.G. van Gelder, 'Rembrandt's vroegste ontwikkeling', *Mededeiingen der Koninklijke Nederlandse Akademie van Wetenschappen, Afd. Letterkunde*, (nieuwe reeks) 16, 1953, pp.273–300

Van Gelder/Jost 1966/67
J.G. van Gelder and I. Jost, 'Elsheimers unverteilter Nachlass', *Simiolus*, 1, 1966/67, pp.136–52

Van Gelder/Jost 1967/1968
J.G. van Gelder and I. Jost, 'Elsheimers unverteilter Nachlass', *Simiolus*, 2, 1967/68, pp.23–45

Van Gelder/Jost 1967
J.G. van Gelder and I. Jost, 'Elsheimers unverteilter Nachlass', *Simiolus*, 1, 1966/67, pp.136–52; 2, 1967/68, pp.23–45

Gerszi 2000
T. Gerszi, 'Hendrik Goudt fece o meno raffigurazioni di ruderi?', in *L'arte nella storia. Contributi di critica e storia dell'arte per Gianni Carlo Sciolla*, edited by V. Terraroli *et al.*, Milan, 2000, pp.379–83

Golden Legend
Jacobus de Voragine, *The Golden Legend: Readings on the Saints*, translated by W.G. Ryan, 2 vols , Princeton, 1993

Gregori/Schleier 1989
M. Gregori and E. Schleier, *La pittura in Italia. Il Seicento*, 2 vols., Milan, 1989

Gronert 2003
S. Gronert, 'Adam Elsheimer in Venedig? Eine kritische Betrachtung zweier Dokumente', *Marburger Jahrbuch für Kunstwissenschaft*, 30, 2003, pp.211–15

Guratzsch 1980
H. Guratzsch, 'Die Auferweckung des Lazarus in der Niederländischen Kunst von 1400 bis 1700', *Ars Neerlandica. Studies in the History of Art of the Low Countries*, 2 vols., Kortrijk, 1980

Hainhofer/Doering 1894
'Des Augsburger Patriciers Philipp Hainhofer Beziehungen zum Herzog Philipp II. von Pommern-Stettin. Correspondenzen aus den Jahren 1610–1619', in *Quellenschriften für Kunstgeschichte und Kunsttechnik des Mittelalters und der Neuzeit (Neue Folge)*, vol.VI, edited by O. Doering, Vienna, 1894

Haverkamp Begemann 1959
E. Haverkamp Begemann, *Willem Buytewech*, Amsterdam, 1959

Heil 1949
W. Heil, 'A Newly Discovered Work by Adam Elsheimer', in *Miscellanea Leo van Puyvelde*, Brussels, 1949, pp.221–24

Heinz/Reiter 1998
M. Heinz and C. Reiter, '"Asia descriptio" und Jüngstes Gericht. Beispiel für die Zweitverwendung einer Kupferplatte von Ortelius', *Cartographica Helvetica*, 17, 1998, pp.25–31

Held 1959
J.S. Held, *Rubens. Selected Drawings*, 2 vols., London, 1959

Held 1980
J.S. Held, *The Oil Sketches of Peter Paul Rubens. A Critical Catalogue*, Princeton, 1980

Held 1986
J.S. Held, *Rubens. Selected Drawings*, 2nd edn., Oxford, 1986

Henkel/Schöne 1967
A. Henkel and A. Schöne, *Emblemata. Handbuch zur Sinnbildkunst des XVI. und XVII Jahrhunderts*, Stuttgart, 1967

Von Henneberg 1999
J. von Henneberg, 'Elsheimer and Rubens: a link in early 17th century Rome', *Storia dell'Arte*, 95, 1999, pp.35–44

Hervey 1921
M.F.S. Hervey, *The Life, Correspondence and Collections of Thomas Howard, Earl of Arundel, Father of Vertu in England*, Cambridge, 1921 (Reprinted New York, 1969).

Heussler 2006
C. Heussler, *De Cruce Christi: Kreuzauffindung und Kreuzerhöhung; Funktionswandel und Historisierung in nachtridentinischer Zeit*, Paderborn, 2006

Hind 1925
A.M. Hind, 'Adam Elsheimer, I. His education and his engravers', *Print Collector's Quarterly*, 12, 1925, pp.233–56

Hind 1926
A.M. Hind, 'Adam Elsheimer, II. His original etchings', *Print Collector's Quarterly*, 13, 1926, pp. 9–29

Hochmann 2003
M. Hochmann, 'Hans Rottenhammer and Pietro Mera. Two Northern Artists in Rome and Venice', *Burlington Magazine*, 145, 2003, pp.641–45

Hoek 1970
D. Hoek, 'Biografische bijzonderheden over Hendrik Goudt (1583–1648)', *Oud Holland*, 85, 1970, pp.54–55

Hoet 1752
G. Hoet, *Catalogus of naamlyst van schilderyen met derzelven pryzen*, 2 vols., The Hague 1752

Hoet/Terwesten 1770
G. Hoet and P. Terwesten, Catalogus of naamlijst van schilderijen, The Hague, 1770

Hoff 1939
U. Hoff, 'Some Aspects of Adam Elsheimer's Artistic Development', *Burlington Magazine*, 75, 1939, pp.59–64

Hoff 1983
U. Hoff, 'Cross-Currents in Dutch and Flemish Painting in the Seventeenth Century', *Apollo*, 118.1, 1983, pp.57–63

Hohl 1973
R. Hohl, 'Elsheimers Figurenzeichnungen. Stilkritik einiger Neuzuschreibungen', *Städel-Jahrbuch*, NF 4, 1973, pp.188–91

Holländer 2000
Erkenntnis, Erfindung, Konstruktion. Studien zur Bildgeschichte von Naturwissenschaften und Technik vom 16. bis zum 19. Jahrhundert, edited by H. Holländer, Berlin, 2000

Hollstein
F.W. Hollstein, *Dutch and Flemish Etchings, Engravings and Woodcuts*, Amsterdam, 1954-

Hollstein German
F.W.H. Hollstein, *German Engravings, Etchings and Woodcuts, ca. 1400–1700*, Amsterdam, 1954-

Holmes 1907
C.J. Holmes, 'Rembrandt and Jan Pynas', *Burlington Magazine*, 12, 1907, pp.102–05

Holzinger 1951
E. Holzinger, 'Elsheimers Realismus', *Münchner Jahrbuch der bildenden Kunst*, 2, 1951, pp.208–24

Holzinger 1962
E. Holzinger, 'Das Ecce Homo von Adam Elsheimer', in *Privatdruck des Städelschen Museums-Verein*, Frankfurt, 1962

Holzinger 1972
E. Holzinger, 'Adam Elsheimer. Die Ausgrabung des Kreuzes Christi/Die Rückführung des Kreuzes Christi im Triumph durch Kaiser Heraklius', in *Privatdruck des Städelschen Museums-Verein*, Frankfurt, 1972

Hoogewerff 1919
G.J. Hoogewerff, *De twee reizen van Cosimo de' Medici Prins van Toscane door de Nederlanden (1667–1669). Journalen en documenten* (Werken uitgegeven door de Historisch Genootschap Utrecht, Derde serie, no.41), Amsterdam, 1919

Houbraken 1718
A. Houbraken, *Groote Schouburgh der Nederlantsche Konstschilders en Schilderessen*, 3 vols., Amsterdam, 1718–21

Houbraken 1753
A. Houbraken, *De Groote Schouburgh der Nederlantsche Konstschilders en Schilderessen*, 3 vols., The Hague, 1753 (reprint Amsterdam, 1976).

Howard 1992
D. Howard, 'Elsheimer's Flight into Egypt and the Night Sky in the Renaissance', *Zeitschrift für Kunstgeschichte*, 55, 1992, pp.212–24

Howarth 1997
D. Howarth, *Images of Rule*, Basingstoke, 1997

Howarth 2002
D. Howarth, 'The Arundel Collection: Collecting and Patronage in England in the Reigns of Philip III and Philip IV', in *The Sale of the Century: Artistic Relations between Spain and Great Britain, 1604–1655*, exh. cat. edited by J. Brown and J. Elliot, Madrid, Museo nacional del Prado, 2002, pp.69–86

Howarth 1985
D. Howarth, *Lord Arundel and his Circle*, New Haven and London, 1985

Ten Hove 1944
J.J. ten Hove [= D.G. Hoek], *Het raadsel van Arend en Hendrik Goudt*, Amsterdam n.d. [1944]

Hubala 1970
E. Hubala, 'Die Kunst des 17. Jahrhunderts', *Propyläen Kunstgeschichte*, 7, Berlin, 1970

Huemer 1996
F. Huemer, *Rubens and the Roman Circle. Studies of the First Decade*, New York and London, 1996

Hüsgen 1780
H.S. Hüsgen, *Nachrichten von Franckfurter Künstlern und Kunst–Sachen*, Frankfurt, 1780

Hüsgen 1790
H.S. Hüsgen, *Artistisches Magazin. Enthaltend Das Leben und die Verzeichnisse der Werke hiesiger und anderer Künstler*, Frankfurt, 1790

Inventar München 1641/42 (1980)
M. Bachtler, P. Diemer and C. Erichsen, 'Die Bestände von Maximilians I. Kammergalerie. Das Inventar von 1641/1642', in *Quellen und Studien zur Kunstpolitik der Wittelsbacher vom 16. bis zum 18. Jahrhundert (Mitteilungen des Hauses der Bayerischen Geschichte 4)*, edited by H. Glaser, Munich, 1980, pp.191–252

Jacoby 1989
J. Jacoby with contributions from A. Michels, *Die deutschen Gemälde des 17. und 18. Jahrhunderts sowie die englischen und skandinavischen Werke, Herzog Anton Ulrich-Museum Braunschweig*, Braunschweig, 1989

Jaffé 1989
M. Jaffé, *Rubens. Catalogo completo*, Milan, 1989

Jost 1966
I. Jost, 'A Newly Discovered Painting by Adam Elsheimer', *Burlington Magazine*, 108, 1966, pp.3–6

Judson 1964
J.R. Judson, 'Pictorial Sources for Rembrandt's Denial of St. Peter', *Oud Holland*, 79, 1964, pp.141–51

Kassel 1996
B. Schnackenburg, *Gemäldegalerie Alte Meister. Gesamtkatalog*, 2 vols., Mainz, 1996

Keyes 1980
G.S. Keyes, 'Jacob Pynas as a Draughtsman', *Bulletin Musees Royaux des Beaux-Arts de Belgique Bruxelles*, 23–29, 1974–80, pp.147–70

Klessmann 1965
R. Klessmann, 'Die Landschaft mit der büssenden Magdalena, Berliner Museen', *Neue Folge*, 15, 1965, pp.7–11

Klessmann 1987
R. Klessmann, 'Elsheimers Aurora-Landschaft in neuem Licht', *Nederlands Kunsthistorisch Jaarboek*, 38, 1987, pp.158–71

Klessmann 1989
R. Klessmann, *Adam Elsheimer Pietà, Herzog Anton Ulrich-Museum Braunschweig/Kulturstiftung der Länder*, Braunschweig, 1989

Klessmann 1997
R. Klessmann, 'Elsheimers "Verspottung der Ceres" – zur Frage des Originals', *Städel-Jahrbuch*, NF 16, 1997, pp.239–48

Klessmann 2004
R. Klessmann, 'Adam Elsheimer Bemerkungen zur Rezeption seiner Kunst im Norden', in *Collected Opinions. Essays on Netherlandish Art in Honour of Alfred Bader*, edited by V. Manuth and A. Rüger, London 2004, pp.54–71

Klessmann 2006
R. Klessmann, 'Fragen zur Ausbreitung und Wirkung der Werke Elsheimers', in Elsheimer 2006

Klessmann 2006 A
R. Klessmann, 'Zum Verhältnis von Malerei und Zeichnung bei Adam Elsheimer', in *Aspekte deutscher Zeichenkunst. Publikation der Tagungsbeiträge des Kolloquiums*, edited by I. Lauterbach. Veröffentlichungen des Zentralinstituts für Kunstgeschichte. Munich, 2006 (forthcoming)

Knipping 1974
J.B. Knipping, *Iconography of the Counter Reformation in the Netherlands: Heaven on Earth*, 2 vols., Nieuwkoop, 1974

Koch 1977
G.F. Koch, 'Adam Elsheimers Anfänge als Maler in Frankfurt', *Jahrbuch der Berliner Museen*, 19, 1977, pp.114–71

Krämer 1973
G. Krämer, 'Das Kompositionsprinzip bei Adam Elsheimer', *Städel Jahrbuch*, 4, 1973, pp.145–72

Krämer 1978
G. Krämer, 'Ein wiedergefundenes Bild aus der Frühzeit Elsheimers', *Pantheon*, 36, 1978, pp.319–26

Krämer 1986
M. Krämer, *Die Maler in Frankenthal, in Ausst. Kat. Die Renaissance im deutschen Südwesten*, edited by V. Himmelein, Karlsruhe, 1986, vol. I, pp.226–39

Krämer 1995
M. Krämer, 'Der Brand von Troja und der Brand von Rom, sieben Versionen von Pieter Schoubroeck', in Frankenthal 1995, pp.97–102

Krifka 2000
S. Krifka, 'Zur Ikonographie der Astronomie', in Holländer 2000, pp.441–444

Ter Kuile 1974/76
O. Ter Kuile, *Rijksmuseum Twenthe Enschede. Catalogus van de schilderijen*, Enschede, 1974/76

Kultzen 1968
R. Kultzen, 'Ein Turmbau zu Babel von Paul Bril als jüngste Leihgabe in der Alten Pinakothek', *Pantheon*, 26, 1968, pp.208–19

Kuznetsow 1964
J.I. Kuznetsow, 'Het werkelijke onderwerp van de werken van A. Elsheimer en N. Knupfer bekend onder de naam "Contento of de jacht naar het geluk"', *Oud Holland*, 79, 1964, pp.229–30

Lavin 1954
T. Lavin, 'Cephalus and Procris. Transformations of an Ordinary Myth', *Journal of the Warburg and Courtauld Institutes*, 17, 1954, pp.260–87

Bibliography

LCI
Lexikon der christlichen Ikonographie, 8 vols., edited by
E. Kirschbaum, W. Braunfels, Freiburg, 1968–76

Lenz 1977
C. Lenz, *Adam Elsheimer. Die Gemälde im Städel*, 1st edition,
Frankfurt, 1977

Lenz 1978
C. Lenz, 'Adam Elsheimer (Rezension Andrews)', *Kunst-chronik*, 21, 1978, pp.163–70

Lenz 1979
C. Lenz, 'Adam Elsheimer. Der Traum Jakobs', *Städel-Jahr-buch*, NF 7, 1979, pp.298–300

Lenz 1989
C. Lenz, *Adam Elsheimer. Die Gemälde im Städel*, 2nd
edition, Frankfurt, 1989

Levey 1959
M. Levey, *The National Gallery Catalogues, The German
School*, London, 1959

Lightbown 1989
R. Lightbown, 'Charles I and European Princely Collecting',
in MacGregor 1989, pp.53–72

London 1981
H. Braham, *The Princess Gate Collection*, London, 1981

Longhi 1913 (1961)
R. Longhi, Due opere di Caravaggio, *L'Arte*, 16 (1913),
pp.161–164, reprinted in *Scritti Giovanili*, Florence, 1961,
vol.1, pp.23–27

Longhi 1943
R. Longhi, 'Ultimi studi sul Caravaggio e la sua
cerchia', *Proporzioni*, 1, 1943, pp.5–63

Longhi 1957
R. Longhi, 'Una traccia per Filippo Napoletano', *Paragone*,
8, no.95, 1957, pp.33–62

Longhi 1965
R. Longhi, 'Un italiano nella scia dell' Elsheimer: Carlo
Antonio Procaccini', *Paragone*, 16, no.185/5, 1965, pp.43–44

MacGregor 1985
'The Cabinet of Curiosities in Seventeenth-Century Britain,
The Origins of Museums', in *The Cabinet of Curiosities in
Sixteenth- and Seventeenth-Century Europe*, edited by O.
Impey and A. MacGregor, Oxford, 1985

MacGregor 1989
*The Late King's Goods: Collections, Possessions and Patro-nage of Charles I in the Light of the Commonwealth Sale
Inventories*, edited by A. MacGregor, London and Oxford,
1989

McLaren/Brown 1991
N. McLaren, *National Gallery Catalogues. The Dutch School
1600–1900* (revised and expanded by C. Brown), 2 vols.,
London, 1991

Mahon 1949
D. Mahon, 'Notes on the 'Dutch Gift' to Charles II: II', *Burling-ton Magazine*, 91, 1949, p.350

Mai 1985
E. Mai, 'Zu einer "Steinigung des Hl. Stephanus" aus Privat-besitz im Wallraf-Richartz-Museum Köln', *Wallraf-Richartz-Jahrbuch*, 45, 1985, pp.305–10

Mai 1996
E. Mai, *Adam Elsheimer 1578–1610. Die Steinigung des Hl.
Stephanus. Thema und Variation*, Wallraf-Richartz-Museum,
Cologne, 1996

Magurn 1955
R.S. Magurn, *The Letters of P.P. Rubens*, Cambridge, Mass.,
1955

Mancini *Considerazioni*
G. Mancini, *Considerazioni sulla Pittura (ca. 1614–21)*, edited
by A. Marucchi and L. Salerno, 2 vols., Rome, 1956

Van Mander 1604
K. van Mander, *Het Schilder-Boeck*, Haarlem, 1604

Van Mander/Miedema, 1994
K. van Mander, *The lives of the Illustrious Netherlandish and
German Painters, from the first edition of the Schilder-Boek
(1603–1604)*, edited by H. Miedema, 6 vols., Doornspijk,
1994–99

Marini 2001
M. Marini, 'Caravaggio "pictor praestantissimus". L'iter
artistico di uno die massimi rivoluzionari dell'arte di tutti i
tempi', in *Quest' Italia. Collana di storia, arte e folclore*, 117,
Rome, 2001

Martinez 1866
J. Martinez, *Discursos practicables del nobilisimo arte de
la pintura*, edited by Valentin Carderera y Solano, Madrid,
1866

Mayer 1910
A. Mayer, *Das Leben und die Werke der Brüder Matthäus
und Paul Brill*, Leipzig, 1910

McEvansoneya 2003
P. McEvansoneya, 'Italian Paintings in the Buckingham
Collection', in Cheney 2003, pp.315–35

Mendez 1978
*Prints after Adam Elsheimer, Christopher Mendez Print
Dealer, Catalogue 40*, London, 1978

Mesenzeva 1983
C. Mesenzeva, 'Zum Problem: Dürer und die Antike. Albrecht
Dürers Kupferstich "Die Hexe"', *Zeitschrift für Kunstge-schichte*, 46, 1983, pp.187–202

Millar 1958–60
'Abraham van der Doort's Catalogue of the Collections of
Charles I', edited by O. Millar, *Walpole Society*, 37 (1958–60)

Möhle 1940
H. Möhle, *Adam Elsheimer. Ein deutscher Malerpoet in Rom*,
Burg. 1940

Möhle 1966
H. Möhle, *Die Zeichnungen Adam Elsheimers*, Berlin, 1966

Moir 1967
A. Moir, *The Italian Followers of Caravaggio*, 2 vols., Cam-
bridge, Mass., 1967

Monkiewicz 1988
M. Monkiewicz, 'A Drawing of Elsheimer in the collection of
the National Museum in Warsaw', *Bulletin du Musée Natio-
nal de Varsovie*, 29, 1988, pp.93–105

Moormann/Uitterhoeve 1995
E.M. Moormann and W. Uitterhoeve, *Lexikon der antiken
Gestalten. Mit ihrem Fortleben in Kunst, Dichtung und Musik
(Kröners Taschenausgabe 468)*, Stuttgart, 1995

Morris/Evans 1984
E. Morris and M. Evans, *Supplementary Foreign Catalogue,
Walker Art Gallery*, Liverpool, 1984

Müller 1956
W.J. Müller, *Der Maler Georg Flegel und die Anfänge des
Stillebens*, Frankfurt, 1956

Müller 1970
W.J. Müller, 'Deutsche Malerei', in Hubala 1970, pp.195–201

Müller Hofstede 1966
J. Müller Hofstede, 'Zu Rubens' zweitem Altarwerk für Sta
Maria in Valicella', *Nederlands Kunsthistorisch Jaarboek*,
17, 1966, pp.1–78

Müller Hofstede 1970
J. Müller Hofstede, 'Rubens in Rom 1601–02. Die Altar-
gemälde für S. Croce in Gerusalemme', *Jahrbuch der
Berliner Museen*, 12, 1970, pp.61–110

Müller Hofstede 1983
J. Müller Hofstede, 'Zwei Antikenstudien von Johann Rotten-
hammer aus dem Besitz Elsheimers', in *Essays in Northern
European Art, presented to Egbert Haverkamp-Begemann on
his Sixtieth Birthday*, Doornspijk, 1983, pp.183–89

Munich 1973
'Deutsche und niederländische Malerei zwischen Renaissance
und Barock', in *Alte Pinakothek München. Katalog I*, 3rd
edition, Munich, 1973

Muller 1989
J.M. Muller, *Rubens: The Artist as Collector*, Princeton, 1989

Munich 1963
*Alte Pinakothek München, Katalog I. Deutsche und nieder-
ländische Malerei zwischen Renaissance und Barock*. edited
by K. Martin, Munich, 1963

Munich 1983
*Bayerische Staatsgemäldesammlungen. Alte Pinakothek
München. Erläuterungen zu den ausgestellten Gemälden*,
edited by E. Steingräber, Munich, 1983

Nagler
G.K. Nagler, *Neues allgemeines Künstler-Lexicon*, 22 vols.,
Munich, 1835–1852

Nagler Monogr.
G.K. Nagler, *Die Monogrammisten*, 6 vols., Munich, 1858–79

Neumeister 2003
M. Neumeister, *Das Nachtstück mit Kunstlicht in der nieder-
ländischen Malerei und Graphik des 16. und
17. Jahrhunderts*, Petersberg, 2003

Nikulin 1987
N.N. Nikulin, *German and Austrian Painting Fifteenth to
Eighteenth Centuries. The Hermitage, Catalogue of Western
European Painting*, Florence, 1987

Nikulin/Aswaristsch 1986
N.N. Nikulin and B. Aswaristsch, *Deutsche und österreichis-
che Malerei*, Leningrad, 1986

Noack 1907
F. Noack, *Deutsches Leben in Rom 1700–1900*, Stuttgart and
Berlin, 1907

Noack 1909
F. Noack, 'Urkundliches über Adam Elsheimer in Rom',
Kunstchronik, NF 21, no.32, 1909–1910, cols. 513–517

Oehler 1967
L. Oehler, 'Zu einigen Bildern aus Elsheimers Umkreis',
Städel-Jahrbuch, NF 1, 1967, pp.148–170

Orbaan 1927
J.A.F. Orbaan, 'Notes on Art in Italy, III: A lost masterwork of
Adam Elsheimer?', *Apollo*, 6, 1927, pp.157–58

Orenstein 1996
N.M. Orenstein, *Hendrick Hondius and the Business of Prints
in Seventeenth Century Holland*, Rotterdam, 1996

Ottani Cavina 1968
A. Ottani Cavina, *Carlo Saraceni*, Milan, 1968

Ottani Cavina 1976
A. Ottani Cavina, 'On the Theme of Landscape II', *Burlington
Magazine*, 118, 1976, pp.139–44

Ovid *Metamorphoses*
P. Ovidius Naso, *Metamorphoses*, translated by D. Raeburn.
London, 2004.

Pariset 1935
F.G. Pariset, 'Effets de clair-obscur dans l'école Lorraine', in
Archives Alsaciennes d'histoire de l'art, 14, 1935, pp.231–48

Parthey (+ no.)
G. Parthey, *Wenzel Hollar. Beschreibendes Verzeichnis seiner Kupferstiche*, Berlin 1853. Appendix and corrections, Berlin, 1858

Passavant 1847
J.D. Passavant, 'Adam Elsheimer, Maler aus Frankfurt am Main', *Archiv für Frankfurts Geschichte und Kunst*, 4, 1847, pp.44–85

Passavant 1858
J.D. Passavant, 'Adam Elsheimer, Maler aus Frankfurt am Main. Nachtrag zum Verzeichniss seiner Werke', *Archiv für Frankfurts Geschichte und Kunst*, 8, 1858, pp.113–22

Pauly/Wissowa
Paulys Real-Encyclopädie der klassischen Altertumswissenschaft, edited by G. Wissowa, Stuttgart, 1901

Pée 1971
H. Pée, 'Johann Heinrich Schönfeld. Die Gemälde', in *Jahresgabe des Deutschen Vereins für Kunstwissenschaft 1969*, Berlin, 1971

Peltzer 1916
A.R. Peltzer, 'Hans Rottenhamme', *Jahrbuch der kunsthistorischen Sammlungen des allerhöchsten Kaiserhauses*, 33, 1916, pp.293–365

Pennington 1982
R. Pennington, *A Descriptive Catalogue of the Etched Work of Wenceslaus Hollar 1607–1677*, Cambridge, 1982

Pepper 1984
D.S. Pepper, *Guido Reni: A Complete Catalogue of his Works with an Introductory Text*, Oxford, 1984

Pigler 1974
A. Pigler, *Barockthemen*, 3 vols., extended 2nd edition, Budapest, 1974

Pignatti 1976
T. Pignatti, *Veronese. L'opera completa*, 2 vols., Venice, 1976

Pijl 1996
L. Pijl, 'Bril, Paul', in *AKL*, vol.14 (1996), pp.228–30

Pijl 1998
L. Pijl, 'Paintings by Paul Bril in collaboration with Rottenhammer, Elsheimer and Rubens', *Burlington Magazine*, 140, 1998, pp.660–67

Pijl 1999
L. Pijl, 'Figure and Landscape: Paul Bril's Collaboration with Hans Rottenhammer and Other Figure Painters', in *Fiamminghi a Roma. Proceedings of the Symposium Held at Museum Catharijneconvent, Utrecht, 13 March 1995* (Italia e i Paesi Bassi 5), edited by S. Eiche *et al.*, Florence, 1999, pp.79–91

Pijl 2002
L. Pijl, 'Elsheimer, Adam', in *AKL*, vol.33, 2002, pp.385–90

Posner 1971
D. Posner, *Annibale Carracci: A Study in the Reform of Italian Painting around 1590*, 2 vols., London and New York, 1971

RAC
Reallexikon für Antike und Christentum, Munich, 1950–

Rapp 1989
J. Rapp, 'Adam Elsheimer "Aeneas rettet Anchises aus dem brennenden Troja". Ein Stammbuchblatt in Deckfarbenmalerei', *Pantheon*, 47, 1989, pp.112–32

RDK
Reallexikon zur deutschen Kunstgeschichte, edited by O. Schmitt, Stuttgart, 1937–

Reitlinger 1921
Henry Scipio Reitlinger, 'Hendrik, Count Goudt', *Print Collector's Quarterly*, 8, 1921, pp.230–45

Renger 1977
K. Renger *et al.*, *Rubens in der Grafik*, exh. cat., Göttingen and Hannover and Nürnberg, 1977

Renger/Denk 2002
K. Renger and C. Denk, *Flämische Malerei des Barock in der Alten Pinakothek*, Munich, 2002

Ridolfi 1648
C. Ridolfi, *Le maraviglie dell'arte, overo Le vite de gl'illustri pittori veneti, e dello Stato*, 2 vols., Venice and Sgava, 1648

Roethlisberger 1968
M. Roethlisberger, 'Claude Lorrain. The Drawings', *California Studies in the History of Art*, 8, 2 vols., Berkeley, 1968

Roethlisberger 1981
M. Roethlisberger, *Bartholomeus Breenbergh: The Paintings*, Berlin and New York, 1981

Ruelens/Rooses 1887–1909
C. Ruelens and M. Rooses, *Correspondance de Rubens et Documents épistolaires concernant sa Vie et ses Oeuvres*, 6 vols., Antwerpen, 1887–1909

Salerno 1977
L. Salerno, *Pittori di paesaggio del Seicento a Roma*, 3 vols., Rome, 1977–80

Sandrart 1675
J. von Sandrart, Teutsche *Academie der Bau-, Bild- und Mahlerey-Künste*. Nürnberg 1675, edited by A.R. Peltzer, Munich, 1925

Saxton 2005
J. Saxton, *Nicolaus Knüpfer (1603/09–1655): An Original Artist. With a Catalogue Raisonné of Paintings and Drawings*, Doornspijk, 2005

Schatborn 1996
P. Schatborn, 'Tekeningen van de gebroeders Jan en Jacob
Pynas. I. Jan Pynas', *Bulletin van het Rijksmuseum*, 44,
1996, pp.37–54

Schatborn 1997
P. Schatborn, 'Tekeningen van de gebroeders Jan en Jacob
Pynas. II. Jacob Pynas', *Bulletin van het Rijksmuseum*, 45,
1997, pp.3–25

Schavemaker 2000
E. Schavemaker, 'Eglon van der Neers "Tobias en de engel" in
het Rijksmuseum', *Bulletin van het Rijksmuseum*, 48, 2000,
pp.163–69

Schilder 1987
G. Schilder, *Monumenta Cartographica Neerlandica II*,
2 vols., Alphen, 1987

Schlichtenmaier 1988
H. Schlichtenmaier, *Studien zum Werk Hans Rottenhammers
des Älteren (1564–1625), Maler und Zeichner mit Werk-
katalog*, Stuttgart, 1988

Schneider 1921
H. Schneider, 'Der Maler Jan Tengnagel', *Oud Holland*, 39,
1921, pp.10–27

Schrevelius 1648
T. Schrevelius, *Harlemias, Ofte, om beter te seggen, De eerste
stichtinghe der Stadt Haerlem, Het toenemen en vergrootinge
der selfden, hare seltsame fortuyn en avontuerin Vrede, in
Oorlogh, Bilegenings*, Haarlem-Fonteyn, 1648

Schweiger 1834
F.L.A. Schweiger, *Bibliographisches Lexicon der gesamten
Literatur der Römer*, 2 vols., Leipzig, 1834 (reprint Amster-
dam, 1962)

Schwerin 1882
F. Schlie, *Beschreibendes Verzeichniss der Werke älterer
Meister in der Grossherzoglichen Gemälde-Gallerie zu
Schwerin*, Schwerin, 1882

Schwerin 1990
K. Hegner, *Kunst der Renaissance, Staatliches Museum
Schwerin*, Schwerin, 1990

Seibt 1885
W. Seibt, *Adam Elsheimers Leben und Wirken*, Frankfurt,
1885

Seifert 2005 A
C. T. Seifert, 'Beiträge zu Leben und Werk des Lindauer
Malers Jakob Ernst Thomann von Hagelstein (1588–1653)',
in *Wissenschaftliches Jahrbuch Zeppelin Museum
Friedrichshafen*, 2005, pp.100–11

Seifert 2005 B
C. T. Seifert, 'Rebekka en Eliëzer bij de put – een onbekend
schilderij van Jan Tengnagel (1584–1635)', *Kroniek van Het
Rembrandthuis*, 2005, no.1–2, pp.14–23

Seifert 2006
C. T. Seifert, 'Adam Elsheimer und Pieter Lastman
Zur Wirkungsgeschichte von Elsheimers Werk in der hol-
ländischen Malerei des frühen 17. Jahrhunderts',
in Elsheimer 2006

Seifertová 2003
H. Seifertová, 'Malowid?a na miedzi w sztuce europejskiej
XVI–XVIII w./Paintings on Copper in European Art from the
16th to the 18th Century', in *Malarstwo na miedzi/Paintings
on Copper*, exh. cat. by H. Seifertová and L. Wojtasik-
Seredyszyn, Legnica and Prague, 2003

Seilern 1955
A.S. (A. Count Seilern), *Flemish Paintings & Drawings at
56 Princes Gate London SW 7*, London, 1955

Sello 1988
G. Sello, *Adam Elsheimer*, Dresden, 1988

Shakeshaft 1981
P. Shakeshaft, 'Elsheimer and G.B. Crescenzi', *Burlington
Magazine*, 123, 1981, pp.550–51

Shawe-Taylor 1991
D. Shawe-Taylor, 'Elsheimer's "Mocking of Caravaggio"',
Zeitschrift für Kunstgeschichte, 54, 1991, pp.207–219

Sluijter-Seijffert 1984
N.C. Sluijter-Seijffert, *Cornelis van Poelenburgh (ca. 1593–
1667)*, Enschede, 1984

Stampfle 1983
F. Stampfle, 'Goudt's Drawings of Tobias and the Angel', in
*Essays in Northern European Art, presented to Egbert
Haverkamp-Begemann on his sixtieth birthday*, Doornspijk,
1983, pp.257–59

Stechow 1966
W. Stechow, *Dutch Landscape Painting of the Seventeenth
Century*, London, 1966

Stolze 1956
A.O. Stolze, *Der Sünfzen zu Lindau. Das Patriziat einer
schwäbischen Reichsstadt*, edited by B. Zeller, Lindau and
Konstanz, 1956

Strieder 1966
P. Strieder, 'Zur Vita des Johann König', in *Anzeiger des
Germanischen National-Museums*, 1966, pp.88–90

Stuffmann 1969
M. Stuffmann, 'Miszellen zu zwei Bildern von Hans Rotten-
hammer und Adam Elsheimer', *Städel-Jahrbuch*, NF 2,
pp.169–77

Sumowski 1992
W. Sumowski, 'Varianten bei Elsheimer', *Artibus et histo-
riae*, 13, 1992, pp.145–61

Sumowski 1995
W. Sumowski, '"The Artist in Despair": A New Drawing by
Adam Elsheimer', *Master Drawings*, 33, 1995, pp.152–56

Swillens 1931
P.T.A. Swillens, 'Jonkheer Hendrik Goudt. Een edelman plaat-snijder te Utrecht in de 17de eeuw', *De Tampon*, 12, 1931, pp.49–70

Swillens 1946
P.T.A. Swillens, 'Hendrik Goudt', *Maandblad van Oud-Utrecht*, 19, 1946, pp.84–87

Tacke 2001
"Der Mahler Ordnung und Gebräuch in Nürmberg". Die Nürnberger Maler (zunft)bücher ergänzt durch weitere Quellen, Genealogien und Viten des 16., 17. und 18. Jahrhunderts, edited by A. Tacke, Berlin, 2001

Van Tatenhove 1983
J. van Tataenhove, 'Tekeningen van David Teniers de Oude (1582–1649)', *Oud Holland*, 97, 1983, pp.201–04

Thielemann 2006
A. Thielemann, 'Natur pur? Literarische Quellen und philosophische Ziele der Naturdarstellung bei Elsheimer', in Elsheimer 2006

Thielemann 2006 A
A. Thielemann, 'Vitruvianische Künstlerklage und neuzeitliche Künstlertopik. Alberti, Alciato, Rivius, Heemskerck, Federico Zuccari, Elsheimer und Poussin', in Elsheimer 2006

Thieme/Becker
U. Thieme and F. Becker, *Allgemeines Lexikon der bildenden Künstler von der Antike bis zur Gegenwart*, 37 vols., Leipzig, 1907–50

Thiéry 1953
Y. Thiéry, *Le paysage flamand au XVIIe siècle*, Paris and Brussels, 1953

Tietze 1936
H. Tietze, *Titian. Gemälde und Zeichnungen*, Vienna, 1936

Tietze 1948
H. Tietze, *Tintoretto. Gemälde und Zeichnungen*, London, 1948

Tietze 1958
H. Tietze, *Tintoretto. The Paintings and Drawings*, London, 1958

Tümpel 1974
A. Tümpel, 'Claes Cornelisz. Moeyaert', *Oud Holland*, 88, 1974, pp.1–163, 245–90

Turin 1866
Catalogo Ufficiale della Galleria Sabauda, Turin, 1866

Turin 1968
La Galleria Sabauda di Torino, Turin, 1968

Turin 1982 A
Pittura fiamminga ed olandese in Galleria Sabauda. Il Principe Eugenio di Savoia-Soissons uomo d'arme e collezionista, Turin, 1982

Turin 1982 B
Conoscere la Galleria Sabauda. Documenti sulla storia delle sue collezioni, Turin, 1982

Turin 1993
Guide Brevi della Galleria Sabuada. Le collezioni del principe Eugenio e di pittura fiamminga e olandese, Turin, 1993

Turner Dictionary 1996
The Dictionary of Art, 34 vols., edited by J. Turner, London, 1996

Uppenkamp 2004
B. Uppenkamp, *Judith und Holofernes in der italienischen Malerei des Barock*, Berlin, 2004

Van de Velde 1605
J. van de Velde, *Spieghel der Schrijfkonste*, Rotterdam, 1605 (reprint Nieuwkoop, 1969).

Veldman 2001
I.M. Veldman, *Crispijn de Passe and his Progeny*, Rotterdam, 2001

Vlieghe 1973
H. Vlieghe, *Corpus Rubenianum Ludwig Burchard VIII: Saints*, 2 vols., Brussels and London, 1973

Volk-Knüttel 1980
B. Volk-Knüttel, 'Maximilian I. von Bayern als Sammler und Auftraggeber. Seine Korrespondenz mit Philipp Hainhofer 1611–1615', in *Quellen und Studien zur Kunstpolitik der Wittelsbacher vom 16. bis zum 18. Jahrhundert (Mitteilungen des Hauses der Bayerischen Geschichte I)*, edited by H. Glaser, Munich, 1980, pp.83–128

Vosmaer 1863
C. Vosmaer, *Rembrandt Harmens van Rijn. Ses précourseurs et ses années d'apprentissage*, The Hague, 1863

Vosmaer 1877
C. Vosmaer, *Rembrandt. Sa vie et ses œuvres*, 2nd edition, The Hague, 1877

Voss 1929
H. Voss, 'Elsheimers "Heilige Familie mit Engeln", eine Neuerwerbung der Gemäldegalerie', *Berliner Museen*, 50, 1929, pp.20–27

Waagen 1854
G.F. Waagen, *Treasures of Art in Great Britain*, 3 vols., London, 1854

Waagen 1857
G.F. Waagen, *Galleries and Cabinets of Art in Great Britain (supplement to Treasures of Art in Great Britain)*, London, 1857

Waddingham 1963
M. Waddingham, 'Bologna in Retrospect: Some Northern Aspects', *Paragone*, 15, no.159, 1963, pp.57–66

Waddingham 1966
M. Waddingham, *Adam Elsheimer (I Maestri de' Colore 130)*, Milan, 1966

Waddingham 1966 A
M. Waddingham, *I paesaggisti nordici italianizzanti del XVII secolo*, Milan, 1966

Waddingham 1967
M. Waddingham, 'Adam Elsheimer and His Circle at Frankfurt', *Burlington Magazine*, 109, 1967, pp.44–48

Waddingham 1970
M. Waddingham, 'Proposte per Teniers il Vecchio', *Arte illustrata*, 3, no.25/26, 1970, pp.58–69

Waddingham 1972 A
M. Waddingham, 'David Teniers the Elder', *Burlington Magazine*, 114, 1972, pp.96–97

Waddingham 1972 B
M. Waddingham, 'Elsheimer Revised', *Burlington Magazine*, 114, 1972, pp.600–11

Waddingham 1978
M. Waddingham, 'An Elsheimer Monograph', *Burlington Magazine*, 120, 1978, pp.853–55

Wegner 1969
W. Wegner, 'Bemerkungen zu Jakob Ernst Thomann von Hagelstein und zur Kunst des Elsheimerkreises', *Städel-Jahrbuch*, NF 2, 1969, pp.178–88

Wegner 1973
W. Wegner, 'Werke deutscher und niederländischer Künstler in Rom und Neapel um 1600', *Pantheon*, 31, 1973, pp.40–45

Weigert/Préaud 1976
R.-A. Weigert and M. Préaud, *Bibliotheque Nationale. Département des Estampes. Inventaire du fonds français. Graveurs du XVIIe siècle*, vol.7, Paris, 1976

Weizsäcker 1910
H. Weizsäcker, 'Elsheimers Lehr- und Wanderzeit in Deutschland', *Jahrbuch der Preußischen Kunstsammlungen*, 31, 1910, pp.170–204

Weizsäcker 1914
H. Weizsäcker, 'Adam Elsheimer', in Thieme/Becker (1914)

Weizsäcker 1921
H. Weizsäcker, 'Ein neuer Elsheimer im Städelschen Institut', *Städel-Jahrbuch*, 1, 1921, pp.129–48

Weizsäcker 1927
H. Weizsäcker, 'Adam Elsheimers Originalradierungen', *Jahrbuch der Preußischen Kunstsammlungen*, 48, 1927, pp.58–72

Weizsäcker 1928
H. Weizsäcker, 'Hendrik Goudt', *Oud Holland*, 45, 1928, pp.110–22

Weizsäcker 1936
H. Weizsäcker, *Adam Elsheimer, der Maler von Frankfurt I. Des Künstlers Leben und Werke*, 2 vols., Berlin, 1936

Weizsäcker 1939
H. Weizsäcker, 'Ein Gemälde von Hendrik Goudt', *Oud Holland*, 56, 1939, pp.185–92

Weizsäcker 1952
H. Weizsäcker, *Adam Elsheimer, der Maler von Frankfurt II. Beschreibende Verzeichnisse und geschichtliche Quellen Aus dem Nachlaß H. Möhle*, Berlin, 1952

Wethey 1969
H.E. Wethey, *The Paintings of Titian*, 3 vols., London, 1969–75

White 1995
C. White, *Thomas Howard the Earl of Arundel*, Malibu, 1995

Willnau 1931/32
C. Willnau, 'Von Elsheimers Contento zu Knüpfers Contentement', *Zeitschrift für Bildende Kunst*, 65, 1931/32, pp.113–20

Winzinger 1963
F. Winzinger, *Albrecht Altdorfer, Graphik. Holzschnitte, Kupferstiche, Radierungen. Gesamtausgabe*, Munich, 1963

Witte 2006
A. Witte, 'Elsheimer's Patrons in Early Modern Rome: Odoardo Farnese and levels of meaning in the Contento', in Elsheimer 2006

Wittkower 1958
R. Wittkower, *Art and Architecture in Italy, 1600–1750*, Baltimore, 1958 (2nd edition, Harmondsworth, 1965).

Wittkower 1965
R. and M. Wittkower, *Künstler, Außenseiter der Gesellschaft*, Stuttgart, 1965

Wohlfromm 1997
G. Wohlfromm, *Rembrandts Auseinandersetzung mit der Kunst Adam Elsheimers*, Frankfurt, 1997

Wood Ruby 1999
L. Wood Ruby, *Paul Bril. The Drawings*, Turnhout, 1999

Wurzbach 1906
A. von Wurzbach, *Niederländisches Künstler-Lexikon*, 3 vols., Vienna and Leipzig 1906

Zoff 1918
Die Briefe des P.P. Rubens, translation and introduction by O. Zoff, Vienna, 1918

Exhibition Catalogues

Amsterdam/Boston/Philadelphia 1987
Masters of 17th-Century Dutch Landscape Painting, edited by
P.C. Sutton *et al.*, Rijksmuseum, Amsterdam; Museum of Fine
Arts, Boston; Philadelphia Museum of Art, Philadelphia, 1987

Amsterdam 1991
*Pieter Lastman: leermeester van Rembrandt/the man who
taught Rembrandt*, compiled by A. Tümpel, P. Schatborn *et
al.*, Museum Het Rembrandthuis, Amsterdam, 1991

Amsterdam 1993
*Dawn of the Golden Age. Northern Netherlandish Art
1580–1620*, edited by G. Luijten, A. van Suchtelen *et al.*,
Rijksmuseum, Amsterdam, 1993

Antwerp 2004
*De uitvinding van het landschap. Van Patinir tot Rubens
1520–1650*, compiled by P. Huvenne *et al.*, Koninklijk
Museum voor Schone Kunsten, Antwerp, 2004

Antwerp 2004 A
A House of Art. Rubens as Collector. compiled by K. Lohse
Belkin and F. Healy, Rubenshuis, Antwerp, 2004

Augsburg 1968
Augsburger Barock, edited by B. Bushart, Rathaus and
Holbeinhaus, Augsburg, 1968

Berlin 1966
Deutsche Maler und Zeichner des 17. Jahrhunderts, com-
piled by R. Klessmann *et al.*, Staatliche Museen Berlin der
Stiftung Preussischer Kulturbesitz, Schloss Charlottenburg,
Berlin, 1966

Berlin 1975
Pieter Bruegel d. Ä. als Zeichner. Herkunft und Nachfolge,
compiled by M. Winner *et al.*, Staatliche Museen Preussischer
Kulturbesitz, Küpferstichkabinett, Berlin, 1975

Bologna 1962
*L'Ideale classico del Seicento in Italia e la pittura di paesag-
gio*, compiled by A. Emiliani, Biennale d'arte antica, 2nd
revised edition, Bologna, 1962

Boston 1981
C.S. Ackley, *Printmaking in the Age of Rembrandt*, Musem of
Fine Arts, Boston, 1981

Brussels/Rome 1995
*Fiamminghi a Roma 1508–1608: Artistes des Pays-Bas et de
la Principaute? de Lie?ge a? Rome a? la Renaissance/
Kunstenaars uit de Nederlanden en het prinsbisdom Luik te
Rom tijdens de Renaissance/ Artisti dei Paesi Bassi e del
Principato di Liegi a Roma durante il Rinascimento*, compiled
by N. Dacos Crifò *et al.*, Palais des Beaux-Arts, Brussels;
Palazzo delle Esposizione, Rome, 1995

Cologne 1977
Peter Paul Rubens 1577–1640. I, Rubens in Italien, compiled
by J. Müller Hofstede Wallraf-Richartz-Museum, held in the
Kunsthalle, Cologne, 1977

Dresden 1972
Europäische Landschaftsmalerei 1550–1650, edited by A.
Mayer-Meintschel, Albertinum, Dresden, 1972

Dublin 2005
Northern Nocturnes. Nightscapes in the Age of Rembrandt,
cat. by A. Waiboer and M. Franken, National Museum of
Ireland, Dublin, 2005

Essen/Vienna 2003
Die flämische Landschaft 1520–1700, edited by K. Schütz *et
al.*, Kulturstiftung Ruhr Essen, Villa Hügel; Kunsthistorisches
Museum, Vienna, 2003

Frankenthal 1995
Kunst, Kommerz, Glaubenskampf. Frankenthal um 1600, cat.
by E.J. Hürkey, Erkenbert-Museum, Frankenthal, l995

Frankfurt 1966
Adam Elsheimer, edited by E. Holzinger, compiled by J. Held,
Städelsches Kunstinstitut, Frankfurt, 1966

Frankfurt 1991
*Von Lucas Cranach bis Caspar David Friedrich. Deutsche
Malerei aus der Ermitage*, edited by S. Ebert-Schifferer,
Schirn Kunsthalle, Frankfurt, 1991

Göttingen/Hannover/Nuremberg 1977
Rubens in der Grafik, cat. by B. Gaetghens, K. Renger and G.
Unverfehrt, Kunstsammlung der Universität Göttingen; Lan-
desmuseum, Hannover; Museen der Stadt Nuremberg, 1977

's-Hertogenbosch 2001
*Panorama op de wereld. Het landschap van Bosch tot
Rubens*, cat. by Paul Huys Janssen, Noordbrabants Museum,
's-Hertogenbosch, 2001

Leiden 1968
Rondom Rembrandt. De verzameling Daan Cevat, Stedelijk
Museum De Lakenhal, Leiden, 1968

London 1955
Artists in 17th Century Rome, compiled by D. Mahon and D.
Sutton, Wildenstein & Co., London, 1955

London 1977
Rubens: Drawings and Sketches, cat. by J. Rowlands, British
Museum, London, 1977

London 1983
The Genius of Venice 1500–1600, edited by J. Martineau and
C. Hope, Royal Academy of Arts, London, 1983

London 1986
*Dutch Landscape. The Early Years. Haarlem and Amster-dam
1590–1650*, cat. by C. Brown, National Gallery, London, 1986

London 1995
*In Trust for the Nation. Paintings from National Trust
Houses*, cat. by A. Laing, National Gallery, London, 1995

London 2001 A
The Genius of Rome 1592–1623, edited by B.L. Brown, Royal Academy of Arts, London, 2001

London 2001 B
The Print in Italy: 1550–1620, cat. by M. Bury, British Museum, London, 2001

London 2002
Inspired by Italy. Dutch Landscape Painting 1600–1700, cat. by L.B. Harwood, Dulwich Picture Gallery, London, 2002

Madrid 1992
David Teniers, Jan Brueghel y los Gabinetes de Pinturas, Museo del Prado, Madrid, 1992

Manchester 1961
German Art 1400–1800 from Collections in Great Britain, compiled by F.G. Grossmann *et al.*, Manchester City Art Gallery, Manchester, 1961

Munich 1998
Die Nacht, edited by S. Rosenthal *et al.*, Haus der Kunst, Munich, 1998

Munich 2005
Von neuen Sternen. Adam Elsheimers 'Flucht nach Ägypten', edited by R. Baumstark, M. Dekiert *et al.*, Alte Pinakothek, Munich, 2005

Naples 1991
Battistello Caracciolo e il primo naturalismo a Napoli, edited by F. Bologna, Castel Sant'Elmo, chiesa della Certosa di San Martino, Naples, 1991

New York 1985
Landscape Painting in Rome 1595–1675, compiled by A. Sutherland Harris *et al.*, Richard L. Feigen & Co., New York, 1985

Naples 1985
Caravaggio e il suo tempo, compiled by N. Spinosa *et al.*, Museo nazionale di

Nuremberg 1962
Barock in Nuremberg 1600–1750. Aus Anlaß der Dreihundertjahrfeier der Akademie der bildenden Künste, Germanischen National-Museum, Nuremberg, 1962

Phoenix/Kansas City/The Hague 1999
Copper as Canvas. Two Centuries of Masterpiece Paintings on Copper 1575–1775, Phoenix Art Museum, Phoenix; Nelson-Atkins Museum of Art, Kansas City; Royal Cabinet of Paintings Mauritshuis, The Hague, 1999

Raleigh 1998
Sinners and Saints, Darkness and Light: Caravaggio and his Dutch and Flemish Followers, cat. by D.P. Weller *et al.*, North Carolina Museum of Art, Raleigh, 1998

Rotterdam 1988
Italianisanten en Bamboccianten: Het italianiserend landschap en genre door Nederlandse kunstenaars uit de zeventiende eeuw, cat. by G. Jansen and G. Luijten, Museum Boijmans Van Beuningen, Rotterdam, 1988

Sacramento 1974
The Pre-Rembrandtists, cat. by A. Tümpel and C. Tümpel, E.B. Crocker Art Gallery, Sacramento, 1974

Stuttgart 1980
Zeichnung in Deutschland. Deutsche Zeichner 1540–1640, edited by H. Geissler, Staatsgalerie Stuttgart, Graphische Sammlung, Stuttgart, 1980

Venice 1999
Il Rinascimento a Venezia e la pittura del Nord (Renaissance Venice and the North), compiled by B. Aikema, B.L. Brown, Palazzo Grassi, Venice, 1999

Washington 1993
Master European Drawings from Polish Collections, edited by A. Kozak and M. Monkiewicz, Travelling exhibition travelling from Nelson-Atkins Museum of Art, Kansas City on, organised by Trust for Museum Exhibitions, Washington DC, 1993

Vienna 1988
Guido Reni und der Reproduktionsstich, cat. by V. Birke, Graphische Sammlung Albertina, Vienna, 1988

Lenders to the Exhibition

DENMARK

Copenhagen, Statens Museum for Kunst

FRANCE

Montpellier, Musée Fabre
Paris, Musée du Louvre, Cabinet des Dessins

GERMANY

Berlin, Staatliche Museen, Gemäldegalerie
Berlin, Staatliche Museen, Kupferstichkabinett
Bonn, Rheinisches Landesmuseum
Brunswick, Herzog Anton Ulrich-Museum
Cologne, Wallraf-Richartz-Museum – Fondation
 Corboud
Dresden, Staatliche Kunstsammlungen, Gemäldegalerie
Frankfurt, Historisches Museum
Hamburg, Kunsthalle
Munich, Bayerische Staatsgemäldesammlungen,
 Alte Pinakothek

ITALY

Florence, Galleria degli Uffizi

LIECHTENSTEIN

Vaduz, Stiftung Wolfgang Ratjen

POLAND

Warsaw, Muzeum Narodowe

RUSSIA

St Petersburg, Hermitage

SPAIN

Madrid, Museo del Prado

UNITED KINGDOM

Cambridge, Fitzwilliam Museum
Chatsworth, Devonshire Collection
Edinburgh, National Gallery of Scotland
Liverpool, Walker Art Gallery
London, The British Museum
London, The National Gallery
London, The Wellcome Institute for the History of Medicine
London, The Wellington Museum, Apsley House
Petworth, Petworth House, The Egremont Collection
 (The National Trust)
The Royal Collection Trust, England

USA

Fort Worth, Kimbell Art Museum
Milwaukee, Dr Alfred and Isabel Bader
Mr and Mrs Edward D. Baker

*and the private collectors who wish to remain
anonymous*

Index

Photographic Credits

Amsterdam, Museum het Rembrandthuis fig.153
Amsterdam, Rijksmuseum figs.72, 92, 152, 154
Bassano, Museo Civico fig.88
Berlin, bpk fig.6; cat.3; bpk – Photo Bulloz, RMN fig.42;
 bpk – Photo Jörg P. Anders figs.10, 12, 51, 64, 102, 106,
 147; cats.7, 45 bpk – Photo RMN fig.90; cat.41; bpk –
 Photo Michèle Bellot, RMN fig.90; cat.39; bpk – Photo
 Christoph Irrgang cat.42
Berlin, Staatliche Museen, Kupferstichkabinett fig.121
Bonn, Rheinisches Landesmuseum, Landschaftsverband
 Rheinland, Photo H.N. Loose fig.27; cat.15
Braunschweig, Herzog Anton Ulrich-Museum figs.103, 104;
 Museumsfoto Bernd-Peter Keiser figs.7, 18, 28, 45;
 cats.16, 29
Cambridge, Fitzwilliam Museum, University of Cambridge
 figs.53a,b; cat.32
Chatsworth, Devonshire Collection, by permission of the
 Chatsworth Settlement Trustees figs.37, 99; cats.24, 44
Cologne, Rheinisches Bildarchiv fig.48; cat.33
Copenhagen, Statens Museum for Kunst figs.50, 100; cat.34
Dresden, Staatliche Kunstsammlungen, Kupferstichkabinett
 fig.13
Dresden, Staatliche Kunstsammlungen, Gemäldegalerie
 Alte Meister, Photo J. Karpinski figs.54, 157; cat.35
Edinburgh, National Gallery of Scotland, Photo Antonia
 Reeve figs.30, 38, 90; cats.19, 25, 40
Florence, Archivio dello Stato figs.32, 33
Florence, Galleria degli Uffizi figs.82, 87, 129
Fort Worth, Kimbell Art Museum, Photo Michael Bodycomb
 2005 figs.35, 130; cat.23
Frankfurt, Institut für Stadtgeschichte figs.2, 59
Frankfurt, David Hall fig.144
Frankfurt, Graphische Sammlung im Städelschen
 Kunstinstitut figs.60, 85, 188; cat.38
Frankfurt, Historisches Museum, Photo Horst Ziegenfusz
 figs.1, 3, 49; cat.30
Frankfurt, Ursula Edelmann figs.58, 61, 62, 63, 73, 75, 79,
 80, 89, 96, 101, 105, 107, 109, 110, 111, 114, 115, 117, 119,
 123, 125, 137; cats.46, 48–60
Friedrichshafen, Zeppelin-Museum fig.144
Grasse, Cathedral (dépot de l'Hospice municipal) Hôpital de
 Petit-Paris fig.24
Hamburg, Kunsthalle figs.39, 94, 95; cat.42
Kingston, Collection of the Agnes Etherington Art Centre,
 Queen's University fig.158
Leeuwarden, Princessehof Leeuwarden, Photo Johan van der
 Veer fig.108
Liverpool, Board of Trustees of the National Museums and
 Galleries on Merseyside (Walker Art Gallery) fig.47; cat.31
London, Bridgeman Art Library fig.132
London, The British Museum figs.82a, 139
London, Courtauld Institute Galleries – The Princess Gate
 Collection fig.140
London, Courtesy of Sotheby's figs.91, 116, 141, 142,
 160, 161
London, English Heritage Photo Library, Photo Nigel Corrie
 fig.21; cat.14
London, National Portrait Gallery figs.126, 127

London, The National Gallery figs.11, 14, 29, 83, 120;
 cats.8, 9, 18
London, The Royal Collection © HM Queen Elizabeth II figs.4,
 131; cats.1, 6
London, The Wellcome Institute for the History of Medicine
 fig.5; cat.2
Los Angeles, The J. Paul Getty Museum fig.128
Madrid, Museo Nacional del Prado figs.40, 52; cat.27
Manchester, The Whitworth Art Gallery, University of
 Manchester fig.133
Milwaukee, Collection of Dr Alfred and Isabel Bader figs.97,
 98; cat.26
Montpellier, Musée Fabre, Photo Frédéric Jaulmes fig.34;
 cat.22
Munich, Bayerische Staatsgemäldesammlungen, Alte
 Pinakothek fig.124
Munich, Residenzmuseum fig.162
Munich, Staatliche Graphische Sammlung fig.113
Naples, Luciano Pedicini figs.46, 155
New York, The Pierpont Morgan Library figs.41, 159
Paris, Collection Frits Lugt, Institut Néerlandais figs.143, 163
Paris, École nationale supérieure des beaux-arts fig.65
Paris, Galerie Terrades fig.56
Penshurst, by kind permission of Viscount De L'Isle from his
 private collection at Penshurst Place fig.86
Private Collections figs.36, 135, 138; cats.12, 17, 28
Rome, Accademia di San Luca fig.43
Rome, Accademia nazionale dei Lincei fig.26
Rome, Galleria Nazionale fig.23
Rome, Palazzo (Verospi) del Credito Italiano, Corso fig.44
Rotterdam, Museum Boijmans Van Beuningen figs.67, 146
Schwerin, Staatliches Museum, Photo Hugo Maertens fig.134
Seville, Fundación Casa Ducal de Medinaceli fig.77
St Petersburg, Hermitage fig.20; cat.13
Stamford, Burghley House, Collection Lady Exeter fig.118
Stockholm, Nationalmuseum fig.25
Stuttgart, Staatsgalerie fig.148
Turin, Galleria Sabauda fig.136
Vaduz, Stiftung Wolfgang Ratjen fig.93; cat.43
Vatican, Photo Vatican Museums figs.68, 76
Venice, Fotoflash Mario fig.74
Venice, Scuola di San Rocco fig.84
Vienna, Gemäldegalerie der Akademie der bildenden Künste
 fig.112
Warrington, National Trust Photographic Library/John
Hammond fig.34; cat.21
Warsaw, Muzeum Narodowe fig.122; cat.47
Weilheim, Artothek figs.8, 9, 16, 31, 57, 66, 151, 156;
 cats.4, 5, 20, 37; Artothek – Alinari 2005 fig.81; Artothek
 – Bayer & Mitko fig.69; Artothek – Blauel/Gnamm figs.17,
 55; cat.36; Artothek – Blauel fig.15; cat.10; Artothek –
 Joseph S. Martin fig.70; Artothek – Ursula Edelmann
 fig.19; cats.11, 20a
Weimar, Staatliche Kunstsammlung fig.78